HEAVENLY DISCOURSES

The proceedings of the
Heavenly Discourses:
Myth, Astronomy and Culture
conference held in Bristol, UK
14–16 October 2011

Edited by Nicholas Campion

SOPHIA CENTRE PRESS

Sophia Centre Press
University of Wales, Trinity St David
Ceredigion, Wales SA48 7ED, United Kingdom.
www.sophiacentrepress.com

Cover Illustration: Näherung (Approximation), *Primo Tempore* series, Michael Hoepfel
1997. www.hoepfel.net. Used with kind permission from the artist.

ISBN: 978-1-907767-07-4

British Library Cataloguing in Publication Data.
A catalogue card for this book is available from the British Library.

Printed in the UK by Lightning Source.

HEAVENLY DISCOURSES

CONTENTS

PART ONE: HEAVENLY DISCOURSES

PART TWO: DISCOURSES IN WORDS

vi Contents

IMAGES

ACKNOWLEDGEMENTS

We are deeply grateful to the University of Bristol Alumni fund and the Sophia Centre for the Study of Cosmology in Culture and the University of Wales Trinity Saint David for funding the Heavenly Discourses conference. As editor of the proceedings, I would like to thank Darrelyn Gunzburg, my co-conference Chair and fellow organiser, as well as the remarkable, effective and efficient support we received throughout from Bernadette Brady. Without them the Heavenly Discourses conference would not have taken place and this volume would not have appeared. Thanks are of course also due to all the conference speakers, as well as to those who submitted their papers to this volume. I also have to thank Kathleen White, who finally helped me pull this volume together. And lastly, thanks are due to the University of Wales Trinity Saint David for their continuing support of the Sophia Centre Press.

A LETTER OF WELCOME: YURI GAGARIN RUSSIAN STATE SCIENTIFIC RESEARCH AND EXPERIMENTAL COSMONAUT TRAINING CENTRE

Note by Nicholas Campion: We are grateful to Boris Boyko for passing on news of the conference to the Russian cosmonauts. And we are especially grateful to the Yuri Gagarin Russian State Scientific Research and Experiential Cosmonaut Training Centre for the arm letter of welcome they sent us, along with a photograph of the statue of Yuri Gagarin at the Centre. We have reproduced the photograph and letter below, followed by a translation by Karine Dilanyan.

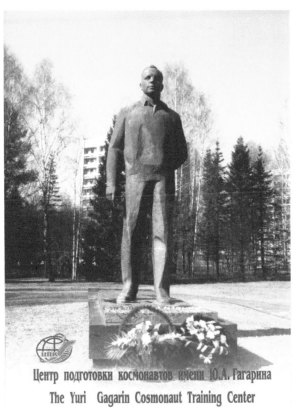

Центр подготовки космонавтов имени Ю.А. Гагарина

The Yuri Gagarin Cosmonaut Training Center

Командование, Отряд космонавтов
Российского государственного научно-исследовательского испытательного
Центра подготовки космонавтов имени Ю.А. Гагарина – Звездный городок, Россия –
сердечно приветствует участников
научной конференции Heavenly Discourses,
проходящей в Бристоле, Великобритания, 14-16 октября 2011 года,
в год пятидесятилетия первого полета человека в космос.

Мир навсегда изменился, когда Юрий Гагарин, преодолев земное притяжение,
совершил героический прорыв в космос 12 апреля 1961 года,
и мы рады, что Вы проводите эту конференцию в честь его
грандиозного достижения.

Желаем всем участникам конференции творческих успехов, здоровья, оптимизма и
бодрости духа,
мы уверены, что конференция будет успешной
и станет важным шагом для осмысления
отношений человека и космоса и его места во Вселенной.

Начальник
Российского государственного научно-исследовательского испытательного
Центра подготовки космонавтов имени Ю. А. Гагарина
Герой Российской Федерации
летчик-космонавт России
кандидат технических наук
генерал-лейтенант

В. ЦИБЛИЕВ

Командир Отряда космонавтов
Центра подготовки космонавтов имени Ю. А. Гагарина
Герой Российской Федерации
летчик-космонавт России
кандидат технических наук
полковник

Ю. ЛОНЧАКОВ

заслуженный тренер России
доктор психологических наук

Н. ЮМАНОВ
Звездный городок

The Command, the Team of cosmonauts of the Yuri Gagarin Russian State Scientific Research and Experiential Cosmonaut Training Centre, Zvezdny Gorodok, Russia, cordially welcome the participants of the Scientific Conference 'Heavenly Discourses', which takes place in Bristol, Great Britain, 14–16 October, 2011, in the year of the fiftieth anniversary of the first human flight in an outer space.

The world has forever changed, when Yuri Gagarin, having overcome terrestrial gravitation, made a heroic break in space on 12th April, 1961, and we are glad that you conduct this conference in honour of this grandiose achievement.

We wish all participants of the conference creative successes, health, optimism and good spirit, we are sure that the conference will be successful and will become an important step into understanding of the relationship of Humanity and Cosmos and the place of Man in the Universe. (*Translation by Karine Dilanyan*)

INTRODUCTION:
DISCOURSING WITH THE HEAVENS

Nicholas Campion

We have grown distant from the Cosmos. It has seemed remote and irrelevant to everyday concerns, but science has found not only that the universe has a reeling and ecstatic grandeur, not only that it is accessible to human understanding, but also that we are, in a very real and profound sense, a part of that Cosmos, born from it, our fate deeply connected with it. The most basic human events and the most trivial trace back to the universe and its origins. —Carl Sagan[1]

We are already in space. The Earth is in space. It tells you all you need to know about how we think, right now, that we presume we are anything other than on a space mission, right now, and always have been. —Caitlin Moran[2]

On 12 April 1961 the Soviet cosmonaut Yuri Gagarin orbited the Earth and for the first time a human being physically travelled into what we now call 'space' – the region beyond the Earth's atmosphere. When Darrelyn Gunzburg and I began to plan a conference to celebrate the fiftieth anniversary of this event we settled on the title 'Heavenly Discourses' because so many features of human culture involve a dialogue – a discourse – with the sky; in the past people spoke to the stars and the stars spoke to them. This was once the normal state of things.

Some time in the last few millennia – we don't know when, for our written records only date back to the third millennium BCE – people began to identify different kinds of stars. Some stars were fixed; they moved but always held the same positions in relation to each other. Others, the ones we now know as planets, wandered in their own paths. Priestesses and priests, diviners, magicians, calendar-makers, mythmakers and navigators became increasingly aware of the stars' function as guides. The celestial bodies assisted travellers on their journeys, diviners in their quests for answers, and political and religious authorities in their development of calendars in order to regulate social, political and religious affairs. Even now most religious calendars depend on the sun and the moon or, in the case of Islam, just the moon. And so do secular calendars, for all life is regulated by the sun's apparent passage through our sky. Humans have for long derived meaning from the movement of the heavenly bodies and the constantly changing appearance of the sky; it is a place to which people

[1] Carl Sagan, *Cosmos: the Story of Cosmic Evolution, Science and Civilisation* (London: Warner Books, 1994), p. 12.
[2] Caitlin Moran, 'Why I don't want us exploring space', *The Times*, 18 January 2014, http://www.thetimes.co.uk/tto/magazine/article3974083.ece [accessed 25 March 2016].

have always looked for salvation, wisdom, self-knowledge and adventure. It a storied place on which we have written our myths, have found meaning by which we have attempted to resolve existential questions, and have constructed a foundation for the order which we introduce into our social, religious and political affairs.

How do we develop a language for talking about the sky? The study of landscapes may come to our aid. In his study of sacred landscapes Belden Lane wrote: 'The human spirit is inexorably drawn to the appeal of place, whether real or imaginary. Landscape, after all, is a constructed reality – a form which is given to nature by a particular human perception'.[3] Lane's point of reference is the landscape, but we could equally consider the extension of the same principle to the skyscape, defined as the ways in which we experience and conceptualise the sky. Adapting the concept of landscape, Fabio Silva wrote that 'Skyscapes extend this [the landscape] upwards to encompass the heavens and the celestial bodies and how they relate back down to human beliefs and practices, to their notions of time and place, to their structures and material remains'.[4] Lane added, 'The poet also reminds us that sacred places are, first, "storied" places – elaborately woven together on a cultural loom that joins every detail of the landscape within a given community of memory'.[5]

Whether the sky is sacred or not is a matter partly of philosophical and religious perspectives, and partly of semantics: what is sacred to one person is not to another. For we humans the sky is many things. The sky is a palimpsest over which generations have written new stories, as cultures compete, rise and fall. We can now look skyward and envision an expanding universe of unimaginable size, populated by gravity waves, quantum ripples and uncountable numbers of galaxies. This current, expanding, relative universe, still less than a century old, is laid on top of the Newtonian one of mechanical order, finite dimensions and a divine creator. The Newtonian clockwork cosmos is in turn laid over a variety of schemes in medieval Europe, in every one of which the stars and planets possessed an intimate relationship with every human being. There was a magical universe in which planets were moved by angels, and a scriptural one in which God's will determined everything, often in competition with evil. Then there was a natural universe in which all things – including planets, people, plants and the Earth itself were connected by the influences they exerted on each other, or by the relationships between things. In recent centuries, first the Newtonian and then the expanding universe have colonised the entire world.

[3] Belden Lane, *Landscapes of the Sacred: Geography and Narrative in American Spirituality*, expanded edition (Baltimore, MD, and London: Johns Hopkins University Press, 2001), p. 37.

[4] Fabio Silva, 'The Role and Importance of the Sky in Archaeology: An Introduction', in Fabio Silva and Nicholas Campion (eds), *Skyscapes – The Role and Importance of the Sky in Archaeology* (Oxford: Oxbow, 2015), pp. 1-7 (p. 3).

[5] Lane, *Landscapes of the Sacred*, p. 59.

But still they compete with religious perspectives, such as a universe ruled in intimate detail by a personal God or gods and goddesses, still favoured by many adherents of all faiths, or ones in which people and planets are still intimately connected. For example, in India *jyotish* (astrology) remains a fully functioning part of popular culture. If the sky is a storied place, then the stories we tell are complex, inconsistent and sometimes contradictory.

The Greek word *ourania* is usually translated either as 'sky' or 'heaven', words which, in English, have radically different meanings. 'Sky' is the space above us, normally regarded as neutral and valueless, but 'Heaven' is a paradise; it is the realm of God in the Abrahamic faiths, the home of angels and saints, and the destination of the virtuous. The ways in which we use these words creates a competition of values and morality between sky and heaven. Yet there is no absolute boundary between the two realms. We often imagine that the sky is 'up there', as in the title of John Milton's recent book on spirituality in nature.[6] The clouds, we say, are in the sky. But there is no boundary between us, on the surface of the planet, and the clouds. There is no point at which our world ends and the world of clouds begins. When we are in the hills we may actually find ourselves in the clouds. When heavy mists arise, we may even be enveloped by clouds at sea level. The sky is not up there but all around us.

We now locate the stars which are beyond our solar system in space, meaning outer space. They actually exist in the far reaches of outer space, in what we now call deep space, a place which is unreachable except in science fiction. Space has a double meaning: first, as the three-dimensional area within which we live and, second, as the area beyond Earth – defined as the edge of the Earth's atmosphere (itself not a precisely defined boundary). There is no boundary where deep space begins. It may be the space we can only see with advanced telescopes, the space beyond our galaxy (extragalactic) or between galaxies (intergalactic), or the space imagined in science fiction series like *Star Trek* and its sequels, such as *Deep Space Nine*.

Ernst Cassirer considered the problem of space in the 1950s, discussing the apparent contradiction between a universe defined and measured entirely by mathematics and one full of myth and wonder:

> We may arrive at a provisional and general characterisation of the mythical intu-
> ition of space by starting from the observation that it occupies a kind of middle
> position between the space of sense perception and the space of pure cognition,
> that is, geometry. It is self-evident that the space of perception, the space of vision
> and touch, does not coincide with the space of pure mathematics, that there is
> indeed a thoroughgoing divergence between the two.[7]

[6] John Milton, *Sky Above, Earth Below: Spiritual Practice in Nature* (Boulder, CO: Sentient Publications, 2006).

[7] Ernst Cassirer, *The Philosophy of Symbolic Forms: Mythical Thought*, Vol. 2 (1955; New Haven and London: Yale University Press, 1971), p. 83.

The problem, then, is how can we reconcile our experience with the universe of mathematics? Our experience is of quality whereas number deals only with quantity:

> The determinations of mathematical space do not follow simply from those of sensory space (the former cannot even be derived from the latter in an unbroken logical sequence); on the contrary, we require a peculiar reversal of perspective, a *negation* of what seem immediately given in sensory perception, before we can arrive at the 'logical space' of pure mathematics. Particularly, a comparison between 'physiological' space and the 'metric' space upon which Euclidean geometry bases its constructions shows this antithetical relationship in every detail. What is established in the one seems negated and reversed in the other. Euclidean space is characterised by the three basic attributes of continuity, infinity and uniformity.[8]

Ultimately, though, as human beings, we perceive the world through our own senses – touch, smell, sound, taste (can we taste the sky?) and sight (the most important sense for our experience of sky):

> But all these attributes run counter to the character of sensory perception. Perception does not know the concept of infinity; from the very outset it is confined within certain spatial limits imposed by our faculty of perception.[9]

The universe, then, is made of what we perceive.

Before we knew of outer space, there was a time when the stars were in the sky: we still talk of starry skies. Or sometimes the stars were on the roof of the sky, holes in the celestial canopy through which we could see the light beyond. But also, as was often well known, at least in historical times, stars could fall to earth. The visual evidence was provided by shooting stars and the material evidence by fragments of meteoritic rock: there was no physical barrier between the 'up there' and the 'down here', any more than there was a psychic barrier.

In all premodern cultures there was no barrier between humanity and the stars. And in cultures in which the soul, that intangible counterpart to the body, was real, there was no bar to travelling to the stars. Asiatic Shaman might reach the stars, and Egyptian Pharaohs united with them when they died. An incantation from the pyramid of Teti (ca. 2323-2291 BCE) on entering the womb of Nut (the sky goddess) reads: 'I go forth to the sky on the cushion that is in the prow and grasp her sandal'.[10] When a comet appeared over Rome in 44 BCE, Octavian, the future emperor Augustus, announced that it was the soul of Julius Caesar, the

[8] Cassirer, *The Philosophy of Symbolic Forms: Mythical Thought*, p. 83.

[9] Cassirer, *The Philosophy of Symbolic Forms: Mythical Thought*, p. 83.

[10] James P. Allen, trans., *The Ancient Egyptian Pyramid Texts*, second edition (Atlanta, GA: SBL Press: 2005), p. 331 (p. 73).

greatest hero of his day, on its way home.[11] For Plato, writing in the early fourth century BCE, the soul ascended to the stars because it had originated in them, so the heavenly ascent always alternated with the earthly descent, and human existence was framed between the two.[12] We wonder now whether we might ever be visited by beings from other planets, orbiting distant stars; but for Plato we ourselves come from the stars. Such ideas became a commonplace amongst Platonic philosophers in the Roman world and the stellar origins of human life were elaborated in the *Corpus Hermeticum*, the body of work composed in Hellenistic Egypt from the second century BCE onwards, and were ritualised in the mysteries of Mithras, one of the major religious cults of the Roman world.[13] The idea that human beings come from the stars is an enduring one in European thought from its ancient roots in classical literature to the modern day.

The Platonic celestial journey survived the collapse of classical learning as the Roman Empire disintegrated in the west, and was carried into early Medieval Europe in Macrobius' *In Somnium Scipionis*, a standard work for the literate from the sixth century to the sixteenth.[14] The translation and publication of the *Corpus Hermeticum* in Latin in 1471 brought the full, rich literature of humanity's intimate psychic connection with the stars back into western European culture, where it existed, often uneasily, with Catholic teachings during the Renaissance.

In the thirteenth century the Dominican friar Albertus Magnus and his student Thomas Aquinas had grappled with another problem of the soul's relationship with the stars.[15] Aquinas responded to cosmological material coming into Catholic Europe from the Arabic world, which argued that the soul was subject to celestial influence.[16] This was deeply problematic, for it exposed human beings to sin as a result of the actions of the planets, and abrogated God's right to determine questions of salvation or eternal damnation to the stars. Albertus and Thomas found a clever solution: they argued that while the sun, moon, stars and planets exerted a physical effect on the body, the soul was autonomous and

[11] Dio Cassius, *Roman History*, trans. E. Cary, 9 Vols (Cambridge, MA: Harvard University Press, 1914-1927), Book xlv, 6.5-7.2; Pliny, *Natural History*, trans. H. Rackham (Cambridge, MA: Harvard University Press, 1929), Vol. 1, Book II, xxii. 92-94, xxx. 99.

[12] Plato, *Republic*, 2 Vols., trans. Paul Shorey (Cambridge, MA: Harvard University Press, 1935), Book X, 614a-621d.

[13] Walter Scott, trans., *Hermetica: The Ancient Greek and Latin Writings which contain Religious or Philosophic Teachings Ascribed to Hermes Trismegistus*, 4 Vols (Boulder, CO: Shambhala, 1982); Roger Beck, *The Religion of the Mithras Cult in the Roman Empire: Mysteries of the Unconquered Sun* (Oxford: Oxford University Press, 2006).

[14] Macrobius, *Commentary on the Dream of Scipio*, trans. W. H. Stahl (1952; New York: Columbia University Press, 1990).

[15] Thomas Aquinas, *Summa Contra Gentiles*, 4 Vols., trans. Vernon J. Bourke (Notre Dame: University of Notre Dame Press, 1975), Book 3, chapter 87.

[16] John North, 'Celestial Influence – the Major Premiss of Astrology', in *Stars, Minds and Fate: Essays in Ancient and Medieval Cosmology* (London: The Hambledon Press, 1989), pp. 243-98.

responsible only to God and his angels. This was not quite a Cartesian split, for the body still influenced the soul, but it was halfway there. Significantly, though, the planets could still exert an indirect effect on the soul. They stirred up the body and the body then disturbed the soul. When the planets were in the wrong disposition the unwary would be tempted into sin and damnation, while the righteous could confess, pray, undertake charitable works and eventually go to Heaven. Human autonomy was asserted while maintaining the proposition that the entire physical universe was an interdependent whole. The Catholic cosmos was a moral arena in which the sky and the celestial bodies played a crucial role in one's chances of eternal bliss or damnation. Sky and society were not separate but indivisible.

Psalm 19.1, a key cosmological text for both Judaism and Christianity, clearly associates what would now be distinguished as 'space', 'stars' and 'heaven' as blended concepts, located 'up there' in a zone which is effectively physically unreachable for human beings, but which represents a source of power, wisdom or morality: 'The heavens recite the glory of God, and the sky tells of the work of His hands'.[17]

The first century CE Alexandrian astronomer Claudius Ptolemy followed with equally inspirational sentiments:

> Mortal as I am, I know that I am born for a day, but when I follow the serried multitude of the stars in their circular course, my feet no longer touch the earth; I ascend to Zeus himself to feast me on ambrosia, the food of the gods.[18]

Ptolemy's contemporary, the Roman emperor Marcus Aurelius, shared his enthusiasm: 'Survey the circling stars', the emperor wrote, 'as though you yourself were in mid-course with them. Often picture the changing and re-changing dance of the elements. Visions of this kind purge away the dross of our earth-bound life'.[19] The soul, Marcus Aurelius believed, could be cleansed by an imaginative union with the stars. Of course it could, for the sky was beautiful.

Veneration of the sky occurs across cultures, as Europeans found as they migrated around the globe. The Spaniard Bartolomé de Segovia left us a colourful description of a solar harvest-festival ritual which took place in Cuzco in 1535, presided over by the Inca – the emperor – and attended by six hundred magnificently dressed nobles. Segovia described the scene:

[17] *The Complete Jewish Bible with Rashi Commentary*, [accessed 7 April 2016]: http://www.chabad.org/library/bible_cdo/aid/16240/jewish/Chapter-19.htm

[18] Claudius Ptolemy, 'Anthologia Palatina', ix.577, quoted in Franz Cumont, *Astrology and Religion Among the Greeks and Romans* (New York: Dover, 1960), p. 81.

[19] Marcus Aurelius, *Meditations*, trans. Maxwell Staniforth (Harmondsworth, Middlesex: Penguin, 1964), V.47, p. 112; see also IX.29, p. 144. See Plato, *Republic*, trans. Paul Shorey, 516B.

They stood in two rows, each of which was made up of over three hundred lords. It was like a procession, some on one side and the others on the other, and they stood very silent, waiting for sunrise. When the sun had not yet fully risen, they began slowly and in great order and harmony to intone a chant; and as they sang they each moved forward... and as the sun went on rising, so their song intensified... And so they sang from the time when the sun rose until it had completely set. And since until noon the sun was rising, they heightened their voices, and after noon they slowly softened them, always in step with the movement of the sun.[20]

In most imperial societies the monarch had a special relationship with the sky, his or her function being to connect people with heaven. In China the supreme deity, Ti, or Di (also known as *Tian huang shang ti*, the August Supreme Emperor of Heaven) was the first (or one of the first) of the gods. Di was connected with the celestial North Pole, the still, quiet point around which the entire sky revolves.[21] God, in the Chinese imagination, is the unmoving central point where there is no change and, therefore, no time. The emperor, conceptualised as Son of Heaven, was the terrestrial partner of the supreme Lord Di. He fulfilled a role which would appear to have remote shamanic origins, in that he functioned as a bridge between the two realms and could be considered messianic; every ritual act he performed was soteriological, ensuring salvation for his people by protecting them from harm. In imperial states, politics ensured that political legitimacy was established by the king's power to mediate between sky and Earth, heaven and people.[22] The sky was often central to political ideology in the ancient and medieval worlds.[23]

Across human culture the sky has functioned as a focus for telling stories, sometimes with a social or moral message, or knowledge about the natural world. We can turn to Australia for an example.

The evening appearance of the celestial shark, Baidam traced out by the stars of the Big Dipper tells Torres Strait Islanders that they need to plant their gardens with sugarcane, sweet potato and banana. When the nose of Baidam touches the horizon just after sunset, the shark breeding season has begun and people should stay out of the water as it is very dangerous![24]

[20] Sabine MacCormack, *Religion in the Andes: vision and imagination in early Colonial Peru* (Princeton: Princeton University Press, 1991), pp. 75-76.

[21] David W. Pankenier, 'A Brief History of Beiji 北極 (Northern Culmen), with an Excursus on the Origin of the Character di 帝', *Journal of the American Oriental Society* 124, no. 2 (April-June 2004): pp. 211-36.

[22] Nicholas Campion, 'Astronomy and Political Theory', in *The Role of Astronomy in Society and Culture*, ed. David Valls-Gabaud and Alec Boksenberg, International Astronomical Union Symposium 260, UNESCO, Paris, 19-23 January 2008 (Cambridge: Cambridge University Press), pp. 595-602.

[23] Nicholas Campion, 'Astronomy and Political Theory', pp. 595-602.

[24] Duane W. Hamacher, 'Stories from the Sky: Astronomy in Indigenous Knowledge', *The Conversation*, 1 December 2014, https://theconversation.com/stories-from-the-sky-as-

In Australia all existence was connected by the Dreaming. In the Dreamtime the ancestors, however they are conceived, whether human, animal or fantastic, moved through a formless land creating the hills, valleys, rivers, plains and forests. As they moved they created the Songlines, paths in the sky and land. If walked, the Songlines will connect the traveller with the Dreaming. Native Australians have given us no written accounts, but as Bruce Chatwin put it, 'legendary totemic beings... wandered over the continent in the Dreamtime, singing out the name of everything that crossed their path – birds, animals, plants, rocks, waterholes... so singing the world into existence'.[25]

And in Polynesia the creator, Kane, chanted the world into existence with the following words:

> Here am I on the peak of day, on the peak of night.
> The spaces of air,
> The blue sky I will make, a heaven,
> A heaven for Ku, for Lono,
> A heaven for me, for Kane,
> Three heavens, a heaven. Behold the heavens!
> There is the heaven,
> The great heaven,
> Here am I in heaven, the heaven is mine.[26]

From Central America we have a poetic account of the origins of the Maya cosmos, which came into being as a gradual emergence of order, of something from nothing. The opening lines of the great creation epic, the *Popul Vuh*, expresses the still beauty of a calm morning, the dawn of everything:

> Now it ripples, now it still murmurs, ripples, still it sighs, still hums and it is empty under the sky.
> Here follows the first words, the first eloquence:
> There is not one person, one animal, bird, fish, crab, tree, rock, hollow, canyon, meadow, forest. Only the sky alone is there; the face of the Earth is not clear. Only the sea alone is pooled under all the sky; there is nothing whatever gathered together. It is at rest; not a single thing stirs. It is held back, kept at rest under the sky.
> Whatever there is that might be is simply not there: only the pooled water, only the same sea.[27]

In China, social stability could be maintained if people lived in harmony with the energies that flowed all around them. This applied to a whole series of practices, including *feng shui*, the art of harmonizing the human environment to *chi*, the energy which pervaded space, and medicine:

tronomy-in-indigenousknowledge-33140 [accessed 25 March 2016].

[25] Bruce Chatwin, *The Songlines* (London: Picador, 1988), p. 2.

[26] Martha Beckwith, *Hawaiian Mythology* (Honolulu: University of Hawaii Press, 1970), p. 44.

[27] Dennis Tedlock, trans., *Popul Vuh* (London: Simon and Schuster, 1996), p. 64.

… macrocosm and microcosm became a single manifold, a set of mutually res-
onant systems of which the emperor was indispensable mediator. This was true
even of medicine... Cosmology was not a mere reflection of politics. Cosmos,
body, and state were shaped in a single process, as a result of changing circum-
stances that the new ideas in turn shaped.[28]

Such ideas allowed room for speculation about the size of the universe, or about
other worlds. The thirteenth-century astronomer Têng Mu described space in
the following modern terms:

> Heaven and Earth are large, yet in the whole of empty space (*hsü khung*) they are
> but as a small grain of rice... It is as if the whole of empty space were a tree and
> heaven and earth were one of its fruits. Empty space is like a kingdom and heaven
> and earth no more than a single individual person in that kingdom. Upon one
> tree there are many fruits, and in one kingdom many people. How unreasonable
> it would be to suppose that besides the heaven and earth which we can see, there
> are no other heavens and no other earths.[29]

The identifiable mechanics of yin-yang and the Five Phases were themselves
contained within the ineffable paradoxes of Taoism. The opening lines of Lao
Tzu's *Tao Te Ching* convey the tone, even if something of its spirit is inevitably
lost in translation:

> The way [tao] that can be spoken of
> Is not the constant way;
> The name that can be named is not the constant name.
> The nameless was the beginning of heaven and earth;
> … Mystery upon mystery –
> The gateway of the manifold secrets.[30]

Paradox is a feature of many early cosmogonies, as it is of the creation stories
encouraged by modern physics. For example, if the universe began with the
Big Bang, what came before it? And if our universe is finite, what lies beyond
it? Consideration of what we mean by space is somewhat simpler. The English
word 'space' has a double meaning, first as the three-dimensional area within
which we live, and second, as the area beyond Earth. In this sense 'space' is also
an abbreviation for 'outer space', the area beyond the Earth's atmosphere, and
includes everything that exists from the Moon to the farthest galaxies. So, when
we look at the sky we actually see 'outer space', most vividly of course at night,

[28] Nathan Sivin, 'State, Cosmos, and Body in the Last Three Centuries B. C.', *Harvard Jour-
nal of Asiatic Studies* 55, no. 1 (June 1995): p. 6.

[29] Têng Mu, *Po Ya Chhin*, cited in Joseph Needham, *Science and Civilisation* (Cambridge:
Cambridge University Press, 1959), p. 221.

[30] Lao Tzu, *Tao Te Ching*, I,I-3a, trans. D. C. Lau (Harmondsworth, Middlesex: Penguin,
1972). See also Pankenier, 'A Brief History of Beiji 北極 (Northern Culmen)', pp. 218-20.

when the blue canopy gives way to a black background and bright stars.

Asiatic Shaman, Egyptian Pharaohs and Platonic souls were all able to contemplate the Earth from above but such sights existed in trance, myth and story. Since 1961 we have been able to look down on Earth from above the atmosphere as physical bodies. As Soviet leader Nikita Khrushchev said at the grand welcoming ceremony in Red Square, Yuri Gagarin was the first man to see the whole Earth from space, to see it moving, and to look down on entire continents and oceans. Cheekily, Khrushchev compared Gagarin to Columbus, usurping the USA's claim to be the New World, and asserting the Soviet Union's historic role in taking humanity forward into the next phase of history. 'We all understand', Khrushchev declared, 'what a world of thoughts and feelings our first space traveller has brought back to earth'.[31]

We need theoretical frameworks for understanding humanity's relationship with the sky. One such is provided by Max Weber's theory of rationality, which offers a model for examining competing narratives in the exploration of space. Weber's discussion of rationality is fairly complex and there have been various attempts to systematise it. Essentially, though, he considered that all humans are fundamentally rational and capable of making considered choices, and what often pass for irrational decisions or actions actually have some element of rational thought behind them. We can organise Weber's rationality into four types, of which two are particularly relevant to the motives for going into space. The first is termed practical rationality, sometimes also called technical rationality. As Stephen Kalberg described it, practical rationality deals with 'practical action in terms of everyday interests', and achieves its ends through 'careful weighing and increasingly precise calculations of the most adequate means'.[32] The second, theoretical rationality, takes abstract concepts rather than pragmatic actions and goals as its starting point and may include the construction of symbolic meanings, metaphysical aspirations and religious and magical perspectives.[33]

Practical, technical rationality can be described as 'means-end', designed to achieve specific goals, while theoretical rationality is 'value-rational', expressing wider narratives rather than practical goals.[34] The boundary between technical/practical rationality and theoretical/value rationality is not watertight, and

[31] Anon., *The First Man in Space. The Record of Yuri Gagarin's Historic First Venture into Cosmic Space: A Collection of Translations from Soviet Press Reports* (New York: Crosscurrents Press Inc., 1961), p. 25, available at https://archive.org/details/firstmaninspace00unse [accessed 7 April 2016]; see also British Pathé, 'Yuri Gagarin Is Welcomed By Moscow 1961', available at http://www.britishpathe.com/video/yuri-gagarin-is-welcomed-by-moscow [accessed 7 April 2016].

[32] Stephen Kalberg, 'Max Weber's Types of Rationality: Cornerstones for the Analysis of Rationalization Processes in History', *The American Journal of Sociology* 88, no. 5 (March 1980): pp. 1145-1179 (p. 1152).

[33] Kalberg, 'Max Weber', pp. 1152-53.

[34] Kalberg, 'Max Weber', p. 1148.

Speech by N. S. Khrushchev in Red Square

April 14, 1961

DEAR COMRADES,

DEAR FRIENDS,

CITIZENS OF THE ENTIRE WORLD:

It is with a feeling of great joy and pride that I address you. For the first time in history a man, our Soviet man, in a ship created by Soviet scientists, workers, technicians and engineers, tore away from earth towards outer space and made the first unprecedented trip to the stars.

The spaceship *Vostok* rose to an altitude of more than 300 kilometers, orbited the earth, and successfully landed in a prearranged area of the Soviet Union.

We ardently hail this remarkable cosmonaut, this heroic Soviet man, Yuri Aleveyevich Gagarin. He displayed noble moral traits: courage, self-possession, and valor. He is the first person who for an hour and a half looked at our entire planet, the earth, which is ever in motion, and viewed its tremendous oceans and continents. Yuri Alexeyevich Gagarin is our pioneer in space flights. He is the first to have orbited our globe. If the name of Columbus, who crossed the Atlantic Ocean and discovered America, has lived on through the ages, what can be said about our wonderful hero, Comrade Gagarin, who penetrated into outer space, circled the entire terrestrial globe, and safely returned to earth! His name will be immortal in the history of mankind.

We all understand what a world of thoughts and feelings our first space traveler has brought back to earth. Everyone here in this historic square understands the deep emotion, pride and joy with which we greet you, our dear friend and comrade.

Permit me on behalf of the Central Committee of the Communist Party of the Soviet Union, the Soviet Government, and our entire people to heartily congratulate you and to express our deep gratitude for your unparalleled feat.

25

Fig. i.1: Nikita Khrushchev's welcome speech for Yuri Gagarin, Red Square, 14 April 1961.[35]

[35] Anon., *The First Man in Space*, p. 25.

value rationality may have goals but they may be envisioned by the broad sweep of history, say, rather than specific outcomes. It is a matter of narratives. So we might then identify narrative truth as distinct from objective truth, two versions of truth derived by modern work on psychoanalysis: narrative truth is personal truth as opposed to the historical, objective truth that genuinely exists in the material world. In *Narrative Truth*, Donald Spence wrote, 'Interpretations are persuasive not because of their evidential value but because of their rhetorical appeal'.[36] The questions then, are 'what value do we put on space exploration?', and 'how does it express our values?'. Above all, what are the stories that we construct about it? These are questions we can examine through the extensive literature on the space programme, and especially through political statements.

The contrast between pragmatic, practical, technical rationality and value-rich, story-telling rationality, is nowhere more evident than in John F. Kennedy's speech to Congress of 25 May 1961 in which he appealed for funding for the Apollo programme. The President began by outlining practical requirements:

> We propose to accelerate the development of the appropriate lunar space craft. We propose to develop alternate liquid and solid fuel boosters, much larger than any now being developed, until certain which is superior. We propose additional funds for other engine development and for unmanned explorations.[37]

Would such dry talk, born of technical rationality and objective truth, ever have persuaded Congress to make the huge financial commitment required to send men to the moon? Probably not. Taking no risks, Kennedy resorted to an overt appeal to America as the home of freedom, locked in a brutal battle with the tyrannical Soviet Union, which had caused panic in Washington by sending Yuri Gagarin on the first human space flight on 12 April, just five weeks earlier. Kennedy appealed for the necessary funding with a brilliantly rhetorical evocation of the American dream, of America as the repository of freedom and hope for the future. Value rationality and narrative truth won the day:

> Finally, if we are to win the battle that is now going on around the world between freedom and tyranny, the dramatic achievements in space which occurred in recent weeks should have made clear to us all, as did the Sputnik in 1957, the impact of this adventure on the minds of men everywhere, who are attempting to make

[36] Donald Spence, *Narrative Truth and Historical Truth: Meaning and Interpretation in Psychoanalysis* (London: W.W. Norton & Co., 1982), p. 32.

[37] John F. Kennedy, 'Special Message to Congress on Urgent National Needs, 25 May 2961', John F. Kennedy Presidential Library and Museum, http://www.jfklibrary.org/Asset-Viewer/Archives/JFKWHA-032.aspx [accessed 1 October 2011]; see also 'The Decision to Go to the Moon: President John F. Kennedy's May 25, 1961 Speech before a Joint Session of Congress', National Aeronautics and Space Administration, NASA History Office, http://history.nasa.gov/moondec.html [accessed 1 October 2011].

a determination of which road they should take... Now it is time to take longer strides – time for a great new American enterprise – time for this nation to take a clearly leading role in space achievement, which in many ways may hold the key to our future on earth.[38]

To put the times into the wider Cold War context, on 17 April, five days after Gagarin's flight, the CIA-sponsored invasion of Cuba at the Bay of Pigs ended in fiasco, and on 13 August, four months later, Soviet control of Eastern Europe achieved its final iconic form when work began on the construction of the Berlin Wall. In American eyes, the free world was in peril. For Kennedy the ascent into space was an absolute necessity driven by geopolitical and ideological rivalry. It was a matter not just of economic and political imperatives, but of a Manichean struggle for control of the universe of the kind subsequently dramatised to great popular effect in the *Star Wars* films. Kennedy's oratory spelt out the message. To travel to the sky will liberate the Earth, and help preserve freedom for the whole of humanity. Throughout the 1960s value rationality remained a largely unspoken part of the space programme.

Value rationality was enrolled in the service of the space programme eight years later, when the US government feared that public support would wane in the aftermath of the successful Moon landing. Religious leaders were enrolled to assist. One was Billy Graham, the most famous of evangelical preachers. In 1969 Graham lent his support and offered a synthesis of Christian theology and belief in extra-terrestrial visitation:

> It is hard to believe that we earthlings are alone in this spacious and wonderful Universe. Already we have received visits by creatures from outer space, including many angels, and Jesus Christ.[39]

A major outburst of value rationality accompanied the journey of British astronaut Tim Peake to the International Space Station in December 2015 due to considerable outreach, education and media promotion by the space industry.[40] That Peake was British was used by the BBC programme 'Star Gazing Live' in order to promote the identification of the space programme with nationalist pride. The launch, for example, was broadcast live to commentary by the presenters Brian Cox and Dara O' Briain from the Science Museum in London; an audience of school children waved Union Jacks and expressed excitement and enthusiasm at the prospect of going into space.[41] The message was clear: to sup-

[38] Kennedy, 'Special Message'.

[39] Billy Graham speaking in 1969, praising the Apollo Moon programme, cited in Kendrick Oliver, *To Touch the Face of God: The Sacred, the Profane, and the American Space Program, 1957-1975* (Baltimore, MD: Johns Hopkins University Press, 2013), p. 53.

[40] 'Principia Mission', https://principia.org.uk/ [accessed 19 April 2016].

[41] 'Blast Off Live', Tim Peake Specials, Episode 1, *Stargazing Live*, 15 December 2015,

port the space programme is to be patriotic.

However, that different narratives were promoted was noticed by journalists writing for women's pages in the UK press. Technically Peake was 'the first Briton to join the European Space Agency's astronaut corps'.[42] As the science journalist Ian Sample reported,

> A 37-year-old helicopter test pilot has joined the European Space Agency as Britain's first official astronaut.[43]

The phrase 'first official astronaut' was all too easily contracted to 'first astronaut', and there was then a small media storm on the grounds that Helen Sharman had actually been the first British astronaut.[44] Jennifer Rigby observed in *The Telegraph* women's pages, the term 'first official astronaut' was easily contracted to 'Britain's first astronaut':

> But those calling Major Peake 'Britain's first astronaut' have still been tripped up by a technicality.
> In fact, he is the first *official* British astronaut – that is, the first publicly funded Briton in space, sent by the European Space Agency (ESA), and the first to visit the International Space Station.
> Helen Sharman was the first Briton ever to actually leave Earth back in 1991, when she was just 27-years-old.[45]

However, Colin Drury, writing in *The Guardian* women's pages, took issue with the 'first official' designation itself on the grounds that Helen Sharman had visited the Mir space station in 1991:

> … she [Sharman] was surprised in 2013 to find the UK Space Agency apparently writing her out of history. In statements, it described Major Tim Peake – who travelled to the International Space Station last December – as the UK's first official

http://www.bbc.co.uk/programmes/b06sgb95.

[42] Ian Sample, 'Tim Peake, Britain's first ESA astronaut, set for liftoff from Kazakhstan', *The Guardian*, 15 December 2015, https://www.theguardian.com/science/2015/dec/14/britain-iss-astronaut-tim-peake-international-space-station [accessed 19 April 2016].

[43] Ian Sample, 'European Space Agency recruits test pilot as Britain's first official astronaut', *The Guardian*, 21 May 2009, https://www.theguardian.com/science/2009/may/20/british-astronaut-european-space-agency-training [accessed 19 April 2016].

[44] Jasper Hamill, 'Is Tim Peake the first British astronaut? Space fans slam 'sexists' who forgot this brave space-woman', *The Daily Mirror*, 15 December 2015, http://www.mirror.co.uk/news/technology-science/science/tim-peake-first-british-astronaut-7015232 [accessed 19 April 2016].

[45] Jennifer Rigby, 'Tim Peake isn't the first Brit in space – don't forget ballsy Yorkshire woman Helen Sharman', *The Telegraph*, 16 December 2015, http://www.telegraph.co.uk/women/life/tim-peake-isnt-the-first-brit-in-space---dont-forget-ballsy-york/ [accessed 19 April 2016].

astronaut. "I asked them: 'What happened to me?'" she says. "I asked what 'official' even meant, and reminded them my mission was part of the Soviet Union space programme. The British government didn't fund it but it was still official."[46]

Peake was neither the first British astronaut, not the first official British astronaut. Even Wikipedia observes that the definition of British is somewhat fluid.[47] So what was behind the narrative that he was the 'first'? An obvious suspect must include pressure on the UK government to fund human space travel. As *The Guardian* noted in 2009:

> The appointment [of Peake], announced at a special ceremony at the space agency's headquarters in Paris yesterday, is surprising because Britain has a long-standing policy of refusing to fund human spaceflight.
> Although Britain is the fourth largest contributor to Esa, its £200m annual donation is used exclusively for satellites and robotic missions.[48]

Following Peake's launch in December 2015, The British Interplanetary Society (BIS) made a substantial argument for UK funding of human space travel,

> The BIS is delighted that in May 2009 the European Space Agency (ESA) appointed Major Tim Peake of the UK as a new "European" astronaut. Now Tim has flown on Expedition 46/47 to the ISS in December 2015, via Soyuz, which is excellent for the UK.
> Also, in November in 2012 the UK's Science Minister David Willetts confirmed at the ESA Ministerial meeting that £12 million would be put into the ELIPS microgravity research initiative and £16 million will help support UK involvement in the NASA Orion crewed spacecraft for the future.
> However, despite being one of the world's largest economies, the UK still has no large scale manned space presence or interest in human space industry activities. … Whilst the rest of Europe, the US, Russia, China, Japan and many emerging industrialised nations (for example Brazil, Malaysia, South Korea and India) all explore space through human approaches, the UK has missed out – *this is against the national good* [my emphasis].[49]

[46] Colin Drury, 'Blast off! Why has astronaut Helen Sharman been written out of history?', *The Guardian*, 18 April 2016 , http://www.theguardian.com/lifeandstyle/2016/apr/18/blast-off-why-has-astronaut-helen-sharman-been-written-out-of-history [accessed 19 April 2016].

[47] 'British Space Programme', https://en.wikipedia.org/wiki/British_space_programme [accessed 19 April 2016].

[48] Ian Sample, 'European Space Agency recruits test pilot as Britain's first official astronaut', *The Guardian*, 21 May 2009, https://www.theguardian.com/science/2009/may/20/british-astronaut-european-space-agency-training [accessed 19 April 2016].

[49] The British Interplanetary Society, 'Human Space Flight', http://www.bis-space.com/what-we-do/advocacy/human-space-flight [accessed 19 April 2016].

The BIS report notes that the UK government block on funding human space travel had been removed, but that much more is needed. After providing some figures it evokes global rivalry and concludes that such funding is in the national good. As in Kennedy's speech, technical, practical rationality is mixed with value rationality and narrative truth, *Star Gazing Live's* equation of human space travel with patriotic endeavour is sustained.

To cap the BIS manifesto, Time Peake provided his utopian statement:

> To me the BIS represents all that is space past, present and future. A Society that fosters science, knowledge and understanding, but also allows us to dream of what might be.[50]

Competing narratives took on a different form in 2011 in NASA's report on the seventy-fifth anniversary of the rocket experiments in 1936 that laid the foundation for the Jet Propulsion Laboratory. First the facts are stated:

> PASADENA, Calif. – The 75th anniversary of the first rocket experiments at the site that became NASA's Jet Propulsion Laboratory in Pasadena, Calif., will be celebrated with a special free, public screening of the new documentary, 'The American Rocketeer' at the California Institute of Technology's Beckman Auditorium on Tuesday, Oct. 25 at 8 PM.[51]

There are the bare facts outlined in the first part of the press release: the rocket experiments took in place in 1936, led to the foundation of the Jet Propulsion Laboratory, and the celebratory film was to be screened at 8 PM. We could call this objective truth. But there is a wider adventure; the NASA press release continued:

> On Halloween day in 1936, a group of Caltech students, led by Frank Malina, conducted the first stand-up rocket engine test in a dirt gulch known to the residents of Pasadena as the Arroyo. Little did they know that this day would go down in history as the beginning of what is now JPL, the world's leading center for robotic exploration of the solar system and beyond.[52]

What is going on here? Quite clearly an attempt by the press-release writer to grab press attention with an appeal to well-known iconography. The experiments took place on Halloween, a day of mystery and magic when the dead walk the earth. They were conducted by students, code for young radicals. And they were located in a dirt gulch: how many Hollywood westerns featured dra-

[50] The British Interplanetary Society, 'Human Space Flight', http://www.bis-space.com/what-we-do/advocacy/human-space-flight [accessed 19 April 2016].

[51] 'Caltech Event Marks 75th Anniversary of JPL Rocket Tests', 11 October 2011, http://www.jpl.nasa.gov/news/news.cfm?release=2011-318 [accessed 13 October 2011].

[52] 'Caltech Event'.

matic set pieces in gulches? One thinks of Deadwood Gulch (near the town of Deadwood) where western legend Wild Bill Hickok was shot. In one sentence the anonymous writer has evoked three key features of modern American mythology. But the past is not everything. The experiments laid the foundation for robotic exploration of the solar system and all space beyond. Other galaxies, perhaps? In that isolated gulch in Halloween an event took place around which the whole of human history pivoted. And if the people who were responsible were students, then they were a kind of 'everyman': for by 2011 most people in the USA were students at some time in their lives. In egalitarian America anyone can change history.

There are other stories, though, which were not included in the press release, perhaps uncomfortable ones. Frank Malina himself left NASA in 1947, disgusted by its employment of Nazis and its pursuit of the militarisation of space; he was persecuted in the anti-communist witch-hunts of 1952 and went into self-imposed exile in France.[53] One of Malina's closest collaborators, Jack Parsons, the man who created the successful mix of rocket fuel, was a practising occultist and master of a branch of Aleister Crowley's magical Ordo Templi Orientis in Pasadena.[54] Parsons would have been completely familiar with Crowley's statement from the beginning of his apocalyptic text, *The Book of the Law*, that 'every man and woman is a star'.[55] Narrative histories can take different forms. NASA romanticised the anniversary for its own purposes, but presented only one version of its history; Malina and Parsons tell another.

We tell stories about space, but space travel has also altered the stories we tell about ourselves. The end result of Kennedy's vision, eight years after his epoch-making speech, was to be the application of the Apollo moon programme photographs of the Earth to stimulate modern environmentalism.[56] The story is illustrative of a strand of value rationality.

It began in 1966 with Stewart Brand, who was one of the prime movers in the psychedelic culture of the mid-Sixties, when he began a campaign for NASA to release the photographs. Brand had already had a vision of a single reference work which would act as a guide for practical living in harmony with the Earth, and he used one of the Apollo photographs on the cover of the first *Whole Earth Catalogue* in 1968. On the cover of the second edition, in autumn 1968, Brand used the iconic 'Earth-rise' picture, taken by William Anders from Apollo

[53] Fraser MacDonald, 'Frank Malina and an overlooked Space Age milestone', *The Guardian*, 14 October 2015, https://www.theguardian.com/science/the-h-word/2015/oct/14/frank-malina-and-an-overlooked-space-age-milestone [accessed 7 April 2016].

[54] John Carter, *Sex and Rockets: the Occult World of Jack Parsons* (Port Townsend, WA: Feral House, 2004); J. W. Parsons, *Freedom is a Two-Edged Sword* (Tempe, AZ: New Falcon Publications, 1989).

[55] Aleister Crowley, *The Book of the Law* (San Francisco: Red Wheel/Weiser, 2011), p. 25.

[56] Denis Cosgrove, 'Contested Global Visions: One-World, Whole-Earth, and the Apollo Space Photographs', *Annals of the Association of American Geographers* 84 (1994): pp. 270-294.

8, showing the Earth in the background against the moon in the foreground. When the photographs were seen they revealed for the first time ever a complete image of the spherical planet. What's more, there were no national divisions, no Iron Curtain, no rich people and no poor. Just one single planet on which we all have to live together.

Brand was tapping into something deep in the human psyche, a sense of wonder when faced with a particularly brilliant sky. Brand's story, though, is a classic account of a narrative truth that doesn't feature in official accounts, and his revelation of the power of the image of the spherical Earth was conceived during an LSD trip. He begins his account:

> It was one month after the Trips Festival at Longshoremen's Hall when the "whole earth" in The Whole Earth Catalog came to me with the help of one hundred micrograms of lysergic acid diethylamide. I was sitting on a gravelly roof in San Francisco's North Beach. It was February 1966. Ken Kesey and the Merry Pranksters were waning towards Mexico. I was twenty-eight.
> In those days the standard response to boredom and uncertainty was LSD followed by grandiose scheming. So there I sat, wrapped in a blanket in the chill afternoon winter sun, trembling with cold and inchoate emotion, gazing at the San Francisco skyline, waiting for my vision.[57]

Brand's vision then began, leading to a visceral experience of the Earth not as flat, as we perceive it in our daily lives, but as curved, as we would see it from far away:

> The buildings were not parallel – because the earth curved under them, and me, and all of us; it closed on itself. I remembered that Buckminster Fuller had been harping on this at a recent lecture – that people believed the earth as flat and finite and that that was the root of all their misbehaviour. Now from the altitude of three stories and one hundred mikes, I could *see* that it was curved, think it, and finally feel it.[58]

LSD may inspire the imagination but it does not wipe out reason; often it enhances the freedom to think logically, free from mundane constraints. As Weber argued, we are always rational. Brand began to reason through his revelation: that to see the Earth as a single sphere would help solve society's ills – the ills evident to him as a member of an inspirational radical network. He was not so far from Ptolemy and Marcus Aurelius and their belief that to look at the stars could heal the soul. Brand switched this round so that to gaze at the Earth, as Plato's souls would have done between incarnations, performed the same function. But

[57] Stuart Brand, 'Why Haven't We Seen the Whole Earth?', in *The Sixties: The decade remembered now, by the people who lived it then*, ed. Lynda Rosen Rost (New York: Random House / Rolling Stone, 1977), pp. 168-70 (p. 168).
[58] Brand, 'Why Haven't We Seen the Whole Earth?', pp. 168-70 (p. 168).

Brand faced a problem. How could the message be disseminated?:

> But how to broadcast it? It had to be broadcast, this fundamental point of leverage on the world's ills. I herded my trembling thoughts together as the winds blew and time passed. A photograph would do it – a color photograph from space of the earth. There it would be for all to see, the earth complete, tiny, adrift, and no one would perceive things in the same way. [59]

He was imagining what Carl Sagan called the 'pale blue dot', the tiny, insecure planet, held in an infinity of space, all the more valuable because of its existential fragility.[60] And finally, he reached his solution: a theatrical play on what he recognised as a widespread paranoid, American tendency to believe that 'we' are being manipulated by a conspiracy managed by 'them':

> But how to accomplish this? How could I induce NASA or the Russians to finally turn the camera backwards? We could make a button! A button with the demand "Take a photograph of the entire earth." No, it had to be made a question. Use the great American resource of paranoia…" Why haven't they made a photograph of the entire earth?" There was something wrong with "entire". Something wrong with "they."
> "Why haven't we seen a photograph of the Whole Earth yet"? Ah, that was it. [61]

The next day, once the drug had worn off, Brand began making lapel buttons and writing to influential people, to promote his case. And so the public dissemination of the seminal, culture-changing image of the whole Earth from space took place as a direct result of one individual's use of LSD. The photographs would have been taken and publicised in the fullness of time, but it was Brand who forced the process along and deliberately endowed the photographs with their meaning as icons of salvation. The psychedelic-user Brand joins the magician Parsons and the communist Malina as a band of radicals who have shaped the achievements and public reception of the US space programme. Perhaps more than anyone else other than Kennedy, Brand brought Weber's value-rationality to the American space arena.

Brand's revelation was derived from his use of LSD, but inspiration from the sky in general has no need of chemical assistance. And since 1969 we have been able to look down on our sky from space. The euphoric consequences of this experience, still enjoyed by a few hundred people, was named the 'Overview Effect' by Frank White in 1987.[62] Interviewed on BBC Radio 4's iPM programme

[59] Brand, 'Why Haven't We Seen the Whole Earth?', pp. 168-70 (p. 168).
[60] Carl Sagan, *Pale Blue Dot: a Vision of the Human Future in Space* (New York: Random House, 1994).
[61] Brand, 'Why Haven't We Seen the Whole Earth?', pp. 168-70 (p. 168).
[62] Frank White, *The Overview Effect—Space Exploration and Human Evolution* (Boston, MA: Houghton-Mifflin, 1987).

on 25 May 2013, the astronaut Geoff Hoffman described his own experience of the Effect.[63] Beginning with the launch, and for the first time on a solo mission, he waited in his capsule completely alone, without the army of technicians who had been present on previous days. The shaking produced by the temperature fluctuations in super-cooled fuel caused first a lurch to the left and then one to the right at ignition, followed by an awesome shaking at lift-off. The vehicle, he said, 'is alive'. A period of transition followed as noise and blue sky gave way to silence and black sky. Hoffman described the shocking beauty of the sunset in a black sky, a black unlike any black he had ever witnessed, followed by the profound sense of dislocation from the body that results from weightlessness. He recalled the strange sensation of looking down at the Earth, watching the terrestrial sky from above instead of from below, witnessing the flash of lightning storms and streaks of light as meteors plunged into the atmosphere. He saw the world as one, drawing salutary ecological lessons from the visible deforestation of tropical areas. Inspired by the ethereal nature of the Earth's halo, Hoffman hesitated to use the word 'spiritual', put to him by his interviewer in a leading question, but was happy to describe the condition he experienced on his mission as being a 'state of grace', words which he said had been suggested to him by a Jesuit priest. Shaman, Pharaohs and Platonic souls may have seen the Earth in their imaginations, but astronauts experience it physically.

The 'Overview Effect' has been institutionalised in the 'Overview Institute', whose purpose is to utilise the Effect for the common good.[64] The Institute's apocalyptic and utopian agenda draws a direct connection between the experience of space travel and the need to save the Earth:

> We live at a critical moment in human history. The challenges of climate change, food, water and energy shortages as well as the increasing disparity between the developed and developing nations are testing our will to unite, while differences in religions, cultures, and politics continue to keep us apart. The creation of a 'global village' through satellite TV and the Internet is still struggling to connect the world into one community. At this critical moment, our greatest need is for a global vision of planetary unity and purpose for humanity as a whole.[65]

For some astronomers, experiences such as Hoffman's provide a radical step into a 'new' politics. As formalised by the Overview Institute and placed into a historical context, they are reminiscent of dreams of new worlds and journeys

[63] Geoff Hoffman, BBC Radio 4, iPM, 25 May 2013,http://www.bbc.co.uk/programmes/b01sjn9l [accessed 7 April 2016]. White, *The Overview Effect*.
[64] 'Overview', http://vimeo.com/55073825 [accessed 7 April 2016]; The Overview Institute, http://www.overviewinstitute.org/ [accessed 7 April 2016].
[65] The Overview Institute: Declaration of Vision and Principles, http://www.overview-institute.org/index.php/about-us/declaration-of-vision-and-principles [accessed 25 May 2013].

into space imagined by human beings since the ancient world. Richard Branson, one of the elite group of entrepreneurs who are actively planning private space flights, takes the Overview Effect as inspiration for his Virgin Galactic company. Citing White's book, and like the astronauts who have experienced the effect, he says that

> We have one planet in our solar system that's habitable and that's the Earth, and space travel can transform things back here for the better. First of all by just having people go to space and look back on this fragile planet we live on. People have come back transformed and have done fantastic things. There's a wonderful book called *The Overview Effect* which has interviews with all the people who've been to space and [tells of] their experiences, and how it's changed them. I look forward to being changed in a positive way.[66]

Branson's interviewer, Andrew Anthony concluded that, 'Put this way, and leaving aside the commercial potential, the journey becomes less spatial than spiritual'.[67]

As we go through accounts of experiences by astronomers, the power of value-rationality is often evident, hidden in texts which emphasise technical rationality. For example, David Levy, famous as the co-discoverer of Comet Shoemaker-Levy which became a media sensation when it crashed into Jupiter in 1994, voiced such thoughts after observing a Mercury transit.

> I was filled with a sense of the solar system in motion... Instead of watching Mercury meander across a silent backdrop, we watched it move gracefully from one solar feature to another... the closest planet to the Sun is capable of putting up a marvellous show.[68]

Cassirer's sensual world trumps science when it comes to personal experience. Levy's observing group included Eli Maor, author of the 2006 Princeton University Press publication, *Venus in Transit*. Maor, Levy tells us, 'is as interested in how the mathematics of the solar system allow such rare events *as he is moved by the physical beauty of them*' (my emphasis).[69] And as the British astronomer Heather Couper once said 'Astronomy is not just about the science. It's visionary, inspirational and romantic'.[70]

In the narrative sense, space exploration is a psychological enterprise, carrying the hopes and aspirations articulated by Kennedy and the Overview

[66] Andrew Anthony, 'The Whole Family Want To Go', *The Observer, The New Review*, 10 April 2016, pp. 19-21 (p. 21).

[67] Andrew Anthony, 'The Whole Family', p. 21.

[68] David H. Levy, 'Our Memorable Mercury Transit', *Sky and Telescope* 113 (May 2007): pp. 84-85.

[69] Levy, 'Our Memorable Mercury Transit', p. 85.

[70] Heather Couper, 'Cosmic Quest', BBC Radio 4, 29 May 2008.

Institute. Technology is an adjunct to this psychological imperative. Objective Truth deals with technology, budgets and finances, and celestial mechanics. But Narrative Truth deals with ideological and cultural contexts manifested through religion, politics, art, religion and propaganda. Equally we may say that space travel is a religious enterprise expressing a desire for salvation, or a mythical one borne of the desire to explore new worlds. Leo Tolstoy gave some thought to this in *War and Peace*. Pierre, the aristocrat who develops a social conscience, is talking, comparing the evil condition of life on Earth to the goodness of the universe:

> 'You say you can't see any reign of goodness and truth on earth. Nor could I, and it's impossible to, if we accept our life here as the end of all things. On earth – here on this earth' (Pierre pointed to the open country) 'there is no truth: it is all lies and wickedness. But in the universe, in the whole universe, there is a kingdom of truth, and we who are now the children of earth are – in the eternal sense – children of the whole universe... '[71]

He continues that, even though Earth and space are distinguished by their moral quality, all is one:

> Don't I feel in my soul that I am a part of the vast, harmonious whole? Don't I feel that I constitute one link, that I make a degree in the ascending scale from the lower orders of creation to the higher ones, in this immense innumerable multitude of beings in which the Godhead – the Supreme Force, if you prefer the term – is manifest?[72]

And divinity, love and truth are represented in the sky:

> 'If there is a God and a future life, then there is truth and goodness, and man's highest happiness consists in striving to attain them. We must live, we must love, we must believe that we have life not only today on this scrap of earth but that we have lived and shall live for ever, there, in the Whole,' Pierre was saying, and he pointed to the sky.[73]

Via Pierre, Tolstoy was paraphrasing Emmanuel Kant, who had written in 1788:

> Two things fill the mind with ever new and increasing admiration and awe, the oftener and the more steadily we reflect on them: *the starry heavens above and the moral law within*. I have not to search for them as though they were veiled in darkness or were in the transcendent reason beyond my horizon; I see them before me and connect them directly with the consciousness of my existence.[74]

[71] Leo Tolstoy, *War and Peace*, trans. Rosemary Edmonds (Harmondsworth, Middlesex: Penguin Classics Version, 1982), Book Two, Part Two, Chapter 12, pp. 454-55.

[72] Tolstoy, *War and Peace*, Book Two, Part Two, Chapter 12, p. 455.

[73] Tolstoy, *War and Peace*, Book Two, Part Two, Chapter 12, p. 455.

[74] Immanuel Kant, *Critique of Practical Reason*, Great Books of the Western World 42, (Lon-

And here is Fred Hoyle, perhaps the most famous British astronomer of the 1960s and 70s:

> Our everyday experience even down to the smallest details seems to be so closely integrated to the grand-scale features of the Universe that it is well-nigh impossible to contemplate the two being separated.[75]

And Heather Couper again, this time from a quote about her, rather than by her, commenting on her 1988 planetarium show:

> And our connections with the stars go deeper than our ancestors ever imagined. Dead heroes do not in fact make up the star-patterns in the sky: but the matter of the stars does make our planet, and our bodies. "And we ourselves," Couper concludes, "are made of star dust".[76]

And lastly, representing a popular voice, the journalist Caitlin Moran writing on the space programme and evoking Carl Sagan:

> Humanity is in love with space, and I am not ashamed to say this moves me. Look at us so small, and scared and alone, in the dark, following our bravest and brightest into infinity. Watched by billions – yet in the loneliest place we've ever gone.[77]

Heavenly Discourses

This volume contains selected proceedings of the Heavenly Discourses conference, divided into four parts. We begin with six papers in a section we have called, simply, Heavenly Discourses. The scene is set by Ed Krupp's wide-ranging view of global culture and the long history of ideas of the celestial ascent. Roger Beck and Shannon Grimes continue with considerations of the classical world, John Hendrix examines English cathedrals, Stanisław Iwaniszewski takes us to Mexico, George M. Young draws a link between ancient ideas and the Soviet space programme in his study of the Russian cosmists.

Our second section is Discourses in Words. We open with a piece by Gillian Clarke, the National Poet of Wales (in honour of our affiliation with the University of Wales Trinity Saint David), on the inspiration of the sky in her own poetry. We then return to the classical world with Ben Pestell's discussion of Aeschylus' *Oresteia*. Steven L. Renshaw takes us to Japan in his account of the tales of 'Urashima Taro' and 'Night of the Milky Way Railroad'. Four papers

don: Encyclopaedia Britannica, 1952), pp. 360-61.

[75] Fred Hoyle, *Frontiers of Astronomy* (Charleston, SC: BiblioBazaar, 2011), p. 304.

[76] Marcus Chown, 'The Life and Death of a Star', review of 'Starburst! new show by Heather Couper at the London Planetarium', *New Scientist*, 21 April 1988, p. 63, available at https://books.google.co.uk/books?id=S-uyZw8e8XAC&pg=PA63&lpg [accessed 7 April 2016].

[77] Moran, 'Why I don't want us exploring space'.

then deal with Medieval and Renaissance Europe: Jennifer Neville on the 'Exeter Book Riddles', Simone Westermann on 'Dante Alighieri's influence on Federici Zuccari', Valery Rees on Marsilio Ficino and Nick Davis on 'King Lear', perhaps Shakespeare's most astronomically significant play. Faisal A. W. Hayder Al-Doori and Leon Burnett takes us to the turn of the nineteenth and twentieth centuries. Al-Doori examines spiritual symbolism in W. B. Yeats's 'The Phases of the Moon' and Leon Burnett explores the use and representation of Ursa Major by both writers and painters. Natalia Karakulina takes us to the core topic of the conference with her exploration of the influence of human space flight on Soviet science fiction and Carrie Patterson combines discourses in words with sound and images in her study of interstellar messaging. Pippa Goldschmidt concludes this section with an important analysis of how astronomy is represented in both scientific papers and fiction.

The next section, Discourses in Sound, consists of just two papers. June Boyce-Tillman takes a wide-ranging view of music's relationship with astronomy. Chris Dooks takes a look at the present relationship between music and astronomy, exploring his own practice in his paper 'Astrosonic Edutainment'.

The final section, Discourses in Images, is the most extensive. Jürgen Heinrichs sets the scene with his important study of how modern space imagery relates to Renaissance art. Valerie Shrimplin considers Byzantine art, Liana De Girolami Cheney takes the story to the Italian Renaissance with her examination of Giorgio Vasari's 'Sala Degli Elementi', and Jennifer Morris discusses Hans Holbein. Clive Davenhall moves to the modern world with his chapter on images of Mars before the space age. John Hatch takes a look at Anselm Kiefer's astronomical paintings. Ruth McPhee moves to the moving image in her study of astronomy in cinema. We have two contributors exploring their own work. Melanie Schlossberg updates classic constellations with her own created imagery, Michael Hoepfel speculates on perceptions of reality, using his own striking images, and Dietmar Hager asks what we are doing when we create images of space. Our concluding chapter is, fittingly, by David Malin, the pioneer of modern deep space photography.

VISIONS OF HEAVEN:
THE EXHIBITION

Darrelyn Gunzburg

The idea for an exhibition of David Malin's deep space photographs, along with some of his original glass photographic plates, came about once Nick Campion and I decided upon the concept for the *Heavenly Discourses: Myth, Astronomy and Culture* conference. Malin was born in 1941 in Summerseat, Lancashire, UK, and although he explored photography from an early age, he trained as a chemist and worked as microscopist. When he moved to Sydney, Australia, and joined the Anglo-Australian Observatory as its photographic scientist in 1975, he shifted from exploring the infinitely small to the infinitely far away. In his work for the Anglo-Australian Observatory he became a pioneer in making true-colour astronomical photographs from black and white plates taken in three separate colours. The novel image enhancement techniques were all incorporated into creating unique three-color photographs of previously unseen deep space objects. These new ways of extracting information from astronomical photographs, known as 'Malinisation', not only changed how we saw deep space but also revolutionized our cultural relationship with the sky.

I had known for some time of Malin's pioneering work and his breath-taking images of deep space. Furthermore, in 1990 I had contacted him with regard to the possibility of interviewing him for a documentary film I was hoping to make. Although the film never came to fruition, it was a correspondence he later told me he remembered. Now it was a matter of whether he would travel the distance from Australia to the UK to present his work at the *Heavenly Discourses* conference as a keynote speaker. When he said yes, then the exhibition as an adjunct to the conference became a certainty.

The question of where to hold the exhibition emerged fortuitously when I learned that Andy Price, the husband of a lecturer in the Department of History of Art at the University of Bristol, had recently opened The Bristol Gallery in Millennium Square by the Bristol waterfront. Due to my connection with the University of Bristol, he generously allowed us to use the space for free. With the help of Bernadette Brady and Rod Suskin, we set about creating the space that would accommodate the photographs. All the photographs in the exhibition were made from data derived from the glass photographic plates using the UK Schmidt or AngloAustralian Telescopes and then digitally remastered. They were printed using Giclée Printing through specialist Bristol print laboratory Hello Blue and framed using nonreflective glass by Damien da Costa. The Australian Astronomical Observatory sent us a selection of Malin's original glass

photographic plates for display in specially hired display cases. I created a catalogue and we arranged an opening night on the first evening of the conference. The exhibition ran from October 2011–April 2102.

We live in rapidly changing times. As Malin says: 'Astronomical imaging has changed completely since I joined the AAO in 1975'. Now images of deep space proliferate on the Internet. Whilst change brings its many benefits, however, something is always lost in the process. Gazing at the stars in total darkness, seated at the prime focus of a 600 tonne telescope, exposed to the cold night air, and waiting for the 30–90 minute exposures to take place on glass plates is no longer necessary, but each of the photographs selected for this exhibition represents those moments, of someone being on the edge – literally – to capture a piece of the sky from a long time ago and far away through lens and glass with such magnificent splendour and brilliance. It is rare to connect pivotal moments in history with those who created them. For me, curating this exhibition was both an honour and a celebration, but above all, it represented the opportunity to capture a piece of awe.

Darrelyn Gunzburg
12 April 2016
Bristol, UK

Ed Krupp, Director of the Griffith Observatory, Los Angeles, introducing David Malin

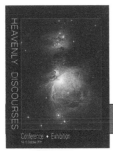

University of BRISTOL
Y Drindod Dewi Sant
Trinity Saint David

HEAVENLY DISCOURSES
MYTH, ASTRONOMY AND CULTURE

Friday 14 - Sunday 16
October 2011

 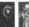

LAUNCH INVITATION

The co-convenors of *Heavenly Discourses* have the pleasure of inviting you to the champagne launch of

Visions of Heaven

an exhibition of David Malin's pioneering astrophotography

Friday 14th October 2011 7:30 pm – 9:30 pm

The Bristol Gallery, Millennium Promenade, Harbourside, Bristol, BS1 5TY

The exhibition will be opened by

Dr Ed Krupp

Director of Griffith Observatory, Los Angeles, CA, USA,

and special guest of honour

David Malin

RSVP: Wendy Buonaventura wendy@cinnabarbooks.co.uk

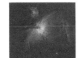

Curator:
Darrelyn Gunzburg.

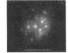

Exhibition duration: 15 -23 October 2011
Monday- Saturday 10am -5pm; Sunday 12pm - 4pm

FREE TALKS AT THE BRISTOL GALLERY:

Professor David Malin
Photography and the Discovery of the Universe
Monday 17 October at 6:00pm.

Darrelyn Gunzburg
The Changing Faces of the Heavens
Friday 21 October at 6:00pm.

Limited places. To book: diane.thorne@bristol.ac.uk

'The most beautiful collection of astronomical photographs ever published.'
From *The Invisible Universe* by David Malin (1999), New York, London: Bulfinch Press.

'Uses spectacular photography to show the colours of stars, galaxies and nebulae.'
From *Colours of The Stars* by David Malin and Paul Murdin (1984), Cambridge: Cambridge University Press.

Connect with *Visions of Heaven* on Facebook | Visit our website:

www.HeavenlyDiscourses.org - 'Exhibition'

 University of BRISTOL

Y Drindod Dewi Sant
Trinity Saint David

HEAVENLY DISCOURSES
MYTH, ASTRONOMY AND CULTURE

Friday 14 - Sunday 16
October 2011

 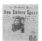

Visions of Heaven

an exhibition of
David Malin's
pioneering astrophotography

held in conjunction with
Heavenly Discourses: Myth, Astronomy and Culture
an interdisciplinary conference organised jointly by
Nicholas Campion
School of Archeology, History and Anthropology, Sophia Centre for the Study
of Cosmology in Culture, University of Wales Trinity Saint David and
Darrelyn Gunzburg
Department of History of Art, University of Bristol.

14 - 23 October 2011
Exhibition curated by Darrelyn Gunzburg

We would like to thank the Australian Astronomical Observatory and The
Brsitol Gallery for their support in the organisation of this exhibition.

Australian Government
Department of Innovation
Industry, Science and Research

The Bristol Gallery

Front cover: The Great Nebula in Orion which appears as a misty patch around the central star of the
line of three which form Orion's sword. Three-colour image made from plates taken at the UK
Schmidt Telescope. *Creator:* David Malin. ©Anglo-Australian Observatory/ David Malin images.

Visions of Heaven
14 – 23 October 2011

Exhibitions bring images together in a complex gathering of perspectives, like a many-faceted conversation that flows endlessly, allowing new insights to be gained.

The verb we commonly use with photographs is 'taken'. However, these are no ordinary photographs. David Malin prefers the verb 'made' and the method he used illustrates that careful and painstaking process of making something distinctive. The works in this exhibition and which are illustrated in this catalogue have been selected from a wider but closed set of images created by David Malin from glass plates when he worked as photographic scientist-astronomer at the Anglo-Australian Observatory from 1975 to 2001.

These images illustrate other worlds that, due to Malin's work, now form part of our world, the known and the unknown, the deep black velvet sky of stars that we see if we are gifted with a clear night, yet images that reveal such an extraordinary jewel-like nature that we can only gasp in wonder.

The images were selected to express the diversity of the sky through David Malin's art but they also show us the diversity of David Malin, the man who first 'coloured' stars and gave us our view of deep space in ways that we now take for granted. In this regard it is my particular pleasure and honour to be presenting his work in Bristol.

Darrelyn Gunzburg

Printing – print laboratory and framing

These superb images have been printed using Giclée Printing through specialist Bristol print laboratory Hello Blue. A Giclée is a very high-resolution ink-jet print onto an acid and bleach free, 100% cotton archival paper. The highest quality light-fast, UV stable inks are used. The print is then coated in a protective spray, which gives it an added level of UV and moisture protection and an extremely high tolerance to environmental factors. Every colour print is light-fast for at least 75 - 100 years. If kept in suitable conditions there is almost no limit as to how long they could last. Giclée Printing is able to reproduce the images so as not to lose shadow detail in the prints. As David Malin explains, the sky should be anything but solid black, as this effectively undermines the enormous amount of time and effort he put into revealing all the faint structures.

The prints are framed using non-reflective glass that maintains the luminosity of the images. Normal framing glass dulls the prints and actually adds a layer of green. Non-reflective glass allows the images to explode with life. The prints have been framed by Framing Bristol. Damien da Costa, the director, is an artist who understands the necessity of quality framing and has developed specialist framing techniques so the image appears to float behind the thin edged frames. His specialty is lacquer frames and the 92 x 73.6 images are all framed using his unique lacquer frames.

The telescopes of the Australian Astronomical Observatory

The two telescopes of the Australian Astronomical Observatory (AAO) are on Siding Spring Mountain in outback northwestern New South Wales, Australia overlooking the Warrumbungle National Park, one of Australia's finest. Both these instruments are constantly updated to exploit their natural advantage of being located beneath some of the world's darkest skies.

Above right: In the foreground is the dome of the Anglo-Australian Telescope (AAT) itself, and around its base is the red packing case that carried its 4 meter mirror from its final polishing in England. Alongside it is the concrete dummy mirror used as a test weight to balance the telescope during construction.

Above left: In the foreground is the small dome of the UK Schmidt Telescope (UKST), constructed in 1974, but since 1988 a vital part of the AAO. Despite its diminutive size the UKST has exquisite optics and a field of view much greater than the AAT. It has been used to make surveys of the largely unexplored southern sky, discovering new objects that are studied in more detail with the AAT.

Both images and text © 1977 -2002 Astralian Astronomical Observatory. Photograph by Davd Malin.

Left: AAT Dome and facilities building, the last of a series of 4m telescopes constructed in the mid-1970s. Of all the telescopes operated on this mountain, the dome of the AAT is the most imposing, rising nearly 50 metres from the ground. The lower, cylindrical portion houses offices, darkrooms, small workshops and the many pieces of equipment required for the efficient operation of a large optical telescope and its complex instruments. The upper, rotating hemispherical portion is the dome itself, within which the telescope resides protected from the elements. When the telescope is in use a small opening in the dome is positioned directly in front of it.

Image © 1977 text ©2010 Astralian Astronomical Observatory . Photograph by Davd Malin.

3

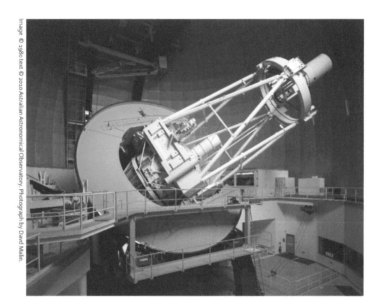

Image © 1980, text © 2010 Australian Astronomical Observatory. Photograph by David Malin.

The Anglo-Australian Telescope (AAT) was the last of a series of several 4m-class equatorial telescopes of similar design that were built in the mid 1970s, and it is one of three that were constructed in the southern hemisphere. The AAT, along with its companion telescope, the 1.2m UK Schmidt Telescope, and offices and laboratories in the Sydney suburb of Epping, comprise the Australian Astronomical Observatory, successor organisation to the Anglo-Australian Observatory. Regularly scheduled observations began with the AAT in July, 1975, and operates every clear night of the year except for a few nights in the southern summer when the mirror is removed for re-aluminising.

Seen here pointing low in the east, the telescope is capable of looking anywhere in the southern sky more than 20 degrees above the horizon. It does so by swivelling on two axes. The motion which follows stars from east to west across the sky is defined by the yellow horseshoe bearing. This rotates resting on pads supported by pressurised oil. The second motion is around an axis between the arms of the horseshoe that permits the white structure holding the large mirror to tip north and south. At the end of the telescope is the tube-like prime focus 'cage' where light from the primary mirror is brought to a focus. It is from this focus that all the AAT colour photographs in this ex-hibition were made between 1978 and 2000, mostly using glass photographic plates. These were mostly intended for scientific purposes, but many of them were suitable for making 3-colour images using an additive process described in this catalogue. Some care has been taken to ensure that the colour in the images derived from these plates is realistic.

4

Photography and the Telescope,
a Heavenly Marriage

When Galileo first turned his telescope to the sky in 1609, he discovered a universe more varied and more mysterious than anyone had imagined. It was not so much the magnification of the telescope that led to this leap in understanding, though this helped, rather it was the detection of faint light. As human vision was extended by ever more powerful telescopes, increasingly fainter objects were seen.

The first astronomical object to be photographed was the Moon, probably by Daguerre in 1839. As it became easier to use, photography was gradually adopted by astronomers, and by 1882 it was demonstrated that it could reveal stars fainter than could be seen by the keenest eye using the same telescope. This transformed it from a mere recorder of what was visible to a detector of the unseen. For a hundred years thereafter it played a key role in advancing our knowledge of the nature of stars and of the distances of the galaxies and ultimately of the age and size of the Universe itself. The application of photography to astronomy was as influential as the invention of the telescope itself.

In the digital age the revolution continues apace, and while the materials and techniques are quite different from those of the photographic era, the idea of extracting as much information as possible from the feeble light of the distant stars and galaxies remains central. A similar series of steps can be seen in the evolution of the microscope, another instrument that completely changed our understanding of the world around and within us.

I have been fortunate to use both types of instruments in my scientific career and found it is possible to use a telescope or a microscope to record some normally invisible aspect of nature in a way that is both scientifically useful and aesthetically pleasing. Indeed several of the techniques I had used in my microscopy work in England were even more useful in astronomy, where there is no possibility of manipulating the position, lighting or environment of the objects of interest, which can only be seen at night, under dark skies, and with an enormous telescope. These techniques involve optical methods applied to the images themselves, to extract more detail — and more information — from the processed files or plates, while respecting and preserving the integrity of the data.

A Universe of Colour

In the mid-1970s, few colour images of astronomical objects apart from the Moon and planets existed. In part this was because those astronomers who still looked through telescopes saw very little colour; the eye is insensitive to colour at low light levels. When colour photography was tried, exposures were extremely long and the colours revealed were unsatisfactory. This was because photographic materials were intended for snapshot exposure times. 'Everyday' film becomes very inefficient as exposure times increase, and the three layers in colour film respond differently. They also require lots of valuable telescope time for an activity that is difficult to justify scientifically in a professional observatory. Thus most successful colour photography was done initially by persistent amateurs, usually with relatively small telescopes.

When I joined the Anglo-Australian Observatory (now the Australian Astronomical Observatory) in the mid 1970s I found that astronomers had long been accustomed to taking separate black and white images in blue and green light as a way of measuring the temperatures of the stars. Very hot stars appear bright on blue-sensitive plates, while cooler, reddish stars seem relatively brighter on green-sensitive plates. Unlike colour film, these special plates were designed to record faint light, and could be made even more sensitive with special hypersensitising processes. All that was need to make a true-colour picture from the blue– and green–light plates was an image of the same object taken in red light. The UK Schmidt Telescope (UKST), alongside the Anglo-Australian Telescope (AAT) at Siding Spring, already had such plates in their archive.

While it was initially difficult to align the separate colour images in register using conventional processes in the darkroom, I realised the James Clarke Maxwell had done this using beams of light from three 'magic lanterns' in 1861, so I adopted his additive colour approach. This used projected red, green and blue (RGB) light images overlapped to recreate the colour images rather than yellow, magenta and cyan pigments or dyes of the subtractive process used by printers and painters. This same method of combining many projected images of the same field in register also improves the signal-to-noise ratio of the final composite. Exploiting this led to several interesting astronomical discoveries unrelated to colour imaging. The first additive three-color images were made from UKST plates in 1978, and I found that the other image manipulation processes I had used to extract information from the plates could be incorporated into the process to make colour images of objects that had never been seen in colour before. These techniques included unsharp masking

(to explore dense negatives of bright objects)(Figs. 1 and 2) and photographic amplification (sometimes referred to as 'malinisation'), a data 'stretching' process which revealed the faintest objects on glass plates.

The End of an Era

Traditional photography is no longer used to detect light in astronomy, but making colour pictures using red, green and blue (RGB) colour separations is now universal in digital imaging in professional and most amateur observatories. It is the only way that a telescope like the Hubble Space Telescope could operate. Nowadays, most digital imaging software includes tools for combining separate images in register, for unsharp masking and for stretching images to emphasise faint detail — and much else that could not be done in the darkroom.

All the images in this exhibition were made from data derived from glass photographic plates using the UK Schmidt or Anglo-Australian Telescopes. These data have been digitally remastered to make the prints and other derivatives seen here.

David Malin

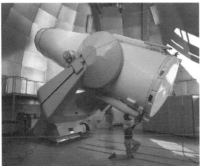

Image and text © 1977–2002 Australian Astronomical Observatory. Photograph by David Malin.

The UK Schmidt is a specialised telescope that was designed primarily for photography. It combines a wide field of view over 6 degrees across with superb optics and a very wide aperture of 1.2m. Imagine having a camera lens with a focal length of over 3 meters, working at F/2.5. It was intended to make a very deep photographic survey of the largely unexplored southern sky in a number of colours. The dark skies of Siding Spring and photographic expertise developed at the telescope ensured that this survey was a revelation to astronomers from around the world. This task is now completed and the survey images are publicly available in digital form, a development not forseen when the telescope was constructed in 1974.

The telescope no longer takes photographs, but much of its effort is now devoted to spectroscopy, using optical fibres to collect the light from numerous individual galaxies and stars. The wide field, large aperture and clear, dark skies over the Warrumbungles remain a priceless advantage, and the telescope continues to make a significant contribution to international astronomy.

7

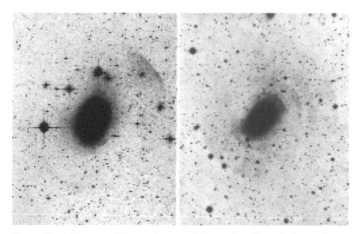

Figure 1. Combining several images of a normally featureless elliptical galaxy such as NGC 1344 *(above left)* can reveal very faint external shell-like features that hint at earlier encounters. At right is NGC 3923, whose internal shells, normally hidden in the brightest parts of the galaxy, are revealed by unsharp masking.

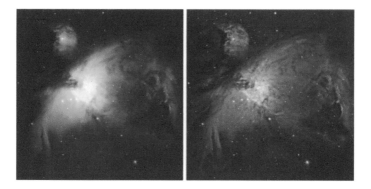

Figure 2. Images of the Orion nebula made from the same set of three, 5-minute exposure plates taken with the Anglo-Australian Telescope in red, green and blue light. The image on the left shows the result of combining these plates directly into a colour image. On the right the separate plates were copied using photographic unsharp masks before combination.

Sources of Colour in Astronomy

We are inclined to think the colourful world around is all there is to see, and even a large telescope used at night does little to dispel that perception. The stars seem more numerous and brighter with a telescope, but there is little obvious colour. That is partly because the eye is blind to colour when light levels are low — moonlight shows us the shape of the nocturnal landscape but not its colour. Also, the eye has trouble perceiving the colour of very small images (small field tritanopia) along with the fact that the astronomical objects that are colourful are almost always extremely faint.

So how do we know that colour exists if we cannot see it? It is an interesting philosophical point: can colour exist if it is invisible? The answer is certainly yes, but the light-gathering properties of photography are needed to make it visible.

Even before photography, astronomers knew that the light from stars was similar to sunlight because it could be split by prism into a continuous rainbow colours (continuum spectrum). But some objects in the sky had spectra that consisted of narrow lines of colour (line spectrum), quite unlike stars or rainbows. We now know these lines are mostly from glowing gas and the physical processes involved are similar to those that create the light in advertising signs such as 'neon' lights. These narrow lines are essentially monochromatic (single colour) and so are as strongly coloured as they can be. But if they are faint they do not seem so when seen by eye in a spectroscope, a device for viewing spectra. When the spectroscope was made into a spectrograph by the addition of a black and white photographic plate to record the pattern of light, it immediately became clear that some 'extended' (i.e. non-stellar) astronomical objects must be strongly coloured, because the light from them was confined to a few, narrow parts of the spectrum, often in the blue-green and deep red regions. But how is a black and white negative turned into a colour picture?

Colour Separation Photography, an Outline

Three separate exposures of the object are made in red, green and blue light, in our case on special black and white photographic emulsions coated on glass plates which can be up to 356 mm (14 inches) square for the UK Schmidt Telescope, or 256 mm (10 inches) square for the AAT. The telescopes were designed in inches and those were the units used by the plate suppliers. The plates were always hypersensitized by baking in nitrogen and hydrogen just before use. This increases their long-exposure speed dramatically, and was an essential part of photographic observing. Preparing the plates just before the observing run often took many more hours that the observing itself. The exposures are made sequentially, but, since the objects of the night sky that we were usually interested in hardly change in millenia, the images can be taken years apart.

RGB photography on the AAT and UK Schmidt was done with a series of three different photographic emulsions, all made by Eastman Kodak, and each with a mysterious code name. These photographic plates went out of production in about 1997, but they had been introduced in the 1930s, initially as special products (Eastman Spectroscopic Plates) from Kodak's famous Research Laboratory. They were further developed in conjunction with astronomers and other scientists, and by 1937, no fewer than 20 different spectral sensitivities were offered with six different types of photographic emulsion.

9

Nowadays it is much simpler to combine the three images using software such as Adobe Photoshop, but before image processing software was invented, many of the image enhancement techniques that are now routine on a computer were performed photographically in the darkroom. Three techniques in particular were important for astronomical photography:

Unsharp Masking

The photographic negatives used for astronomy were special high contrast, fine grained materials designed to capture the faintest cosmic light behind the uniform glow of the night sky. They were also processed in energetic developers for maximum sensitivity, so astronomical negatives are usually contrasty and very dense (black) where any light at all was captured. Technically speaking, their Dmax was about 5, which means that in the darkest parts of the processed negative transmitted only 0.00001 percent of the light (from an enlarger, for instance) incident upon it. These negatives could not be printed like 'everyday' negatives, where the Dmax is 1.5, and they transmitted a few percent or so of light, making photographic printing easy.

My solution was to this to make a contact copy of the negative on a sheet of low contrast film, but with the back side of the glass in contact with the film. If this light source was diffuse, the resulting positive would be unsharp — blurred — and the amount of blurring could be controlled by adding extra layers of glass. The density and contrast of the mask could also be controlled by varying the exposure and processing of the mask film.

Once processed and dried, the mask was replaced in position on the back of the original plate and a contact copy was made in the normal emulsion-to-emulsion manner, again using the diffuse light copier. The unsharp positive had the effect of canceling unsharp information in the negative and reducing its dynamic range, so the resulting positive appeared sharper and was much easier to print.

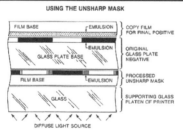

This process is closely analogous to the Adobe Photoshop unsharp masking tool. The variation in glass thickness controls the area over which the mask works, equivalent to radius in digital unsharp masking, and the density and contrast of the photographic mask control the amount of unsharp masking that is applied.

Photographic Amplification ('Malinisation')

Although the negatives were already contrasty, for many science purposes it was desirable to extract as much faint information from the images as possible, even at the cost of sacrificing the image highlight tones. This was done by making a high contrast copy of the original plate (without unsharp masking), using a lith-type film with extremely high contrast and a diffuse-light copier. The exposure is controlled so that the sky background of the resulting positive had a low density, thus the highest density on the copy film was between 0.4 and 0.5. This requires the copy exposure to be controlled with great precision, but has the effect of exaggerating the near-surface image grains that carry much of the faint detail hidden in the emulsion layer, as shown on this diagram.

The resulting thin, but very contrasty positive was then printed on high contrast photographic paper. This analogue process is similar to selecting a small section of the levels histogram in Photoshop. All highlight detail is lost and minute variations in photographic density (corresponding to faint astronomical objects) are revealed. However, photographic grain is also exaggerated, so, while the signal is increased, so is the noise. But there is a cure for this.

Multi-image addition

In astronomy, it is not uncommon to make many long-exposure photographs of the same part of the sky for survey purposes. In each of these separate photographs, the stars, galaxies and faint detail are the same, but the grain structure of the image is different. The image can be considered as signal (stars and galaxies) and noise (the grain structure). By combining many separate, photographically-amplified images in register, it is possible to dramatically decrease the amount of noise, rendering the signal more obvious. This method of increasing the signal-to-noise ratio has been very useful for detecting the faintest features of bright galaxies amongst other things. This was done manually in the darkroom by sequentially projecting many identical, photographically amplified positive images on to a sheet of paper or film, using a simple home-made device. However, each image had to be carefully aligned before the exposure was made, and the exposure equally divided among the several (or many) separate images available, so that each contributed equally to the final result.

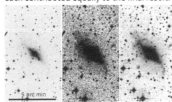

Original appearance *(left)*, after photographic amplification *(centre)* and seven images combined *(right)*, all at the same scale. Plates taken in blue light with the UK Schmidt Telescope.

Exactly the same can now be achieved digitally, using the 'layers' transparency control in Adobe Photoshop, and alignment is achieved using the 'transform' and 'rotate' options. Especially useful in Photoshop are the skew and distort possibilities for precisely aligning images that had unavoidable distortions from chromatic or other optical aberrations. This was always difficult and sometimes impossible in the darkroom.

Microscope to Telescope

Though a chemist by training, I have had a lifelong interest in the interplay of optics, colour, light and the use of the photographic process as a way of recording these phenomena, often in scientific context. These interests were fostered by working for many years for a large international chemical company with extensive laboratories in the north of England. I used optical and electron microscopes and X-ray diffraction techniques to explore problems in pure and applied chemistry, often on coloured, crystalline products such as pigments and dyestuffs. In the 1960s and 70s the major enabling technology for these analytical techniques was photography, where it functioned as a detector of unseen radiation, as a recording medium and almost incidentally as a way communicate complex findings to a wider audience.

I also soon learned that my photographs were more likely to be looked at if they were attractive to the eye while remaining faithful to the science. In the course of my work I also developed an interest in the remarkable chemistry and physics of the photographic process itself, which records an astonishing amount of information entrained in a tiny amount of energy.

Figure 3. Scanning electron micrographs of house dust mites out to lunch *(left)* and a 3-colour image showing a tungsten-aluminium alloy seen at at different accelerating voltages *(right)*.

In 1975, this notion became much more relevant when I applied for the position of photographic scientist at Anglo-Australian Observatory (now the Australian Astronomical Observatory), where the Anglo-Australian Telescope (AAT) had recently been commissioned. I was based in Sydney, but with regular visits to the telescope itself, which was located far from the city, under the dark skies of the Australian outback. I soon found that the methods of handling photographic data I had developed ina completely different field were very useful in astronomy. Indeed there were many parallels, including the idea of the photographic material

12

as a detector, rather than simply a recorder of radiation, and that what was being recorded were scientific data from which images can be made, rather than merely pictures.

However, unlike the work in the laboratory with microscopes and X-rays, observing with a large optical telescope offered an entirely new experience. For a start, it is obviously not a job with regular daylight hours, working with colleagues in a convivial laboratory atmosphere. Indeed the most important and challenging aspect of the work takes place at night, on a remote mountain-top far away from city lights with one or two highly specialised technicians for company. Unlike a microscope or other laboratory equipment, a large telescope is not free to use when the need arises. Instead, time on such an instrument is applied for months in advance, and subject to rigorous peer review by a committee faced with a heavily over-subscribed telescope. In a good year an allocation of 10 nights is considered generous, and on average two or three of those would be cloudy.

Capturing faint light

The once-familiar business of loading a roll or cassette of film into a lab microscope camera was replaced with what seemed like a step backwards in time. The photographic materials used at a professional telescope were large glass plates coated with special emulsions, made to order by the Eastman Kodak Company in the USA. Rather than being old-fashioned, these emulsions were among the most sensitive ever produced, so sensitive that the plates had to stored and shipped around the world in refrigerated containers. Coated on film and kept on a shelf in a retail store these products would rapidly fog and be useless in a week or so.

Before use the plates had to be hypersensitized to make them even more sensitive to faint light. This usually involved baking them in nitrogen in a moderate oven, and then exposing them to hydrogen gas for a few hours at room temperature, all of it in light-tight containers. This reduced their shelf life even further, so they had to be prepared a few hours before use, and my photography-chemistry background was very useful in understanding and exploiting these mysterious processes.

With a large telescope like the AAT, the photographic observer sat at the top end the 600 tonne telescope, at its prime focus, which at the AAT is 12.7 meters above the 4-m diameter primary mirror and 25 meters or so above the floor of the cavernous dome. Exposed to the cold night air, in total darkness and with one's back to the stars there were long periods of inactivity as feeble, ancient light was turned into a latent image on the photographic plate in the plate-holder between your knees. Exposures were typically 30 to 90 minutes, occasionally

13

longer, which gave plenty of time to gaze at the stars overhead and listen to music piped up from the control room far below. In between each exposure there was a brief period of intense activity as the telescope slewed to the next object, the top end of the telescope rotated, a new plate and filter was inserted and a suitable guide star found. If all went well, 90 seconds or so later a new exposure was begun, and so on, throughout the night. Before going to bed the plates had to be processed, one at a time, again in total darkness. Only then could the lights be turned on and the night's work assessed.

The past tense here is deliberate, for astronomical imaging has changed completely since I joined the AAO in 1975. Light is now detected using a solid-state charge-coupled detector (CCD) mounted at the prime focus, and controlled remotely from the control room. Observing now involves watching a bank of electronic monitors, exposures are much shorter and the image readout is almost instantaneous. Image processing is done digitally, often on the fly. The light sensors are much more sensitive than the photographic plate ever was, and it is electronics, not chemistry that makes the image visible.

Much has been gained with electronic imaging in astronomy, but at a big telescope something has been lost as well. It is much more efficient and versatile than photography ever was, but it is now neither convenient nor necessary to sit at the end of the telescope beneath the stars, contemplating origins and destiny.

David Malin

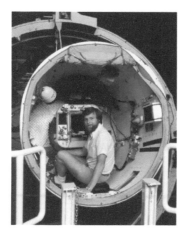

David Malin at the prime focus of the Anglo-Australian Telescope in 1976. Behind his head is the camera back, designed to take 250 mm (10-inch square) photographic plates.

14

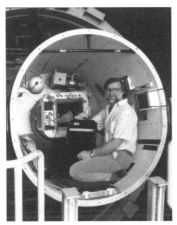
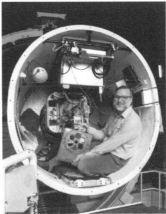

Above left: David Malin at the prime focus of the Anglo-Australian Telescope in 1991. In the mid 1990s astronomical images began to be acquired with increasingly sophisticated electronic detectors known as CCDs (charge-coupled devices), and these have now completely replaced traditional photography. These are larger and much more elaborate versions of the light detectors used in most digital cameras. In practice they are now operated remotely from the telescope control room, or even from another location

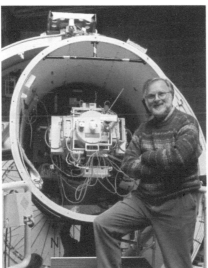

entirely, but as they were being developed the observer was required to change the filter and to make other adjustments necessary for observing. The picture made in 1997 *(above right)* shows the observer holding a filter wheel.

However, now there is now no need for the observer to ride inside the 'cage' at all, as the image made in 2000 *(left)* shows. Not only is there no need — there is no room! Indeed for ease of access to the much more elaborate devices produced after this photograph was made, the prime focus cage is a hinderance and has been removed.

THE SOPHIA CENTRE FOR
THE STUDY OF COSMOLOGY IN CULTURE

SCHOOL OF ARCHAEOLOGY, HISTORY AND ANTHROPOLOGY
THE UNIVERSITY OF WALES TRINITY SAINT DAVID

http://www.uwtsd.ac.uk/sophia

The Sophia Centre for the Study of Cosmology in Culture is a research and teaching centre within the School of Archaeology, History and Anthropology at the University of Wales Trinity Saint David. We define cosmology in the traditional sense as a view of the cosmos, and humanity's place within it. All cultures and all people therefore have a cosmology, and the Centre's remit is the consideration of how we live on planet Earth, with particular reference to the sky, stars, planets and cosmos as part of the wider environment. Our work includes exploration of the ways in which people have tried to live in harmony with the cosmos.

The Centre's academic and scholarly work is partly historical, partly anthropological and partly philosophical and draws strongly on recent developments in the study of religions. It has a wide-ranging mission to investigate the role of cosmological, astronomical and astrological beliefs, models and ideas in human culture, including the theory and practice of myth, magic, divination, religion, spirituality, architecture, politics and the arts. We deal with the modern world as much as indigenous or ancient practices, and our work ranges from the study of Neolithic sites to medieval cosmology, the history of astrology in the ancient world, India and the west, the nature of space and place on Earth as well as in the sky, and the ethics of modern space exploration. We have been instrumental in developing the concept of the skyscape as a vital feature of human cultures and can support work in any time period or culture.

The main qualification we teach is the distance-learning, online MA in Cultural Astronomy and Astrology, the only degree in the world which explores humanity's relationship with the sky. There is no need to live in the UK to study this MA and we have a global community of students and scholars in other MAs at the University, including the MAs in Ancient Religion, Body and Environment, and Ecology and Spirituality. We also contribute to the undergraduate module in Land, Sea and Skyscapes.

The Centre supervises PhD students, holds conferences, publishes books and articles, sponsors events and manages research projects. Aside from its annual

conference, held every year since 2003 (at Bath Spa University from 2003 to 2007) the Centre has sponsored five other international conferences. In addition to the 2011 Heavenly Discourses conference these include the 2007, 2010 and 2015 conferences on the Inspiration of Astronomical Phenomena (INSAP) and the 2016 conference of the European Society for Astronomy in Culture (SEAC).

In addition to the volumes published by the Sophia Centre Press, our publications include the peer-reviewed history journal, *Culture and Cosmos*, and *Spica*, the online postgraduate journal written and edited by students. Our recent sponsored publications include: N. Campion, F. Pimenta, N. Ribeiro, F. Silva, A. Joaquinito and L. Tirapicos, eds, *Stars and Stones: Voyages in Archaeoastronomy and Cultural Astronomy – a Meeting of Different Worlds* (Oxford: British Archaeology Reports, 2015); Daniel Brown, ed., 'Modern Archaeoastronomy: From Material Culture to Cosmology', *Journal of Physics: Conference Series* 865, no. 1 (2016); Nicholas Campion, Barbara Rappenglück, Michael Rappenglück and Fabio Silva, eds, *Astronomy and Power: How Worlds are Structured* (Oxford: British Archaeology Reports, 2016); and Nicholas Campion and Dorian Gieseler Greenbaum, eds, *Astrology in Time and Place: Cross-Cultural Currents in the History of Astrology* (Newcastle: Cambridge Scholars Publishing, 2016). We also sponsor the *Journal of Skyscape Archaeology*, the peer-reviewed journal dedicated to examining the role and importance of the sky in the interpretation of the material record.

Our major research project of the moment is 'Welsh Monastic Skies', an investigation of the alignment of Welsh abbeys in relation to major features in the sky and land. We are also working on *Kepler's Astrology*, which hopes to make all Kepler's horoscopes available for study.

If you are interested in the way we use the sky to create meaning and significance then the Centre may be the best place for you to study. By joining the Sophia Centre you enter a community of like-minded scholars and students whose aim is to explore humanity's relationship with the cosmos.

For all academic inquiries and for further information, please contact Dr Nicholas Campion at n.campion@uwtsd.ac.uk.

'The work of the Centre is as broad as possible and the MA syllabus is groundbreaking, unique and innovative. We study the many ways in which human beings endow the cosmos with value and use the sky as a theatrical backdrop to tell stories and create meaning.'

— Dr Nicholas Campion

CONTRIBUTORS

Dr Faisal Al-Doori is a poet, story writer, critic, journalist and translator and has won many literary prizes in Arabic, including those for The Arabic Union for Writers in 2000 and Naji Namaan in 2014. Al-Doori finished his PhD studies at Aberystwyth University in 2015, and his PhD project is on the mysticism found in W. B. Yeats. He holds a technical diploma from The Institute of Medical Technology, Baghdad (1974); a B.Ed and an MA in English literature from Tikrit University (1998 and 2003); and an LLB from the College of Law, Baghdad University (2006). He taught as a lecturer at Tikrit University 2003-2010. Al-Doori has shared his papers on poetry in many international academic conferences in Iraq, the UK, Ireland, Austria and Portugal. He has published many books in Arabic on poetry, short story, and literary criticism and published numerous papers in English on Dickens, Wordsworth, Fielding, Defoe, Hardy and Yeats.

Professor Roger Beck is Professor Emeritus at the University of Toronto, where he began his career at Erindale College and Department of Classics (Lecturer 1964-65, Assistant Professor 1968-74, Associate Professor 1974-84, Professor 1984-98, Professor Emeritus since 1998). He received his BA from Oxford (1961) and his PhD in Classical Philology at University of Illinois (1971). He was Secretary of the Classical Association of Canada from 1977-79 and Review Editor (1978-82) and Associate Editor (1982-86) for the journal *Phoenix*. His current research interests are Mithraism and religion in the Roman Empire; ancient astrology and astronomy; and Petronius and the ancient novel. His works include *The Religion of the Mithras Cult in the Roman Empire* (2006) and *A Brief History of Ancient [this word added 2/16] Astrology* (2006). His collected articles, many of them having to do with ancient astronomy and astrology, were published by Ashgate in 2004 as *Beck on Mithraism: Collected Works with New Essays*.

The Rev. Professor June Boyce-Tillman MBE is currently Professor of Applied Music and Artistic Convenor of the Centre for the Arts as Wellbeing at the University of Winchester and an Extraordinary Professor of the North West University, South Africa. She is a composer specialising in music and spirituality. She is a hymn writer *(A Rainbow to Heaven 2007)*. Her one-woman shows have been performed in three continents. She has been very active in issues concerning gender in music particularly in the area of liturgical music – *In Tune with Heaven or not – Women in Christian Liturgical Music* (2014). Among her books are *Unconventional Wisdom* (2007) and *Experiencing Music: Restoring the Spiritual – The Arts as Wellbeing* (2016). She has been actively engaged in interfaith dialogue and the use of music for peace making. She is an ordained Anglican priest.

Dr Leon Burnett is former Director of the Centre for Myth Studies at the University of Essex (2008-2014). His research and publications are mainly in Com-

parative Literature and Mythology. He was the main editor of the British Comparative Literature Association's house journal, *New Comparison*, for eight years (1992-2000) and, more recently, he has co-edited three books: *The Art of Accommodation: Literary Translation in Russia* (2013), *Myth, Literature, and the Unconscious* (2013), and *Translating Myth* (2016).

Dr Liana De Girolami Cheney is presently a Visiting Scholar in Art History at SIELAE, Universidad de Coruña, Spain, and at the Università di Aldo Moro in Bari, Italy. She is an emerita Professor of Art History, at UMASS Lowell, MA. Dr Cheney received her BS/BA in Psychology and Philosophy from the University of Miami, Florida; her MA in History of Art and Aesthetics also from the University of Miami, Florida; and her PhD in Italian Renaissance and Baroque from Boston University, MA. Dr Cheney is a Renaissance, Mannerist and Pre-Raphaelite scholar, author, and co-author of numerous articles and books, including: *Botticelli's Neoplatonic Images*; *Neoplatonism and the Arts*; *The Homes of Giorgio Vasari* (English and Italian); *Giorgio Vasari's Teachers: Sacred and Profane Love*; *Giorgio Vasari's Prefaces: Art and Theory*; *Giorgio Vasari's Artistic and Emblematic Manifestations*; *Giorgio Vasari in Context*; *Edward Burne-Jones' Mythical Paintings*; *Agnolo Bronzino: The Florentine Muse*; and *Radiance and Symbolism in Modern Stained Glass: European and American Interrelations in Material Culture*.

Gillian Clarke was born and brought up in Cardiff, and now lives in Ceredigion. She is a poet, playwright, editor, translator (from Welsh), and President of Ty Newydd, the writers´ centre in North Wales, which she co-founded in 1990. Her poetry is studied by GCSE and A Level students throughout Britain. She has been National Poet for Wales since 2008. In 2010 she was awarded the Queen's Gold Medal for Poetry, the second Welsh poet to receive the honour. In 2011 she was made a member of the Gorsedd of Bards.

Dr Clive Davenhall has a long-standing interest in the history of astronomy. He has contributed to the *Journal of Astronomical History and Heritage* and written entries for the *Biographical Encyclopaedia of Astronomers*. He was a Founder Member of the Society for the History of Astronomy and formerly edited its *Bulletin* (previously *Newsletter*) and has been a member of its Council. In real life he is a Project Manager and Software Developer in the Wide Field Astronomy Unit, Institute for Astronomy, University of Edinburgh, based at the Royal Observatory Edinburgh. He has degrees from the universities of London and St Andrews.

Dr Nick Davis is a Senior Lecturer in the English department at Liverpool University. His main research interests are European transitions to modernity (fourteenth to early eighteenth century), narratology, relations between European and Asian cultures, varieties of popular culture, and forms of interaction

between literature and science. He has published on a range of authors which spans the *Gawain*-poet and J. G. Ballard.

Dr Christopher Dooks is a former director of television documentaries including *The South Bank Show*. He is now a prolific multimedia artist and post-doctoral researcher working with themes of cosmology, natural history and wellbeing at the University of The West of Scotland. In 1999, Dooks became ill with Myalgic Encephalomyelitis. Since then, he has been funded for numerous artist residencies examining the efficacy of 'micro art projects' within a reflexive art and health praxis. Since 2014, Dooks has offered these approaches to others seeking to improve the quality of their lives through methods not offered by healthcare providers. His work has been used by Durham University, and has been cited by Professor Sir Simon Wessely. Philosophical and artistic methods developed around accessing astronomy feed a large part of this research. The title of his doctorate is *The Fragmented Filmmaker – Emancipating The Exhausted Artist* and can be viewed at www.idioholism.com and at www.drdooks.wordpress.com

Pippa Goldschmidt is a writer based in Edinburgh. As a former astronomer much of her writing is inspired by science. Her novel, *The Falling Sky*, was a finalist in the Dundee International Book Prize in 2012. Her short story collection *The Need for Better Regulation of Outer Space* was long listed for the Frank O'Connor International Short Story Collection Award, and she also co-edited an anthology of short stories and essays inspired by general relativity, *I Am Because You Are*. (All three books are published by Freight Books.). She has been a writer-in-residence at the ESRC Genomics Policy and Research Forum at the University of Edinburgh and also at the Hanse-Wissenschaftskolleg Institute for Advanced Study in Germany. Her short stories, poetry and non-fiction have been broadcast on the radio and appeared in a wide variety of publications including *The Independent*, the *TLS* and the *New York Times*, as well as numerous anthologies. Find out more at http://www.pippagoldschmidt.co.uk.

Dr Shannon Grimes is an Associate Professor of Religious and Ethical Studies at Meredith College in Raleigh, North Carolina, which is one of the largest women's colleges in the United States. She earned her PhD at Syracuse University in 2006, specializing in Early Christianity and Greco-Roman religions. Dr Grimes is particularly interested in the intersection of ancient religion, science and cosmology. Her research has focused on nature and cosmology in late ancient alchemy, and most recently on astronomy and religion in the Greco-Roman world.

Dr Dietmar Hager was born in 1969 in Linz, Austria. He attended medical school in Vienna, and trained in microsurgery, hand surgery and orthopaedic trauma-surgery in Austria, Germany, Italy, France and the USA. He has been involved with astrophotography and public educational lectures from the age

of 18. He is a Consultant of the Ars Electronica Center Linz, ESO-Ambassador for public outreach, and a professional speaker and lecturer at various public educational facilities in Austria.

Dr John G. Hatch is Associate Dean for the Faculty of Arts and Humanities and an Associate Professor of Art History in the Department of Visual Arts at the University of Western Ontario. His research interests are diverse, resulting in publications on the work of Max Ernst, Francis Bacon and Frantisek Kupka, to name a few. He is particularly fascinated with the influence of the physical sciences on art and architecture, ranging from the use of Keplerian cosmology in the seventeenth-century buildings of Francesco Borromini to looking at the impact of entropy on the earthworks of the American artist Robert Smithson.

Jürgen Heinrichs teaches Art History and Museum Studies at Seton Hall University in New Jersey. He holds a PhD in Art History from Yale University and master's degrees in Art History and German Studies from the Universität Hamburg. His research and publications explore the artistic reception of Black culture in Weimar Germany, the impact of climate change on contemporary visual culture, and the intersections between art and science, among them the relationships between art, astronomy and medical imaging.

Professor John Hendrix lives in Rhode Island in the United States and teaches classes at Roger Williams University. For the last eight years he has been a research professor at the University of Lincoln, UK. During that time he published four books on English Gothic architecture and medieval philosophy: *The Splendour of English Gothic Architecture*; *Bishop Robert Grosseteste and Lincoln Cathedral*; *Architecture as Cosmology: Lincoln Cathedral and English Gothic Architecture*; and *Robert Grosseteste: Philosophy of Intellect and Vision*. He is also the author of several other books on architectural history and theory, including *The Contradiction between Form and Function in Architecture*, *Architecture and Psychoanalysis*, and *Architectural Forms and Philosophical Structures*.

Michael Hoepfel is an artist who studied visual communication in AV Media at Offenbach Academy of Art and Design from 1991-1999. In 1997 he co-founded meso, a laboratory for media systems research and design in Frankfurt am Main. From 2009 he held a university teaching position at Kunsthochschule Weissensee, Berlin, for computer aided fashion design. In 2011 he was temporary head of Medienwerkstatt Bethanien, Berlin. He has lectured and had exhibitions in Germany, Austria, Switzerland, France, Luxemburg, the Netherlands, Bulgaria, Hungary, Greece and the USA. He works with digital and mixed media for image, animation, object, installation and projection. He deals with science, iconography and representation, and lives and works in Berlin. http://www.hoepfel.net.

Dr Stanislaw Iwaniszewski is Professor-Researcher of Archaeology at the EN-AH-INAH, Mexico City, and a former ISAAC president 2007-2014. In 2015, he made habilitation with the monothematic cycle of publications on *Theoretical and methodological aspects of research in archaeoastronomy*.

Natalia Karakulina is working on a PhD in Russian Studies at the University of Exeter. She is taking part in a project, 'Reconfiguring the Canon of Twentieth-Century Russian Poetry, 1991–2008', led by Katharine Hodgston and Alexandra Smith. She is interested in Soviet and post-Soviet Russian literature and its representation in the English speaking world. Her current research focuses on Vladimir Maiakovskii; as well as researching his position in the contemporary Russian literary canon, she is interested in translating his earlier works into English. Natalia has an MA in Literature (2009) and a BA in Literature and Myth (2008) from the University of Essex; her MA dissertation aimed at analysing problems with translating Russian fiction into English.

Dr E. C. Krupp is an astronomer and Director of Griffith Observatory in Los Angeles, who conceived and successfully led the recently completed $93-million renovation and expansion of Griffith Observatory. A graduate of Pomona College in Claremont, California, Dr Krupp earned his MA and PhD in the Department of Astronomy at UCLA, where he studied the properties of rich clusters of galaxies under the guidance of the late Dr George O. Abell. He is the author of several books on ancient astronomy and the celestial component of belief systems, including *In Search of Ancient Astronomies, Archaeoastronomy and the Roots of Science, Echoes of the Ancient Skies, Beyond the Blue Horizon – Myths and Legends of the Sun, Moon, Stars, and Planets*, and *Skywatchers, Shamans, & Kings – Astronomy and the Archaeology of Power*. He has also written four illustrated astronomy books for children. Now recognized internationally as an expert on ancient, prehistoric, and traditional astronomy, Dr Krupp has visited more than 2000 sites throughout the world and regularly leads field study tours to exotic locations that have astronomical and archaeological interest.

Adjunct Professor David Malin was born in England and trained as a chemist, working for many years with a large international chemical company in the north of England. There he used optical and electron microscope and X-ray diffraction techniques to explore the very small before turning his attention to much larger and more distant things in Australia, where he worked for 26 years at the Anglo-Australian Observatory (now the Australian Astronomical Observatory) as photographic scientist and astronomer. There he developed hypersensitising processes which can give enormous gains in speed to the photographic materials used in astronomy. He also invented new ways of revealing information on astronomical plates. His true-colour astronomical photographs have been published on the covers of hundreds books and mag-

azines, including *LIFE* and *National Geographic* and as a series of Australian postage stamps. They have also been appeared in international solo art exhibitions in Australia, Britain, China, France, Italy, India and the USA. Malin has lectured widely and published numerous scientific papers and popular articles on astronomy and photography, as well as nine books. His contributions to photographic science and astronomy have received international recognition, including honorary degrees from two Australian universities. Malin is an Adjunct Professor of Scientific Photography at RMIT University in Melbourne.

Ruth McPhee is an independent scholar working in the areas of cinema studies and continental philosophy, with publications including writing on the films of Catherine Breillat, discourses of self-harm, and recent horror cinema. Her monograph *Female Masochism in Film: Sexuality, Ethics and Aesthetics* was published by Ashgate in 2014. She currently works at the Fitzwilliam Museum in Cambridge.

Jennifer A. Morris holds a postdoctoral fellowship at the Muscarelle Museum of Art at the College of William & Mary, where she is concurrently pursuing a JD in the law school. She received her A.B. *summa cum laude* from Duke University in 2008, and earned her MA and PhD from the Department of Art & Archaeology at Princeton University in 2011 and 2015, respectively. In addition to building upon her doctoral research, which relates to the visual and intellectual culture of post-Reformation Germany, Jennifer enjoys researching cultural heritage law and preservation issues in developing countries.

Dr Jennifer Neville teaches Old English poetry in the English Department of Royal Holloway, University of London. Her first monograph, *Representations of the Natural World in Old English Poetry*, was published by Cambridge University Press in 1999. She has presented papers and published articles on a variety of topics including seasons, law codes, plants, chronicles, horses, national identity, and the Assumption of the Virgin in Anglo-Saxon England. She is currently working on a monograph on the Exeter Book Riddles.

Carrie Paterson is an independent artist, researcher on space, editor and writer based in Los Angeles. Her visual art practice emphasizes the fertile nexus between the disciplines of science, art and engineering, and includes olfactory works. In 2014 Carrie published a co-authored article on space greenhouses and astronaut olfactory health in the peer-reviewed journal *Acta Astronautica* and was recently invited to give presentations at Parsons, at SETI, at the International Astronautical Congress, and at KOSMICA, an art/science festival in Mexico City organized by the Arts Catalyst. In 2015 she was a finalist for the Institute for Art and Olfaction's Sadakichi Award emphasizing excellence in the

experimental uses of scent. Carrie also holds a utility patent for a multi-layered perfume bottle, and in her last career taught writing and visual culture for over ten years in universities throughout Southern California. From 2011-2015 she was Associate Editor at the Los Angeles art magazine *Artillery*. Her publishing company, DoppelHouse Press, which she started in 2011, specializes in art, architecture, memoirs and biographies of exiles. She holds a degree in Literature from Yale University and an MFA from the University of California, Irvine.

Dr Ben Pestell has taught literature, myth and interdisciplinary studies at the University of Essex, where he serves on the executive committee of the Centre for Myth Studies. His PhD argued for the contemporary vitality of mythical language and structures of thought, using Aeschylus' *Oresteia* as an exemplary text for the synthesis of mythical and rational modes. At Essex he co-founded the thriving, cross-disciplinary Myth Reading Group. He is co-editor of *Translating Myth* (Legenda, 2016), and has published on Aeschylus and contemporary classical reception. His current project examines the presence of myth in modern and contemporary English literature.

Valery Rees works on the Ficino *Letters* project at the School of Economic Science in London. Ten volumes of *The Letters of Marsilio Ficino* are now in print and the remaining volumes are in preparation. She has published articles on many aspects of Ficino's work, including a study of his influence on the poetry of Edmund Spenser (*Spenser Studies*, XXIV, 2009); 'Marsilio Ficino and the Rise of Philosophic Interests in Buda' (*Italy & Hungary. Humanism and Art in the Early Renaissance*, ed. Péter Farbaky and Louis A. Waldman, Villa I Tatti, 2011); and 'Four Ficino Codices from the Corvina Library' (*Corvina Augusta*, ed. Edina Zsupán, Budapest, 2014). She is currently preparing an edition of Ficino's St Paul commentary for the I Tatti Renaissance Library. Her wide-ranging study, *From Gabriel to Lucifer. A cultural history of Angels*, was published by I. B. Tauris (London) in 2013. She co-edited *Marsilio Ficino: his Theology, his Philosophy, his Legacy* with Michael J. B. Allen (Brill, 2002) and *Laus Platonici Philosophi: Marsilio Ficino and his Influence* (Brill, 2011) with Stephen Clucas and Peter Forshaw.

Dr Steven Renshaw is a Research Fellow in the Center for Asian and Pacific Studies at the University of Iowa in the United States. He received his BA in mathematics and MA and PhD in communication and social psychology. He has conducted research in both the history of astronomy in Japan as well as the significance of astronomical phenomena in the history and development of Japanese culture. Articles have appeared in *Archaeoastronomy, The Journal of Astronomy in Culture, Griffith Observer, Astronomy across Cultures*, and the *Biographical Encyclopedia of Astronomy*.

Melanie Schlossberg, artist. Through depictions of plants, animals and stars,

Schlossberg's work explores cycles of kinesis and stasis, patterns of growth and change, and meditations on vulnerability and the passage of time. She holds a bachelor's degree of Fine Arts in Metalsmithing from Syracuse University, NY. Her works, both flat and dimensional, have been shown in galleries throughout the United States. Schlossberg resides in Houston, Texas, where she runs a fine and graphic art studio. She also heads the marketing department for a Houston-based art consulting firm, Skyline Art Services, which focuses on the health care industry and the healing aspects of artwork.

Dr Valerie Shrimplin has lectured and published widely on the influence of astronomy and cosmology in art. Her book, 'Sun Symbolism and Cosmology in Michelangelo's *Last Judgment*', examines the influence of Copernican heliocentricity on the Sistine Chapel frescoes. She has presented papers internationally on topics ranging from cosmological symbolism in domed architecture to visual interpretations of the beginning and the end of the universe, and astronomical and astrological symbolism in Byzantine and Renaissance art. Valerie is a member of the International Committee of the conferences on the Inspiration of Astronomical Phenomena (INSAP) and was an organiser of INSAP IV (Oxford 2003) and INSAP IX (London 2015).

Simone Westermann is a PhD candidate in the Department of Art History at the University of Zurich. After graduating with a BA (Hons.) in the History of Art and Architecture from Newnham College, University of Cambridge in 2008, she pursued her MPhil in Art History in Zurich (Switzerland), where she graduated with a thesis entitled *The "Divine Spark" – Lightsymbolism in Federico Zuccaro's Oeuvre* (Sup.: Prof. T. Weddigen) in 2011. During her MPhil at the University of Zurich she also received an MA in Italian Literature and in the History and Theory of Photography. Simone is currently a PhD fellow at the Bibliotheca Hertziana in Rome (Italy) where she is working on a project regarding the work of the artist Altichiero da Verona and the concept of fourteenth-century Naturalism in art.

George M. Young has a BA in English from Duke University and a PhD in Slavic Languages and Literatures from Yale University. He has taught Russian, English and Comparative Literature at Grinnell College, Dartmouth College and the University of New England, and is currently a Fellow of the Centre for Global Humanities at the University of New England. Relevant publications include: *Nikolai F. Fedorov: An Introduction*, 1979; *The Russian Cosmists: The Esoteric Futurism of Nikolai Fedorov and His Followers*, Oxford University Press, 2012; as well as numerous essays, academic articles and encyclopaedia entries on Fedorov and 19th and 20th century Russian literature and thought in scholarly journals, general periodicals and chapters in edited volumes on Russian and esoteric subjects, 1980s to the present.

PART ONE: HEAVENLY DISCOURSES

INTO THE BLUE:
TRANSCENDENTAL ACCESS
AND CELESTIAL ASCENT

E. C. Krupp

ABSTRACT: The wild blue yonder, the black canopy of night, the transcendental territory of celestial gods – for the ancients the sky was all of these things. It provided access to power and an ordered world. Our ancestors saw a celestial anchor in a cosmic axis that linked heaven to earth and saw divine access in celestial ascent. This conduit was revealed in the fundamental character of the sky – its appearance, its motion, and its content. Ancient and traditional peoples all over the world incorporated these images into their sacred traditions, and the ways in which people have manipulated the concept of celestial ascent reveal, in part, the meaning and importance behind a simple notion: going 'up'. These same themes persist in our own era, but they are now expressed in the vocabulary of the exploration of outer space, in our attraction for worlds beyond our own, and in the iconography of the space age. In the era of human spaceflight, inaugurated 50 years ago by Yuri Gagarin's orbital milestone, our monuments to cosmic access are the spacecraft we launch, not pyramids and temples bound to the ground. Although most of our tales of celestial ascent are now told in advertising, entertainment, and unsubstantiated rumour of extra-terrestrial contact, some of the tales the Apollo astronauts brought back from the moon, as unexpected engagements with transcendence, indicate a new local angle on cosmic order.

The way we look at the universe affects how we behave. Our discourse with heaven was irrevocably transformed in 1957 with the launch of *Sputnik 1*, the first artificial satellite, and we have been behaving differently since then. Our contact then took a more personal turn 50 years ago with the flight of Yuri Gagarin, who put the conversation on a higher footing. Gagarin's celestial ascent was a technical triumph that elevated the prestige of the Soviet Union to orbital altitude for one 108-minute circuit of the planet in *Vostok 1*. He left Tyuratam in what is now Kazakhstan in the daylight, and although he soon crossed the Pacific Ocean and into the night, he scarcely had time to take in the universe. When he rounded Cape Horn, he hit daybreak and reported, 'The horizon blazed in a bright orange which gradually changed into all the colours of the rainbow'.[1] He was a test pilot, but that did not rule out the capacity for an aesthetic response to the landscape. It was, however, still a landscape. He described his view as like what is seen from a jet aircraft at high altitude. Although he was a lot higher than any jet, he was not high enough to see the earth as globe. He did sense that it is round.

[1] Yuri Gagarin, 'Wednesday, April 12, 1961', in *To the Moon!*, ed. Hamilton Wright, Helen Wright, and Samuel Rapport (New York: Meredith Press, 1968), p. 243.

Gagarin was the first to glimpse the world from space, and although he did not see the earth as a world in space, he was the beginning of a fundamental change in our direct experience of the sky.

Long before Gagarin first took the high road, people had imagined celestial ascent. Ancient Mesopotamian literature identifies Etana as 'a shepherd who ascended to heaven'.[2] The oldest texts that document his story are from the Old Babylonian period, from Susa, in Elam, in what is now Iran. Etana is also included as the 12th ruler of Kish in the Sumerian King list. Kish was a powerful city of Sumer. Transported by an eagle to the realm of the celestial gods, Etana got a bird's-eye view of the earth he'd left behind. This celestial flight appears to be illustrated on Akkadian cylinder seals from the second half of the third millennium BCE (Fig. 1.1).[3]

Before Etana is cleared for lift-off, the myth details the divine establishment of Kish.[4] The city has been designed. Its brickwork foundation has been laid by the gods. It's ready to go, but it needs a king. So, the gods are recruiting a ruler after the Great Flood. The deluge destroyed the world, and its fundamental institutions, the mechanisms and mandates of government, are still missing in the post-Flood era.

Fig. 1.1: Etana's eagleback flight to the celestial realm is illustrated on several Akkadian cylinder seals.[5]

[2] Piotr Bienkowski and Alan Millard, eds., *Dictionary of the Ancient Near East* (Philadelphia: University of Pennsylvania Press, 2000), p. 109.

[3] Stephanie Dalley, *Myths from Mesopotamia* (Oxford: Oxford University Press, 1989), p. 191.

[4] Dalley, *Myths from Mesopotamia*, pp. 190-202.

[5] Drawing from Olive Beaupré Miller, *My Book of History, Volume 1, Beginnings* (Chicago: The Bookhouse for Children, 1929).

Etana, for his part, has been looking for work. He apparently has the right stuff because the gods and he negotiate a contract. A tree sprouts in the throne shrine of Kish, pushes towards the clouds, and represents a new bond between the gods and the king, between heaven and earth. Something is still missing, however: Etana has no heir, and without dynastic lineage there is no legitimate kingship. The rest of the narrative is really the resolution of this conundrum. It involves a snake, an emblem of the earth, and an eagle, an emblem of the sky. They inhabit this world-axis tree that has turned the throne into a world-navel, a point of connection between heaven and earth. The plot gets complicated, but the key development is Etana's flight on the eagle through the heavens to Ishtar, who possesses the Plant of Birth. Text is damaged and missing, but we can tell several flights are involved. Etana's view from the high frontier is described. Everything experienced as huge from the ground turns tiny from above. Eventually, it all works out. The mission is accomplished. The royal bloodline is established. Etana's trips to transcendental heights were missions on behalf of the hereditary continuity of the king.

International prestige is not the same thing as the favour of the gods, but power politics is what leveraged Yuri Gagarin into orbit. Celestial ascent in both of these tales solidifies authority through a demonstration of profound cosmographical bond. Antiquity routinely forged a bond with gods through access to the sky.[6] The sky was sacred territory. It operated as a realm of cosmic order. The route to the realm of cosmic order was up, into the blue and into the dark. The sky reveals the fundamental architecture of space and time so explicitly, it is conscripted to forge a cosmological framework for ideology. Ideology is expressed symbolically in monument, ritual and other institutions and so fortifies the political, social, economic and moral order with the cosmic order. That capacity is the sacred. When Etana took the route to the sky, he allied himself with realm above, immersed himself in the sacred, and authenticated kingship with celestial order.

Going Up

As the Greeks saw things, to go up you start at the bottom, and earth was the heaviest of four elements. Earth sank to the centre, and the centre was, in a sense, the bottom. Beyond the realms of water, air and fire circled the celestial objects.[7] Ptolemy increased the system's geometric sophistication and imagined higher spheres beyond the stars to account for observed motions.[8] The whole structure was wrapped with heaven, a transcendental realm identified in Medieval

[6] See E. C. Krupp, *Beyond the Blue Horizon: Myths and Legends of the Sun, Moon, Stars, and Planets* (New York: Harper Collins Publishers, Inc., 1991).

[7] Aristotle, *Meteorologica* (Cambridge, MA: Harvard University Press (Loeb Classical Library), 1952), Book I, Chapter 2.

[8] Ptolemy, *Almagest*, trans. G. J. Toomer (New York: Springer-Verlag, 1984), pp. 38-47.

cosmology with the celestial Paradise. Islam embraced the same notion and expressed it, for example, in Muhammad's Night Journey from what is now the Dome of the Rock in a vertical route to heaven and Allah's Throne.[9]

A layered cosmic hierarchy was not limited to Europe. In ancient Mexican cosmology, the world system has 13 heavens and 9 underworlds.[10] These pictures of cosmic order all emphasize the transcendental nature of the sky. However these kingdoms of heaven may be conceived, the road up leads to the supreme gods and to transcendent sacred power. Action, initiative, authority, power and exhilaration are attributes of celestial gods and attributes of the sky. The shamans and mystics and holy men and souls who sought audiences with those celestial gods had several ways to get there: poles, trees and mountains.[11] These all make sense because they all reach for the sky while resting firmly planted on the earth. They are, in fact, connections between earth and sky, and a tree transparently fulfilled that vocation in the myth of Etana's celestial ascent. All three of these metaphors – poles, trees and mountains – are often stand-ins for the cosmic axis. This axis hits the sky at the one point in it that does not move, the celestial pole (north or south), and it acquired almost universal recognition as a fundamental element of cosmic order. In the northern hemisphere, the north celestial pole is the centre of the circular movement of all of the night's stars. As the hub of the sky, it steadies and stabilizes the cosmos, and it establishes the order of the landscape by singling out a favoured direction – north.

Cultural transformations of these ideas are found worldwide and are not inhibited by social complexity.[12] The Chukchi, in eastern Siberia, put the Pole Star, which they call the 'Nail Star', at the centre of sky. The Tungus of Manchuria speak an Altaic language, and they centre the universe on the North Star. They imagine a pillar that extends to it from the earth, and they equate the central ritual birch pole running through the shaman's tent with the cosmic axis (Fig. 1.2). In west Saharan Africa, the Dogon of Mali picture the world as a flat disk, and the post that emerges from its centre and supports the sky is the pillar of Amma, the high god. In ancient Norse cosmology, the world axis was symbolized by Yggdrasill, the towering, transcendental ash tree that holds the

[9] Edith Jachimowicz, 'Islamic Cosmology', in *Ancient Cosmologies*, ed. Carmen Blacker and Michael Loewe (London: George Allen & Unwin Ltd, 1975), pp. 148-55.
[10] Michael Coe, 'Native Astronomy in Mesoamerica', in *Archaeoastronomy in Pre-Columbian America*, ed. Anthony F. Aveni (Austin, TX: University of Texas Press, 1975), pp. 6-8.
[11] See Krupp, *Beyond the Blue Horizon*, pp. 275-99; and E. C. Krupp, *Skywatchers, Shamans, & Kings: Astronomy and the Archaeology of Power* (New York: John Wiley & Sons, Inc., 1997), especially pp. 153-96.
[12] Again, see Krupp, *Beyond the Blue Horizon*, pp. 275-99; and Krupp, *Skywatchers, Shamans, & Kings*, especially pp. 153-96. Also, Roger Cook, *The Tree of Life: Image for the Cosmos* (New York: Avon Books, 1974); E. O. James, *The Tree of Life: An Archaeological Study* (Leiden: E.J. Brill, 1966); Nigel Pennick, *The Cosmic Axis* (Cambridge, England: Runestaff Publications, 1985); Mrs. J. H. Philpot, *The Sacred Tree* (London: Macmillan and Co., Limited, 1897).

universe together. When Black Elk, the Oglala Sioux medicine man, ascended to the 'other world', his entranced body was left behind at the base of a sacred tree. His vision transported him to the Centre of the World, where the Tree of Life, a cosmic axis that quartered the world, operated as 'the living center of the nation'. The Titan Atlas held up the sky in the archaic Greek cosmos and personified the cosmic axis. At the top of the sky there was foundation and structure in their lives; the north celestial pole was an anchor that held the world axis in place.

Fig. 1.2: The world axis on this Siberian shaman's drum links the sky and the north celestial pole (top) with the terrestrial realm, populated by animals and a drum-holding shaman, and the underworld (bottom).[13]

The Cosmic Mountain

The same things that make a pole, pillar and tree out of the world axis also turn it into a cosmic mountain that supports the sky and is rooted in the earth. High mountains seem to touch the sky and are said to be homes for celestial gods. Climbing a mountain carries a pilgrim closer to the sky and makes the idea of celestial ascent seem real. As the source of water and the stage of storms, the mountain sustains life with the fertility of springs and runoff. Lightning in remote peaks demonstrates that mountains transmit celestial power to earth. The mountain is a cosmic battleground, the point of the world's creation, the very centre of the world, and therefore a navel at which the earth is nurtured by celestial gods. A place where heaven connects with earth is sometimes called the 'navel of the earth'.[14] The world is moored to the sky there as an unborn

[13] Griffith Observatory, after Cook, *The Tree of Life: Image for the Cosmos.*
[14] E. A. S. Butterworth, *The Tree at the Navel of the World* (Berlin: de Gruyter, 1970); Uno

child is linked to its mother because a navel is a place where life and power are exchanged. Celestial order, power, and authority – conveyed by the world axis umbilical cord – converge upon a 'navel' of the earth and make it the centre of the world. The centre is where heaven is in contact with earth, and that place is made sacred by the contact.

Mircea Eliade explored the role of sacred places in several of his books and explained why such sites are designed according to cosmic blueprints.[15] Cities like Imperial Beijing and ceremonial platforms like Templo Mayor in the Aztec capital miniaturized the cosmos in monumental architecture and replicated the fundamental structure of the cosmos. These places are sacred because they incorporate cosmic order.

These ideas also make the sacred centre the place of Creation. Creation is the establishment of world order, and when that order reappears in the design of the sacred site, it is as if the original creation has taken place all over again. The same principles extend into ritual. On-going, cyclical repetition of ceremonies at the shrine re-enact that first event and reinstate the world order every time they are performed. For all of these reasons, cosmic mountains and shrines that mimic their sacred properties are frequently said to be or represent the world axis. We find this concept in Mesopotamia, transformed into mountain-like ziggurats dedicated to celestial gods. In Mesopotamian cosmography, the world's central hill, like the world axis, connected earth and sky.

The ancient Egyptians mimicked mountains with cardinally oriented pyramids that housed the bodies of their pharaohs and provided their souls with a mechanism for reaching heaven. Mesoamerican pyramids were also artificial cosmic mountains, and they could symbolize the realms of heaven in the stack of platforms they pushed into the sky. The same pile of platforms could also symbolize descent into the multi-layered underworld. Mount Meru is the true polar axis in Hindu belief. A vast mountain at the centre of the flat world disk, Meru is the home of the gods. It is located at the world's north pole, and the Pole Star shines from its summit. The Milky Way cascades upon the summit and becomes the Ganges. Its currents divide and flow down to the four quarters of the world. Mount Kailas, in Himalayan Tibet, is the terrestrial incarnation of Mount Meru.

South of Siberia's Altai Mountains, the Kalmucks patterned their world

Holmberg, *The Mythology of All Races, Volume IV – Finno-Ugric, Siberian* (1916; New York: Cooper Square Publishers, Inc., 1964, reprint), pp. 341-60; William Lethaby, *Architecture Mysticism and Myth* (1891; London: The Architectural Press Ltd., 1974, reprint), pp. 71-93; Shirley Park Lowry, *Familiar Mysteries – The Truth in Myth* (New York: Oxford University Press, 1982), pp. 139-58.

[15] Mircea Eliade, *Cosmos and History (The Myth of the Eternal Return)* (New York: Pantheon Books, Inc., 1954); Mircea Eliade, *Patterns in Comparative Religion* (1958; New York: New American Library, 1974 reprint); Mircea Eliade, *The Sacred & the Profane: The Nature of Religion* (New York: Harcourt, Brace, Jovanovich, 1959).

mountain after Mount Meru. The Buddhists also share the Hindu notion of Mount Meru, and Tibetan mandalas compress esoteric spiritual knowledge along with a picture of the world-axis mountain into geometric diagrams.

Fig. 1.3: Borobudur, ninth-century CE in Java, is a monumental stupa, and in plan, it resembles a Buddhist mandala. Its spiritual meaning is linked to cosmic order through cardinal orientation, which originates in the fundamental rotation of the sky. It symbolizes the world and the world-axis mountain, which pilgrims climb, a terrace at a time, to the summit, where earth meets sky. (Griffith Observatory)

Climbing the Cosmic Mountain

Javanese Buddhists saw a story of spiritual pilgrimage in the cosmic mountain and contrived an artificial mountain, a monumental representation of the spiritual and cardinally-oriented cosmological mountain of the world, at Borobudur, about 25 miles northwest of Yogyakarta in central Java. The structure is about 1100 years old. The plan of Borobudur is like a Buddhist mandala (Fig. 1.3). It incorporates the circle that represents heaven and the square that stands for the earth. The four main stairways coincide with the cardinal directions. Ten terraces lead to the top, and each floor represents a stage in a person's life and spiritual development. Pilgrims walked its stairways and terraces, circling the centre nine times, to reach the top.

At the top, the confined view during ascent opens to the sky with a liberating effect. Spacious and architecturally abstract, the highest level is intended to awaken a change in consciousness, a kind of enlightenment, when you reach it. The physical message clarifies the spiritual message of the climb. Ascending Borobudur takes you up. You are in a transcendent realm and in the celestial realm. At Borobudur, spiritual advancement is identified with the sky, and the polar axis fortifies religious belief (Fig. 1.4).

Fig. 1.4: *The view of a Buddhist pilgrim negotiating an ascent through the ten terraces of the Borobudur, in Java, is confined by passageway walls to the scenes carved in deep relief on them, but at the top level, a vista of open sky liberates the pilgrim's perspective in which the figurative scenes are replaced by the abstract geometry of the symbolic architecture. (Photograph E. C. Krupp)*

To Infinity and Beyond

Today, we no longer see the universe as a sacred landscape, and so we cannot find that transcendental tree or cosmic mountain at the centre of the world. But awe and wonder can regularly be read between the lines in any astronomy textbook. In astronomy we contemplate the biggest, the farthest, the oldest, the brightest, and the strangest things we know. It shouldn't surprise us, then, that the idea of cosmic transcendence re-emerges in our symbolic vocabulary of celestial metaphors. Most astronomers and astronauts do not enjoy audiences with angels and aliens while gathering photons from the far corners of the cosmos or while soaring in orbit, but our childhood in outer space has supplied

us with many people who report encounters with extraterrestrials and shining disks. And even if flying saucers pass beyond the pale of at least part of our credulity, the concept of life on other worlds is cocktail conversation. We still want to make room for the miraculous. To do that now, we dress it in the costumes of science and outer space.

There is a belief system in operation on urbanized twenty-first century earth, and some of the themes it includes are space travel, extraterrestrial life, and contact with aliens. You don't have to believe in these things personally to be affected by them. We encounter them all of the time. When entertained by a movie like *Close Encounters of the Third Kind* or *E.T.* or *2001: A Space Odyssey*, we realize we are enjoying a story, but we forget to ask why such a story is so appealing to us, so successful. But millions of people wouldn't have gone to see *E.T.* or *Star Trek* and wouldn't enjoy the marketing of their characters into icons of our time if the fables didn't touch us deeply.

We also respond emotionally to astronomical discovery and space exploration. Witnesses to Space Shuttle launches are submerged by the roar of its engines and transfixed by the vision of power and flame. People spontaneously applaud, shout, and cry. It's not just a rocket-borne boxcar going up. It's the human spirit.

Our ancient ancestors pondered the sky. We, on the other hand, are trying to inhabit it. We have put ourselves into the sky and have left footprints on the moon.

How High the Moon?

Although our travel to the moon was publicly portrayed as a technological triumph, as a heroic endeavour, and as a touchdown in the geopolitical scrimmage, the moon's role in our dreams of transcendence endured in the personal experience and perspective of most of the astronauts who went there; numerous publications and broadcasts from the past 40 years demonstrate this.[16] Our romance with the moon is probably prehistorically old, and it may be documented in the Palaeolithic notations Alexander Marshak imagined to be a symbolic narrative in its phases, which turned it into the timekeeper that ordered our lives.[17] To our ancestors, the moon was a rhythmic mystery that bundled the days in cycles of growth and decay, birth and decline.

In ancient Mesopotamia, Egypt and Greece, the moon was personified, deified, and perceived as an influence. For the Greeks and the Romans, however, the moon was not only a goddess. It was also a place – a supernatural realm,

[16] For example, Davis Thomas, *Moon: Man's Greatest Adventure* (New York: Harry N. Abrams, Publishers, Inc., no date, circa 1971); Andrew Chaikin, *A Man on the Moon: The Voyages of the Apollo Astronauts* (New York: Viking, 1994); Buzz Aldrin and Malcolm McConnell, *Men from Earth* (New York: Bantam Books, 1989); and E. C. Krupp, 'Silver Moon', *Sky & Telescope* 88, no. 1 (1994): pp. 68-69.

[17] Alexander Marshack, *The Roots of Civilization* (New York: McGraw-Hill Book Company, 1972), pp. 53-55, 109-23.

a kingdom of souls, a gateway to the Beyond. By the time of Aristotle, in the fourth century BCE, the moon had become a component of the cosmic system. Its physical nature was unclear, but it was something physical and part of the hierarchy of the heavens.

In the second century CE, Lucian of Samosata figured you could go there and fictionally transported sailors to the moon by whirlwind.[18] He gave the moon a kind of terrestrial geography. It wasn't exactly a world, but it was a place. Other dream voyages to the moon were imagined in antiquity, and through the centuries the moon was both a physical and a supernatural realm.[19] In 1516, Ludovico Ariosto, in *Orlando Furioso*, sent Astolfo, an English knight, to an earthlike moon with St. John the Evangelist on the chariot that had transported the Old Testament prophet Elijah to Heaven.[20]

Galileo, however, really called in the chips of natural philosophy in 1609, when he observed the moon through a telescope and described its features.[21] Spotting mountains, basins, craters, plains, and what he thought were seas, Galileo realized the moon is an environment. It became a world, out of reach but beckoning. Jules Verne turned the moon into a target in the nineteenth century and shot his pioneering science fiction astronauts by cannon into space (*From Earth to the Moon*).[22] The moon became a genuine destination. A variety of other mechanisms for space travel were enlisted by other visionaries: Baron Munchausen's ship,[23] Hans Pfall's balloon (Edgar Allan Poe),[24] and *Destination Moon*'s rocket ship (George Pal/Robert Heinlein),[25] but on 20 July 1969, men from earth achieved the real thing. The moon became a landscape.

For all practical purposes, the moon seemed to be secularized by space travel,

[18] Lucian, *The True History*, excerpt in *Somnium and Other Trips to the Moon*, ed. John Miller and Tim Smith (San Francisco: Chronicle Books, 1995), pp. 115-42.

[19] See Peter Leighton, *Moon Travellers* (London: Oldbourne Book Company, 1960); John Miller and Tim Smith, eds, *Somnium and Other Trips to the Moon* (San Francisco: Chronicle Books, 1995); Marjorie Nicolson, *Voyages to the Moon* (New York: The Macmillan Company, 1948); Faith K. Pizor and T. Allan Comp, eds, *The Man in the Moone and Other Lunar Fantasies* (New York: Praeger Publishers, 1971); Hamilton Wright, Helen Wright, and Samuel Rapport, eds, *To the Moon* (New York: Meredith Press, 1968).

[20] Leighton, *Moon Travellers*, pp. 88-89.

[21] Galileo Galilei, *Discoveries and Opinions of Galileo*, ed. Stillman Drake (Garden City, NY: Doubleday Anchor Books, 1957), pp. 31-45.

[22] Jules Verne, *Space Novels of Jules Verne: From Earth to the Moon and All Around the Moon* (New York: Dover Publications, Inc., no date).

[23] Baron Munchausen, *The Adventures of Baron Munchausen* (Garden City, NY: De Luxe Editions Club, no date), pp. 89-94.

[24] Edgar Allan Poe, 'Hans Pfaal', in *Tales of the Grotesque and Arabesque* (Garden City, NY: Doubleday & Company, Inc., no date), pp. 183-230.

[25] Munchausen, *The Adventures of Baron Munchausen*, pp. 89-94; Poe, 'Hans Pfaal', *Tales of the Grotesque and Arabesque*, pp. 183-230; George Pal, *Destination Moon*, film, directed by Irving Pichel, Eagle-Lion, 1950.

but a funny thing happened on the way to moon. The first inkling accompanied *Apollo 8*, which performed the first circumnavigation of the moon over Christmas in 1968. The astronauts reported the moon to be 'essentially gray. No color. Looks like plaster of Paris or sort of a grayish beach sand'.[26] It is, said astronaut Frank Borman, 'a vast, lonely, forbidding-type of existence, or expanse of nothing'.[27] Later, on the surface, *Apollo 11* astronaut Buzz Aldrin called it 'magnificent desolation'.[28] The *Apollo 8* astronauts were, however, struck by something else. According to James Lovell, 'The vast loneliness… is awe-inspiring, and it makes you realize just what you have back there on Earth'.[29] Lovell wasn't just restating a common sentiment about home. He could see the earth, and he said, 'The Earth from here is a grand oasis in the big vastness of space'.[30]

Earth, in fact, and not the moon, was *Apollo 8*'s great discovery. The astronauts were the first to see with their own eyes the whole earth – a small but fetching blue marble in space, and they took pictures. And they sent them back. And they altered our perspective dramatically. Earth was obviously the most attractive planet around (Fig. 1.5). William Anders captured that experience on the fourth time the spacecraft pulled around the far side of the moon. An astonishing aquamarine earth rose out of a bleak and battered lunar horizon. The photograph was so iconic, it wound up on a postage stamp. *National Geographic* turned it into a three-page fold-out (Fig. 1.6).[31]

Men from earth did not get that kind of view again until May 1969, when *Apollo 10* took a crew to the moon to practice operation of the Lunar Module without actually touching down on the moon's surface. On that mission astronaut Eugene Cernan looked at earth and sensed he was 'wrapped in infinity'.[32]

[26] Lt. Gen Sam C. Phillips, '"A Most Fantastic Voyage"', *National Geographic* 135, no. 5 (1969): p. 620.

[27] Phillips, '"A Most Fantastic Voyage"', p. 629.

[28] Aldrin and McConnell, *Men from Earth*, p. 241.

[29] Phillips, '"A Most Fantastic Voyage"', p. 629.

[30] Phillips, '"A Most Fantastic Voyage"', p. 629.

[31] Phillips, '"A Most Fantastic Voyage"', pp. 595-97.

[32] Eugene Cernan (with Don Davis), *The Last Man on the Moon* (New York: St. Martin's Press, 1999), p. 208.

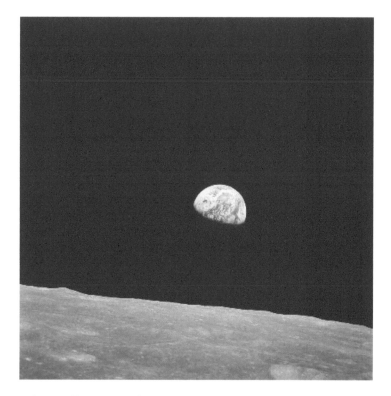

Fig. 1.5: When Apollo 8 emerged from its passage over the far side of the moon on 24 December 1968, astronaut William Anders captured a view of the rising earth, a scene no one had ever seen before. It is regarded as one of the most influential photographs ever taken, for it changed the perspective of everyone who saw it. It placed the planet in a new, unfamiliar and authentic context. (NASA)

As he looked in every direction toward familiar stars, he saw 'even more stars, stretching beyond my imagination. Stars and eternal distant blackness everywhere. *There is no end*'.[33] He has explained he is not an overly religious person, but he confirms he was profoundly affected by seeing 'the endlessness of space and time' with his own eyes.[34] When the spacecraft made its first passage around the moon, Cernan said, 'It was breathtaking to watch our planet climb from below the lunar horizon, its sharp colors seeming to warm the bleakness of space'.[35] It was 'overpoweringly beautiful'.[36]

[33] Cernan, *The Last Man on the Moon*, p. 209.

[34] Cernan, *The Last Man on the Moon*, p. 209.

[35] Cernan, *The Last Man on the Moon*, p. 210.

[36] Cernan, *The Last Man on the Moon*, p. 210.

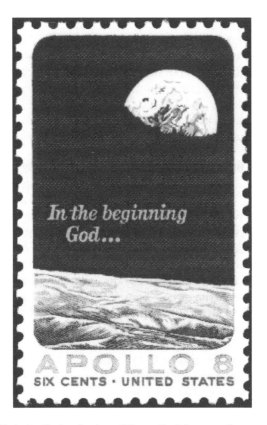

Fig. 1.6: Apollo 8's instantly iconic view of the earth rising over the moon was transformed into a U.S. postage stamp just four months after the spaceflight to commemorate the first time anyone had travelled to the moon. (Collection E. C. Krupp)

Two months later, Neil Armstrong and Buzz Aldrin were on the surface of the moon. Their time there was short, and they were preoccupied with assigned tasks and new wonders. Nonetheless, Aldrin, in his 1989 book, *Men from Earth*, preserved the memory of looking high above the dome of the Lunar Module at the earth hanging in the black sky, as a 'disk cut in half by the day-night terminator'.[37] Mostly blue, it was ornamented with swirling white cloud. He could also make out continental land. He was struck by the difference between the two worlds, one dynamic and the other a static relic.

In 2009, Aldrin published another memoir, *Magnificent Desolation*, and by then, the impact of his experience on the moon had crystallized into meaning. He recalled opportunities for reflection on the flight back to earth and remarked, 'it was an interesting feeling looking back at Earth. Our blue and brown

[37] Aldrin and McConnell, *Men from Earth*, p. 243.

habitat of humanity appeared like a jewel of life in the midst of surrounding blackness'.[38] In the book he expresses his regret that the astronauts were neither directed to capture nor capable of capturing the emotions of the experience and sharing them with the world, but most of the personal accounts written by these men convey without artifice the emotional impact of the journey and make its meaning accessible.

Apollo 12 experienced the whole earth from space,[39] and although the crisis on Apollo 13 precluded celestial reverie, the return to earth was particularly inviting to that crew.[40]

Alan Shepard, brought to the moon by Apollo 14 (February, 1971), looked up at the earth, two-thirds dark, 'encased in diamond-hard blackness'.[41] The remaining crescent, 'a third of a world'[42] hung 'magically in the void, incredibly dimensional, suspended, floating, levitated… breathtaking… gorgeous'.[43] It was, he said, home and where all his friends were,[44] but from the moon, it was '… very finite, very fragile… so incredibly fragile'.[45] He was a 'test pilot, astronaut, explorer, adventurer, master of winds and rocket fire, hero to millions',[46] but on the moon, the earth made him weep. For him, that view was the real reason they had come to the moon, that 'one single, long look at fragile, beautiful earth'.[47] It was 'as though he were sent here, he and the others, so they might look back at that lovely, sensitive sphere and then carry home the message that everyone must learn to live on this planet together'.[48]

In July, 1971, Al Worden flew to the moon on Apollo 15 and, as Command Module Pilot, remained in orbit while Dave Scott and James Irwin went down to the surface. Even before Worden reached the moon, he noticed the earth. The brightness and intensity of the 'bottomless blue'[49] oceans and of the clouds were 'something photos cannot capture'.[50] 'The horizon,' he added, 'was paper thin. There seemed to be nothing that separated the surface from the deep blackness

[38] Buzz Aldrin (with Ken Abraham), *Magnificent Desolation* (New York: Harmony Books, 2009), p. 9.

[39] Chaikin, *A Man on the Moon*, pp. 231-84.

[40] Jim Lovell and Jeffrey Kluger, *Lost Moon* (Boston: Houghton Mifflin Company, 1994).

[41] Alan Shepard and Deke Slayton (with Jay Barbree and Howard Benedict), *Moon Shot* (Atlanta: Turner Publishing, Inc., 1994), p. 310.

[42] Shepard and Slayton, *Moon Shot*, p. 310.

[43] Shepard and Slayton, *Moon Shot*, p. 310.

[44] Shepard and Slayton, *Moon Shot*, p. 310.

[45] Shepard and Slayton, *Moon Shot*, p. 310.

[46] Shepard and Slayton, *Moon Shot*, p. 310-11.

[47] Shepard and Slayton, *Moon Shot*, p. 311.

[48] Shepard and Slayton, *Moon Shot*, p. 311.

[49] Al Worden (with Francis French), *Falling to Earth* (Washington, DC: Smithsonian Books, 2011), p. 171.

[50] Worden, *Falling to Earth*, p. 171.

of space. Earth looked very vulnerable, in a way I never understood before'.[51]

Worden effectively describes his extended observation of the moon in his book, *Falling to Earth*, but despite the entrancing character of the moon, he emphasized that he 'never grew tired of watching the Earth rise above the moon'.[52] In his entire six days in lunar orbit, three of them in solitary confinement, no matter what he was doing, he stopped to watch each and every earthrise. 'It was,' he wrote, 'the most beautiful thing I had ever seen or imagined'.[53]

'Perhaps,' Worden added, 'you have to go to the moon to feel it. But I could see the Earth was truly finite... Once it is gone, it is gone... The experience was mind altering... I had journeyed all this way to explore the moon, and yet I felt I was discovering far more about our home planet, our Earth'.[54] The beauty and the fragility of the planet had elevated another astronaut to a new and sacred cosmography.

Every time Worden went behind the moon, his trajectory carried him through a zone where neither light emitted by the sun nor light reflected by the earth could reach him. It was utterly darker than any other sky, and he saw tens or hundreds more stars than could ever be seen with the unaided eye on earth. 'There were so many,' he wrote, 'I could no longer find constellations. My vision was filled with a blaze of starlight... There was more to this universe than I had ever imagined'.[55]

Another element of this new perception of space and time was granted to Worden during a spacewalk on the return to earth. When he looked in one direction, he saw the entire moon hanging in space. He turned his head and saw the entire earth, hanging in space. This perspective – this new cosmic axis linking the earth and the moon – is possible only when you are far enough away from both, and Worden said, 'In all of human history, no one had been able to see what I could just by turning my head'.[56] In space, it's an entirely different cosmic axis.

Apollo 16 ferried men to moon again in April, 1972, and it was the same story.[57]

Eugene Cernan returned to the moon with *Apollo 17*, and on the outbound leg, his crewmate Harrison Schmidt was struck by 'how fragile a piece of blue' the earth seems when seen from a distance.[58] Cernan, like all of the Apollo astronauts, was entranced by moon, but during the descent of the Lunar Module, he was permitted only two quick looks out the window. He already knew there

[51] Worden, *Falling to Earth*, p. 171.
[52] Worden, *Falling to Earth*, p. 144.
[53] Worden, *Falling to Earth*, p. 192.
[54] Worden, *Falling to Earth*, p. 193.
[55] Worden, *Falling to Earth*, p. 197.
[56] Worden, *Falling to Earth*, p. 215.
[57] Chaikin, *A Man on the Moon*, p. 484.
[58] Cernan, *The Last Man on the Moon*, p. 308.

was something 'rather spectacular out there',[59] and he was intent on seeing it. For a moment, the earth 'dangled like a colorful Christmas ornament' in the middle of the window.[60] They got to the ground and marvelled at the Taurus-Littrow landscape, but, Cernan wrote, 'The Earth kept drawing my gaze away from the bleak surface, and reality felt like a hallucination. I had already seen it many times, but was still mesmerized by the most spectacular sight of the entire journey. Memories from *Apollo 10* flooded back as I reflected on the rare privilege of standing on the Moon and looking back at the only known place in the universe that contained life. *So perfect'*.[61] Later, as he prepared to leave the surface of the moon, he reflected, 'I knew that I had changed in the past three days, and that I no longer belonged solely to the Earth. Forever more, I would belong to the universe'.[62]

Many years after Gene Cernan's return from the moon, a conversation with his five-year-old granddaughter prompted an epiphany. He tried to explain he had flown by rocket to the moon and lived three days there. After a long pause, she responded, 'Poppie, I didn't know you went to Heaven'.[63] Cernan said, he 'felt a jolt'.[64] Her remark had 'unlocked the riddle that had puzzled me for so many years'.[65] 'My space voyages,' he wrote, 'were not just about the Moon, but something much richer and deeper – the meaning of life, weighed not only by facts from my brain, but also by the feelings from my soul. For a moment, I was again standing on another world, watching our blue Earth turn in the sable blackness of space. *Too much logic. Too much purpose. Too beautiful to have happened by accident.* My destiny was to be not only an explorer, but a messenger from outer space, an apostle for the future.'[66]

We can't say that every Apollo astronaut on every mission sensed the same majesty, heartache and awe, but they all were put into an environment unlike anything anyone else has known. We are lucky to have the personal accounts some have written, and all of those stories are about majesty, heartache and awe. They are narratives that document the transformative power of space travel. What we thought were expeditions were really pilgrimages.

It isn't about what we learned about the moon. It's about what it is like to be there. It's about 'What does it mean', and we have to rely on astronauts for the answer. Buzz Aldrin confesses it took him forty years to understand it all. He recently wrote, 'I have come to believe that the real value of *Apollo 11* was not the experiments we set up or the rocks we brought back. It was in the shared

[59] Cernan, *The Last Man on the Moon*, p. 315.
[60] Cernan, *The Last Man on the Moon*, p. 316.
[61] Cernan, *The Last Man on the Moon*, p. 324.
[62] Cernan, *The Last Man on the Moon*, p. 337.
[63] Cernan, *The Last Man on the Moon*, p. 347.
[64] Cernan, *The Last Man on the Moon*, p. 347.
[65] Cernan, *The Last Man on the Moon*, p. 347.
[66] Cernan, *The Last Man on the Moon*, p. 347.

experience in which people throughout the world who witnessed our landing participated. Nothing like that had ever happened before, no other single event had ever galvanized the world's attention to such a degree; people on every continent shared our triumph as human beings... I have not seen any other single event evoke such a response'.[67] He told a Congressional committee, 'It's not the value of the rocks that we brought back, or the great poetic statements that we all uttered. It's that people witnessed the event'.[68]

Traveling to the moon altered, once and for all, our traditional and archaic sense of earth and sky. The old cosmic framework – with its horizon, its vault, its zenith, and its world axis – was anchored by the way the sky looked, and seemed to work, from the surface of the earth. It was an abstraction rooted in observation and perception, and when observations and perception were amplified by space travel, a different relationship between earth and sky began to affect what we do. Although the Apollo astronauts' experience of the earth in space from the moon introduced a new sensibility, the abstraction is no more accurate than the mechanism that we had already embraced for millennia. It is still a narrow, local view. It has, however, altered our behaviour. The new axis – an earth perceived from the moon – has infiltrated culture.

In 1997, I wrote about two concepts that had emerged as agents of ideological unification – the environmental sanctity of the earth and the cosmic mystery of space.[69] That was not a prediction. The process was already underway, and it continues today. Space travel was not the only force at work, but it was a powerful and essential driver. We are operating under a new ideology leveraged by a different cosmovision.

The Apollo astronauts were inadvertent missionaries, and no matter how audiences forty years ago and now regard what happened and how it looked and what it meant, it changed everything. It was a watershed event in all human experience. We really went into the blue, and the astronauts didn't even have to tell us what they felt at the time. The pictures alone irrevocably altered the way the rest of us now operate.

[67] Aldrin, *Magnificent Desolation*, p. 58.
[68] Aldrin, *Magnificent Desolation*, p. 249.
[69] Krupp, *Skywatchers, Shamans, & Kings*, pp. 316-17.

THE ANCIENT MITHRAEUM
AS A MODEL UNIVERSE PART 1[1]

Roger Beck

ABSTRACT: Archaeological remains and an essay by the third-century philosopher Porphyry show that the meeting rooms of the Roman cult of Mithras were designed and furnished as 'images of the universe'. The design was functional: to enable in imagination and ritual the 'descent and return of souls'. The underlying principle is one of common sense: if you want to be a cosmonaut but lack an actual space ship, build a model cosmos, not a model space ship. The illustrated lecture explains the mini-cosmos of the mithraeum, essentially an instantiation of the classic Ptolemaic model, and how it works.

In an essay titled 'On the Cave of the Nymphs in the *Odyssey*', Porphyry, a leading third-century Neoplatonic philosopher, describes the form and function of the meeting places of initiates of the Roman cult of Mithras. These meeting places, for which we now use the pedestrian neologism 'mithraea' (singular 'mithraeum'), were called 'caves' by their original users, and they were designed to suggest caves in their décor, in their frequent location in windowless interior rooms, and in the use of natural caves where available. Archaeology has amply confirmed these facts about mithraea, for which Porphyry provides the following rationale in the form of a foundation myth:

> Similarly, the Persians perfect their initiate by inducting him into a mystery of the descent of souls and their exit back out again, calling the place a 'cave'. For Eubulus tells us that Zoroaster was the first to dedicate a natural cave in honour of Mithras, the creator and father of all; it was located in the mountains near Persia and had flowers and springs. This cave bore for him the image of the cosmos which Mithras had created, and the things which the cave contained, by their proportionate arrangement, provided him with symbols of the elements and climates of the cosmos.[2]

When Porphyry speaks of 'Persians', he does not mean real-life Persians living the other side of the eastern frontier of the Roman Empire. He means citizens and subjects of the empire who happened to be members of the Mithras cult. The god Mithras himself was indeed of Persian origin, as were some of the cult's trappings and some of its myths. But its cosmology – and this is the important point – was fundamentally Greco-Roman. Porphyry's account is an aetiological

[1] Part 2 to be published in *Culture and Cosmos*, Vol. 18, no. 2 (Autumn/Winter 2014).
[2] Porphyry, *On the Cave* 6. I have adapted the translation of the Arethusa edition: Porphyry, *The Cave of the Nymphs in the* Odyssey, edited and translated by Seminar Classics 609 SUNY Buffalo (Buffalo: Arethusa, 1969).

myth: it explains, by telling a story, why something is the way it is and how it got to be that way. The 'something' which Porphyry is explaining is the mithraeum. The narrative itself is a piece of fiction. To ascribe the institutions of a religion to the activities of a putative founder or *prophêtês* – the more exotic the better – was standard practice among ancient intellectuals.

When we screen out the narrative, we are left with the following information about the form and function of the mithraeum: (1) the mithraeum is a 'cave'; (2) as a 'cave', the mithraeum is an 'image of the universe' (*eikona* [nominative *eikôn*] *kosmou*); (3) the contents of the mithraeum, 'by their proportionate arrangement' (*kata symmetrous apostaseis*), serve as symbols 'of the elements and climates of the universe' (*tôn kosmikôn stoicheiôn kai klimatôn*); and (4), the mithraeum is so designed and furnished in order to 'induct the initiate into a mystery of the descent of souls and their exit back out again'.

How do we evaluate the accuracy of Porphyry's information? Primarily, we do so by comparing it with the copious archaeological data from excavated mithraea. Do we find there, for example, vestiges of 'contents' which might answer to the description 'symbols of the elements and climates of the universe' in 'proportionate arrangement'? Porphyry's first piece of information, that the mithraeum is a 'cave', we have already accepted as accurate. Inscriptions found *in situ* sometimes call the place a 'cave' (*spelaeum*), natural caves were used where possible, and many mithraea were windowless rooms, often inside larger buildings complexes. The Roman propensity for barrel vaulting furnished an appropriately cave-like ceiling.

Porphyry's second piece of information, that *qua* 'cave' the mithraeum is an 'image of the universe', is of a different order. It does not assert a fact which can be verified by reference to archaeological data – no inscription mentions the term or its Latin equivalent – but rather a fixed correspondence: cave = (symbolically) universe. Porphyry does not treat it as an esoteric correspondence within the Mithras cult alone, but rather as a correspondence accepted as a given by his learned readership. We may certainly suppose that for Porphyry and his Neoplatonic peers the correspondence held – otherwise, why would he deploy it at such length in his essay? Whether or not it was operative for the Mithraists depends on confirming Porphyry's third piece of information, that the contents of the mithraeum demonstrably include 'symbols of the elements and climates of the universe' in 'proportionate arrangement'.

Does Porphyry speak from first-hand knowledge? Had he ever been inside a mithraeum to check it out? Extremely unlikely. First, he admits he got the information from an earlier scholar by the name of Eubulus. Secondly, 'check-it-out' is not the way ancient scholarship worked, at least not in Porphyry's time and not in the scholarly circles in which he moved. Thirdly, what went on in a mithraeum was a 'mystery', in the strict ancient sense of that word: religious business for initiates only.

We today are actually much better placed than either Porphyry or Eubulus or

indeed any non-initiate of the cult in ancient times. We can literally and physically enter a mithraeum and take a look around. No uninitiated contemporary could have walked in off the Roman street and done that. So how do we recognize 'symbols of the elements and climates of the cosmos' when and if we see them in mithraea? First, we have to know what, in the cosmos, count as 'elements' and 'climates'.

In the macrocosmic context, the term 'elements' (*stoicheia*) means primarily the stars, both 'fixed' and 'wandering'. The fixed stars are those which the ancients thought were literally fixed to the outermost sphere of the heavens, exhibiting no change of position relative to each other. The wandering stars or planets are those celestial bodies which *do* exhibit change relative both to each other and to the fixed stars. Seven such 'wandering' stars were identified by the ancients: the five planets visible to the naked eye (Mercury, Venus, Mars, Jupiter, Saturn) plus the Moon and the Sun.

These seven planets, it was thought, circled the Earth in orbits at different distances. The Moon's orbit was the closest, then Mercury's, then Venus's, then the Sun's, then Mars's, then Jupiter's, and then Saturn's, the most distant of all. These orbits were envisaged as transparent spheres rather than circles. Beyond Saturn's sphere lay the sphere of the fixed stars. The planets revolve counter clockwise or eastward, each in its proper period, from the Moon's month to Saturn's almost thirty years. They move at varying speeds, and the five planets proper sometimes even appear to stop and reverse direction. The sphere of the fixed stars revolves clockwise or westwards in the period of a single 24-hour day. Its motion is transmitted inwards to all other celestial bodies, as anyone who has seen the Sun rise in the east and set in the west can attest. The seven planets thus participate in universal westward motion at the same time as they move much more slowly eastwards.

In a belief widely held in the ancient world, the human soul was thought to travel inwards from the realm of the fixed stars through the seven spheres of the planets down to mortal life on Earth.[3] At death it retraced its path up and out into immortality. Porphyry maintained that the Mithraists shared this belief. In fact this is precisely his fourth piece of information about the mithraeum: that the mithraeum is designed and furnished as it is in order to 'induct the initiate into a mystery of the descent of souls and their exit back out again'.[4] We shall want to see whether there is any archaeological (or other) evidence that a soul-path of sorts was designed into the mithraeum's cosmic symbolism.

The term 'elements' could be used not only for the planets and the fixed stars individually but also for the collectivities of stars which we know as the constellations and particularly for the signs of the zodiac. The planets and

[3] See I. P. Culianu's *Psychanodia I* (Leiden: Brill, 1983), passim; and Roger Beck, *Planetary Gods and Planetary Orders in the Mysteries of Mithras* (Leiden: Brill, 1988), pp. 73-85.

[4] Porphyry, *On the Cave* 6.

the signs of the zodiac are intimately linked, in that the zodiac is the celestial background against which the seven planets appear to perform their complicated manoeuvres. As most people know, there are twelve signs of the zodiac, named after their original background constellations. By the first century CE, these signs were treated as equal arcs of thirty degrees each, measured in sequence from the spring equinox at the start of Aries.

Before moving on to the term 'climates', it would be as well to display the celestial sphere as basic Greek astronomy conceived it. This is the cosmos which the mithraeum, at least according to Porphyry, replicates as image, likeness, or model (*eikôn*).

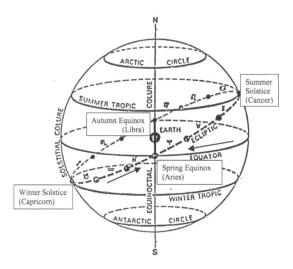

Fig. 2.1: Celestial sphere as conceived in basic Greek astronomy. Author's drawing.

The diagram too is an 'image of the universe'. It presents a two-dimensional view of the universe *from the outside*. This a paradox, since the universe by definition has no 'outside'. It is a paradox we should keep consciously in mind. All the lines, with one exception, represent circles on the celestial sphere. The celestial sphere, together with everything on it and inside it except the Earth at its centre, rotates daily in the direction shown by the arrow drawn next to the celestial equator. The celestial equator is the great circle equidistant from the north and south celestial poles.

The dotted circle represents the ecliptic, which is the central line of the zodiac and the apparent annual path of the Sun around the heavens. The direction of the motion of the Sun, the Moon and the other five planets is indicated by the other arrow. Seen from Earth, these seven celestial bodies move independently of each other against the background of the zodiac. The ecliptic is oblique to the equator. The two great circles intersect at the equinoxes. The spring equinox

(on the 'near' side of the sphere in the diagram) is the point at the start of Aries reached by the Sun in spring when day will begin to be longer than night. The autumn equinox (on the 'far' side) is the point at the start of Libra reached by the Sun in autumn when night will begin to be longer than day. The other two cardinal points on the ecliptic are the solstices: the summer solstice at the start of Cancer, reached by the Sun in midsummer when daytime is at its longest; and the winter solstice at the start of Capricorn, reached by the Sun in midwinter when daytime is at its shortest. The summer solstice is the northernmost point on the ecliptic, the winter solstice the southernmost.[5]

In this context, it is natural and unavoidable to speak of north as 'up' and south as 'down'; hence, of the Sun or another planet moving northward along the ecliptic/zodiac as 'ascending' and of the Sun/planet moving southward as 'descending'. In astronomical talk, the Greeks certainly spoke in this way and so do we. Nevertheless, it is important to keep in mind that the usage is metaphorical and conventional.[6]

The diameter of the universe running from the spring equinox through the Earth to the autumn equinox is marked in the diagram by a broad line. Since the viewpoint of our imaginary observer 'outside' the universe is directly above (i.e., to the north of) a projection of this equinoctial diameter, the line is obscured by the equinoctial colure which lies 'in front' of it. Were one to travel along this line from one or other equinox *down* to Earth and *back up* to the other equinox ... well, the point makes itself in the language I cannot help using. One comes *down* from heaven to Earth and goes *up* from Earth to heaven. This was true in Greco-Roman culture, whether the talk was of gods coming and going or, astronomically, of one planet being 'higher' than another in the order 'up' from Earth to the sphere of the fixed stars. The talk in Porphyry's *On the Cave* is a blend of both of those discourses. It should now be clear how important it is to distinguish 'upward = northward' from 'upward = heavenward' and 'downward = southward' from 'downward = earthward'.

Let us now attempt to fit this template of the universe to actual mithraea (postponing again discussion of the meaning of the 'climates of the cosmos'). First, however, we must consider the implications of the diagram's *external* viewpoint. Since what is represented is the universe, it is a stance no one can

[5] Other circles shown in the diagram: The colures are the great circles passing through both poles; the solstitial colure passes through the solstices and the equinoctial colure through the equinoxes. The summer tropic is parallel to the equator and tangent to the ecliptic at the summer solstice; it marks the path of the Sun on the day of the summer solstice. The winter tropic likewise is parallel to the equator and tangent to the ecliptic at the winter solstice; it marks the path of the Sun on the day of the winter solstice. (For present purposes the arctic and antarctic circles may be ignored.)
[6] On the fundamental role of metaphor in cognition and the construction of meaning, see George Lakoff and Mark Johnson, *Metaphors We Live By* (Chicago: University of Chicago Press, 1980 [reprinted 2003 'with a new Afterword']).

actually take, although anyone can imagine taking it. Similarly, anyone standing outside a mithraeum can imagine 'seeing' its interior from that perspective. What one cannot or, rather, *should not* be able to 'see' is its *exterior surface*. If the mithraeum is a true image of the universe it should have no exterior surface. Which is why mithraea were created in natural caves where available (what is the exterior surface of a cave?) and in rooms in larger buildings (what is the exterior surface of a room?), and why, when mithraea were constructed in free-standing buildings, no attention was drawn to their exteriors, either architecturally or by statuary or inscriptions, in dramatic contrast to the classic ancient temple. *The mithraeum, like the cave, like the universe, is an inside without an outside.*

Entering a mithraeum, we encounter a rectangular chamber distinguished by two 'side-benches', podia on either side of a central aisle, on which the initiates reclined, as at a banquet. At one end of the aisle is the entrance, at the other the 'cult-niche', in which a standardized image of the god Mithras sacrificing a bull was located. This image we now call the 'tauroctony'. The initiates reclined on the side benches in ritual celebration of the banquet shared by Mithras and Sol, the Sun god, on the hide of the bull killed by the former. (It is one of the paradoxes of cult theology that Mithras both is and is not the Sun, for he is called 'the Unconquered Sun' and yet Sol is frequently represented in scenes of the cult myth as another person interacting with him.)

How can a *rectangular* room represent a *spherical* universe? Or to ask a prior question, why *choose* a rectangular room to represent a spherical universe? The prior question is easily answered. A room with a dome would be beyond the means of a small group of the non-elite. There were indeed domed rooms or buildings, such as Nero's dining room in his *domus aurea* or the still standing Pantheon, both in Rome, which were intended as models of the universe.[7] But simply to name them is to indicate that this type of structure was unaffordable by the socially intermediate and numerically limited collectivities of Mithraists.

Necessity, then, that proverbial mother of invention, required the Mithraists to *imagine* sphericity in a rectangular room; or, more precisely and most pressingly, to imagine *circularity* in the rectangular *periphery* of the mithraeum at floor or bench level. So which celestial great circle is that periphery to represent? The first and most obvious candidate is the ecliptic/zodiac. Fortunately, there is an extant mithraeum, the Mithraeum of the Seven Spheres (Sette Sfere) in Ostia, Rome's port city, that explicitly confirms this candidate by the placement of images of the signs of the zodiac on the benches, six one side and six the other. Here is a plan of this mithraeum:

[7] On these and other high-end 'images of the universe' see Roger Beck, *The Religion of the Mithras Cult in the Roman Empire* (Oxford: Oxford University Press, 2006), pp. 120-28; the most publicly accessible 'image of the universe', a functional one, was the sundial (pp. 126-28).

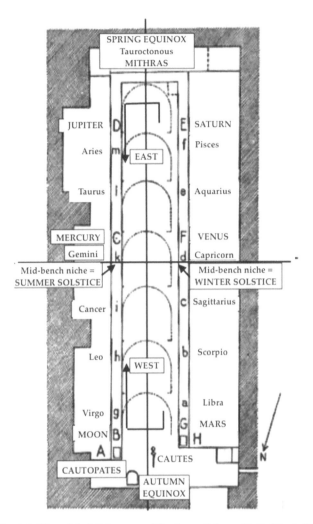

Fig. 2.2: Plan of the Mithraeum of the Seven Spheres (Sette Sfere), Ostia.[8]

The peripheral zodiac is so arranged that the first sign, Aries, is to the right of Mithras in the cult-niche (Mithras's right, not the viewer's). The signs then run in their proper order along the bench to his right as far as Virgo at the end nearest the entrance. The sequence continues on the opposite bench with Libra at the entrance end and the last sign, Pisces to Mithras's immediate left. From this arrangement it follows that the cult-niche represents the spring equinox (at the

[8] Author's drawing, superimposed on a photocopy of Fig. 71, p. 122 of Vol. 1 of M. J. Vermaseren, *Corpus Inscriptionum et Monumentorum Religionis Mithriacae* (The Hague: Martinus Nijhof, 1956).

end of Pisces and the start of Aries) and the entrance represents the autumn equinox (at the end of Virgo and the start of Libra).

By coincidence – which of course is no coincidence at all – this arrangement corresponds precisely to that described by Porphyry in a later passage in *On the Cave*:

> To Mithras as his proper seat (*oikeian kathedran*) they assigned the equinoxes....
> As creator and master of genesis, Mithras is set on the equator with the northern signs to his right and the southern signs to his left....[9]

Porphyry's language – again, not coincidentally – suits the location of Mithras both in the macrocosm and in the microcosm of the mithraeum. From his 'proper seat' in the cult-niche, which represents and so *is* the spring equinox, Mithras confronts the entrance which represents and so *is* the autumn equinox. He thus commands the mithraeum's aisle, its central line which represents and so *is* the equinoctial diameter of universe. To his right he does indeed have the six northern signs of the zodiac, represented by their images on the bench in proper sequence (i.e., 'proportionately arranged') from Aries to Virgo; and to his left he has the southern signs, Libra to Pisces, likewise represented by their images on the opposite bench from entrance to cult-niche. In the macrocosm, of course, the 'northern signs' are those to the north of the celestial equator, the southern those to the south.

All this can be verified by comparing the two diagrams. Bear in mind, however, that while the basic layout of all mithraea is the same, no mithraeum is as lavishly embellished as Sette Sfere with explicit cosmic symbols. Consequently, to vindicate Porphyry fully we shall have to establish that what is explicitly true for Sette Sfere is implicitly true for other mithraea (or at least for a substantial block of them) where 'symbols of the cosmos' in the form of conventional images are less in evidence.

From the fact that the bench to Mithras's right is 'northern' and the bench to his left 'southern' it does *not* follow that the former is the northern *side* of the mithraeum or the latter the southern side in any *geographical* sense. Mithraea were in fact geographically oriented every which way – inevitably so, since their ground plans were usually predetermined. Nor should one postulate a symbolic orientation for the sides and ends of the mithraeum. Since the mithraeum is a model universe, 'north' is *above* the initiates on their benches, 'south' *below*. From the same premise it also follows that 'east' and 'west' are directions *around* the mithraeum, the former counter clockwise and the latter clockwise (see Fig. 2.2). The mithraeum's central aisle, we have established, is a diameter of the circle of the ecliptic. It is also a diameter of the circle of the celestial equator. It lies on the planes of both great circles where the two intersect. This commonality of significance allows the initiates to imagine themselves, without a conscious

[9] Porphyry, *On the Cave*, ch. 24.

sense of paradox, on *both* great circles.

The qualification is important. The initiates' knowledge of their cosmic location is experiential, not propositional. Consequently, we do not have to decide, for example, whether the centre of the mithraeum's ceiling marks, and thus is, the north pole of the axis of universal daily revolution or the north pole of the axis of the ecliptic, the axis of the revolutions of the planets. In the apprehension of the initiate it could be either – or both. Only when one consciously 'does science' do the two options become mutually exclusive.

To appreciate in this context the human cognitive ability to 'eat one's cake and have it', the conceptual blending theory of Gilles Fauconnier and Mark Turner is helpful.[10] On this theory, we may say that the Mithraic initiates construct a 'mental space' which blends the topographical templates for universe and mithraeum so that the latter is a true image of the former. Since the level side benches in the actual mithraeum represent both the celestial equator and the ecliptic/zodiac in the actual universe, the planes of the ecliptic and the equator are necessarily 'compressed' in the blended mental space.

This is the point at which to introduce the 'climates of the universe', the symbols for which, together with those for the 'elements', we are supposed to find designed into the mithraeum. In Greek astronomy, 'climate' (*klima*) was a narrower technical term than 'element' (*stoicheion*). In its primary sense, it denoted a band of geographical latitude parallel to the Earth's equator. The number of climates was never definitively fixed. In one popular system,[11] for example, there were seven climates extending north from equator to pole. These terrestrial climates could be projected outwards from the terrestrial globe to the sphere of the fixed stars. There the *klimata* would be zones or bands parallel to the celestial equator.

Do we find 'climates of the universe' represented in the mithraeum? We do, but indirectly via the 'proportionate arrangement' of the symbols of the 'elements'.

The diagram in Fig. 2.3 presents the planes of the equator and ecliptic in the macrocosm, viewed side-on. Three climates are shown to the north of the equator and three to the south, each being a zone the width (north to south) of a particular pair of signs. For example, zone N1, the first zone north of the equator, is the climate of Aries and Virgo.

[10] Gilles Fauconnier and Mark Turner, *The Way We Think: Conceptual Blending and the Mind's Hidden Complexities* (New York: Basic Books, 2002), pp. 89-137.

[11] O. Neugebauer, *A History of Ancient Mathematical Astronomy* (Berlin: Springer, 1975), Part 1, p. 44.

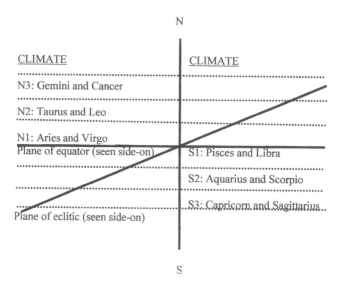

Fig. 2.3: 'Climates' in the Mithraeum of the Seven Spheres.

In Fig. 2.3 the planes of the equator and ecliptic are 'decompressed', because only so can the climates' northernness and southernness, i.e., their distance north and south of the equator, be displayed. To demonstrate the 'proportionate arrangement' of the climates *in the mithraeum*, one must return to a view from 'above', i.e., from the north. This viewpoint necessarily 'recompresses' the two planes. The diagram in the next figure (Fig. 2.4) shows how the climates are instantiated in, and proportionately arranged on, the side-benches of the mithraeum. To make the point more clearly, the benches are shown curved so as to form a closer approximation to the circle of the zodiac which they represent.

Mithras at Spring Equinox		
Aries N1	E	S1 Pisces
Taurus N2	Q	S2 Aquarius
Gemini N3	U	S3 Capricorn
Summer Solstice	A	Winter Solstice
Cancer N3	T	S3 Sagittarius
Leo N2	O	S2 Scorpio
Virgo N1	R	S1 Libra
Autumn Equinox		

Fig. 2.4: 'Climates' in the Mithraeum of the Seven Spheres.

Here, unfortunately and with apologies, I must conclude. I think I have now in large measure made my case. What Porphyry said is substantially true: it is confirmed by the archaeology. The Mithraic cave-in-quotes was indeed an 'image of the cosmos' (as the ancients construed the cosmos), and this 'cave' did indeed contain in 'proportionate arrangement... symbols of the elements and climates of the cosmos'. It remains to be shown precisely how the model functioned as both map and instrument for 'perfecting the initiate by inducting him into a mystery of the descent of souls and their exit back out again'.

I close with a caveat: my example, virtually my sole example, has been the Ostian Mithraeum of the Seven Spheres. Is there a plethora of other examples? And is it legitimate to generalize from Sette Sfere on details where Sette Sfere is either unique or has very few peers?

UNDER A STAR-SPANGLED BANNER: POLITICS AND ASTRAL RELIGION IN THE ROMAN EMPIRE

Shannon Grimes

ABSTRACT: The belief that the stars and planets are gods – a notion borrowed from ancient Near Eastern cultures – entered into Greek thought with a force in the fourth century BCE. A new cosmology also developed during this time, and this focus on the stars gave rise to new understandings of religion and the soul. This paper briefly describes the rise of astral religion in the Hellenistic age, but its primary focus is on the ways in which the stars were represented in Roman political discourse. Not only were the Roman emperors portrayed as astral gods on Earth, I argue that the political elite also utilized astral religion as a means of promoting imperial goals, such as the upholding of social order and obedience to Roman law. Cosmic imagery served to naturalize these imperial goals and to convincingly present them as divine will. Furthermore, drawing on postcolonial theories that aim to recover the voices and perspectives of the colonized, I also argue that the political dimensions of astral religion might have some bearing on the rise of cosmic dualism in the first centuries CE, particularly among Jewish and Christian Gnostics who viewed the cosmos as a prison run by despots and false gods, and who sought to escape to their true spiritual home beyond the stars.

The Hellenistic Age (332 BCE-4th c. CE) was a time of great political, economic, and cultural expansion for the Greeks and Romans, who had set out to conquer and rule the known world.[1] An interesting development in the Greco-Roman religious imagination also occurred during this time, as people began to envision the stars and planets in new ways. The belief that the stars and planets are gods – a notion borrowed from ancient Near Eastern cultures – entered into Greek thought in the fourth century BCE, while advances in astronomy led one of Plato's students, Eudoxus of Cnidos, to formulate a new geometric model of the universe based on rotating geocentric, homocentric spheres.[2] This geocentric model was refined by subsequent astronomers, including Ptolemy (90-168 CE), whose version became the standard cosmology in the West until it was upended by the heliocentric models of the Copernican Revolution in the sixteenth centu-

[1] I am using the fourth century CE as a *terminus ad quem* for the Hellenistic period to encompass the influence of Greek language and learning, as well as the pagan dominance of the empire, which began to wane after Constantine.

[2] On the rise of astral religion among the Greeks, see Franz Cumont's classic work, *Astrology and Religion Among the Greeks and Romans* (New York: G. P. Putnam's Sons, 1912), 23-30. On Eudoxus of Cnidos, see M. R. Wright, *Cosmology in Antiquity* (London: Routledge, 1995), p. 26.

ry.[3] The blending of religion and science in the Hellenistic Age gave rise to different forms of astral religion, including various systems of astrology, methods for securing the favours of astral deities, and mystical journeys through the seven heavens, but here I will be focusing particularly on how certain aspects of astral religion were adopted and utilized by Roman imperial powers. Not only were the Roman emperors portrayed as astral gods on earth, but astral imagery, I argue, was also used to 'naturalize' the universalist goals of the *Pax Romana*.

My political reading of astral religion is informed by Bruce Lincoln's work on the role of discourse (both verbal and symbolic) as a key instrument in social construction. Those in power can use symbolic discourse strategically to encourage obedience, suppress deviance, and mask inequities. Conversely, subordinate groups can use the same symbols to critique, deconstruct, and de-legitimize the forces and discourses that contribute to their subordination.[4] In this political reading of astral religion, I examine how discourse about the stars supported imperial goals, and how it was also used to criticize and challenge them. I will demonstrate this by comparing Mithraism, which uses astral religion and the new cosmology in ways that uphold imperial social ideals, with certain Judeo-Christian 'Gnostic' writings that challenge imperial structures in their portrayals of the stars and planets as oppressive cosmic forces.

Astral religion comes in many forms, but there are a few key concepts that became prominent in Roman political discourse. The first is the philosophical notion that the stars were divine, rational beings, whose orderly, predictable journeys across the sky were viewed as proof that the universe was intelligently designed and providentially governed. Plato was the first to articulate this, and it was also a popular topic in Stoic philosophy.

Now, the Greek word *kosmos* has many definitions. In Plato's *Timaeus* (ca. 360 BCE) – which was the first extant account of creation to incorporate the new geocentric cosmology – he says that the divine stars were created as an adornment (*kosmos*) for the heavens.[5] Our word 'cosmetics' preserves this ancient meaning of cosmos as decoration. Cosmos could also mean universe, world, ruler and government. In all of its uses it denotes something well ordered or well arranged, whether that be a decoration, the structure of the universe, or government rule. The semantic link between the stars and world order was not lost on the Stoics, who described the stars as citizens of the universe, as gods that unite all of humanity in a common worship under common laws,

[3] See Thomas Kuhn, *The Copernican Revolution: Planetary Astronomy in the Development of Western Thought* (1957; Cambridge: Harvard University Press, 1995).

[4] Bruce Lincoln, *Discourse and the Construction of Society* (New York: Oxford University Press, 1989), pp. 1-9.

[5] Plato, *Timaeus*, trans. F. M. Cornford (Indianapolis: Bobbs-Merrill, 1958), 40a.

and who reveal God's providential care and governance. Cicero, for example, portrayed the cosmos as 'a city of gods and men' and argued that all of us *cosmopolitans*, or citizens of the world, have a duty to uphold the cosmic law and order revealed by the heavens.[6] Of course, the astral theologies that developed in the Hellenistic Age coincided with the expansion of the Greek and Roman empires and the new cosmopolitanism and 'world order' that was being created. Not only did the stars serve as a model for the rational ordering of the human soul, they also served as a model for political governance. The stars were functioning as an emblem of the universal goals of the *Pax Romana*, uniting all people under common rule and law, thereby creating a well-ordered society. It is not surprising, then, that the administration of the stars was mapped onto human forms of administration. Manilius, a Roman astronomer who composed a lengthy didactic poem about the stars for the emperor Augustus, associates the planets with the ruling classes, and the numerous stars of the Milky Way with the innumerable citizens of the world. He wrote:

> And as in great cities the inhabitants are divided into classes, whereof the senate enjoys primacy and the equestrian order importance next to this, and one may see the knights followed by the commons, the commons by the idle proletariat, and finally the innominate throng, so too in the mighty heavens there exists a commonwealth wrought by nature, which has founded a city in the sky. There are luminaries of princely rank and stars which come close to this highest eminence; there are all the grades and privileges of superior orders. But outnumbering all these is the populace which revolves about heaven's dome; had nature given it powers consonant with its legions, the very empyrean would be helpless before its fires, and the whole universe would become embroiled in the flames of a blazing sky.[7]

This text argues that social hierarchy and order are reflected in the hierarchy of stars in the astral commonwealth: as above, so below. It also alludes to the danger of social uprising. If the populace attempted to display force in accordance with their numbers, they could easily destroy this system of governance and order. But since the multitudinous stars do not display this kind of rebellion against their more illustrious citizens, neither should the masses rebel against the upper classes here on earth.

In addition to this idea of the stars representing both heavenly and earthly order and stability, astral symbolism also played a prominent role in imperial religion. Both Julius Caesar and Augustus were said to have descended from

[6] Cicero, *On the Ends of Good and Evil* 3.64, in M. R. Wright, *Cosmology in Antiquity* (London: Routledge, 1995), p. 34.

[7] Manilius, *Astronomica*, trans. G. P. Goold (Cambridge, MA: Harvard University Press, 1977), 5.734-45.

the stars. This dates back to the transition of power shortly after Caesar's death, when a comet appeared during the games that Octavian was holding in Caesar's honour; this was interpreted as a sign not only of Caesar's divinization, but also as a sign that a new age was dawning for Rome, with Augustus at the helm.[8]

Fig. 3.1: Coin depicting Augustus on front, and comet of 'Divine Julius' on reverse.

Augustus seized upon this astral imagery and attached a star to every statue of Caesar, and the stars thus became a sign of the emperor's divinity.[9] Depictions of the emperor crowned with stars and planets can be found on statues and coins that date from the time of Augustus, and this practice continued well into Diocletian's reign.

In addition to being a type of star-god, the emperor came to be associated with the sun, in particular. The sun was often declared to be the emperor's companion and personal protector. The sun is the largest, brightest 'planet' in the sky, the most important since it gives us warmth and light. In terms of Ptolemaic cosmology, the sun occupies an important place in the heavenly spheres. As the fourth planet, it rests in the middle of the seven planets, flanked by three planets on one side, and three planets on the other. For many ancients it was a physical representation of the divine fire that it is at the centre or core of all things. Under the rule of Aurelian (270-275 CE), the emperor became known as *sol invictus*, the unconquered sun.[10] This sun-god was the preeminent deity of the later Roman Empire, and emperors were often portrayed as *sol invictus* on imperial statues and coinage. Just as the sun occupies the most important, honoured space in the universe, so the emperor occupies the most important, honoured position in his cosmopolis.

Given the political dimensions of astral imagery, it is worthwhile to examine Greco-Roman religions that make extensive use of astral symbolism in light of

[8] See John T. Ramsey and A. Lewis Licht, *Caesar's Comet: The Comet of 44 BC and Caesar's Funeral Games* (Atlanta: Scholars' Press, 1997).

[9] Lily Ross Taylor, *The Divinity of the Roman Emperor* (Middletown CT: American Philological Association, 1931), p. 92.

[10] Allen Brent, *The Imperial Cult and the Development of Church Order* (Leiden: Brill, 1999), p. 252.

these imperial goals of universalism and world order. Edward Said's method of contrapuntal analysis is useful in this regard, which involves a 'simultaneous awareness of both the metropolitan history that is narrated, and of those other histories against which (and together with which) the dominating discourse acts'.[11]

First I will look at Mithraism as an example of an astral religion that supported imperial goals and helped to suppress social and political deviance. Mithras was originally a Persian god of treaties and contracts, and therefore has a long-standing association with politics.[12] Mithras was embraced in the Greco-Roman period as a cosmic ruler and god of light. Since there are no extant writings from the Mithraic cult, much of what we know about them is deduced from the iconography of its underground temples, the *mithraea*. The *mithraea* are loaded with cosmic symbolism, including signs of the zodiac, planets, star constellations, depictions of devices used to make astronomical calculations, and a ladder with seven gates that represents the ascent through the planetary spheres and the seven degrees of initiation in the Mithraic mysteries. It is clear from the astral iconography that Mithras was seen as a cosmic ruler, and that the mysteries of this religion had to do with integrating the soul into the cosmic order.

When the Mithraic mysteries were introduced in Rome in the second century, the cult became popular among soldiers of the Roman army. Initiations into this male-only cult involved physical tests of courage, bravery and strength. As Richard Gordon argues, this system of initiation also allows for rapid advancement through the ranks if one displays social and military virtues, such as loyalty and submission to authority.[13] Given that many of its members consisted of both imperial slaves and private slaves, Gordon argues that submission to authority was at a premium, especially since the Roman army was in constant danger of mutiny – its soldiers notorious for being disloyal and badly behaved. Slaves, too, could be a threat to Roman order by rising against their masters.[14] By inculcating the virtues of submissiveness and obedience to authority, rewarding these by advancement in the initiatory system, and reinforcing this as a religious and civic good through a promise of heavenly salvation, Mithraism and its astral symbolism thereby supported the political goals of those in power, which was to keep the legions of stars in their proper place, lest they disrupt the cosmic and worldly order that was divinely ordained by both god and emperor.

[11] Edward Said, *Culture and Imperialism* (New York: Knopf, 1993), p. 51.

[12] On the Persian worship of Mithra and the way this god was conceived in different regions of the Mediterranean in the Greco-Roman period, see Manfred Clauss, *The Roman Cult of Mithras: The God and His Mysteries*, trans. R. Gordon (New York: Routledge, 2001), pp. 1-5.

[13] Richard Gordon, 'Mithraism and Roman Society', *Image and Value in the Graeco-Roman World: Studies in Mithraism and Religious Art* (Brookfield, VT: Ashgate, 1996), pp. 103-4.

[14] Gordon, 'Mithraism', p. 105.

Roger Beck argues that the celestial iconography associated with the Mithraic cult is best understood as a type of 'star-talk.'[15] This concept is useful for understanding other types of astral symbolism, which, as Beck elucidates, is not merely symbolic or a type of jargon used by astronomers and astrologers, though it does include these things. Star-talk, he writes, is a language system that includes 'other presumed speakers, and therein lies its peculiarity. In the culture of antiquity the celestial bodies were gods, and philosophers endowed them with reason of a very high order. We should never forget that for the ancients, the stars spoke – or the gods spoke through them'.[16] The stars, then, function as both signs *and* signifiers. In the examples of the Roman politicization of the stars, the starry sky not only *represents* the universalism of the *Pax Romana* and the ideal of social harmony that comes from obedience to law and order, but the stars also *communicate* that this universalized form of social order is god's will. This order must exist on earth as it does in heaven. Thus, the political aims of the Roman Empire were naturalized, dictated by the language of the stars, as it were.

Now, of course, not everyone in the Roman Empire agreed with these sentiments. Astral religion is diverse, and star-talk, like any language or symbolic system, is open to interpretation. People were critical of astrology for its inaccuracies and its fatalism, for example, and the planetary system – especially when used as an emblem of Fate, or *heimarmene* – was sometimes portrayed as an aggregate of demonic forces to be overcome.[17] These negative depictions of the heavens are most notably found in Jewish and Christian Gnosticism, though it would be unfair to characterize all gnostic texts as anti-cosmic. The 'star-talk' used in gnostic texts is varied, and some of it celebrates the cosmos; however, many of the texts, including the quintessential gnostic myth, *Apocryphon of John*, portray the creator and ruler of the cosmos as a false god who is either ignorant or jealous of the spiritual realms above.[18] He governs the cosmos with the aid of his evil minions, the planets (called 'archons' or rulers), who impose an oppressive law and order on the world and whose role is to ensure that humans remain ignorant of their true spiritual nature. The Gnostics believe that their true spiritual home lies beyond the cosmos, and their desire is to return to this divine realm, where they will be free from the false gods and corrupt powers that rule this earth.

[15] Roger Beck, *The Religion of the Mithras Cult in the Roman Empire* (New York: Oxford, 2006), p. 153

[16] Beck, *The Religion of the Mithras Cult*.

[17] For Roman critiques of astrology, see Tamsyn Barton, *Ancient Astrology* (London: Routledge, 1994), pp. 52-57. For a thorough study of how astral bodies came to be seen as demonic instruments of Fate, see Nicola Denzey Lewis, *Cosmology and Fate in Gnosticism and Greco-Roman Antiquity* (Leiden: Brill, 2013).

[18] See Michael Williams, *Rethinking "Gnosticism": An Argument for Dismantling a Dubious Category* (Princeton: Princeton University Press, 1996), ch. 5.

Figure 3.2. Gnostic view of the cosmos. By permission Rev Max.

These anti-cosmic sentiments can be read, in part, as social political critique directed against an oppressive imperial government which was, at that time, actively persecuting Christians (and sometimes Jews) for their social deviance, including their refusal to sacrifice to the emperor. By depicting the cosmic order as a tyrannical regime that is greedy for power and jealous of the divine realms beyond, Gnostics were insinuating that imperial rule was a perversion of God's rule. The emperor, who was viewed as a god by his subjects, is caricatured in texts like the *Apocryphon of John* as a false god who is ignorant of true divine will, and who flatters himself by proclaiming that he is the only god. In many gnostic texts the cosmic ruler is closely identified with the biblical God, though instead of being called Yahweh, he is referred to as Yaltabaoth (child of chaos), Saklas (fool) or Samael (blind god).[19] As Karen King has argued, the association of this false ruler with the biblical god seems to be a clever way for Gnostics to camouflage their imperial critique, possibly to avoid trouble or punishment by

[19] See, for example, *The Apocryphon of John* 11.15-19.

Roman authorities. Their indictment of the emperor is also masked by a refusal to explicitly name him.[20] However, given the prevalence of astral discourse and portrayals of the emperor as an astral deity, these veiled critiques were probably quite transparent, especially for the ancient reader who would be well versed in such 'star-talk'.

Paying attention to this symbolic discourse – the ways in which humans talk about the stars and even the ways that the stars 'speak' to humans – helps explain the ways in which Roman imperialism and the universal goals of the *Pax Romana* were being naturalized and framed as the earthly counterpart of divine governance, which they believed was self-evident in the orderly motions of the heavens. The use of the starry sky as an emblem of Roman imperialism shows that astral imagery could indeed evoke a sense of unity, patriotism and obedience to Roman authority – the stars, after all, look the same whether one is in Rome or in the Eastern provinces; they truly are a universal symbol of order, regularity and unity. But this vision of a united people under a star-spangled banner is a flag that not everyone wanted to fly. In sum, I think that the types of astral discourse and iconography I have delineated here had a larger role in spreading imperial goals – and in resisting them – than is usually recognized.

[20] Karen King, *The Secret Revelation of John* (Cambridge, MA: Harvard University Press, 2006), pp. 165-67.

CELESTIAL VAULTS IN ENGLISH GOTHIC ARCHITECTURE

John Hendrix

ABSTRACT: Many of the vaults in English Gothic cathedrals and churches are catechisms of cosmologies and celestial vaults. The tierceron and lierne ribs at Lincoln Cathedral and the later lierne and net vaults at Bristol Cathedral and Saint Mary Redcliffe, for example, display the geometries that can be found in medieval cosmologies such as the *De Luce* and *De Lineis, Angulis et Figuris* of Robert Grosseteste in the 13ᵗʰ century. The vaults can be read as intelligible structures of matter and the heavenly bodies. The vaulting of the nave of Lincoln Cathedral between 1235 and 1245, during the bishopric of Grosseteste, introduces basic vocabulary elements continued in later vaulting, and can be seen as a catechism of Grosseteste's cosmologies. The lierne vault of the choir of Bristol Cathedral, built between 1300 and 1330, has a structural organic quality. The nave vault, completed to its medieval design in the 19ᵗʰ century, is a Lincoln-style tierceron vault. The transept vaulting, from between 1460 and 1480, presents an intelligible geometrical structure intended as a cosmology. The vault of the North Porch of St. Mary Redcliffe, from 1325, has a crystalline organic form. The curvilinear vaulting in the transepts, from the early 14ᵗʰ century, presents a cosmology of Euclidean geometries. The nave vault, from between 1337 and 1342, suggests organic topographical lines and vectors of forces in nature and heavenly bodies, simulating the celestial vault. The choir vault, from around 1450, revives the Euclidean geometries of classical cosmologies, in particular the *Timaeus* of Plato.

Many of the vaults in English Gothic cathedrals and churches are catechisms of cosmologies and celestial vaults.[1] Matter was seen as originating in light, and expanding through reflection and refraction in geometrical terms, in increasing lengths of straight lines and curved lines, to form volumes. The tierceron and lierne ribs at Lincoln Cathedral and the later lierne and net vaults at Bristol Cathedral and Saint Mary Redcliffe, for example, display the geometries that can be found in medieval cosmologies such as the *De Luce* and *De Lineis, Angulis et Figuris* of Robert Grosseteste in the thirteenth century. The vaulting of the nave of Lincoln Cathedral (Fig. 4.1) between 1235 and 1245, during the bishopric of Grosseteste, introduces basic vocabulary elements continued in later vaulting, and can be seen as a catechism of Grosseteste's cosmologies.

In the *De Lineis, Angulis et Figuris*, or *On Lines, Angles and Figures* of Grosseteste, written around 1230, the *virtus* or strength from the natural agent, light, is more active and more unified if it is along a shorter line, because it is closer to the recipient, the passive agent, and it is less active along a longer line, because of

[1] John Shannon Hendrix, *Architecture as Cosmology: Lincoln Cathedral and English Gothic Architecture* (New York: Peter Lang, 2011).

the greater distance from the recipient.[2] A light is brighter if it is closer to the eye, for example. Shorter lines contain a more condensed *virtus*; in architecture they are more structurally sound and exert greater force on an adjoining member. In the vaulting at Lincoln Cathedral, the ribs are divided into the long longitudinal ridge pole; the transverse ribs which cross the vault; the tierceron ribs which connect the ridge pole to the springer but do not provide structural support for the vault; and the lierne ribs, the shortest of the ribs which connect the transverse or tierceron ribs, do not reach the springers of the vault on the sides, and provide no structural support.

Fig. 4.1: Lincoln Cathedral Nave. Photo by author.

The hierarchy of ribs in the vault corresponds to the hierarchy of lines described by Grosseteste, with different degrees of *virtus* and different concentrations of *species* or visual form. The *virtus* in *De Lineis* proceeds immediately from the natural agent along either a straight line or a bent line. The action of the *virtus* is greater along a straight line, as was established by Aristotle in Book V of *Physics*, where a straight line is the shortest path between two points, and in Book V of *Metaphysics*, where the straight line is more unified than the bent line.[3] Nature always takes the shorter of two possible paths, according to

[2] Robert Grosseteste, *Libellus Lincolniensis de Phisicis Lineis Angulis et Figuris per quas omnes Acciones Naturales complentur* (*On Lines, Angles and Figures*) (Nurenburge: 1503).

[3] Aristotle, *Physica* (*Physics*), trans. William David Ross (Oxford: Clarendon Press, 1936);

Grosseteste, because the *virtus* is greater. The straight and bent lines, the latter formed by the lierne ribs, are present in the vaulting of the cathedral and in the tracery of the stained glass.

In *De Lineis*, the *virtus* is weaker along the reflected or incident line, as, for example, light is weaker when it is reflected. In the *De anima* of Aristotle, both light and sound are weaker when they are reflected. Light is strongest in reflection when it is reflected from smooth surfaces like mirrors, and weakest when it is reflected from rough surfaces, as then the *species* is more dissipated, less concentrated. The *virtus* is greater in a reflection of light from a concave surface, because then the rays of light converge at a point, forming a cone of light. Lines emanating from a concave surface and converging at a point, in the form of a cone, can be seen in the vaulting at Lincoln Cathedral: the ribs of the vault begin at the ridge pole and converge at the top of the springer shaft, forming a convex surface in a cone which is formed by the severies between the ribs, or the surface of the vault which the ribs define. The corbel at the top of the springer shaft can be seen as a point of convergence, a nodal point, at which the *virtus* is greatest and the *species* the most concentrated, as is intended in the architecture, as the corbel is the most important visual point in the divisions of the bays longitudinally in elevation and vaulting and the most important visual point in connecting the vaulting to the elevations.

In Grosseteste's *De Luce*, or *On Light*, written between 1225 and 1228, he explains that as light extends matter in all directions equally into the form of a sphere through infinite multiplication, the further out the parts of matter are, the closer to the surface of the sphere, the more extended and rarefied they are.[4] There is a hierarchy of rarefaction in matter, as there is a hierarchy of rarefaction in the architectural forms in the cathedral. This can be seen in particular in the vaulting systems and the tracery in the stained glass, where the density at the centre gives way to thinner and less dense membrification toward the outer edges. In the vaulting, the density of the cluster of ribs at the corbel gives way to more spread out membrification toward the ridgepole at the centre of the vault. In each case the membrification can be seen to be rarefied toward a circumference, as matter is rarefied toward the sphere of the cosmos by the autodiffusion of *lumen*, physical light, emanating from *lux*, spiritual light, at the centre.

In the architecture of Lincoln Cathedral, the rectilinear geometries of the elevation are contrasted with the curvilinear geometries of the vault and in the nave, transepts and choir. The elevations are of the earthly, material world, the sublunary spheres, and the vault is of the celestial world, in the nine

Aristotle, *Metaphysica* (*Metaphysics*), trans. William David Ross (Oxford: Clarendon Press, 1924).

[4] Robert Grosseteste, *De Luce* (*On Light*), trans. Clare C. Riedl (Milwaukee: Marquette University Press, 1942).

circular spheres, so the geometries correspond to the representational role of the architecture as a microcosm of the structure of the cosmos. The hierarchy of the architecture represents the contrast between the sensible world and the intelligible world, and between the physical world and the spiritual world, body and soul. The hierarchy corresponds to the trivium and quadrivium of Scholasticism: curvilinear forms represent the higher arts of the triune spirit – grammar, rhetoric and logic which involve the *virtus intellectiva* or *nous poietikos*, higher forms of reasoning – while rectilinear forms represent the lower arts of the material world – mathematics, geometry, music and astronomy, which involve only *ratio* or discursive reason, what Grosseteste calls *virtus cogitativa*.

Bristol Cathedral, the Cathedral Church of the Holy and Undivided Trinity, or Saint Augustine's Abbey, was founded by Robert Fitzharding in 1140 as a foundation of Augustinian canons and made a cathedral by Henry VIII in 1542.[5] The nave and west front of the cathedral were built by George Edmund Street between 1868 and 1888. The chapter house, with its blind arcades of intersecting arches and diapering, survives from the Norman building circa 1165. The north choir aisle, Eastern Lady Chapel and choir or chancel are the earliest parts of the Gothic cathedral, from between 1298 and 1330, and it is these parts of the cathedral which represent the originality of the cathedral in architectural terms and which reflect the international importance of medieval Bristol, one of the wealthiest cities in England and its most important port.

The vault of the choir or chancel of Bristol Cathedral (Fig. 4.2), built under Abbot Knowle, between 1300 and 1330, is close to the Lincoln-style tierceron vault, with tiercerons rising from conoid springers towards a ridgepole, and shorter tiercerons intersecting transverse ridge ribs in front of the window heads, as in the Lincoln nave. As in the Eastern Lady Chapel at Bristol, the tiercerons are intersected before they reach the ridgepole by liernes forming diamonds, and the ridge pole is eliminated, or reduced to an imaginary line running down the centre of a series of diamonds formed by the liernes. Lierne diamonds are also placed between the transverse ribs and the shorter tiercerons in front of the window heads. There are bosses on the joints and the dark ribs contrast with the white severies, as in the Eastern Lady Chapel, but in the choir vault the diamonds are in addition cusped on the inside, increasing the density of the surface texture and the curvilinear content of the vocabulary elements, turning the lierne lozenges into tracery motifs. The cusping of the liernes originated in this vault, and was soon taken up in the vaults of the choirs of Wells Cathedral and Tewkesbury Abbey, and at Saint Mary Redcliffe.

[5] John Rogan, ed., *Bristol Cathedral: History and Architecture* (Stroud, Gloucestershire: Tempus Publishing, 2000).

Fig. 4.2: Bristol Cathedral Choir. Photo by author.

The lierne vault in Bristol choir does not have a structural appearance, as it did in the undercroft of Saint Stephen's Chapel, for example. The liernes of the vault have an organic structural quality, like a crustaceous skeletal form, but not a functionally structural quality in relation to the building; it is thus an 'intelligible organism', and the line is blurred between the sensible form, *species sensibilis*, the visual form of the vault, and intelligible form, *species apprehensibilis*, the conceptual organization of the vault, in Grosseteste's terms. The architectural forms play a structural role as a catechism, of the structure of matter and the relation between the material and spiritual, but the vault is not a physical structure. The bays of the vault can be read as individual or as doubled, corresponding to the elevation bays, thus producing an oscillation of reading, as in the Lincoln nave vault. The vaults of the Eastern Lady Chapel and choir are the products of the same building campaign, the Eastern Lady Chapel having been completed first.

Vaulting in the crossing and north and south transepts of Bristol Cathedral dates from between 1460 and 1480, under Abbot William Hunt. The crossing features a centralized lierne star vault pattern, with tiercerons springing from the corners and a pattern of cusped lierne diamonds around the centre, creating an effect similar to the vaulting in the North Porch of Saint Mary Redcliffe, suggesting an intelligible structure underlying organic form, a *species apprehensibilis*, in relation to the perceived forms of nature.

Saint Mary Redcliffe, begun in the 1290s by Simon de Burton, Mayor of

Bristol, is the only cathedral-like parish church in England. The vault (Fig. 4.3) in the North Porch dates from 1325. Four tiercerons spring from each bay between the window heads, but none of them reach the central boss. They all connect to one of six transverse ridge rib segments; the inner joints are connected by a lierne hexagon around the central boss. The bosses are large gilded foliate bosses, contrasting with the grey stone. The two tiercerons on each side of the severies of each bay meet the transverse rib which runs from the window head across the vault through the hexagon in the centre, resulting in three continuous transverse ridge ribs. The surface of the vault is a series of folds creating flat surfaces, with a palimpsest of patterns overlaid.

Fig. 4.3: Saint Mary Redcliffe North Porch. Photo by author.

The vault looks like a snowflake, or a pattern in a kaleidoscope, merging the structure of the building with the surface texture of the ribbing, and merging the intelligible form of the architecture, the structure as understood in the mind, called by Grosseteste the *species apprehensibilis*, with the visible form of the architecture, the *species sensibilis*, as perceived by the senses, in the same way that the *species apprehensibilis* of natural forms is connected to the *species sensibilis*. In order to perceive a form in nature, it must first be understood by the mind, and in that way the laws of nature are revealed. In order to perceive a form in architecture, it must first be understood by the mind, and in that way the secrets of architecture are revealed. In this way the architecture accommodates the intellectual ascension and comprehension of the spectator, as a model for under-

standing nature, and the archetypal intelligence of the world.

Fig. 4.4: Saint Mary Redcliffe Nave Vault. Photo by author.

The nave vault (Fig. 4.4) of Saint Mary Redcliffe was begun in 1337 and completed in 1342. The vault pattern, fifty-four feet above the floor, is a more complex and distorted version of the transept vault begun earlier. The nave vault is composed of a series of springer clusters in each bay of the vault, between the window heads of the clerestory, with seven tiercerons per bay. The arches of the clerestory windows are extremely wide, so the tierceron clusters of each bay, spreading out like fingers across the surface of the vault, are easily distinguished. Liernes interrupt the tiercerons above the window heads, but not in the springer conoids. While the bays of the transept vault at Saint Mary Redcliffe are clearly divided by pronounced transverse arches, the presence of the springers is minimized, and the square bays are filled out with the diamond and square lierne patterns; the vault reads as a series of centralized square bays, distinct

from each other; the presence of a ridge line is minimized as well.

The nave vault is dominated by the presence of the tierceron springers and the longitudinal ridge line – it is only imaginary, but it is reinforced by zigzagging lines of liernes running parallel to it. This is the first in a series of vaults in the curvilinear style dominated by zigzagging liernes running parallel to the ridge line. The tiercerons in each bay extend to form transverse ribs and diagonal transverse ribs which run to the window heads and responds in the next bays over, forming a crossing pattern of diamonds longitudinally, which is extended by the zigzagging liernes running parallel to the ridge line and more liernes added to form diamonds above the window heads. The vocabulary is the same as in the transept vault – painted ribs with cusping and gilded bosses against white severies – but the pattern leaves the regular geometrical organization of the transept vault, and begins to suggest the irrational forms of nature. The line between the sensible form, *species sensibilis*, and intelligible form, *species apprehensibilis*, is blurred.

The ribs undulate and fold across an uneven vault surface, suggesting topographical lines, and they are unevenly clustered and thorny, with the cusping, all suggesting natural growth. There are similar instances in the architecture of Lincoln Cathedral where the patterns suggest topography and charts of the vectors of the *virtus* of natural forces, corresponding to the treatises on natural philosophy of Robert Grosseteste, such as the astronomical treatises, *Computus I*, *Calendarium*, *Computus Correctorius* and *Computus Minor*; the treatise on light, *De Luce*; treatises on the heavenly bodies, *De Generatione Stellarum*, *De Motu Corporali* and *De Motu Supercaelestium*; treatises on meteorological phenomena, *De Impressionibus Elementorum*, *De Iride*, *De Colore* and *De Calore Solis*; and the cosmology *De Lineis*. Perhaps the vaulting pattern in the nave, along with the vaulting pattern in the North Porch, reflects the growing influence of natural philosophy, and the attempts to understand natural phenomena through geometry and mathematics and other rational means, as well as the desire on the part of the Church to evoke the wonders of divine creation and the infinity of divine intelligence, with the stretched canopy of the vault simulating the starry vault of the heavens.

The visual effect of the vaulting is like that of a billowing tent being stretched to the corners and bays of the walls, structured by the geometries. It seems to be a skeletal and structural variation of the effect found in Byzantine building, such as the Baptistery of the Orthodox in Ravenna or the Hagia Sophia, designed to represent the vaulting of the heavens and complete the metaphorical role of the building as a microcosm of the cosmos. In the terms of contemporary science, the severies of the vaulting might be seen as an epigenetic landscape. In Complexity Theory, organisms undergo structural changes in morphogenesis, in increasing complexity to avoid torpor or entropy. In morphogenesis, the organism can undergo changes as a result of influences on it from its environment, in epigenesis. In Topology Theory, an epigenetic landscape, in the

form of waves, fields, or fronts, is the result of the action of the environment on unstable, structureless forms.

The relief features of the folds or fields of an epigenetic landscape, as in waves or dunes, for example, are the product of a complex network of interactions underneath the surface, in the form of vectors, nodal points and directional movements. The undulating folds of the severies in the vaulting can be seen as a topological field, an epigenetic landscape. Robert Grosseteste also described the fields and forms found in nature, such as hills, valleys, clouds, etc., as the product of underlying geometrical and mathematical forces. These are described in his treatise *De natura locorum*, an extension of the treatise *De Lineis, Angulis et Figuris*. *De natura locorum* attempts to apply the mathematics and geometry which are understood to be the underlying structure of light as it diffuses into matter in *De Lineis*, to natural phenomena. The relation between surfaces in natural forms and geometry is on display in the vaulting of the nave, as an *edificium* of the structure of matter and the celestial vaults.

THEY WERE LIKE THEM:
THE STARS IN MESOAMERICAN IMAGERY

Stanisław Iwaniszewski

ABSTRACT: Both linguistic and historical evidence suggests that pre-Columbian Meso-americans conceived of celestial bodies as animate beings. Since they were believed to be-have like humans, their acts were explained in terms of the symbolic rather than through rational logic. Certainly, celestial bodies of the Mesoamerican skies were not the material or inert objects of modern astronomers. The paper seeks to explain who the stars and planets were in ancient Mesoamerican imagery.

Introduction

Since the beginning of recorded history, the evidence suggests that people around the world have selected certain stars and asterisms perceived by them as features essential for their daily life and grouped them together into constel-lations often named after mythological figures, animals or tools.[1] As the regular appearance or disappearance of certain stars and planets had been perceived as correlated with other seasonal changes and annual events, rotating skies became linked closely to the daily lives of the community and played diverse roles in its economical and ritual activities and social and political events. When individual stars or star groups were identified and named, they were often used as a means for marking the passage of time and for the ordering of the inhabited world. Celestial bodies and events were part of the intimate human inhabitation and experience of the world. Like all other elements found in human lifeworlds – the 'familiar worlds of everyday life' – celestial phenomena should be viewed as things contributing to human relations and providing a specific context for a so-cial life.[2] It quickly becomes evident that in the remote past people experienced celestial bodies more in relation to their existential meaning and less with regard to their logical scientific meaning.[3] It is thus important to learn about those con-ceptions of the skies which may extend beyond scientific rationality.

[1] See, for example, Richard H. Allen, *Stars Names: Their Lore and Meaning* (1899; New York: Dover, 1963) and Julius D.W. Staal, *The New Patterns in the Sky: Myths, and Legends of the Stars* (1961; Blacksburg: The McDonald and Woodward Publishing Co., 1988).

[2] Alfred Schutz and Thomas Luckmann, *Las estructuras del mundo de la vida* (Buenos Aires: Amorrortu, 2003), pp. 25-29.

[3] Stanisław Iwaniszewski, 'The sky as a social field', in *Archaeoastronomy and Ethnoastron-omy: Building Bridges between Cultures*, ed. Clive L. N. Ruggles (Cambridge: Cambridge University Press, 2011), p. 36.

Mesoamerica

What we know of the astronomical ideas of the ancient Mesoamericans in their own words comes from texts inscribed in monuments and a few survived codices.[4] Indirect evidence is provided by astronomically-aligned architecture, including architecturally-expressed Mesoamerican calendars, fixed instruments like pecked cross-circle designs placed either on stucco floors or on rock outcrops, and ideologically and religiously motivated iconographic depictions. This evidence is often combined with information derived from colonial records made in the sixteenth and seventeenth centuries and sometimes confronted by the information supplied by current anthropological research.

From this evidence we know that the ancient Mesoamericans conceived of their lifeworlds as containing networks of interacting animated beings. They imagined the earth as a living being metaphorically represented either as a turtle or a crocodile floating upon the waters of a primordial ocean. They ascribed forms of life and agency to mountains, cliffs, caves, bodies of water, maize, agave and cacao plants, animals, clouds, winds, rains, thunders, celestial bodies and specific places. They also attributed gender to them. The specific ways human life was shaped in Mesoamerica had consequences for peoples' dealings with the phenomena perceived in the sky. Yet, it is not enough to say their skies were peopled by animated beings.

Based on ethnographic, ethnohistoric and archaeological data, several years ago Susan Milbrath argued that the Classic Maya visualized their heavens with celestial gods and heroes traveling from the sky to the underworld.[5] However, the analysis of the celestial bodies in Maya imagery entails a consideration of the nature of supernatural beings themselves. It is not clear whether the Classic Maya already developed a concept of specific gods or still maintained the notions of more or less impersonal spirituals attributed to natural forces.[6] Certainly, the Maya gods were not discrete, separate entities like the gods of the Greek and Roman pantheons. They could both merge with one another and exchange forms with one another and their traits were not fixed or permanent. In sum, there are many deities known of Post-Classic Yucatan, but many of them were not present in the Classic period. Many of Classic times deities had at least slightly different functions, attributes or guises.

Very little is known about the ways in which Maya and Nahua (Aztec) sky-

[4] Barbara Tedlock, 'Maya Astronomy: What We Know and How We Know It', *Archaeoastronomy, The Journal of Astronomy in Culture* 14, no. 1 (1999): pp. 39-58.

[5] Susan Milbrath, *Star Gods of the Maya: Astronomy in Art, Folklore, and Calendars* (Austin: University of Texas Press, 1999).

[6] See Karl A. Taube, *The Major Gods of Ancient Yucatan, Studies in Pre-Columbian Art & Archaeology* 32 (Washington, DC: Dumbarton Oaks Research Library and Collection, 1992), pp. 7-9; Mary Miller and Karl A. Taube, *The Gods and Symbols of Ancient Mexico and the Maya* (London: Thames and Hudson, 1993), pp. 89-90; and Claude-François Baudez, *Una historia de la religión de los antiguos Mayas* (México: UNAM-CEMCA, 2004).

watchers might have conceptualized stars, asterisms and constellations. To define celestial bodies as animate beings is only one step in defining the relationships between human beings and their lifeworld. By focusing on celestial bodies as animate beings, my aim is thus to more closely define those relationships.

According to the sixteenth-century Nahua testimonies, every human body absorbed the spiritual energy in form of three entities, often referred to as 'souls':[7]

1. *tōnalli*, 'warmth of the sun, summertime, day' – the spiritual caloric entity responsible for individual vitality and fate, inherent on the day of birth.[8]
2. *(te)yōlia/yōlli*, 'heart' – the spiritual entity sent to the Netherworld after death.
3. *ihīyōtl*, 'breath, respiration, one's life, sustenance' – the spiritual entity associated with diverse substances emanated from a body, like breath, shadow and sweat.

Animate entities that populated the physical environment in which the Mesoamericans dwelled were described as beings existing somewhat analogously to the human body. The physical environment was populated by various categories of animate beings: deities, spiritual entities and the souls of deceased individuals, with whom people shared the lifeworld. Both animate and inanimate entities were regarded as possessing a spiritual entity, 'a structured unit endorsed with a capacity to be independent from the organic site in which is located'.[9] Accordingly, celestial bodies were not physical objects but animate entities engaged with people in many particular ways.

The Sun

Celestial imagery was important to the representation of social and political relations in Mesoamerica and the belief that human souls become stars after death has been one of the most pervasive concepts in the spiritual life of Mesoamericans.[10] Also, the region's rulers have regularly depicted themselves in the guise of supernatural beings or gods. Very often they have presented themselves wearing the costumes of the Maize God because the life cycle of the maize plant provided a metaphor for life after death. According to Mesoamerican mythology, the dead Maize God was decapitated by the Lords of the Netherworld, but later he would resurrect and emerge from the underworld through a split made

[7] I follow Alfredo López Austin, 'Cuerpo humano e ideología: las concepciones de los antiguos nahuas', vol. 39 (México: Universidad Nacional Autónoma de México [UNAM], Instituto de Investigaciones Antropológicas, 1980), pp. 221-262; and Roberto Martínez González, *El nahualismo* (México: UNAM, 2011), pp. 28-67.

[8] López Austin, 'Cuerpo humano e ideología', pp. 233, 236-37.

[9] Martínez González, *El nahualismo*, p. 29.

[10] See Oswaldo Chinchilla Mazariegos, 'Los soberanos: la apoteosis solar', in *Los mayas: las voces de piedra*, ed. Alejandra Martínez de Velasco y María Elena Vega (México, DF: Editorial Ambar Diseño, 2011), pp. 266-68.

in the surface of the earth just in the same manner as each year the young maize plant sprouts from the seed previously planted in the earth.[11] The diurnal path of the sun in the sky provided another metaphor for human life after the death. It was believed that each day the young and strong sun rose in the east and the aged sun set in the west. During the night the sun god travelled through the Underworld to reappear again in the early morning. The images of the rising young sun and the setting aged sun were used as models for genealogical connections.

During the Classic period, the Maya rulers often added the name of K'inich Ajaw, the Sun God, to their royal titles.[12] The name of the sun was *k'in* (with variants *k'ihn* or *k'iin*) meaning 'sun', 'day', with other meanings of 'time', 'day', 'heat' or 'wrath', anger'. The title *k'i[h]nich* written as an adjective before the noun may be translated as 'sunny' or 'heated', making references to the name of the Sun God, K'inich Ajaw, 'Sunny Lord', 'Heated Lord', or 'Lord of Hot Face'.[13] However, if this title is written after the noun, it denotes a name 'Lord who is Hot'. The heat is a vital quality ultimately derived from the Sun, but it was also accumulated with the advance of the age as well as with the offices of public or ritual functionaries that an individual person accumulates throughout his/her life.[14] All animate objects, including human bodies, have their own *k'iinil*.[15] This may be the reason that explains the uses of the adjective *k'ihnich* in the names of the Maya rulers.[16] If this interpretation is correct, then the adjective *k'ihnich* and the name *k'ihnich* would much resemble the Nahua concept of *tōnalli* (see above). The solar god K'inich Ajaw had a nocturnal aspect in the form of Jaguar God of the Underworld.

The Moon

The ancient Maya believed that the Moon represented the feminine principle of the world.[17] The lunar goddess is simultaneously the young woman and the old

[11] See Mary Miller and Simon Martin, *Courtly Art of the Ancient Maya* (San Francisco and London: Fine Arts Museum and Thames and Hudson, 2004), pp. 52-58.

[12] Virginia M. Fields and Dorie Reents-Budet, eds., *Mayas, señores de la creación* (San Sebastian: Editorial Nerea, 2005), p. 137.

[13] Erik Velásquez García, 'Los vasos de la entidad política de 'Ík': una aproximación histórico-artística. Estudio sobre las entidades anímicas y el lenguaje gestual y corporal en el arte maya clásico' (PhD thesis, National Autonomous University of Mexico, 2009), p. 157.

[14] According to Søren Wichmann, ed., *The Linguistics of Maya Writing* (Salt Lake City: The University of Utah Press, 2004), pp. 80-81. For ethnographic examples consult Calixta Guiteras Holmes, *Los peligros del alma: visión del mundo de un Tzotzil* (Mexico: Fondo de Cultura Economica, 1965), pp. 248-49.

[15] William F. Hanks, *Referential Practice: Language and Lived Space among the Maya* (Chicago and London: University of Chicago Press), p. 86.

[16] Velásquez García, 'Los vasos de la entidad 'Ík', p. 543.

[17] See Gabrielle Vail and Andrea Stone, 'Representations of Women in Postclassic and Co-

one, the goddess of fertility and of death, the humid goddess who brings rains to water the fields, and the dry goddess that destroys the fields. In the form of a beautiful young lady, called U' Ixik, 'Woman of the Moon', or Ixik Kaab', 'Earth Lady', she symbolized fertility and the feminine part of the Earth. The goddess is also depicted as an aged, senile woman, the patroness of beekeeping, weaving, divination and medicine, called Chak Chel, 'Great' or 'Red Horizon', or 'Red Rainbow'. In the form of young mistress, the goddess portrays the waxing moon, and in the form of a senile woman, the waning moon. The Moon Goddess is closely related to the mythology of maize, since her changing phases mark the periods that are suitable to seed, plant and harvest.

The Full Moon was sometimes regarded as a Night Sun, or as a kind of an anti-moon: it crossed the skies from the east to the west and was portrayed as a male moon and identified with the jaguar.

Venus

By the end of the Classic period (eighth to ninth centuries) another celestial body, Venus, started to be represented as an anthropomorphic entity acting upon the world.[18] In the *Dresden Codex* the Morning Star god is showed as an armed anthropomorphic being spearing and chasing other beings. It was associated with the figures of well-known men-gods such as Quetzalcoatl and Kukulcan.

Deified Ancestors

The characteristic feature of Mayan religion was the cult of the ancestors.[19] The capacity of rulers to interact with their ancestors was a common characteristic of the Mayan divine kingship. In public ceremonies the rulers interceded between humans and gods for the welfare of the community and this notion was utilized to display the ancestors also as mediators between their living descendants and animated forces of nature. This was done in many ways. Hieroglyphic inscriptions often provided the names of dead rulers as ancestors of the current ruling family, the living rulers were portrayed as performing auto-sacrificial blood rituals in order to be able to communicate with their ancestors, and the deceased

lonial Maya literature and Art', in *Ancient Maya Women*, ed. Traci Ardren (Walnut Creek: Altamira Press, 2002), pp. 210-15.

[18] See, for example, Arturo Pascual Soto and Erik Velásquez García, 'Relaciones y estrategias políticas entre El Tajín y diversas entidades mayas durante el siglo IX d.c.', *Contributions in New World Archaeology* 4: pp. 208-15; Alfonso Lacadena, 'Animate versus Inanimate: The Conflict between Mayan and European Astronomical Traditions in Mayan Colonial Documents', paper presented at the SAA Session on 'Celestial References in Mesoamerican Creation Stories', Vancouver, 26-30 March 2008.

[19] For example, Patricia McAnany, *Living with the Ancestors: Kinship and Kingship in Ancient Maya Society* (Austin: University of Texas Press, 1995), pp. 7-8, 39-40, 125-30; James L. Fitzsimmons, *Death and the Classic Maya Kings* (Austin: University of Texas Press, 2009), pp. 15-16, 170-78.

rulers were depicted as royal ancestors in the form of heads looking down and floating over the figures of the current lords.

Sometimes the deceased rulers were portrayed as beings impersonating celestial bodies.[20] On stone monuments the ancestors were usually displayed in the form of disembodied heads floating over the figures of current Mayan rulers and looking downward. Male ancestors whose heads are hanging over current rulers were depicted in guise of the Sun God. The identification of the sun with vital energy, the individual destiny of rulers and with dynastic descent allowed the Maya to honour deceased male rulers apotheosized as the sun.

The male and female ancestors (animated full-body figures) were also placed inside solar and lunar cartouches. The deified parents were transformed into celestial beings, providing a heavenly mandate for a current ruler. An iconographic depiction of Classic Maya ancestral rulers clearly associated male ancestors with the Sun and female ancestors with the Moon. It is likely that the Underworld was not the final destination for deified rulers and their families.

Like the Hero Twins of the *Popol Vuh* who after having died transformed into heavenly bodies, deified members of ruling lineages were also believed to ascend to the skies after their death. Recent investigations of the figures of deceased rulers suggest that they were rendered as living individuals rather than as a dead people.[21] The figures of deceased rulers placed on monuments represented individuals who had acquired a specific status or quality. But, at present, it is not entirely known whether the figures of deceased rulers impersonated celestial deities (as they did during the public ceremonies performed during their lives), posed as the celestial bodies, or were transformed into celestial bodies (men into the Sun, women into the Moon). Not only royal ancestors were apotheosized as the Sun and the Moon. On four squared feet supporting the well-known sarcophagus of K'inich Janaab Pakal, the famous ruler of Palenque who ruled between 615 and 683, the portraits of deceased nobles fixed within glyphic stars were portrayed.[22] They all bear the titles of *sajal* (an office usually held by nobles of secondary rank) and of *aj k'ujuun* (literally 'he of the books') and their names and faces are rendered as part of *ek'* ('star') signs, suggesting they all acquired stellar status after their deaths.

The ancient Maya also believed human beings had three spiritual entities, or souls, some of which died along with the body while some remained alive after death. This is why the royal and/or deified ancestors displayed on monuments are conceptualized as animate entities (*b'aaj, tōnalli*-like) of already deceased

[20] Perhaps the best known examples are from Palenque and Yaxchilán, see Carolyn Tate, *Yaxchilan: The Design of a Maya Ceremonial City* (Austin: University of Texas Press, 1992), pp. 59-62; Fitzsimmons, *Death and the Classic Maya Kings*, pp. 52-60.
[21] Compare Harri Kettunen, 'Nasal Motifs in Maya Iconography' (PhD thesis, University of Helsinki, 2006), p. 308; and Velásquez García, 'Los vasos de la entidad 'Ík'', pp. 560-562.
[22] Oswaldo Chinchilla Mazariegos, 'The stars of the Palenque sarcophagus', *RES: Anthropology and Aesthetics* 49/50 (2006): pp. 40-58.

individuals who are dressed in the guise of solar and lunar deities because both luminaries grant them an animate and individualized existence after death. Thus, the animate entities of the deceased and deified ancestors needed to be transformed into personifications or substitutes of celestial bodies before they were pictured on monuments.[23] Therefore, what we see on monuments are manifestations of only a part of the *b'aaj* (soul) identities of deceased rulers who reside in the celestial domains of the Sun and Moon deities. Similarly, the Nahua believed that the death of the body does not terminate *tōnalli* which continues to survive.

The belief that human souls become stars after death was a common concept in Mesoamerica. We may now assume that after the death of a human being a *tōnalli* or *b'aaj*-like animate entity situated in the head was projected onto the sky. Since, during the individual's life, a *tōnalli*-soul is transformed into the recipient of energies emanating from the sun (especially during childbirth, as the naming the child was seen as taking *tōnalli* from the sun), it may be speculated that the stars seen in the sky were taken as emanations of individual *tōnaltin*.[24] Therefore their movements in the sky could have been predicted by those who had knowledge of the *tōnalpōhualli* – the 260-day divinatory calendar.

Mythological Beings and Objects

There is evidence that the ancient Maya populated the skies with numerous mythological beings, which are unfortunately still poorly understood. These beings can easily be recognized as entities bearing celestial symbols, most importantly, the *ek'*, 'star' sign, or attached to the sky-band motif. The so-called *Vase of the Stars* pictures twelve personages with the *ek'* sign possibly displaying a mythical scene known from the sixteenth-century creation myth of Zipacna (or Sipac) who killed the four hundred boys, 'who are said to have gone to be stars'.[25] The apotheosis of the stellar beings in the primordial war against Zipacna offers an additional explanation of the stellar role in human lifeworld. The stars themselves were warriors, providing models for the life of their earthly counterparts.[26]

It has been suggested that the turtle, one of the constellations displayed in the *Paris Codex*, in the so-called 'zodiac' pages, represents Orion.[27] Based on the

[23] Velásquez García, 'Los vasos de la entidad 'Ík'', pp. 568-69.

[24] López Austin, 'Cuerpo humano e ideología', pp. 230-33, 237.

[25] As translated by Munro S. Edmonson, ed., *The Book of Counsel: The Popol Vuh of the Quiche Maya* (New Orleans: Tulane University, 1971), p. 48.

[26] Oswaldo Chinchilla Mazariegos, 'Cosmos and warfare on a Classic Maya vase', *RES: Anthropology and Aesthetics* 47 (2005): pp. 107-34.

[27] Harvey M. Bricker and Victoria R. Bricker, 'Zodiacal references in the Maya Codices', in *The Sky in the Mayan Literature*, ed. Anthony F. Aveni (New York: Oxford University Press, 1992), pp. 148-83.

ethnographical record and *Popol Vuh* interpretation,[28] the three stones of a cre-
ation story were identified with the stars Alnitak, Saiph and Rigel of the modern
Orion constellation and with the three bigger stones found in domestic hearths.[29]
The Nahua-speakers of Central Mexico located *māmalhuāztli*, the fire-drill instru-
ment for lighting fires, on the sword and belt of Orion. In both cases the objects
represented in the sky were utilized by the gods in creation myths and remained
inanimate.

Other Classic Maya representations show celestial bodies (stars, asterisms,
constellations) in the guise of animals such as a deer, turtle, scorpion, turkey or
peccary.[30] We may therefore expect to find that the ancient Maya populated the
celestial firmament with various mythological entities or supernatural beings
and attributed to them the traits or qualities stemming from their collective
lifeworld representations. The diverse stellar beings that appear in the Maya
skies seem to represent mythological figures active in the Creation Stories. By
placing their images in the sky, the Mesoamericans utilized notions of cosmic
order to model their life on earth.

Conclusions

Though the ancient Mesoamericans seem to have been well acquainted with the
starry sky, only a few constellations or stars appear to have been named by them
and the number of celestial gods was rather small. The overall impression given
by the sources is that only the sun, the moon and, in later periods, the Morning
Star were regarded as gods, that is, as animate and autonomous beings capable
of acting upon the world and people. The sun, the moon and the Morning Star
were expected to act like humans.

Deceased royal ancestors ascended to the heavens into the road of the sun and
the moon. After the Classic period the same status was ascribed to the souls of
warriors killed in the battlefield. Accordingly, the sun accompanied their *tōnalli*
souls on their journey from the sunrise to midday and, eventually, the souls
were fused into the sun to make a single entity. Today, the belief that human
souls become stars after death is still a very common idea. It seems that, after
death, a *tōnalli* or *b'aaj*-like animate entity (soul) located in the head was projected
onto the sky. Those animate entities were also believed to act like humans, but
their influence upon humans was limited: they interceded between their living
descendants and gods and their actions were activated by those spiritual beings

[28] Dennis Tedlock, *Popol Vuh: The Definite Edition of the Mayan Book of the Dawn of Life and
the Glories of God and Kings* (New York: Simon and Schuster, 1985), p. 161.

[29] David Freidel, Linda Schele, and Joy Parker, *Maya Cosmos: Three Thousands Years on the
Shaman's Path* (New York: Morrow, 1993), pp. 79-83; Linda Schele and Peter Matthews, *The
Code of Kings: The Language of Seven Sacred Maya Temples and Tombs* (New York: Scribner,
1998), p. 37.

[30] Bricker and Bricker, ' Zodiacal references'; Freidel et al., *Maya Cosmos*.

(gods) who controlled the cosmos. The examples cited above suggest that deified ancestors who were associated with the sun and moon became integrated into political and ideological processes in ancient Mesoamerica and were closely tied to the office of rulership.

The third group of celestial bodies, in addition to the gods and deceased rulers, refers to mythological beings. They are depicted as animals with anthropomorphic arms and legs, often standing up on two legs and gesticulating like human beings. Made up of human and animal parts they are depicted as animals acting like humans – they represent hybrids. Probably, they were modelled after human beings and were represented as acting according to the rules of human agents; at least relationships between them are described in terms of inter-human relations.

Since Mesoamerican sources described the sun and moon as supernatural and engendered entities, respectively called 'our father' and 'our mother', they should have been regarded as collective symbols representing the male and female cultural archetypes. As animate entities they were believed to act like humans and closely related to human populations through genealogical connections, for which reason the sun and moon were addressed through kinship terms such as 'our father' and 'our mother'. As the same time this fact indicates they were treated in generic and collective terms rather in terms of entities containing individualized agents. The Mesoamerican lifeworld consisted of networks of interacting entities, and their identities and statuses were shaped both by historically specific cultural values and social structures. The sun and moon gods shared their attributes with other supernaturals with often overlapping functions, for example during the Late Classic and Postclassic periods there were two major female divinities representing distinct aspects of Mayan women, earth and moon. People's motivations were constrained by their linkages to others in a collectivity (with exceptions limited to a few outstanding members of the royal elites) so their personal identities were more collective in character rather than individual. In other words, people's identities were heterogeneous, mixed and hybrid rather than homogeneous, bounded and categorically aisled ones. Thus, in viewing the celestial bodies of the ancient Mesoamericans, we observe the remarkable similarity between the corporate identities of elite members or collective identities of the commoners on the one side, and solar and lunar figures blended with other divine entities on the other. Studying the identities of celestial bodies may serve to gain insight into the structures of past human consciousness and experience. Mesoamerican celestial bodies were not like us, individually differentiated members of Western societies, but like them – the peoples and societies living in the vast area of ancient Mesoamerica.

THREE RUSSIAN COSMISTS:
FEDOROV, TSIOLKOVSKY, CHIZHEVSKY

George M. Young

ABSTRACT: The Russian Cosmists were a loosely connected group of nineteenth- and twentieth-century Russian thinkers, three of whom developed radical – and perhaps eccentric – ideas about the role human beings should play in the evolution of the cosmos, and the role the cosmos has played in the evolution of humanity. Nikolai Fedorov (1829-1903), the illegitimate son of a Gagarin prince and the inspiration for subsequent Russian Cosmism, urged his countrymen to undertake space travel and colonization as part of a grandiose project for the resurrection of the dead. His protégé, the grandfather of Russian rocket science, Konstantin Tsiolkovsky (1857-1935), believed that life exists in some form throughout the cosmos. Tsiolkovsky's protégé, Alexander Chizhevsky (1897-1964), found significant correlation between solar eruptions and major events in human history. This paper will discuss these three thinkers and their ideas in relation to the western esoteric tradition.

In the late nineteenth and early twentieth centuries, a tendency emerged in Russian thought that went beyond considerations of socio-economic, political or geographic man, to examine our cosmic dimensions, to suggest that our field of awareness, activity and influence extends beyond city, state, continental and even planetary boundaries to include the entire universe.

The Russian Cosmists, as these thinkers are known today, did not consider themselves part of a coherent school, and only in retrospect can be seen to have shared a common core of themes and convictions.[1] Some, like Vladimir Solovyov, Nikolai Berdyaev, Sergei Bulgakov and Pavel Florensky, were primarily religious thinkers. Others, like Vladimir Vernadsky, Konstantin Tsiolkovsky and Alexander Chizhevsky, were scientists. What they shared was a conviction that we are very much more than earthly beings, that we are active agents of our own evolution, and that we should direct all spiritual, scientific, and even esoteric knowledge and effort to realize the long and widely held dream of universal human immortality. We are, as one of the thinkers put it, not earthlings, but 'heaven dwellers'.[2]

Of the ten or so major Cosmist thinkers I would like to focus here on three: Nikolai Fedorov (1829-1903), the eccentric librarian and futuristic religious thinker from whom – or sometimes against whom – all the later Cosmists

[1] For further information on the Cosmists, see George M. Young, *The Russian Cosmists: the Esoteric Futurism of Nikolai Fedorov and his Followers* (New York: Oxford University Press, 2012).

[2] Nikolai F. Fedorov, *Filosofiia obshchago dela: stat'i, mysli, i pis'ma Nikolaia Fedorovicha Fedorova* [FOD], 2 vols, ed. V. A. Kozhevnikov and N. P. Peterson (first printed Moscow: 1902; Vernyi, 1913; Farnborough, UK: Gregg, 1970), Vol. I, p. 283.

develop their positions; Konstantin Tsiolkovsky (1857-1935), who, as a teenager, considered Fedorov his 'university' and went on to become the grandfather of the Russian space program; and Alexander Chizhevsky (1897-1964), who as a young man was mentored by Tsiolkovsky and who investigated, among other things, periodicity in nature and the influence of cosmic energy on cycles of human behaviour.

Fedorov (pronounced and sometimes transliterated Fyodorov), the founder of the Cosmist tendency, was born in the south of Russia, an illegitimate son of Prince Pavel Gagarin, who was the black sheep of one of Russia's oldest and most distinguished families.[3] The roots of the Gagarins extend back to Riurik, the legendary founder of Russia, and extend forward to include Yuri Gagarin, the first man in space. Almost nothing is known about Fedorov's mother, and the surname and patronymic came from the godfather at the christening. Fedorov grew up as both a Gagarin and not a Gagarin, and in his mature writings he always takes the point of view of the outsider looking in, a voice from the uneducated masses speaking to a learned elite. A major theme in all his writings is the need to overcome divisions: between classes, generations, academic disciplines, theory and practice, temporality and eternity, ideal and reality. All now divided must be brought back together, especially sons and fathers, the living and the dead. Fedorov's own father, Prince Pavel, left the Gagarin estates to lead a bohemian life as impresario of a theatre and burlesque house in Odessa. Duty and responsibility would become cardinal virtues in Fedorov, absent in the world as it is, dominant in the world as it ought to be.

In his lifetime Fedorov was best known for his twenty-five years of service in the great Rumiantsev Museum, which now forms a wing of the enormous Russian National Library. Occupying a minor position and refusing all offers of promotion, he became a legend of erudition, said to know not only the title but a summary of the contents of every item in the vast library, and when a reader ordered materials for research, he would often receive extra items he had not even heard of, items that turned out to be relevant, even essential, to his research. A lifelong ascetic bachelor, Fedorov lived alone, changing residences every year or so, usually a single closet-sized rented room or corner of someone's apartment. He slept on a humpback trunk, sometimes bare, sometimes covered with newspapers, placing under his head not a pillow but some hard object, usually a book. The only coat he wore every day, summer or winter, was more rag than coat, and strangers easily mistook him for a beggar on the streets. He had no furniture, and each time he moved to new quarters he gave away whatever objects the room had accumulated. He spent nothing on entertainment, diversion, or any conveniences, and he refused to take cabs even in the coldest winter months. He drank only tea, ate hard rolls, sometimes accompanied by

[3] Young, *The Russian Cosmists*, pp. 46-91. For an earlier, fuller monograph, see George M. Young, *Nikolai F. Fedorov: An Introduction* (Belmont, MA: Nordland, 1979).

a piece of old cheese or salt fish, and lived for months without a hot meal. He considered wealth poisonous and vile, rejected all offers of raises, gave away most of his very meagre salary, and cursed himself if he came home at night with a few kopecks left in his pocket that he had not managed to give away.

Every researcher at the library knew him as an ideal, if eccentric librarian. But only a very few knew that Fedorov was also a thinker – in Berdyaev's opinion the most original and 'most Russian' in Russian history.[4] Leo Tolstoy, who looked down on Tsars, Generals, Popes and French Emperors, considered himself fortunate to have lived in the same century as Fedorov. Solovyov, usually considered Russia's greatest philosopher, considered Fedorov his master and spiritual father and Fedorov's idea the first forward movement of the human spirit since the time of Christ. So what was so important about Fedorov?

In Isaiah Berlin's famous dichotomy between foxes who know many things and hedgehogs who know one big thing, Fedorov would qualify as a supreme hedgehog, a thinker with one huge idea.[5] And though it is a very complex idea with any number of parts, in its simplest statement his idea is that we all should stop everything that we are now diversely doing and devote all our time, energy, effort and knowledge to what he called 'the common task' of resurrecting all the dead. And he meant this literally. In his view, everything in the physical, social and moral universe is now disintegrating and pointed toward death, and it is humanity's task to overcome death and redirect everything toward eternal life. Nature is the force of disintegration, he argued, and God gave us human reason to regulate nature. We should therefore be mindless nature's mind, and blind nature's eyes. For Fedorov, an Orthodox believer, true Christianity can only be the practice of actively resurrecting the dead. All science must become the science of resurrection. As early as the 1860s, Fedorov was proposing possibilities such as those we now call cloning, genetic engineering and artificial organs, as well as space travel and colonization. For Fedorov, all matter contains particles of our disintegrated ancestors: advanced science must find a way to restore whole persons from individual particles, and since some of those particles have dispersed beyond earth, we must go into space to gather in the dispersed particles of our ancestors. By combining knowledge and action, science, religion and art, everyone will be encouraged to join the project, and everyone living will become a resurrector, Christian in practice, regardless of belief or unbelief. Sons and daughters will resurrect their parents, who in turn will resurrect their parents, and so all the way back to Adam and Eve. To those who worried about overpopulation and wondered where on Earth we would put all those resurrected ancestors, Fedorov answered: that's why we must colonize space. The resurrected ancestors would have new bodies engineered to live in places

[4] For Fedorov's relationship to contemporary and subsequent Russian thinkers, see Young, *The Russian Cosmists*, pp. 63-68.

[5] Isaiah Berlin, *The Hedgehog and the Fox: An Essay on Tolstoy's View of History* (London: Weidenfeld and Nicolson, 1953).

throughout the universe currently unable to support life. Going even further, Fedorov proposed that as part of regulating nature we would learn to overcome gravity and time, and eventually should be able to guide our planet out of its natural orbit and sail it like a boat toward directions of our own rational choice. A hundred years before Buckminster Fuller, Fedorov proposed, in effect, that we become 'captain and crew of spaceship earth'. In today's terminology, Fedorov wanted to turn the exploding cosmos into an eternal steady state, shaped not in imaginary constellations drawn from pagan Greek myths, but as a human regulated sidereal icon of the Holy Trinity.

The few contemporaries who learned of Fedorov's idea and incorporated at least parts of it – the moral and religious, not scientific or technological parts – into their own works included three literary and intellectual giants: Tolstoy, Dostoevsky, and Solovyov. Another younger contemporary who did incorporate Fedorov's scientific ideas into his own was Konstantin Edouardovich Tsiolkovsky[6], a nearly deaf raw youth who came to Moscow penniless but in hopes of somehow obtaining in the great library an education beyond his minimal schooling back home in Kaluga. Fedorov immediately recognized the young man's potential, took him under his wing, brought him stacks of guided readings, set problems for him, discussed all the subjects with him, taught him to take notes and create a conspectus, provided money for necessities whenever possible, and as Tsiolkovsky later gratefully wrote, took the place of the university professors under whom he was unable to study.

After a few years in Moscow, Tsiolkovsky returned to his village near Kaluga to become an elementary science teacher while dreaming of interplanetary travel. He began to make notebook sketches for rocket boats, rocket wagons and rocket-powered space ships, and to write fictional accounts of space voyages. What distinguished Tsiolkovsky's imagination from that of any of his contemporaries, is that after writing fantasy narratives and drawing rough pencil sketches, he developed the mathematical formulas that would make the realization of some of his fantasies possible. Over the years, while still a school teacher and working after hours in a homemade attic laboratory, he built a series of large wooden model rockets, dirigibles, aerostats, wind tunnels, centrifuges and primitive space vehicles, and wrote the papers that would eventually lay the foundation for the 1957 launching of Sputnik I, the world's first artificial satellite. Soviet historians of science have noted that Tsiolkovsky's works contain in embryo nearly all the scientific-technical attainments of the Soviet Union in the exploration of space.

[6] For more on Tsiolkovsky, see Young, *The Russian Cosmists*, pp. 145-54; K. E. Tsiolkovsky, *Selected Works* (Moscow: Mir, 1968); Asif Siddiqi, *The Red Rockets' Glare: Spaceflight and the Soviet Imagination, 1857-1957* (New York: Cambridge University Press, 2010); Michael Hagemeister, 'Konstantin Tsiolkovskii and the Occult Roots of Soviet Space Travel', in Birgit Menzel, Michael Hagemeister, and Bernice Glatzer Rosenthal, *The New Age of Russia: Occult and Esoteric Dimensions* (Munich-Berlin: Sagner, 2012), pp. 135-50.

Tsiolkovsky's great accomplishment as a scientist was not only to quantify the dream of space travel through mathematical equations, but also to actively promote and popularize the idea of flight beyond earth, to inspire an enthusiasm for rocket science among young people and even school children throughout the Soviet Union. He provided a kindly, grandfatherly, down-to-earth image for an otherwise daunting field of study. Among Tsiolkovsky's young readers who grew up to be outstanding scientists were the cosmonaut and first man in space Yuri Gagarin, and the Cosmist heliobiologist Alexander Chizhevsky, whose ideas we shall discuss below.

But it is not only rocket scientists who are interested in Tsiolkovsky. From early in his career through to his later life, he speculated profusely about humanity's relationship to the cosmos. Some of these speculations found their way into his science fiction narratives, others were published in tiny editions as discursive pamphlets or tracts, but most remained unpublished during his lifetime and have only begun to emerge since the collapse of the Soviet Union.[7] As a result of these speculations, many of them Gnostic or theosophical in orientation, Tsiolkovsky has become something of a New Age cult figure in Russia, and his home and museum in Kaluga have become a destination for esoteric as well as scientific pilgrims.

One of Tsiolkovsky's central ideas has to do with the presence of life and spirit in all matter. He writes that he is not only a materialist, but also a panpsychist, recognizing the sensitivity of the entire Universe. He considered sensitivity and feeling to be inseparable from matter. Everything, he tells us, is alive, but with the provision that we consider living only that which possesses a sufficiently strong sense of feeling. Moreover, since everything that is matter can, under favourable circumstances, convert to an organic state, then we can conditionally say that inorganic matter is in embryo, potentially living.

An idea at the heart of most of his non-technical writings is that of the 'atom-spirit' (atom-dukh) inherent in every particle of matter in the cosmos, recalling Fedorov's idea of all matter as the dust of ancestors. But where Fedorov believed that we must redirect and reshape the cosmos, Tsiolkovsky's view of the cosmos is that it is already teleological, rationally organized, and hierarchical. Lower life forms, consisting mainly of matter in which spirit is dormant, naturally evolve into higher ones in which the spirit is awakened and more dominant, and eventually, as we approach perfection, we will outgrow our material envelopes and join the rays of cosmic energy that constitute something like the pleroma of the Gnostics. The dark side of Tsiolkovsky's ideal of self-perfecting humanity is that it requires the elimination, the 'weeding out', of those of us who are in some way defective. Unlike Fedorov, whose future resurrection society must include absolutely everyone, Tsiolkovsky's future perfect society is highly selective –

[7] See especially two earlier articles by Tsiolkovsky, 'Monism vselennoi' and 'Kosmicheskaia filosofiia', in S. G. Semenova and A. G. Gacheva, *Russkii Kosmizm: Antologiia Filosofskoi Mysli* (Moscow: Pedagogika-Press, 1993), pp. 264-77 and 278-82.

losers of any kind will not make the cut. In articles titled 'Grief and Genius' (*Gore i genii*) and 'The Genius Among the People' (*Genii sredi liudei*), Tsiolkovsky offers his variation on Plato's idea of the philosopher-king, suggesting that scientific geniuses and inventors should occupy the key positions in future government, and that the many nations of the world should become a single cosmic political system governed by the most advanced and therefore most nearly perfect specimens of humanity.[8] In Tsiolkovsky's view, our earth probably represents an early, primitive stage of planetary evolution, and elsewhere in the cosmos life forms have advanced much further. These advanced 'atom-spirits' are already in communication with us, but only geniuses – artists, scientists, mahatmas and the like – are attuned to their messages.

Just as in the 1870s Fedorov was mentor to the sixteen-year-old Tsiolkovsky, so in 1914 Tsiolkovsky became mentor to seventeen-year-old Alexander Chizhevsky, a sensitive but fragile *wunderkind* from a privileged background, who began his intellectual life as a poet and painter, talents which he continued to exercise through life.[9] As a child, Chizhevsky was taken to Italy every winter where, as he writes in his autobiography, he began his lifelong fascination with, and even worship of, the sun. When his father was appointed commander of the regiment in Kaluga, the family moved there and the boy genius Chizhevsky soon came under the wing of the eccentric rocket genius Tsiolkovsky. Though they worked in different fields, their close association continued for the rest of Tsiolkovsky's life, and today in Kaluga the Tsiolkovsky Museum of Cosmonautics houses a Chizhevsky Museum as a wing. It was under Tsiolkovsky's influence that Chizhevsky's intellectual interests, always broad, ranging from ancient languages to post-impressionist painting, gradually began to expand further to include the sciences.

The works that would earn him an international reputation as the 'Da Vinci of the twentieth century' and a nomination (though unsuccessful) for a Nobel Prize, were his discoveries in aero-ionization, which included the invention of an air purification device called the 'Chizhevsky Chandelier', and studies in hemodynamics, which shed new light on the cycling of blood through living bodies. These studies, some first published in French, others in Russian, fell within the limits of acceptable Soviet science and brought Chizhevsky high national and international honours.

But his most important work, in heliobiology, demonstrating the effects of solar pulsations on human life, provoked accusations of mysticism, occultism and irrationality. Eventually, during the Stalinist terror, these accusations led to his arrest as an 'Enemy under the Mask of a Scientist', resulting in sixteen years in prison camps and exile, from 1942 until his rehabilitation in 1958. During this

[8] L. V. Golovanov and E. A. Timoshenkova, eds, *K. E. Tsiolkovskii: Genii sredi liudi* (Moscow: Mysl, 2002).
[9] For more on Chizhevsky, see Young, *The Russian Cosmists*, pp. 163-71; A. L. Chizhevskii, 'Kolybel Zhizni i Pul'sy Vselennoi', in Semenova and Gacheva, *Russkii Kosmizm*, pp. 163-71.

period of imprisonment and exile, despite special punishment for refusing to wear a large prison number on his back and for objecting to being addressed in the familiar second person singular, he still painted, wrote poetry and, with whatever means he could find, continued to conduct scientific research. At one point, realizing that they had an internationally famous biologist in their hands, the prison authorities dragged Chizhevsky, who was barely alive, from a punishment cell to see if he could help stop a cholera epidemic that was sweeping the camp – which, with bleaching powder and other crude remedies at hand, he managed to do. As a reward, he was allowed to set up a minimal laboratory in the prison clinic, in which, using only a borrowed microscope and glass capillaries, he conducted ground-breaking investigations into the movement of blood that would later, after his rehabilitation, be publicly endorsed by the President of the Academy of Sciences of the USSR.

In one of his most controversial works, published in 1922, he provides a number of charts in which he correlates the fluctuations of sunspots with the up and down periods of violence in human history.[10] In these charts, the correlation is almost too perfect, with periods of what he calls maximum universal excitability coinciding with maximum solar activity, and stretches of relative international calm coinciding with minimal solar activity. He calls this new science 'historiometria', and though Chizhevsky's charts and graphs suggest that some rough relationship may well exist between cosmic energies and mass human actions, it seems clear that historiometria, at least in this charted and graphed form, is not yet ready to join the academic mainstream as an accredited scientific discipline.

During his career, Chizhevsky, like the other Cosmists, was frequently accused of trying to take science back to a pre-scientific state, for attempting to replace chemistry with alchemy and astronomy with astrology. Chizhevsky, like the other Cosmists, strongly denied these allegations, but added that he did respect and did wish to restore to modern science not the actual practices of alchemy and astrology, but the intuition underlying those pre-scientific efforts: that in some very profound and mysterious but eventually definable way we and all matter in the cosmos are one, and that through exchanges of energies and matter, via particles and rays, transformations between elements, cosmic and local, physical and psychological, can result.

The significance of the scientific branch of Russian Cosmism may not lie so much in the specific discoveries that emerged, but rather in the Cosmists' willingness to seek new scientific truths in bodies of knowledge and manners of investigation long discredited as esoteric, occult, pseudo-scientific. As one of them noted, Marx's injunction to 'challenge everything' should also be applied

[10] Available in English as: A. L. Tchijevsky, 'Physical Factors of the Historical Process', *Cycles* (January, 1970), at http://cyclesresearchinstitute.org/cycles-history/chizhevsky1.pdf [accessed 17 November 2014].

to the axiom that true knowledge began with the scientific revolution.[11] In Russian Cosmism, the scientific imagination is extended to treat such ancient instances of outdated credulity as the resurrection of the dead, the vitality of all matter, and the influence of cosmic forces on human behaviour as legitimate topics for scientific investigation, as tasks for practical application. The Russian Cosmists pioneered the once surprising but now frequently observed similarity between models of the cosmos presented in theosophical and other esoteric literature and models of the cosmos emerging from advanced particle physics, chemistry, biology and astronomy. The legacy of Russian Cosmism might in the end by characterized as the emergence of a more scientific esotericism and a more esoteric science.

[11] Vasilii Fedorovich Kuprevich, 'Dolgoletie: Real'nost' Mechty', in S.G. Semenova and A.G. Gacheva, *Russkii Kosmizn: Antologiia Filosofskoi Mysli* (Moscow: Pedagogika-Press, 1993), p. 348.

PART TWO: DISCOURSES IN WORDS

MAN, MYSTERY, MYTH AND METAPHOR: POETRY AND THE HEAVENS

Gillian Clarke

A team of roadmen was working the lanes of Banc Siôn Cwilt, a folk name for the small patch of high land where we live. One of them was described as 'simple'. He believed the earth to be flat. The other men teased him. 'What's over the horizon then, Dai?' He replied, 'There's a ditch. In the ditch there are workmen making stars out of old moons'.

Was he simple? Or a poet, wiser than they knew, making myth from mystery? We live in a dark place. There are no street lights. To the west is the sea, to the east, hill country hides the lights of distant villages, to south and north no light stains the sky. The trig point behind our house records the height: 'At One Thousand Feet'.[1]

> Nobody comes but the postman
> and the farmer with winter fodder.
>
> A-road and motorway avoid me.
> The national grid has left me out.
>
> For power I catch wind.
> In my garden clear water rises.
>
> A wind spinning the blades
> of the mill to blinding silver
>
> lets in the rumour,
> grief on the radio.
>
> America telephones.
> A postcard comes from Poland.
>
> In the sling of its speed the comet
> flowers to perihelion over the chimney.
>
> I hold the sky to my ear to hear
> pandemonium whispering.

Now that we are connected to the national grid, the windmill has gone, but one day a road-man asked us if our small turbine was permitted by the electricity company. 'Aren't you stealing their wind?' he asked. I once knew a star-gazer

[1] Gillian Clarke, 'At One Thousand Feet', in *Collected Poems* (Manchester: Carcanet Press, 1997), p. 85.

and an archaeologist who one single day and night discovered a new star in the heavens and ancient bones in the earth, metaphors for our search for meaning in the earth and the sky.

> **'Looking'²**
> Kate in full day in the heat of the sun
> looks into the grave, sees in that unearthing
> of a Roman settlement, under a stone
> only the shadow of a skeleton.
>
> Gwyn on his back in the dark, lying
> on the lawn dry from months of drought,
> finds in the sky through the telescope
> the fuzzy dust of stars he has been searching.
>
> Imprint of bones is a constellation
> shining against silence, against darkness
> and stars are the pearly vertebrae
> of water-drops against the drought, pelvis,
>
> skull, scapula five million light years old
> wink in the glass, and stardust is all we hold
> of the Roman lady's negative
> in the infinite dark of the grave.

We have always sought an understanding that shines against silence, against darkness. I ask you to suspend all your self-doubt for an hour, and to join me in believing that, as the blackbird has evolved to sing, so the human mind has evolved to think in poetry; that all human beings are poets; that it is poetry that distinguishes the human animal from other living creatures; that poetry – as epic, lyric, narrative, myth, in formal or free verse – is the truth, though not necessarily fact; that it is through poetic devices that we have always explained the inexplicable to ourselves, ever since we have been human. The Poet Laureate, Carol Ann Duffy, defines poetry as the music of being human. I think of poetry as a rhythmic way of thinking. I think we are both saying that poetry is the rhythm of human thought, reason and imagination, and metaphor is, and always has been, our human way of explaining to ourselves the manifestations of the heavens and the mysteries of the universe. What we don't understand, in art, science, technology, engineering, mathematics, religion, philosophy, we explain to ourselves in metaphor, in poetic narrative. The Internet uses metaphor to describe itself. The 'mouse' moves under your right hand. We travel the 'web'. Radio records a few minutes of 'wild sound' to fill the silence in a recorded programme. A television cameraman complains of 'a hare (hair) in the gate' of the camera. Architects call tracks worn by human feet across landscaped areas around buildings, 'paths of desire'. The poet R. S. Thomas, speaking of his religious faith, spoke of putting his hand in the empty form of a hare, and finding it still warm. The offence, allegedly committed by Sam Warburton in a Wales v.

² Gillian Clarke, 'Looking', in *Letting in the Rumour* (Manchester: Carcanet Press, 1989), p. 33.

France match in the Rugby World Cup, tackling, lifting and dropping an opponent, is called a 'spear'. The player got a red card, the match was played with fourteen men, and lost by a point. The battle of the Gododdin all over again! In the battle, the 6th century British/Celtic tribe were all slaughtered in the Battle of Catraeth (Catterick). All, that is, but one, the poet Aneirin, who recorded it in the earliest British poem by a named poet, preserved in an early medieval manuscript known as *The Book of Aneirin*, in the language we know as Welsh.

This argument for poetry's truth is not about religion, but its power to fire an arrow of understanding straight to the heart. George Herbert ends his poem 'Prayer' with a perfect definition of poetry: it is 'something understood'.[3] I was once teaching a workshop on metaphor to primary school children, though they thought we were just writing a group poem about a tree. I asked them what a tree was like. Like a hand, said one child. I asked for words connected with hands. What do hands do? I asked. They gave me words like wave, write, stroke. At last, I confessed I'd played a trick, and read their poem back to them, the word 'tree' replacing 'hand'. When I read aloud the line, 'The tree writes on the sky', up jumped the least able boy, the naughty one, the slow reader, the one threatened by his teacher, behave or you're out. He stood up, his two hands in the air, shouting, 'YES! I get it! Hand! Tree!' It was 'something understood'.

We, human, poets all, look up at the night sky, and we map it for the shapes we see, the Square of Pegasus, the Plough, Orion. We name it for the gods who ride their chariots up there, who shake the heavens with lightning, who send an occasional comet to remind us of our subordinate place in the order of things, who cause floods, earthquakes, hurricanes to warn us we are killing the planet. We can't erase that ancient naming, or forget the mythology. Words and images are powerful. The sky is the page on which the story of human life is written.

When I was a child my father would take me out on a clear night to look up at the sky. Often, quoting from Sean O'Casey's 'The Plough and the Stars', he'd say: 'What is the stars.'[4] Once, at Tŷ Newydd, our Welsh Writers house in Gwynedd, back in the 1980's, I was tutoring a poetry course for 16 year olds from Reading. One clear summer night we doused the house lights and stepped out to watch the Perseids, the August meteor shower. We lay on our backs on the lawn. Between their chorus of cries at every shooting star, I pointed out the planets, the constellations, the Milky Way. The students were astonished. For them such heavenly bodies were the stuff of fantasy, the content of science fiction novels, comics and movies. Suddenly one of the boys uttered these immortal words: 'Wow! Do we 'ave these in Reading?'.

I remembered my father's voice, the huge sky over my grandmother's

[3] George Herbert, 'Prayer', in the *English Poems of George Herbert*, ed. Helen Wilcox (Cambridge: Cambridge University Press, 2007), p. 176.

[4] Sean O'Casey, 'The Plough and the Stars', in *Three Dublin Plays* (London: Faber and Faber, 1988), p. 44.

farm in Pembrokeshire, my heart huge with wonder. 'What is the stars?' The words illuminated science and mystery. Broadcasting Engineer, BBC Wales, he explained radio's long-waves, the speed of light, the age of stars, the Heaviside Layer. He told me it was the lowest layer of the ionosphere, closer to Earth at night, and that he bounced his BBC radio waves off it. He failed to tell me it was named after Professor Heaviside, who discovered it. I continue to this day to imagine a traditional Welsh blanket, known as a *carthen*, in the sky.

Has wonder been eradicated? Do we think we have solved the last mystery, found the final piece of the jigsaw, the god-particle? Are wonder, and worship, no more? Could it be that, in the blind heavens of Reading, and every neon-lit city, town, village in the whole world, the night sky is available only on television? My key words are wonder, worship and story. I'm not talking about religion, certainly not theology, absolutely not dogma. Wonder is what our ancestors felt, worship arose from it, and story was how they explained the inexplicable to themselves. It is no surprise to know that our ancestors worshipped the heavens and the earth, and that we are inclined not to worship anything. Yet we do feel wonder, don't we? Wonder is a questing, questioning word. It leaves the heart and mind open. Its manifestation is a kind of worship, an urge to follow the thrill of wonder by wanting to save the planet. R. S. Thomas, our, great, late Welsh poet, a priest himself, wrote in his poem 'The Moor', 'It was like a church to me.'[5] In her memoir, *Pilgrim at Tinker Creek*,[6] Annie Dillard, poet and poetic writer of prose, describes seeing a mockingbird drop like a stone from the top of a four-storey building, to open its wings a breath before reaching the ground. Another time she saw green waves roll ashore off Florida, translucent and back-lit by the sun, each one carrying the twisting bodies of sharks. 'The least we can do,' she writes, 'is try to be there'. All that the poet in each of us can do is 'be there', letting wonder, even worship, electrify us.

Our earliest ancestors knew wonder. We have evidence that they were as watchful of the sky above them as they were of the earth they walked on. Observation of the moon and stars, of sunrise and sunset, the change of seasons, the weather, were all they knew of science, and of worship. Those who live and work in the real countryside are still aware of these things. Years ago, when our house in Ceredigion was still a ruin, without running water or electricity, just a two-roomed *bwthyn* to camp in during the summer, we stepped out on a dark night to brush our teeth and spit into the grass. Low in the north we saw strange shafts of green light moving in the sky. No town lay in that direction. We thought of a travelling fair, maybe. Then, on the late night weather forecast we learned that the Aurora Borealis had been seen in many parts of Britain. How many times do we miss such phenomena, as we might have missed that one? In

[5] R. S. Thomas, 'The Moor', in *Pietà* (London : Rupert Hart-Davis, 1966), p. 24.
[6] Annie Dillard, *A Pilgrim at Tinker Creek* (New York: Harper's Magazine Press, 1974), p. 16.

Brut y Tywysogion, or *The Chronicle of the Princes*, it is recorded that between 685 and 691, 'the earth quaked in Brittany', 'there was a rain of blood in the island of Britain and Ireland'. 'The butter and the milk turned to blood'. 'And the moon was blood'. Those events were clearly understood as warnings.

As we move towards winter, we look out for Jupiter, stepping along the planet-road, flanked by his moons, four of them clearly discernible through our telescope in the dark skies over Banc Siôn Cwilt in Ceredigion. Siôn Cwilt was a smuggler working the coast close to where we live. He wore a coloured quilt for a coat, hence his name. The place he haunted is named for him, as we name the planets in the dark sky above us. To name them is to possess them. To name them humanly, poetically, is to make them part of our world and our story. As Shakespeare says;

> The poet's eye, in a fine frenzy rolling,
> Doth glance from heaven to earth, from earth to heaven;
> And as imagination bodies forth
> The forms of things unknown, the poet's pen
> Turns them to shapes and gives to airy nothing
> A local habitation and a name.[7]

Poetry is the mind's and the imagination's struggle to move from 'things unknown' to 'something understood'. In the moonlit wood, the fox sees not the moon in the night sky, but its light on the woodland floor, trees, shadows of trees, movement of enemy or prey. Badger, hedgehog and owl use its light, but do not consider it. I don't suppose they spend time looking at the moon. The moth, however, must yearn for it, as it yearns hopelessly at the glass for the light bulbs inside our rooms at night. Most nocturnal creatures keep watch on their earthly surroundings. It is we human beings who turn our eyes to the heavens, urging our companions to do the same. 'Look! Look at the moon!'

My border collie sleeps in the sun. She understands shade, and sunlight. If she gets too hot she will move into the shade. She knows these things from experience. The sun shines through the glass gable of the room where I am trying to write, using a laptop, and I am too dazzled to work. At noon, this time of year, the low sun fills the room with sunlight. I also know that soon the Earth will roll over, leaving the room and my table in shadow. My Iron Age ancestors knew what the sun could do, but not what it was. They could calculate. Keeping careful watch, they could measure and predict the length of the day, the angle of the sun, the waning and waxing of the moon, seasonal changes, the mathematics of observation. In 'The Sundial' I record my son, aged six, making his clock from stones, a circle of paper, a broken bean stick.[8]

[7] William Shakespeare, *A Midsummer Night's Dream*, Act 5, scene 1, lines 12-17.

[8] Gillian Clarke, 'The Sundial', in *Collected Poems* (Manchester: Carcanet Press, 1997), p. 11.

> In the still
> Centre he pushed the broken bean
> Stick, gathering twelve fragments
> Of stone. placed them at measured
> Distances. Then he crouched, slightly
> Trembling with fever, calculating
> The mathematics of sunshine.

He calculated time from sunlight, as did our ancestors five thousand years ago, those who built the passage-grave at Newgrange in the Boyne Valley in Ireland. At dawn after the longest night, a slit over the portal lets in a spear of light reach deep into the passage to touch the great stone. Their building was constructed to a precise calculation. After the sterility of winter, the ray of sunlight touching the stone at sunrise on the shortest day of the year symbolises a wakening, a quickening, an insemination of the earth itself, urged into ripeness after winter sleep. All along the Atlantic coast the remains of these powerful buildings are evidence of human reason and calculation hand in hand with worship in the culture of our ancestors. Plant pollens have been found in some of the oldest burial sites on earth, telling us that, faced with the mystery of death and grief, they brought flowers, they were human, and reverential as we are. We 'glance from heaven to earth, from earth to heaven'. Then something else happens,

> as imagination bodies forth
> The forms of things unknown, the poet's pen
> Turns them to shapes and gives to airy nothing
> A local habitation and a name.[9]

Poetry is our narrative, and at the heart of the telling is repetition, memorable sound. Story has always been crucial to our understanding of 'life, the universe and everything,' of heaven and earth. How else to explain the sun, the moon, the extreme weathers of storm, thunder, flood, hurricane, earthquake, darkness and light? The gods were angry, or pleased. The moon was blood. Early humans explained the great, omnificent gold sun by calling it a god. We know it is a star, but that does not erase from our minds, our literature, our music, our culture the memory and naming of the gods. On the contrary, it leaves an extra shade of meaning, and to this day stories are the means by which we fathom the unfathomable. Early poetry, like poetry today, uses rhythm, repetition and metaphor to help us memorise, to explain things simply to ourselves and to each other. 'Grandma's gone to heaven', we tell a child. That is not a lie. It is a metaphor, because the truth is we don't know where she's gone. How can the dead live in us still, as they do, if they are nothing but bones in the ground, or ashes blown away on the wind? Only metaphor comes to our rescue at such a moment.

It is easy to imagine the narrative epic, sung, maybe, to the harp, passed from speaker to listeners round a fire under the stars. Maybe it was chanted as a song

[9] Shakespeare, *A Midsummer Night's Dream*, Act 5, scene 1, lines 15-18.

repeated to each other and to the gods. 'Song' and 'poem' both lie in the Welsh words *cân* and *cerdd*. In English too, a particular kind of poem, the *lyric*, suggests the words of a song, and the epic suggests story. The stories we tell ourselves allow us to escape the trap of literalism, and, that most unattractive human flaw, certainty, the 'I am right' of the doctrinal zealot. The verse narrative tells the human story with imagination, not dogma.

The oldest stories we know, and the earliest art, show that human beings used the moon and the sun for their calculations. To 'worship' is human. It recognises Earth's mysterious relationship with sun and moon, stars and planets, seasons and the weather, and of our subordinate place in it. No wonder they felt the need to appease the gods. We know, and they knew, that if we hurt the planet, we die. How could we not gaze at the heavens? The first humans observed the shadow edging across the moon, a little more each night, the sun rising every day, the shortening and lengthening days, and they lived by their light. I recall watching a complete eclipse of the moon. Slowly it lost first its edge then its brilliance. In complete eclipse it was just a stone. No longer a goddess, but a stone that looked so close and commonplace I could pluck it from the sky, all the more moving for being just a pebble. Then it struck me – it was our shadow, Earth's shadow, that had put out its light and turned it to stone. This metaphor for the shadow we cast reminded me of three old men I saw sitting on a bench in the sun. A white moth fluttered past them. One of the old men reached out and, without a pause, crushed it in his fist.

Circa 600 BCE an anonymous Chinese poet said, on seeing the new moon rise over the hill, 'my heart lays down its load'. A thousand years later, in Arthur Waley's translation of Yang-Ti, we read, of the same moon,

> Suddenly a wave carries the moon away
> And the tidal water comes with its freight of stars.[10]

Milton describes Lucifer after his fall from grace, he, who had been brightest of all the angels,

> 'as when the sun, new-risen,
> Looks through the horizontal misty air
> Shorn of his beams'…[11]

We talk of the man in the moon. In parts of Africa it is the hare in the moon. To no one is it just a stone. The moon, the same moon by which we measure months and years, which inspires and rules us, is female in our culture, male in others. Goddess or god, written about by poets from ancient times to today in every culture, shone down on Juliet and her Romeo. In 'The Stone Hare', I consider a sculpted limestone hare, and imagine moonlight on ancient, shallow

[10] Yang-Ti, 'Flowers and Moonlight on the Spring River', lines 2-4, in Arthur Waley, *Chinese Poems* (London: Routledge, 2005), p. 115.
[11] John Milton, *Paradise Lost* (Edinburgh: 1773), lines 594-96, p. 73.

seas as limestone was forming in what is now Derbyshire, before a single human foot had trod the earth.[12]

> Think of it waiting three hundred million years,
> not a hare hiding in the last stand of wheat,
> but a premonition of stone, a moonlit reef
> where corals reach for the light through clear
> waters of warm Palaeozoic seas.
> In its limbs lies the story of the earth,
> the living ocean, then the slow birth
> of limestone from the long trajectories
> of starfish, feather stars, crinoids and crushed shells
> that fill with calcite, harden, wait for the quarryman,
> the timed explosion and the sculptor's hand.
> Then the hare, its eye a planet, springs from the chisel
> to stand in the grass, moonlight's muscle and bone,
> the stems of sea lilies slowly turned to stone.

George Herbert's sonnet, 'Prayer', considers the heavenly discourse of the spirit and the mind, and arises from the human to deity dialogue that began when we named the gods, or in Herbert's case, the God. But Herbert was a poet, and his definition of prayer equally well defines what poetry is, and it is that human meaning I choose to stress. Herbert's sonnet brings my interpretation of our theme – heavenly discourses – to a conclusion where, I hope, wonder, worship and story meet, eluding the trap set by the literalists and their demand for absolutes. Instead, we follow poetry's way, imagination's way. The poem has wonder, worship and story. It leaves the mind open to each generation's understanding and interpretation of an Earth under heavens bright with stars, planets, and legends to live by. The mystery is 'understood', as he says, but only for a moment, before it shimmers into uncertainty again and leaves us disturbed, as the best poetry does:

> The Church's banquet, Angels' age,
> God's breath in man returning to his birth,
> The soul in paraphrase, heart in pilgrimage,'
> The Christian plummet sounding heav'n and earth;
> Engine against th' Almighty, sinner's tower,
> Reversed thunder, Christ-side-piercing spear,
> The six-days'-world transposing in an hour,
> A kind of tune, which all things hear and fear;
> Softness, and peace, and joy, and love, and bliss,
> Exalted manna, gladness of the best,
> Heaven in ordinary, man well dressed,
> The milky way, the bird of Paradise,
> Church bells beyond the stars heard, the soul's blood,
> The land of spices, something understood.[13]

[12] Gillian Clarke, 'The Stone Hare', in *Making the Beds for the Dead* (Manchester: Carcanet Press, 2004), p. 27.
[13] Herbert, 'Prayer'.

THE STARS' EARTHLY MIRROR: HEAVENLY INVERSIONS IN THE ORESTEIA OF AESCHYLUS

Ben Pestell

ABSTRACT: In ancient Greek epic, although the stars are impossibly distant, they are simultaneously held in mysterious proximity to the earth. In Homer's *Iliad*, the constellations are washed by the great encircling Ocean as they dip beneath the horizon. More prosaically, in Hesiod's *Works and Days*, the movements of the stars describe the passage of the seasons. In both cases the stars occupy a liminal space between the earth and the heavens. I argue that the divine power of the stars is brought vividly into focus by the *Oresteia* of Aeschylus. Here, the stars are symbolically mirrored on earth by the signal flares which announce the Argive victory at Troy. The flares form a relay between the cities of Troy and Argos, crossing air and water, much like the invisible lines which create the constellations across the vacuum of space. This image commences a trilogy replete with the nocturnal imagery of sleeplessness, disturbed dreams and light in the dark. I show that this motif of light in darkness gains its power in Aeschylus' trilogy by metonymically bringing the stars to earth. The fires of this earthly mirror are fuelled by indifferent necessity and polluted divinity. The light rushes home, preceding the doomed king Agamemnon, whose death demands the eventual reconciliation under the joyful processional torches of the trilogy's conclusion.

The stars are distant objects to many in the twenty-first century: not only in the vast objective physical distances which separate us from the heavenly bodies, but also in our relationships with them. It is a commonplace to observe that stars had a central role in many aspects of pre-industrial life. This chapter examines one aspect of starlight in Classical Greek tragedy. I argue that the stars have a quality which is inherently divine to the Ancient Greek mind: they are portents of good and ill – like the gods. The physical distance of the astral bodies was, of course, an insurmountable obstacle for the Greek stage. Therefore, the main force of my argument concerns the way in which Aeschylus, in his trilogy the *Oresteia*, is able to harness the symbolism of the stars by inverting the source of nocturnal light. I shall very briefly survey the status of the stars in Greek mythology before examining Aeschylus' inversion; and we begin in the forge of Hephaestus.

In book eighteen of Homer's *Iliad*, Thetis, the mother of Achilles, comes to Hephaestus to ask for a new shield and armour for her son. Hephaestus, the god of the forge, crafts an astonishing shield, exhibiting intricate detail. The shield portrays a geocentric universe within which, being a god, Hephaestus is able to include an incredible amount of life and activity. The shield depicts a wedding, a siege, a ploughland scene, a king's estate at harvest, a vineyard, a herd of cattle attacked by lions, a sheep meadow, and a dancing circle. But along with these microcosmic details, we also have a grand, macrocosmic view of the entire universe, with the earth, the sky and the sea. Included in this panorama

are the sun, the moon and the constellations of the Pleiades, the Hyades, Orion the Hunter and the Great Bear. This last constellation Homer also calls by another name, the Wagon, since it 'turns about in a fixed place and looks at Orion/and she alone is never plunged in the wash of the Ocean'.[1] The Great Bear is the only constellation that the Greeks recognised which remains visible throughout the celestial year. All the others are washed in the Ocean as they sink beneath the horizon: Homer's stars fall within the limits of the sea. This is clearly visualised on the shield, where Hephaestus made 'the great strength of the Ocean River / which ran around the uttermost rim of the shield's strong structure'.[2] The Shield of Achilles thus provides a visualisation of the Homeric universe, with the earth – and all its activity – at the centre; the sun, moon and stars around it; and encircling this whole universe is the ocean which lies beyond even the stars. The Shield of Achilles shows us that the heavens are within the realm of human cognisance: when we see the sun and stars rise and set, we see them emerge from our own world.

That other Greek epic poet, Hesiod, also gives an account of the stars. According to Hesiod's *Theogony*, the stars are born of the goddess Dawn, so they are very much a part of the same numinous structure that orders the human world.[3] For mortals, the stars also have another, very specific role which Hesiod describes in his *Works and Days*. There, Hesiod tells us of the Pleiades, which rise in May to bring the harvest; of Sirius, the Dog-Star, associated with high summer and the dog days of summer; of the rising of Arcturus in late winter as a herald to spring; and June, 'when Orion's strength first shows itself', which is the time to be winnowing the grain.[4] For Hesiod, the stars are a way of dictating how to work the land: they are herald to the seasons, and the good and bad days that each season brings; and they are intimately connected to the earth and the fruits that come from the soil. Together, Hesiod's *Theogony* and *Works and Days* demonstrate his portrayal of the mythological and the scientific with equal seriousness. As in the former poem, which describes Ouranos, the unruly god of the heavens, impregnating (some say with the rains) the goddess Gaia, whom some still know as Mother Earth; in the latter, Hesiod still sees the heavens as having a bearing on everyday life. To many watch-wearers, diary-owners and smart-phone handlers of today, who may struggle to identify more than one or two constellations, the stars are simply mysterious points of light, many light-years away; but Hesiod could read them like a calendar and a plan of the day's work on the land.

In book eight of the *Iliad*, Homer describes the amassed Trojan army, fifty-

[1] Homer, *The Iliad*, trans. Richmond Lattimore (1951; Chicago: University of Chicago Press, 2011), XVIII.488-89.

[2] Homer, *Iliad*, trans. Lattimore, XVIII.606-7.

[3] Hesiod, *Theogony*, 381-82, in Hesiod, *Theogony, Works and Days, Testimonia*, trans. Glenn W. Most (Cambridge, MA: Harvard University Press, 2010).

[4] Hesiod, *Works and Days*, 383-600, in Hesiod, *Theogony, Works and Days, Testimonia*, trans. Glenn W. Most (Cambridge, MA: Harvard University Press, 2010).

thousand-strong, camped outside their city walls at night, surrounding their blazing watch fires. In an epic simile, the poet likens this scene to the constellations around the moon.[5] The fires dotted around the night landscape form an effective analogue to the points of light in the night sky. Aeschylus adopts this image, but carries it further, imbuing it with terrible divine import.

The *Oresteia* of Aeschylus (comprising the plays *Agamemnon*, *Libation Bearers* and *Eumenides*) begins at the end of the Trojan War. In his opening scene, Aeschylus brings Homer's starry simile rushing home to the Greek city of Argos. The first scene is a monologue delivered by the Watchman who has spent the past year on the roof of Agamemnon's palace; he is crouched like a dog. With this simple opening image we have both inversion and metamorphosis: earth-born man resides on the roof – outside the palace home – and he also loses a measure of humanity in his canine posture.[6] Inversion and metamorphosis are well established as among the dominant themes of the trilogy: we see it in Queen Clytemnestra's mastery over her husband Agamemnon and over her lover Aegisthus, and in the abundance of animal imagery.[7]

The Watchman then tells us how thoroughly he knows 'the throng of stars of the night, and also those bright potentates, conspicuous in the sky, which bring winter and summer to mortals'.[8] From Hesiod, we well recognise his allusion to the stars and constellations which mark the seasons. This year-outside, roof-dwelling dog-man is intimate with the heavenly bodies, or at least with their earthly significance: their heralding of the seasons. But this astral message is one-way traffic, the stars he has lived under for a year are less messengers than the message itself: they are mute, unresponsive; they remain aloof, distant, untouchable. The Watchman does not feel blessed in his vocation, but begs the gods to release him from his misery. Aeschylus enforces the Watchman's loneliness and this distance before presenting the great inversion that is the substance of this chapter: bringing the terrible majesty of the heavenly bodies to the earth. The Watchman announces the way this is to be done. His look-out is for a beacon: the man-made light which bears its own message, not of the irresistible passing of time and seasons that the stars presage, but news of a momentous human event. And, twenty lines into the play, the light arrives, bright as day.

[5] Homer, *Iliad*, VIII.553-65.

[6] This simile also foreshadows numerous other canine references, including one to Sirius, the dog-star, *Agamemnon*, 967.

[7] For discussion of both these themes, see, for example, Pierre Vidal-Naquet, 'Hunting and Sacrifice in Aeschylus' *Oresteia*', in Jean-Pierre Vernant and Pierre Vidal-Naquet, *Myth and Tragedy in Ancient Greece*, trans. Janet Lloyd (New York: Zone Books, 1990), pp. 141-59. For a more recent discussion of animal imagery, see John Heath, 'Disentangling the Beast: Humans and Other Animals in Aeschylus' *Oresteia*', *The Journal of Hellenic Studies* 119 (1999): pp. 17-47.

[8] Aeschylus, *Agamemnon*, 4-6, in *Oresteia*, trans. Alan H. Sommerstein (Cambridge, MA: Harvard University Press, 2008).

The message is of victory at Troy – more than two hundred miles away – and the victory was won the same night that we hear the news in Argos. The play's Chorus of Argive citizens sensibly asks, 'what messenger could come here with such speed?'[9] Clytemnestra – ruling in Agamemnon's absence – gives the reply. She tells us of a relay of beacon fires sent from Mount Ida near Troy, visible at the next watch-post, where a second fire is lit to be seen at the next, and so on, establishing a sequence of fires, lit as soon as the previous one was seen, lighting up a ring around the Aegean Sea, hurrying the message to Argos.

Clytemnestra accounts for the stages with telling symbolism of their divine import.[10] She invokes Hephaestus when she speaks of the first fire at Mount Ida, and Hephaestus is appropriate, not just because he is the god of the forge and the fire, but he is the one who made the shield of Achilles which encompasses the earth and heavens. Hephaestus is cartographer of the land and stars, emphasising the connectedness of the earthly and celestial realms. The next stage is Hermes' Crag on Lemnos, and Hermes is apt, messenger god that he is. The third, Mount Athos, is described as 'the steep height of Zeus'.[11] The light then shines to Mount Macistus, producing a fire 'like another sun', Clytemnestra says.[12] The attendants at Macistus ward off sleep, lighting a blazing fire that is seen at Mount Messapium; but from Messapium the light is no longer like the sun, but is now 'like the shining moon'.[13] As the signal advances on Argos, the stages are placed closer together, heightening the tension. But at this stage – at the halfway mark of the signals (though not halfway in terms of distance) – Clytemnestra's imagery begins to take a different hue. The switch from likening the beacons to the sun to likening them to the moon is more than just a search for a new simile: it heralds the turn in imagery from day to night, and from benign to sinister. This is appropriate enough, since the beacons were lit at night and send the message of a city's destruction. But by turning to the night, Clytemnestra subtly prepares us for the later dominance of the trilogy's action by the Erinyes, or Furies – older, pre-Olympian goddesses of vengeance, those self-described daughters of Mother Night who will threaten Athens with ruin.[14] This turn to the night also happens to come along the stretch between Mounts Messapium and Cithaeron, that is, over Aulis. Aulis was the scene of the sacrifice the goddess Artemis required Agamemnon to perform before sailing to war at Troy: a bitter location for Agamemnon and Clytemnestra because the required victim was their daughter, Iphigenia. This act of sacrifice had just been recounted by the

[9] Aeschylus, *Agamemnon*, trans. Sommerstein, 280.

[10] Aeschylus, *Agamemnon*, 281-310.

[11] Aeschylus, *Agamemnon*, trans. Sommerstein, 285. Here the text is corrupt; Sommerstein (p. 35 n. 62) endorses M. L. West's proposal that Peparethos was the next stage, but this is missing from the extant manuscripts.

[12] Aeschylus, *Agamemnon*, 288.

[13] Aeschylus, *Agamemnon*, 297-98.

[14] Aeschylus, *Eumenides*, 321-22, 417, 745 (Mother Night); 780-87 (Athens' ruin).

Chorus, so it would be fresh in the audience's mind, and it is this sacrifice that later constitutes Clytemnestra's primary motive for her murder of Agamemnon upon his return.[15] Furthermore, from this stage, Clytemnestra no longer mentions the positive or neutral symbolism of the Olympian gods – the likes of Hephaestus, Hermes and Zeus. The turn to night and fury which occurs at the site of Agamemnon's crime is maintained through the final stages. The next place the light passes over, from Mount Cithaeron, is Gorgopis bay. Reminiscent of the Gorgons, the word *gorgōpis* literally is *fierce-eyed* which recalls the eyes of Iphigenia which stared accusingly at her killers once she had been gagged at the sacrificial altar.[16] The next stage is Mount Aegiplanctus: the mountain of goats. This continues the sacrificial theme, for, only seventy lines earlier, the Chorus had compared Iphigenia at the altar to a young she-goat. Another animal marks the next stage: Arachnaeum, *the spider's crag*. The spider nested just outside Agamemnon's home foreshadows the net in which Clytemnestra will enmesh her husband before delivering her fatal blows,[17] and whether the audience is expected to grasp this detail or not, the general air of foreboding is clear enough. Finally, from here, the light is seen by the Watchman on the palace roof in Argos, his gaze drawn from the heavenly host to their imitation on Earth.

Through these stages Aeschylus gives us a mirror of the stars: crossing air and water, much like the invisible lines which create the constellations cross the vacuum of space. They are new lights in the sky bringing not the message of the seasons, but a message of victory, and with victory, the return of the longed-for Greek army, and with that, the return of King Agamemnon, the one who killed the happy daughter of the house. As the stars for Hesiod were a prompt for action, so the beacons are to Clytemnestra, and after a decade of waiting while the army fought at Troy, Clytemnestra can enact her revenge. It is a terrible message that these lights bring, yet the initial response is one of joy – though soon mixed with disquiet. This mixed portion of great joy and tragedy is in the very nature of divinity and fate that the heavens represent.

The ambivalence of the Greek gods is well established. Homer gives us the controlling, capricious Olympians, Hesiod gives us both the stars, bound up with daily and yearly rituals of humans, and Ouranos, who must be suppressed. Hesiod tells us in his *Theogony* that Ouranos, the 'starry sky', is born of Gaia, the earth.[18] Ouranos repeatedly impregnates Gaia, producing offspring which eventually sire the Olympian pantheon. But generally, Ouranos is troublesome. The solution to his superabundance of enthusiasm is found when his son, Kronos,

[15] Aeschylus, *Agamemnon*, 1521-29. It is not her only motive, but it is the most compelling for the purposes of this discussion.

[16] Aeschylus, *Agamemnon*, 239-42. This is also reminiscent of grey-eyed or flashing-eyed Athena: *gorgōpis* is another of her epithets in Sophocles, *Ajax* 450. As for the Gorgons, they had their own place in the Ptolemaic constellations.

[17] Aeschylus, *Agamemnon*, 1382-83.

[18] Hesiod, *Theogony*, 126-27.

castrates him.[19] This subsequently keeps the sky at a distance from Gaia. It seems that such heavenly divinity must be *managed*; it must not be allowed to mingle too intimately with earthly matters. The inverted image of the stars produced by the signal fires in the *Oresteia* symbolically extends the reach of this divinity. The tragic fate rushes home to Argos through these earthly conduits of the divine light. The symbolism of the artificial, earth-bound constellation announces the arrival of divine pollution and murderous revenge, but, unlike the castration of over-active Ouranos, Aeschylus finds a civilised way to contain the trouble.

In the conclusion of the trilogy the violence and disorder heralded by the beacons is brought to an end in a court scene in which the gods Apollo and Athena are present and take an active part. Apollo stands with Orestes, the son of Agamemnon and Clytemnestra, who, in retaliation against his mother's murder of his father, in turn has killed Clytemnestra herself. Against him stand the Furies, chthonic divinities who take the side of the murdered mother. Athena, presiding over a democratic judiciary of Athenian citizens, acquits Orestes, sending him home to Argos.[20] The Furies are insulted by this judgement and threaten to use their formidable powers to make Athens a barren city.[21] Athena is eventually able to mollify them, offering them a new home as exalted goddesses by the Acropolis, taking the Furies into the heart of the city, and into culture. This movement is effected with one final display of light – one which balances the troublesome display at the trilogy's start. The Furies are escorted to their new shrine under the earth by a torch-bearing procession.[22] Thus the daughters of Night are illuminated by torches: symbolic starlight finally shines on their midnight blackness, and we are returned to the image we started with: the vision of the numinous constellations inverted on the earth's surface. While in the first part of the trilogy the inversion of starlight brings divinity to earth in all its uncontainable *miasma*, here, such divine power is harnessed in a harmonious procession accompanied by a song of unity.[23]

The conclusion of the *Oresteia* endorses democracy and the rule of law, housing the formerly free-roaming Furies. The Furies maintain their fearsome powers, but the powers are tempered by the blessings that the goddesses bestow on the city. By containing the Furies and their procession of lights under the Acropolis, Aeschylus completes the move begun in the observation of the stars, and their mirror around the Aegean which brought them to earth. Finally the divine light is ushered *into*, or *under* the earth. The procession takes the symbolism of starlight as a representation of divinity, bringing the heavenly – in its terrible ambivalence – to our world, harnessing the numinous as the foundation of civilisation.

[19] Hesiod, *Theogony*, 132-82.
[20] Aeschylus, *Eumenides*, 763-66.
[21] Aeschylus, *Eumenides*, 778-92.
[22] Aeschylus, *Eumenides*, 1003-5.
[23] Aeschylus, *Eumenides*, 1036-47.

TRAVELLING THE COSMOS:
CELESTIAL JOURNEYS IN THE JAPANESE STORIES OF 'URASHIMA TARO' AND 'NIGHT OF THE MILKY WAY RAILROAD'

Steven L. Renshaw

ABSTRACT: Loved by children and adults in Japan, the stories of 'Urashima Taro' and 'Night of the Milky Way Railroad' are excellent examples of Japanese literature that involve individuals traveling imaginary yet culturally enlightened journeys in the cosmos of their respective eras. To understand their significance as cultural dialog with the heavens, this article includes: (1) synopses of the stories with explanation of historical and cultural contexts, (2) analysis of the astronomical and cosmological bases, (3) comparisons and contrasts of Japanese cultural values and principles in each story, (4) contrasts with values reflected in 'Western' stories and (5) a brief assessment of the continual impact of the stories not only in Japan but elsewhere following translation into other languages.

1. Introduction

Two of the most famous stories in Japan are the legend of 'Urashima Taro', records of which go back to the eighth century, and the early twentieth century 'Night of the Milky Way Railroad' by Kenji Miyazawa. Loved by children and adults, both are excellent examples of Japanese literature that involve individuals traveling imaginary yet culturally enlightened journeys and interacting directly with the cosmos as viewed in their respective eras. Both stories incorporate foreign symbols and materials with strong indigenous cultural values. For *Urashima*, it is a cosmological voyage uniting sea with heaven and including imported Chinese astral symbols of longevity, seasonality in cardinal directions, and the culturally significant asterisms of *Subaru* (Pleiades) and *Ame Furi Boshi* (Hyades). For Giovanni, the main character of 'Night of the Milky Way Railroad', it is a somewhat poignant tour of 'Western' summer constellations with poetic narrative that reflects understanding of more modern conceptions of stellar composition, distance and galactic structure.

Though separated by more than a millennium, these stories have served as vehicles for imparting many long-standing cultural values such as cooperative behaviour, responsible maturity, lineal accountability and loyalty to family, friends and society. To understand their significance as cultural dialog with the heavens, this article includes: (1) synopses of the stories with explanation of historical and cultural contexts, (2) analysis of the astronomical and cosmological bases, (3) comparisons and contrasts of Japanese cultural values and principles in each story, (4) contrasts with values reflected in 'Western' stories and (5) a brief assessment of the continual impact of the stories not only in Japan but

elsewhere following translation into other languages.

2. *Urashima Taro* (The Man from Ura Island)

Origins of the legend of *Urashima Taro*, or the man from Ura Island, are uncertain. It is mentioned in the *Nihongi* (*Chronicles of Japan*) and thought to have been first recorded in the *Tango Fudoki* (an early eighth-century topography of the Tango Region, an area of Kyoto facing the Japan Sea).[1] There are many versions of the story in Japanese, and several have been translated into English.[2] Almost all versions include the concept of *Tokoyo no Kuni* or 'other world', a region where deities reside. As in many cultures dependent on the sea for sustenance, Japanese historically saw the stars rise from and set into the sea. Both the heavens and the depths of the sea were seen as *Tokoyo no Kuni*. Thus, the fact that the story of *Urashima* takes him on a journey beneath the sea where he meets symbols of stars and the heavens is not a strange concept. The story contains images of Chinese cosmology where the centre or earth (or palace in the story) is associated with the colour yellow and perceived to exist within a canopy of the heavens with directions all related to colours and seasons (see Fig. 9.1).[3] The Chinese cosmos has also been compared to a turtle with its body as the earth and its shell as the round canopy of heaven.[4] Symbolism of the turtle as a sacred animal is at the heart of the story of *Urashima*.

The story begins with Chinese cosmological symbolism when the fisherman *Urashima*, having rowed out on the sea alone and having caught no fish for three days, at last retrieves (some versions have 'rescues') a turtle of five colours.[5] Falling asleep, he is awakened by a lovely voice. The turtle has changed into a beautiful woman (princess). He asks from where she has come, and she replies that she has come on the clouds and the wind from the house of the 'Immortal in the Sky'. She asks if he would have her, and *Urashima* cannot resist. 'I will take you to *Tokoyo no Kuni* (another world)', she says. Presently, they are deep beneath the sea and come to a great palace (most versions have 'great dragon palace'). At

[1] W.G. Aston, trans., *Nihongi: Chronicles of Japan from the Earliest Times to A.D. 697* (Tuttle Edition) (Tokyo: Charles E. Tuttle Co., 1972), Vol. I, p. 398; and K. Akimoto, ed., *Fudoki* (Topography: Record of Earth and Wind) (in Japanese), 5th edition (Tokyo: Iwanami Shoten).

[2] 'The Story of Urashima Taro, the Fisher Lad', in Y. T. Ozaki, ed., *The Japanese Fairy Book* (Tokyo: Charles Tuttle, 1970), pp. 26-42; 'Urashima the Fisherman', in R. Tyler, ed., *Japanese Tales* (New York: Pantheon Books, 1987), pp. 134-36; and 'Urashima and the Tortoise', in F. H. Davis, ed., *Myths and Legends of Japan* (New York: Dover Pub., 1992), pp. 324-28.

[3] X. Sun and J. Kistemaker, *The Chinese Sky During the Han: Constellating Stars and Society* (New York: Brill, 1997); and J. S. Major, *Heaven and Earth in Early Han Thought: Chapters Three, Four, and Five of the Huainanzi* (New York: State University of New York Press, 1993).

[4] S. Allan, *The Shape of the Turtle: Myth, Art, and Cosmos in Early China* (New York: State University of New York Press, 1991).

[5] From Akimoto, *Fudoki*, pp. 470-77. The author would like to express appreciation to Saori Ihara for help in translating this material.

the gate, seven children come out, then followed by eight more. When *Urashima* asks who the children are, the princess tells him the seven are *Subaru* (Pleiades) and the eight are *Ame Furi Boshi* (literally 'rain' stars', the Hyades). These are more indigenous references. Significantly, both the Pleiades and Hyades were symbols associated with spring ritual and planting. Much lore, especially around *Subaru*, developed throughout Japan's history.[6]

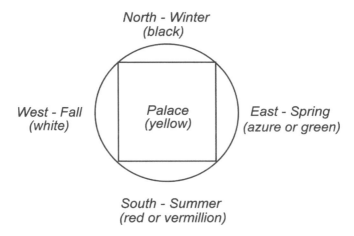

Fig. 9.1: Cardinal directions, associated seasons, and respective colours, all reflecting Chinese cosmological symbolism of a square earth in a round cosmos.

Within the palace, *Urashima* turns to each direction. In the north he sees the many wonders of winter. In the east, he sees beautiful scenes of spring. To the south are the wonders of summer and to the west delicate scenes of fall. *Urashima* and the princess experience much happiness within the palace, but after what seems an all too short time, *Urashima* begins to miss his family. Though he loves the princess greatly, he longs for home. Sadly, the princess sees him back to his island and gives him a beautiful jewelled box. She also tells him never to open it. 'You must keep it as a memory of me', she says.

At home, *Urashima* recognizes no one. In turn, no one recognizes him, and when he tells them who he is, they scoff and ask 'Why do you ask about an ancient man?' He then realizes that some 300 years have passed since he left that day to fish. Feeling sad and alone, he cannot control his urge to open the box. On opening it, he is immediately covered with clouds, but they float up and vanish in the sky. Never again can *Urashima* see the princess.

[6] S. Renshaw, 'The Inspiration of Subaru as a Symbol of Cultural Values and Tradition in Japan', paper presented at the Seventh International Conference on the Inspiration of Astronomical Phenomena, INSAP VII, Bath, United Kingdom, October, 2010.

Some versions of what many might see as a 'Rip van Winkle' style story place less emphasis than the *Fudoki* on seeing deities related to stellar asterisms, but virtually all include some form of seasonality and directional association. In many versions, *Urashima* dies at the end, but some leave him merely sad and lonely and wishing he had never opened the box. Virtually all seem to emphasize the dangers of forgetting family, friends, and the value of 'mundanity' – being at home. All seem to warn of treading too close to *Tokoyo no Kuni*.

3. Night of the Milky Way Railroad

Kenji Miyazawa (1896-1933) was known as a poet, novelist, teacher, amateur scientist and astronomer. His own father wrote what is still considered the most authoritative biography,[7] but esteem for this writer's life and work has even found its way even into manga adaptations.[8] The post-Meiji Reformation era (1868-1912) brought rapid incorporation of many 'Western' concepts in Japan, and these were especially influential in Miyazawa's life. Strong influences of science and education as well as Buddhist roots and indigenous Japanese values and symbols are at the base of Miyazawa's work. Having such a strong interest in astronomy, this particular story represents what is often seen as the paradox of Japanese culture and virtue played against a Westernized celestial backdrop. The Japanese *Genga Tetsudo no Yoru* has been translated as '*Night on the Milky Way Railway*'[9] and also simply '*Milky Way Railroad*'.[10] The story remains, for many young Japanese, their first association with the wonder of the 'starry sky'. Figure 9.2 shows the celestial area associated with the '*Night on the Milky Way Railroad*'.

Miyazawa's mix of East and West begins with the names of the two young characters: *Jovanni* (Giovanni) and *Kanpanera* (Campanella). As the story begins, these friends and other students have been learning about the stars in school (emphasizing Miyazawa's concept that it 'all begins with a teacher'). It is the time of the imaginary 'Centaurus' Festival when lanterns are lit to show deceased ancestors the way home (a strong Buddhist reference). This imaginary festival occurs in August, and in the story Miyazawa portrays images of children running and scampering, yelling that Centaurus is 'dropping dew' (perhaps an indirect reference to the Perseids).

[7] T. Sato, *Miyazawa Kenji* (in Japanese) (Tokyo: Fuzambou, 1942).

[8] Y. Ko, *The Manga Biography of Kenji Miyazawa* (Saitama, Japan: Japan and Stuff Press, 2010).

[9] K. Miyazawa, *Night on the Milky Way Railway*, trans. S. Strong (New York: M. E. Sharp, 1991).

[10] K. Miyazawa, *Milky Way Railroad*, trans. J. Sigrist and D. M. Stroud (Berkeley, CA: Stonebridge Press, 2009).

Fig. 9.2: From 'Hakuchou Station' (Cygnus) *upper left to the Southern Cross lower right, the area traversed in Night of the Milky Way Railroad. Simulation of sky and constellation figures by Starry Night Pro Version 6.3.9.*

On the night of the festival, Giovanni is sent to the store to get some milk. On the way, he stops on a hill to lay and gaze at the stars. He hears a voice that sounds like a train conductor saying 'Milky Way Station!' and suddenly finds himself with a seat on 'The Milky Way Train'. Across from him sits his friend, Campanella.

Miyazawa highlights many experiences for Giovanni and Campanella, carefully weaving phenomena with fantasy. One of the first stops for the youths is at '*Hakuchou* Station' (Swan or Cygnus) where the boys see an image of a cross made by 'the frozen north cloud'. Here they also see a 'beach' over 500 million years old where a palaeontologist is digging the fossil of the ancient ancestor of a cow (Miyazawa's poetic use of stellar distance and time coupled with ever present 'milk'-related images). Some experiences involve phenomena not readily seen with the naked eye. For example, the travellers pass the observatory at Albireo where blue and gold markers measure the flow of the Milky Way River (a reference to the binary components of the star Albireo). One 'stop' references the galactic centre; just south of '*Washi* Station' (Eagle or Aquila) where the river divides, and on the 'sand bar', a signalman is lighting lanterns (referring to the bright region of Sagittarius) as a warning that swans, eagles, peacocks and crows may be crossing.

The story continues with a number of experiences and brilliant images as

the journey traverses the Summer Milky Way. One especially poignant train stop occurs at Scorpio. The bright light from Sagittarius 'makes trees cast shadows', and there is something that shines clear and red like a ruby (Antares). For Giovanni, this star symbolizes the responsibility one has to others and the sacrifice that one is willing to make in order to help ones friends, even to the point of dying (shedding blood). He makes a special note of the accompanying stars (probably Nu and Omega Sco) and is reminded of a very ancient Japanese association with these stars: the importance and closeness of friendship.

After passing the 'hole in the sky' (coal sack), the train makes its final stop at the Southern Cross. Giovanni looks around and notices that Campanella has disappeared. He suddenly awakes and finds himself on the hill near his home. As he continues into town on his errand, he sadly learns that Campanella has actually drowned earlier in the evening while trying to save friends swimming in a nearby river.

There were several editions of Miyazawa's story. In the first, the journey continued around the whole galaxy. The final edition (in synopsis above) concentrated on the Summer Milky Way. The bittersweet end may seem somewhat strange. Yet, it is just this significant virtue of self-sacrifice that defines so much of the traditional Japanese view of responsibility to others and forms the basis for what some might mistakenly interpret as a fatalistic spirit. Especially notable is the association of *Oyakoukou Boshi* in the reference to Antares with its two mates. This concept involves the idea of filial piety where friends, siblings or parents are supported by the child.[11] Sadly, Miyazawa's own younger sister died two years before he began writing this story, and many believe that this formed the basis not only for the ending, but also the emphasis on 'relationship'.

4. Comparisons and Contrasts of Values and Symbols

While separated by some 1200 years, the stories of '*Urashima Taro*' and 'Night of the Milky Way Railroad' both contain Buddhist symbolism as well as fundamental Japanese cultural aspects such as linealism and optimism. These values are discussed in detail by Brown and Kidder as well as explicated in a cultural astronomy context by Renshaw and Ihara.[12] Buddhist symbolism with a sense of life in the present and longevity in 'another world' or 'another cosmos' is seen in *Urashima's* 300-year sojourn and in Giovanni's perception that his dead friend is

[11] See more on this concept in S. Renshaw and S. Ihara, 'A Cultural History of Astronomy in Japan', in H. Seline, ed., *Astronomy across Cultures: The History of Non-western Astronomy* (Dordrecht, Nederland: Kluwer Academic Publishers, 2000), pp. 385-407.

[12] D. M. Brown, 'The Early Evolution of Historical Consciousness', in D. M. Brown, ed., *The Cambridge History of Japan, vol. 1, Ancient Japan* (Cambridge: Cambridge University Press, 1993), pp. 504-77; J. E. Kidder, 'The Earliest Societies in Japan', in D. M. Brown, ed., *The Cambridge History of Japan, vol. 1, Ancient Japan* (Cambridge: Cambridge University Press, 1993), pp. 48-107; and Renshaw and Ihara, 'A Cultural History', p. 389.

at last on 'the far bounds of the Milky Way'.[13] Emphasis on linealism is seen in the strong sense of loss and loneliness for *Urashima* when separated from family and in the consistent references of Miyazawa to values of loyalty and personal sacrifice.

Optimism is emphasized in both stories as movement forward through seasons and cycles of life, regardless of circumstances, with eventual outcomes in positive space despite any sadness or loss. The knowledge of present realities is seen as confirmation of a bright future, that is, when such perception of the future is accompanied with patience and not 'opening the box' too soon (as in the case of *Urashima*), or grounded firmly in education and filial piety as in the case of Giovanni.

Both stories fully incorporate the inevitability of aging and death and plainly accept the reality of such. While both stories have been read countless times to children in Japan, these fundamental concepts have rarely been de-emphasized in versions of either story.

Given the similarities, the two stories obviously differ markedly in their perceptions of the cosmos. Both incorporate what were in their respective eras accepted 'foreign' concepts and understanding of the heavens in relation to the earth. *Urashima* incorporates accepted Chinese cosmology as well as symbolism indigenous to the Japan of its origins. Night Train is full of references to 'Western' values, names and symbols with emphasis on education and scientific knowledge. *Urashima* appears to place strong emphasis on values of family, home, nature and acceptance of social position. Night Train seems to highlight values of sacrifice, friendship, dedication to country and education.

5. Contrasts with 'Western' Stories and Cultural Symbols

When compared to motifs in many 'Western' stories, 'Urashima Taro' and 'Night of the Milky Way Railroad' differ not only in perception of the cosmos, but in their reflection of cultural values and symbolism. The Chinese cosmos exemplified in *Urashima* obviously differs from that of 'Western' sources in the first millennium CE, and while Miyazawa incorporates more modern 'Western' science and astronomical nomenclature, the significance of such seems to reflect a quite different set of perceptions.

Both stories incorporate a central character, but neither contains a hero or heroine battling good over evil. Concepts of 'battle' or 'good and evil' in any moralistic sense are missing altogether. With some humour, the Jungian scholar Hayao Kawai has argued that it might be difficult for many children in the West to avoid boredom when told about looking to the different directions and seeing seasonal sights. Kawai points out that the dragon symbolism in *Urashima* is certainly not that of a beast to be slain but rather that of strength and beauty.[14]

[13] K. Miyazawa, *Night on the Milky Way Railway*, trans. S. Strong, p. 142.
[14] H. Kawai, *Dreams, Myths, and Fairy Tales in Japan* (Einsiedeln, Switzerland: Daimon Ver-

Too, with the exception of its ability to outlast a rabbit, a turtle is seldom given the kind of sacred prominence in 'Western' literature as is seen in the story of *Urashima*.

Archetypes in these stories tend to be more social and cultural than individual. While *Urashima* falls in love with a beautiful lady, romance in this relation is de-emphasized relative to social and cultural experiences shared within a domain tied to nature. Attention given to family relationships and virtual antagonism toward individual freedom without social conscience are at the base of both stories. When *Urashima* pursues his own course without this sense of social conscience, the consequences are tragic. Giovanni without his loyalty to Campanella, or Campanella making any other choice but to save drowning friends while losing his own life, would leave 'Night of the Milky Way Railroad' flat and devoid of its central message.

6. Conclusion

Founded in fantasy views of the cosmos, the stories of '*Urashima Taro*' and 'Night of the Milky Way Railroad' nevertheless contain strong images of reality in social relationships, responsibility and the inevitability of aging and death. They have generally been translated in whole but have been somewhat adapted relative to cultural perceptions in the country of the target language. Some 'Western' audiences may obviously find the endings somewhat disturbing, and parents may be hesitant to bring realities such as aging, death and lack of an end where everyone 'lives happily ever after' to children as a bedtime story.

Though perhaps not appropriate in full for Disney adaptation, these stories have remained strong vehicles for transmitting cultural values to generations of Japanese children, incorporating the cosmological views of their respective eras. Furthermore, despite their difference with traditional 'Western' fare, they continue to gain acceptance throughout the world not only as stories that include beautiful poetic imagery of the cosmos, but also as stories that are filled with the human values of patience, sacrifice, social responsibility, learning and devotion to family and friends.

lag, 1995), pp. 98-105.

SPACE FOR UNCERTAINTY:
THE MOVEMENT OF CELESTIAL BODIES
IN THE EXETER BOOK RIDDLES

Jennifer Neville

ABSTRACT: It is a commonplace that astronomy died out in western Europe during the Dark Ages: despite the continued observations of computists, who diligently recorded the information needed to calculate the date of Easter, or of monks who sought guidance on blood-letting based on the phases of the moon, the history of astronomy tends to leap from the Greeks to the Arabs as if no one looked at the sky for hundreds of years. In this paper, I look at three short riddles from the tenth-century anthology of Old English poetry known as the *Exeter Book Riddles* to explore what the Anglo-Saxons saw when they looked at the sky. For the most part, they saw themselves, and so *Riddles* 6, 22, and 29 reflect social structures and values familiar from other texts of the time: ideologies imposed to explain the mysteries of the sky. However, the *Exeter Book Riddles*, unlike the modern conception of riddles as two-part, open-and-shut texts, do not merely present sun, moon and stars as ambiguous objects to be identified. Instead, they reveal the unsuccessful struggle to assimilate the vast unknown, with the result that the narratives used to describe the movement of celestial bodies across the sky remain ambiguous, consciously inaccurate and insufficient. Although the riddles cannot be considered steps forward in the history of astronomy, they nevertheless provide insight into a wavering understanding of the shape of the heavens at a time when most commentators assume that Christian doctrine had fixed all meaning and ended all questions.

It is a commonplace that, because of the Church's stranglehold on literacy and education, astronomy died out in Western Europe during the so-called 'Dark Ages' (roughly 500-1000 CE).[1] As a result, despite the continuing observations of the computists who diligently recorded the information needed to calculate the date of Easter, and of the monks who sought guidance on blood-letting and other medical practices based on the phases of the moon, the history of astronomy tends to leap from the Greeks to the Arabs as if no one looked at the sky for hundreds of years.[2] In terms of points on a line leading to our present understanding

[1] See, for example, John W. Abrams 'The Development of Medieval Astronomy', in David L. Jeffrey, ed., *By Things Seen: Reference and Recognition in Medieval Thought* (Ottawa: University of Ottawa Press, 1979), p. 194.

[2] For a brief introduction to computus, see *Bede: The Reckoning of Time*, trans. Faith Wallis (Liverpool: Liverpool University Press, 1999), pp. xviii-xxxiv. For medical practices based on the phases of the moon, see discussion in Roy Michael Liuzza, 'Anglo-Saxon Prognostics in Context: A Survey and Handlist of Manuscripts', *Anglo-Saxon England*, vol. 30 (2001), pp. 181-230. For the history of astronomy see, for example, Peter Doig, *A Concise History of Astronomy* (London: Chapman and Hall, 1950), p. 44; Clarisse Doris Hellman,

of the sky, this history cannot be disputed. Nevertheless, in the following discussion I aim to insert something into that gap in the history of astronomy. A continuing interest in the sky can be observed in a collection of riddles contained in a tenth-century English manuscript now known as the *Exeter Book*. This interest, despite modern derision, is not solely determined by religious interpretations; instead, the *Exeter Book Riddles* reveal both acute observation and ongoing questioning of the nature of the heavens.

The *Exeter Book* is a large, rather plain, but beautifully executed manuscript.[3] It is remarkable in many ways, but for this discussion its main interest lies in the texts that constitute its end: a collection of close to 100 riddles, offering paradoxical and puzzling descriptions of a wide range of topics, ranging from the profound to the mundane and from the obscene to the devout. In particular, there are three riddles that deal specifically with the movement of the sun, stars, and moon across the sky. The first of these is *Riddle 6*:

> Mec gesette soð sigora waldend
> Crist to compe. Oft ic cwice bærne,
> unrimu cyn eorþan getenge,
> næte mid niþe, swa ic him no hrine,
> þonne mec min frea feohtan hateþ.
> Hwilum ic monigra mod arete,
> hwilum ic frefre þa ic ær winne on
> feorran swiþe; hí þæs felað þeah,
> swylce þæs oþres, þonne ic eft hyra
> ofer deop gedreag drohtað bete.

[The true ruler of victories, Christ, created me for battle. I often burn the living, oppressing the countless races of the earth, (and) I afflict (them) with war when my lord commands me to fight, although I do not touch them. Sometimes I gladden the minds of many; sometimes I comfort those against whom I previously strove fiercely from afar. Nevertheless they feel the latter as well as the former, when I again improve their condition over the deep tumult.]

Solutions to the *Exeter Book Riddles* remain an issue for debate rather than certainty, for the simple reason that there are no solutions in the manuscript.[4] This is an important fact, and I will return to it, but in the case of *Riddle 6* there is little

The Comet of 1577: Its Place in the History of Astronomy, Columbia University Studies in History, Economics, and Public Law 510 (New York: Columbia University Press, 1944), p. 65; and Giorgio Abetti, *The History of Astronomy*, trans. Betty Burr Abetti (London: Sidgwick and Jackson, 1954), p. 44.

[3] The manuscript remains at Exeter Cathedral; it can also be consulted in the electronic facsimile that accompanies the latest edition: Bernard J. Muir, ed., *The Exeter Anthology Of Old English Poetry*, 2 vols. (Exeter: University of Exeter Press, 2006). Citations of the riddles are taken from this edition. All translations are my own.

[4] For an overview of solutions proposed by scholars, see Donald K. Fry, 'Exeter Book Riddle Solutions', *Old English Newsletter* 15 (1981): pp. 22-33.

debate regarding its solution: it is almost universally solved as 'sun'. Solving the riddle does not, however, terminate the text's interest, for *Riddle* 6 does not merely present the sun but also reveals the discourses in which the Anglo-Saxons embedded their observation of natural phenomena. The first thing to note is the framing of the action in terms of battle. This is a common literary technique in Old English poetry, which characteristically transforms even the passive suffering of saints into heroic action, but it is not a usual way of describing the sun (in Britain, at least). Here the sun is 'created for battle', and it 'burns', 'fights', 'strives fiercely' and 'afflicts' the races of the earth. It also comforts and gladdens, but its primary role is as a warrior serving the 'ruler of victories'. Such unusual views of everyday objects and phenomena are an important feature of the *Riddles*. Throughout the collection, the familiar is made unfamiliar, and the everyday is seen afresh.

One component of the Church's stranglehold on knowledge of the natural world is the tendency to look for spiritual and moral interpretations rather than accurate detail about the natural phenomena themselves. In the Bestiaries, for example, the emphasis is less on facts than on significances.[5] The description awarded to each animal in the catalogue leads to a spiritual interpretation that explains the significance of physical details. Although not explicitly allegorical like the Bestiaries, there is room for significance as well as fact in *Riddle* 6, too: the sun that travels over the earth and oppresses its races may be interpreted as a symbol of the Gospel. That is, the Gospel's metaphorical 'light' may bring either the need for painful repentance *or* hope; regardless, it ultimately 'improves humanity's condition' in the great sea-like tumult to which the earthly condition was often compared. Although *Riddle* 6 is not often read in this way, this interpretation results in a coherent reading consistent with the ideology of the time. At the same time, however, such a reading does not eliminate the literal meaning of the original text: the sun, with its unaccustomedly fierce relationship with the human race, does not disappear when we compare it to the Gospel.

What allows this comparison to be made is the important fact of the absence of fixed, authoritative solutions in the manuscript, and it is worth returning to this point and exploring its significance a little further. Modern readers have a very limited and limiting expectation of riddles in general. The modern emphasis on solutions means that, once a solution has been found, the text is considered finished.[6] In contrast, the absence of solutions in the *Exeter Book* means that we can never be certain that the process of interpretation has finished. The text obliges its readers to continue to question, even if a satisfactory solution has been found. As a result, the *Exeter Book Riddles* do not work like a lock and key:

[5] For a discussion of the bestiaries, see, for example, Wilma George and Brunsdon Yapp, *The Naming of the Beasts: Natural History in the Medieval Bestiary* (London: Duckworth, 1991).
[6] See, for example, Annikki Kaivola-Bregenhøj, 'Riddles: Perspectives on the Use, Function and Change in a Folklore Genre', trans. Susan Sinisalo, *Studia Fennica Folkloristica 10* (Helsinki: Finnish Literary Society, 2001): p. 19.

it is not enough to unlock a metaphor and discover the correct answer. Instead, interpreting these texts is like opening a can of worms; once the process has started, a tangle of possibilities that overflow the boundaries of categories like 'natural' and 'spiritual' quickly emerges – a tangle that cannot be contained neatly in any box. For *Riddle* 6, for example, thinking about both the sun and the Gospel in terms of violent attacks requires its readers to think differently about *both* things. This may not be science, or progress toward science, but it is interaction with the heavens that does not reduce them to a simple reflection of social or religious ideas.

Riddle 22 provides a similarly open-ended experience of interpreting the heavens alongside an apparently keen interest in accurate observation:

> Ætsomne cwom LX monna
> to wægstæþe wicgum ridan;
> hæfdon XI eoredmæcgas
> fridhengestas, IIII sceamas.
> Ne meahton magorincas ofer mere feolan,
> swa hi fundedon, ac wæs flod to deop,
> atol yþa geþræc, ofras hea,
> streamas stronge. Ongunnon stigan þa
> on wægn weras ond hyra wicg somod
> hlodan under hrunge; þa þa hors oðbær
> eh ond eorlas, æscum dealle,
> ofer wætres byht wægn to lande,
> swa hine oxa ne teah ne esna mægen
> ne fæthengest, ne on flode swom,
> ne be grunde wod gestum under,
> ne lagu drefde, ne on lyfte fleag,
> ne under bæc cyrde; brohte hwæþre
> beornas ofer burnan ond hyra bloncan mid
> from stæðe heaum, þæt hy stopan up
> on oþerne, ellenrofe,
> weras of wæge, ond hyra wicg gesund.

[Sixty men came together, riding horses to the shore; the horsemen had eleven steeds, (and also) four white ones. The warriors could not pass over the sea as they attempted to do; rather the flood was too deep, the crash of waves terrible, the banks high, the currents strong. The men began to climb into a wagon and load their horses together under the pole; then the wagon bore off to land the horses, steeds, and men, proud of their spears, over the water's dwelling, in such a way that neither oxen nor a troop of servants nor a riding-horse pulled it, nor did it swim on the water, nor did it go along the ground under its guests, nor did it disturb the sea, nor did it fly out of the air, nor did it turn back. Rather it brought the men and their mounts with them over the stream – so that those courageous men and their horses stepped from one high bank up on the other, safe out of the wave.]

The basic scenario here – the metaphorical surface of the riddle – is a group of men and horses who are initially unable to cross the sea but then climb into a wagon that transports them all safely to the other side. Such a familiar, homely

image is neither dramatic nor enigmatic. However, this wagon is not pulled by oxen, men or horses, and it does not travel on land or sea, or through the air. The riddle thus requires us to determine what kind of wagon, men, horses, and sea is being described. Unlike *Riddle 6*, there has been some debate about *Riddle* 22's solution. The jury has generally been split between those who think that this is a riddle about the passage of time – i.e., a calendar riddle – or a riddle about stars. Recently, the star camp has been in the ascendant, and recent work by Patrick Murphy has shown how much astronomical observation might have gone into this particular text.[7]

The 'wagon' of *Riddle* 22 can be identified as Charles' Wain, also known as The Plough, The Big Dipper or part of Ursa Major. Leaving aside the number of men and horses for the moment, the 'pole' under which they load themselves is the Celestial Pole, currently marked by Polaris, the Pole Star. The eleven horses, plus another four, may be identified as the fifteen stars in the constellation Draco, which might be seen as being 'loaded' on top of the Wagon and under the Pole. Murphy suggests that the four 'shining ones', which are distinguished from the other eleven horses, are the four stars in Draco's head, but since only two of these four stars are actually very prominent, I would suggest that the 'shining ones' refer to the four brightest stars in the constellation (Eltanin, Rastaban, Altais and Aldibain), two of which are in the head and two in the body of the dragon. As for the sixty warriors shining with spears, Murphy argues that these are the stars listed by Hyginus, a classical authority known to the Anglo-Saxons, as constituting the constellations of Andromeda, Cassiopeia, Cepheus, and Ursa Minor. According to Hyginus, the number of stars in these constellations adds up to sixty, and, like the 'horses' in Draco, these stars 'ride' on top of the 'wagon' of Ursa Major.

Whether or not the riddle has the correct number of stars, however, is less interesting than the close observation of circumpolar stars that it betrays, along with its extended metaphor of the sky as sea. In this text the issue is not which stars set below the horizon, as we might have expected, but rather the question of *how* the stars travel across the expanse of the sky itself, which is seen as dangerous, stormy sea full of strong currents – an image that may reflect the textured appearance of the Milky Way in a sky unpolluted by artificial light.[8] Of course, imagining the sky as a sea does not constitute a scientific breakthrough, but it does reflect some serious thinking about the nature of the sky, and it is worth noting that this image is neither the accepted, scholarly view of the heavens nor reducible to a spiritual reality.[9] The text does not simply encode

[7] Patrick J. Murphy, *Unriddling the Exeter Riddles* (University Park: Pennsylvania State University Press, 2011), pp. 111-23. The paragraph below is deeply indebted to his discussion.

[8] I am indebted to a personal communication from David Malin for this suggestion (15 October 2011).

[9] For the contemporary scholarly idea of the heavens, see Bede's adaptation of Isidore in his *De Natura Rerum*, ed. C. W. Jones, CCSL 123A, V-VII (pp. 196-99). For translation see

stars going across the sky into a cut-and-dried metaphor but remains uncertain and enigmatic, and so, once again, the sky is not a simple mirror of human issues, nor an allegory of God's divine plan, nor a site for straightforward observation of the natural world. It remains a space in which the struggle to assimilate the vast unknown into humanly comprehendible structures is acknowledged to be unsuccessful.

Riddle 29 similarly presents the sky through familiar discourses that fail to explain it fully:

> Ic wiht geseah wundorlice
> hornum bitweonum huþe lædan,
> lyftfæt leohtlic, listum gegierwed,
> huþe to þam ham of þam heresiþe;
> walde hyre on þære byrig bur atimbran,
> searwum asettan, gif hit swa meahte.
> Ða cwom wundorlicu wiht ofer wealles hrof,
> seo is eallum cuð eorðbuendum,
> ahredde þa þa huþe ond to ham bedraf
> wreccan ofer willan, gewat hyre west þonan
> fæhþum feran, forð onette.
> Dust stonc to heofonum, deaw feol on eorþan,
> niht forð gewat. Nænig siþþan
> wera gewiste þære wihte sið.

[I saw a creature load up its plunder strangely between its horns: a light-filled sky-cup, adorned artfully. It (brought) that booty home from its battle-journey. It wanted to build a bower in its fortress for it, establish it skilfully, if it could do so. Then (another) strange creature, which is known to all earthdwellers, came up over the wall's roof. It recaptured the plunder and drove the exile home against its will. (The exile) went west from there to escape from the feud (and) hastened away. Dust rose to the heavens, dew fell on the earth, (and) night went forth. After that no man knew that creature's journey.]

As with *Riddle* 22, it is possible simply to translate the details of this riddle to give a solution: the moon, here identified as a 'horned' creature carrying its stolen booty of light, is pursued by the sun until, deprived of its treasure, it departs from sight. This booty may be understood as earthshine,[10] the light reflected from the earth onto the moon, which is sometimes visible on a slim crescent moon just before sunset or sunrise.[11] The scenario in *Riddle* 29 takes place at sunrise: the moon is observed carrying the reflected glow from the earth, but, once

Bede: On the Nature of Things and On Times, trans. Calvin B. Kendall and Faith Wallis (Liverpool: Liverpool University Press, 2010), pp. 76-77.

[10] Craig Williamson, ed., *The Old English Riddles of the Exeter Book* (Chapel Hill: University of North Carolina Press, 1977), p. 228.

[11] For a brief explanation of earthshine, see N. J. Woolf, P. S. Smith, W. A. Traub and K. W. Juck, 'The Spectrum of Earthshine: A Pale Blue Dot Observed from the Ground', *Astrophysical Journal* 574, no. 1 (2002): p. 430.

the sun rises, its light obscures the 'stolen' light and thus deprives the moon of its 'treasure'. The rising dust, like the stormy sea of *Riddle* 22, may be yet another reference to the now hardly visible spectacle of the Milky Way, which once presented a speckled backdrop to the starry sky.[12] As with *Riddle* 6, it is also possible to create spiritual interpretations, particularly to explain some of the puzzling details: the dust that rises at the end could be a reference to resurrection and the dew to salvation from heaven as the Son of God rescues souls from a horned devil as part of the Harrowing of Hell.[13] I do not find this interpretation compelling, but, even if it were, explaining the details with spiritual references does not finish the riddle any more than providing a solution to it does.

For this discussion what is more interesting than the identity of the two creatures or any spiritual significance that they might have is the way in which the heavens are imagined. Instead of the stormy sea of *Riddle* 22, *Riddle* 29 represents the sky as a building with walls and a roof. This image echoes that in another Old English poem, *Genesis A*, which represents the creation of the world as God's construction of a great hall in the midst of a dark sea.[14] There the universe reflects the Anglo-Saxons' own timbered halls, built within defensive enclosures designed to keep out the hostile chaos beyond the known circle of light. In *Riddle* 29, too, we can observe an Anglo-Saxon poet portraying natural phenomena through a series of familiar scenes and behaviours. Thus the universe is a timbered hall with a roof and walls; the moon is a warrior fighting for treasure; the sun takes vengeance for previous military campaigns against it. At the same time, however, the universe is quite clearly *not* a timbered hall, and the amazing creatures that climb over it are *not* simply warriors conducting military campaigns. The projection of familiar images upon the heavens does not explain them; it holds them up for further questioning.

In conclusion, the heavenly bodies in *Riddles* 6, 22, and 29 are firmly embedded in traditional, Anglo-Saxon discourses of settlement, war and feud, but they are not fully contained by them. Thus the *Exeter Book Riddles*, unlike the modern conception of riddles as two-part, open-and-shut texts, do not merely present sun, moon and stars as objects to be identified. Instead, they reveal the unsuccessful struggle to assimilate the vast unknown, with the result that the narratives used to describe the movement of celestial bodies across the sky remain ambiguous, inaccurate and insufficient. Although these narratives may strike modern readers as a step backward from the Greeks' observations, they demonstrate that the Anglo-Saxons did indeed continue to look at the sky and, more importantly, did not believe that the stories that they told themselves

[12] Again, I am indebted to David Malin (15 October 2011).

[13] Murphy, *Unriddling*, pp. 123-39.

[14] See my discussion in *Representations of the Natural World in Old English Poetry*, Cambridge Studies in Anglo-Saxon England 27 (Cambridge: Cambridge University Press, 1999), pp. 57-59.

about them fully explained them. In the *Riddles* space remains for uncertainty – and for the continuing observations and questions that eventually led to new ideas about the sky.

DANTE ALIGHIERI'S DIVINE COMEDY AS REFERENCE POINT FOR FEDERICO ZUCCARI'S LATER OEUVRE (1575-1607)

Simone Westermann

ABSTRACT: The concept of heaven shaped in Dante Alighieri's *Divine Comedy* was the most detailed and elaborate illustration of what people could expect after death throughout the late Middle Ages and the Renaissance. Widely read and cited in Italy at the time, Dante's 'Paradiso', the third part of the *Divine Comedy*, influenced art, literature and philosophy and did not cease to be a scientific and religious model of the universe, even after Galileo Galilei began disseminating his writings in favour of Nicolaus Copernicus' heliocentrism. In this paper I will argue for the importance of Dante's concept of Paradise for Renaissance and particularly Counter-Reformation Art in Italy during the late sixteenth century. The discussion will focus on the frescoes of the Last Judgement executed by Giorgio Vasari and Federico Zuccari for the cupola of the Cathedral of Santa Maria del Fiore in Florence. Dantean ideas not only exerted a profound impact on the frescoes' iconographic programme, but both heavenly and terrestrial topographical notions as established in the the *Divine Comedy* would continue to exert an influence on Zuccari's oeuvre over the course of his career. Radiant light and concentric circles of ether would henceforth be the essential structure of Zuccaro's depiction of Paradise – be it in his ceiling fresco of the Pauline Chapel in the Vatican or the frescoes of the Basilica of Santa Sabina in Rome. Although this paper will focus on one work in particular, the *Last Judgement* of Santa Maria del Fiore, the argument will also take a wider, contextual approach and thus call into consideration the reception of Dante's 'Paradiso' in late sixteenth-century art.

The poet W. B. Yeats once called Dante Alighieri 'the chief imagination of Christendom'.[1] Considering the breathtaking philosophical, poetic and imaginary depth with which Dante elucidates theological concepts and ideas in the *Divine Comedy*, Yeats' comment can surely be considered appropriate. The descriptions of Hell, Purgatory and Paradise in Dante's epic poem were an immediate success, which was further aided by the poet's decision to write the *Divine Comedy* in Italian as opposed to Latin, the common language among the intellectual elite in the fourteenth century.[2] The influence Dante exerted on the arts and popular belief in the following centuries, thus, should not be underestimated.[3]

This article will explore the influence of Dante's description of Paradise in the work of one specific artist, Federico Zuccari (ca. 1540-1609), from 1575 to

[1] Quoted in Kenelm Foster, 'The Celebration of the Order: Paradiso X', in *Dante Studies*, No. 90 (1972), p. 111.

[2] See Simon Gilson, *Dante and Renaissance Florence* (Cambridge: Cambridge University Press, 2005), p. 4.

[3] Gilson, *Dante and Renaissance Florence*.

1607. As will be shown, Zuccari utilised philosophical thoughts and theological theories as expounded in Dante's *Divine Comedy* in order to both enhance his pictorial work with intellectual depth and elaborate an art and art theory that would easily conform to the counterreformation demands of the Catholic Church in the sixteenth century.

Zuccari first came into contact with the *Divine Comedy* during his work at Santa Maria del Fiore in Florence, where he was asked to continue the fresco decorations that had been left unfinished after Giorgio Vasari's death in 1574. The commission was supervised and ideated by Vincenzo Borghini, humanist and artistic advisor to Cosimo I de' Medici. Borghini was also a renowned expert on Dante's writings and produced texts in defence of the poet, who had come under attack during the Dante debate in Florence in the 1570s.[4] Humanists had started to doubt the historical accuracy of the *Divine Comedy* and discussed its implications for theological dogmas also in regard of the counterreformation.[5]

Notwithstanding this, Borghini stood firmly on the side of the great poet.[6] This allegiance can also be seen in Borghini's use of the *Divine Comedy* in devising the iconographic programme for the cupola frescoes of Santa Maria del Fiore. In his *Invention for the paintings of the Cupola*, Borghini initially states that the general theme to be followed is 'the last judgement, where should be the sky; and above that should extend the whole Paradise'.[7] However, the octagonal shape of the dome proved difficult to fit into any existing iconography for the last judgement.[8] As a solution, Borghini assigned one whole section of the dome to the *Deisis*, the judging Christ and his court. The remaining seven sections were ordered according to the passion instruments, saints, virtues and – most importantly – planets. The southeastern section features, for example, the crown of spines closest to the dome's lantern, then a group of beatified emperors, kings and princes and underneath the virtue of justice. The planet assigned to this particular section was Mercury (Fig. 11.1).[9]

[4] Michael Brunner, *Die Illustrierungen von Dantes Divina Commedia in der Zeit der Dante-Debatte (1570-1600)* (Munich: Dt. Kunstverlag, 1999), p. 75 ff.; Ottavio Gigli, *Studi sulla Divina Commedia di Galileo Galilei, Vincenzo Borghini* (Florence: Felice le Monnier, 1855), p. 157 ff.

[5] See Davide Dalmas, *Dante nella crisi religiosa del Cinquecento italiano* (Rome: Vacciarella, 2005).

[6] Gigli, *Studi*, p. 157 ff.

[7] Cesare Guasti, *La Cupola di Santa Maria del Fiore* (Florence: Barbera Bianchi, 1857), p. 133, my translation.

[8] Karl Frey and Herman-Walther Frey, eds, *Giorgio Vasari, Der Literarische Nachlass* (Hildesheim: Georg Olms, 1982), p. 523.

[9] See Acidini Luchinat's structure of the frescoes, in *Cupola di Santa Maria del Fiore*, ed. Cristina Acidini Luchinat and Riccardo Dalla Negra (Rome: Istituto Poligrafico, 1996), p. 39.

Fig 11.1: Federico Zuccari, Benedetto Busini explains to Federico Zuccari the Iconographic Programme for the Cupola of the Florentine Dome, oil on panel, ca. 1578. Copyright: Bibliotheca Hertziana.

Vincenzo Borghini clearly stated that 'it should be drawn into each of the sections, referring myself in this to Dante, the fitting star or planet'.[10] Although the planets themselves were not depicted, their significance for the overall structure of the fresco is cardinal. For the basic structure of his 'Paradiso', Dante had drawn on the geocentric model of the universe as described by Ptolemy in his *Almagest* (Fig. 11.2).[11]

[10] Guasti, *Cupola*, p. 136, my translation.
[11] Ptolemy, *Almagest*, trans. G. J. Toomer (London: Duckworth, 1984), Book I, 5 (H17) and Book IX, 1 (H207).

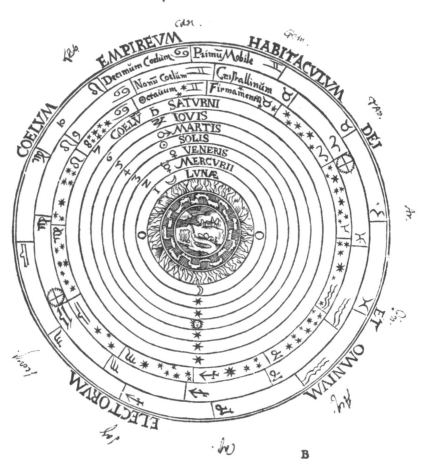

Fig. 11.2: The cosmology according to Aristotle. *Woodcut from the Cosmographic of Petrus Apianus, 1540. Copyright: bpk / Kunstbibliothek, SMB.*

This third book of the *Divine Comedy* tells of the protagonist's travels with Beatrice from the earthly Paradise across the universe towards the *Empireo*, God's

residing place, to take part in a vision of the Holy Trinity. On the way, they pass through each planet, inside of which they meet saints and beatified people. The novelty of Dante's depiction of Paradise lies in his grouping of the saints into various planets according to their characteristics and virtues. The protagonist encounters emperors and kings within the planet Mercury, for they were given the virtue of strength through the planet's influence. In the sun he converses with Saints Thomas Aquinas and Bonaventure, for the poet had placed them there in recognition of their virtue of wisdom.[12]

At the time Dante was composing his 'Paradiso', astronomy and astrology had become widely studied and practiced.[13] The introduction of the astrolabe to Western Europe made measuring the positions of the stars considerably less difficult and astrological tables were designed based on these measurements.[14] One of the most famous of such tables is Pietro d'Abano's *Astrolabium Planum* of around 1300. Dante was surely familiar with d'Abano's writings, which describe the influences that planets were thought to exert on humans when they were born within the planets' 'houses' and constellations. Indeed, d'Abano was convinced about stellar determinism and went almost as far as to neglect human free will. Although Dante did not agree with d'Abano on determinism, the poet similarly believed in the importance of stars in human life.[15] His grouping of saints in the 'Paradiso' according to the characteristics and virtues that had been conveyed to them via their stars or planets highlights this conviction.

Giorgio Vasari and Federico Zuccari both followed the instructions by Vincenzo Borghini on the organisation of the fresco cycle in Santa Maria del Fiore. Thus, the dantesque grouping of saints can be observed throughout the *Last Judgement*. While in the *Divine Comedy* the planets tend to signify the common characteristics of the saints within them, the represented virtues and groups of saints in the frescoes of Santa Maria del Fiore imply the presence of the planets that were not, however, explicitly depicted.

When Zuccari took over Vasari's unfinished work in 1575, he opted for a major change that was to radically alter the fresco's overall appearance. Instead of following Vasari's light blue as background colour, he decided to implement a golden background.[16] If we can assume from Borghini's mentioning of Dante and the actual structure of the fresco that Zuccari consulted the *Divine Comedy* during his work in Florence, this chromatic change seems to confirm this assumption.

[12] Note that the sun and moon were considered planets during the Middle Ages. See Dante Alighieri, *The Divine Comedy, Paradiso*, trans. John Ciardi (New York: The Modern Library, 1996), Pd VI, VII and Pd X-XIV.

[13] James Hannam, *God's Philosophers* (London: Icon Books, 2009), pp. 119-30.

[14] Hannam, *God's Philosophers*, pp. 28-29.

[15] Francesco Aldo Barcaro, *Tre Grandi Europei Del Trecento* (Padua: Panda, 1991), pp. 20-21.

[16] Cristina Acidini Luchinat, 'Federico Zuccaro e l'ispirazione dantesca nella Cupola del Duomo di Firenze', in *Federico Zuccari e Dante*, ed. Corrado Gizzi (Milan: Electa, 1993), pp. 43-56.

Although it cannot be excluded that Zuccari looked at various pictorial models for the chromatic change, such as at Signorelli's *Last Judgement* in Orvieto or Venetian art of the time, the concept of Paradise as a body of light is very much inherent to Dante's 'Paradiso'. In the first canto of the book, Dante explains the difference between the earthly world and Paradise in terms of light and sound. Rising from the earthly Paradise to the heavenly spheres, the protagonist only becomes aware of the change of location through 'the beauty of sound and the great luminosity'.[17] Furthermore, the poet describes the planets and saints Dante encounters during his journey as bodies of light. Upon entering Venus, the protagonist recounts his vision of the saints within the planet:

> And as a spark is visible in the fire,
> and as two voices may be told apart
> if one stays firm and one goes lower and higher;
> so I saw lights circling within that light
> at various speeds, each, I suppose, proportioned
> to its eternal vision of delight.[18]

The importance of light-metaphors becomes more apparent the closer Dante and Beatrice come to the *Empireo*, God's residing place.[19] Here, Dante tries to define his experience of the numerous angels surrounding him. To him they seem like sparks:

> And at her last word every angel sphere
> began to sparkle as iron, when it is melted
> in a crucible, is seen to do down here.
> And every spark spun with its spinning ring.[20]

Shortly after these experiences, Beatrice explains to Dante the nature of this great luminosity. According to her definition, the *Empireo* is a 'heaven of pure light. / Light of the intellect, which is love unending'.[21] In the *Divine Comedy*, Paradise is made up of pure light with intellectual and charitable properties. This light is thus morally good.[22]

It is highly probable that Federico Zuccari was inspired by Dante's definition and use of light when changing the appearance of the *Last Judgement* frescoes in Santa Maria del Fiore. The fact that Zuccari composed his own illustrated

[17] Dante, *Paradiso*, Pd I, v.82.

[18] Dante, *Paradiso*, Pd VIII, v.16-21.

[19] See also Simon Gilson, *Medieval Optics and Theories of Light in the Works of Dante* (New York: Edwin Mellen Press, 2000), p. 250ff; Mauro Gagliardi, *Lumen Gloriae – Studio interdisciplinario sulla natura della luce nell'Empireo dantesco* (Vatican City: Libreria Editrice Vaticana, 2010).

[20] Dante, *Paradiso*, Pd XXVIII, v.88-91.

[21] Dante, *Paradiso*, Pd XXX, v.39-40.

[22] Gagliardi, *Lumen*, p. 176 f.

manuscript of the *Divine Comedy* only a few years after completing the Florentine fresco cycle strengthens this hypothesis. The artist created the *Dante historiato da Federico Zuccaro* during his sojourn in Spain, where he worked at the Escorial for Philip II from 1585 until 1588. Zuccari was not commissioned to illustrate the *Divine Comedy*, which therefore arouses the question as to what his personal intentions were for the project. Michael Brunner suggests that the illustrated *Comedy* was used later as a study book by Zuccari's students.[23] Although the exact reasons for the illustrations cannot be known, it can be stated that Zuccari engaged himself closely with Dante's writings during the creation of this work.[24]

Zuccari's illustrations of Dante's 'Paradiso' attempt to depict the extreme luminosity that the poet accredits to Paradise. The use of red charcoal and pen, as opposed to the black charcoal or pen he had used in the illustrations of Hell and Purgatory, allows the artist to play with the intensity of fire and sparks as described by Dante. The images of cantos XXII and XXIII, where Dante and Beatrice reach the heaven of fixed stars, shows how Zuccari evokes the rays coming from the *Empireo* and the sun (Fig. 11.3). These two sources of light play an essential role in the *Divine Comedy*; the emanating light from God is the good and intelligent light whereto the pious Christian should direct him- or herself. It represents the idea of *caritas* and denotes the positive influence of God on the world.[25] The rays of the sun themselves do not possess a moral value. However, the sun plays a pivotal role in astrology, for it determines the star sign, also called sun sign, of a person at the time of his or her birth.

In canto XXII, Dante reaches the heaven of fixed stars and finds himself standing in his own star sign Gemini. Bernardino Daniello, one of the sixteenth-century commentators of the *Comedy* on whose explanations Zuccari based his illustrations, describes this moment as follows:

> [...] he moved fast into the heaven of the fixed stars, & into the sign of Gemini; [...] because when he was born, the Sun was in that sign, & when he was graciously allowed to rise from the seventh to the eighth sphere, this sign of Gemini received him. The latter (the sun) is father of all mortal life, because as the Philosopher says, the Sun & the human create a human.[26]

[23] Brunner, *Illustrierungen*, p. 65.

[24] Andrea Mazzucchi, *Introduzione*, in Federico Zuccari, *Dante historiato da Federico Zuccaro*, ed. Andrea Mazzucchi (Rome: Salerno, 2005), pp. 26-29.

[25] Gagliardi, *Lumen*, p. 176 f.; Gilson, *Optics*, p. 84ff.

[26] Bernardino Daniello, *La Divina Commedia Dante con l'espositione di M. Bernardino Daniello da Lucca, sopra la sua comedia dell'inferno, del purgartorio, & del paradiso* (Venedig: Pietro da Fino, 1568), pp. 643-44; my translation; capitalization taken from the original.

Fig. 11.3: Federico Zuccari, Dante historiato da Federico Zuccaro, *detail: Par. XXII 109-54 & XXIII 1-45 of the Divine Comedy, red and black charcoal, mm. 570x430, 16th c. Copyright and inventory number: Uffizi, 3474-3561 F categ. II cart.*

'The philosopher' here means Aristotle, who had stated in his *Physics* that 'In

Nature man generates man; but the process presupposes and takes place in natural material already organized by solar heat and so forth'.[27] The fact that Dante the protagonist enters the heaven of fixed stars within his sun sign shows his interest in astrology that we already encountered in his grouping of saints into the various planets. However, it also shows the importance the poet ascribes to the sun and light in general. Indeed, in the *Divine Comedy* the sun becomes an analogy for God and Christ. In 'Paradiso' XXIII, Dante describes Christ as 'one Sun that lit them all, as our own Sun / lights all the bodies we see in Heaven's height'.[28] Christ is like a sun that illuminates everything, just as, in Dante's belief, the natural sun illuminates the surrounding stars.

Light in the *Divine Comedy* maintains a fundamentally religious meaning in its ultimate denotation of God's presence.[29] It is thus that Zuccari utilizes the depiction of light in his later oeuvre. In the frescoes of the Pauline Chapel in the Vatican and in the Basilica of Santa Sabina in Rome, the artist demonstrates a use of light similar to that in his works in Santa Maria del Fiore and the illustration of the *Divine Comedy*.[30]

One of the most striking examples of this understanding of light, however, can be found in Zuccari's theoretical treatise *Idea de' pittori, scultori e architetti* of 1607. Here Zuccari elaborates his theories on artistic creativity and production. He argues that the two fundamental aspects of artistic creation are *disegno esterno* and *disegno interno*.[31] These two untranslatable terms roughly denote the action of expressing one's ideas externally via drawing and the internal process of ideation, respectively.[32] The motive of ideation was an especially important

[27] Aristotle, *Physics*, ed. and trans. Philip H. Wicksteed and Francis M. Cornford (Cambridge, MA: Harvard University Press, 1958), Book 2, II, 194b13: 'ἄνθρωπος γὰρ ἄνθρωπον γεννᾷ καί ἥλιος'. See also Aristotle, *Metaphysics*, 1080ᵇ25.

[28] Dante, *Paradiso*, Pd XXIII, v. 29-30.

[29] Also see two recent studies on the concepts of light in the *Divine Comedy*: Marco Ariani, *Lux inaccessibilis. Metafore e teologia della luce nel* Paradiso di Dante (Rome: Aracne, 2010); Gerhard Wolf, 'Dante's Eyes and the Abysses of Seeing. Poetical Optics and Concepts of Images in the *Divine Comedy*', in Alina Payne, ed., *Vision and its Instruments. Art, Science and Technology in Early Modern Europe* (University Park, PA: The Pennsylvania State University Press, 2015), pp. 122-37.

[30] Claudio Strinati, 'La "chiamata verso la luce" di Federico Zuccari', in *Federico Zuccari: la Pietà degliangeli*, ed. Kristina Herrmann Fiore (Rome: Gebart, 2001), pp. 5-14; Sebastian Schütze, 'Devotion und Repräsentation im heiligen Jahr 1600', in *Der Maler Federico Zuccari – Einrömischer Virtuoso von europäischem Ruhm*, ed. Matthias Winner and Detlef Heikamp, Römisches Jahrbuch der Bibliotheca Hertziana, No. 32 (Munich: Hirmer, 1999), pp. 231-63; Acidini Luchinat, *Zuccari*, pp. 45-46.

[31] Federico Zuccaro, 'L'Idea de Pittori, Scultori, et Architetti', in *Scritti d'arte di Federico Zuccaro*, ed. Detlef Heikamp (Florence: Leo S. Olschik, 1961).

[32] Zuccari, *Idea*, p. 153; Ulrich Pfisterer, 'Die Entstehung des Kunstwerks. Federico Zuccaris "L'Idea de' Pittori, Scultori et Architetti"', in *Zeitschrift für Ästhetik und allgemeine Kunstwissenschaft*, No. 38 (1993), p. 245.

concept for Zuccari to clarify. He determined that the *disegno interno* is, in the end, a *Scintilla della Divinità* – a spark of divinity.[33] It is, therefore, a divine light within the artist that causes ideation. Where such a light is more intensely present, a better ideation is possible.[34] With this concept, Zuccari clearly draws on Dante's Christianised or, more precisely speaking, Thomistic version of Aristotle's formulation of the sun (i.e., light) being a fundamental part to human creation.[35]

The question of why Zuccari drew from Dante's *Divine Comedy* and, most importantly, its commentaries for his later works cannot be settled for sure. Under the guidance of Vincenzo Borghini at Santa Maria del Fiore, Zuccari was surely inspired to read the epic poem, whilst he must have studied Dante extensively when illustrating the *Divine Comedy* only a few years later.[36] Zuccari was eager to belong to the intellectual elite. This scholarly ambition is evident in his *Idea*, where he develops a fascinating speculative theory of artistic invention.[37] Surely he drew on contemporary treatises and artistic writings, such as Vasari's *Lives* or Lomazzo's *Trattato dell'arte* and *Idea del Tempio della pittura*. Yet, Dante's poem would have provided the artist with the knowledge he desired on a vast range of subjects. In the *Idea*, as in the frescos of Santa Maria del Fiore, Zuccari's expression of philosophical and scientific theories might therefore well have rested on Dante.

Erwin Panofsky remarked in 1924 that Zuccari quite clearly adopted medieval and scholastic lines of thought in his treatise.[38] This and Zuccari's reception of Dante is probably also due to the aesthetic and moral preferences of a time during which artistic activity was controlled by counterreformation legislation.[39] The *Divine Comedy*, although shedding critical light on the Catholic Church, was little affected by counterreformation censorship and never condemned as heretical by the Inquisition.[40] Indeed, Dante's work did not cease to be read and Zuccari did not run any theological risk in relying on the poet. However, it remains to be analysed how much of Dante's thought is present in Zuccari's work. How much instead reflected current artistic, philosophical and astrological trends? This article argued that a medieval literary influence in art and art theory can be traced in the second half of the sixteenth century and that, at least in Federico Zuccari's oeuvre, one can point to a specific source; Dante's *Divine Comedy*. The actual extent of such thought in Zuccari's works is, however, still to be determined.

[33] Zuccari, *Idea*, pp. 158, 162, 296 f.
[34] This is, of course, a simplification of the concept. For further clarification, see Zuccari, *Idea*, p. 150; Erwin Panofsky, *Idea – Ein Beitrag zur Begriffsgeschichte der älteren Kunsttheorie*, ed. John Michael Krois (Hamburg: Philo Fine Arts, 2008), p. 127; Pfisterer, *Entstehung*, p. 247.
[35] See footnote 27.
[36] Acidini Luchinat, *Zuccari*, p. 46.
[37] Panofsky, *Idea*, p. 126; Pfisterer, *Entstehung*, p. 251 ff.
[38] Panofsky, *Idea*, p. 131.
[39] Steven Ostrow, *Art and Spirituality in Counter-Reformation Rome* (Cambridge: Cambridge University Press, 1996), p. 1ff.
[40] Dalmas, *Dante*, pp. 7-26, 267-68.

CELESTIAL BODIES IN THE WRITINGS
OF MARSILIO FICINO (1433-1499)

Valery Rees

ABSTRACT: Astronomical imagery and astrological interpretation both occupy consider-
able space in the writings of Marsilio Ficino. From the pages of the *Platonic Theology* (1474)
to his *Three Books on Life* (1489) and a treatise on *The Sun and Light* (1493) and throughout
his letters, Ficino is concerned with the metaphysics and the physics of light, as well as
planetary motion and celestial influences. Yet his stance on celestial matters is not al-
ways easy to determine and conflicting views have been expressed in recent scholarship.
This paper will present a brief review of some of the evidence on which these conflicting
views are based, and will attempt to assess the relative significance of the varying con-
texts in which they may be interpreted: astronomy, theology, psychology and medicine.
Examples will range from a possible indication of heliocentric tendencies in Ficino to his
espousal of an early form of biodynamic principles in agriculture; it will include his love
of astrological conceit, his use of natal charts and astro-mythological interpretations, his
engagement with astral magic and talismans in *De vita*, and his adoption of a Proclan
metaphysic, yet one fully in accordance with Christian beliefs. The heavenly realm is, for
Ficino, mankind's proper aim and destination. Because of Ficino's widespread influence
upon his contemporaries as well as on Renaissance poetry and prose, it is a matter of
some importance to clarify Ficino's thinking on the celestial bodies in order to avoid mis-
interpretation of his views and his standing in fifteenth-century Florence.

'The heavens declare the glory of God; and the firmament sheweth his handy-
work'. These words from Psalm 19 allow an important affirmation for Marsilio
Ficino, philosopher, physician and priest in Renaissance Florence. With them,
he links astronomical observations with theological verities and natural science
with theories about prophecy and miracles. For him, celestial signs signify the
thoughts of the divine powers 'as through glances and nods'.[1] But how were
those signs read by Ficino and by the politicians, philosophers, poets, painters
and doctors of physick who followed him? When Ficino spoke of the heavens,
was he thinking of constellations, comets and conjunctions, of astrolabes and
charts? Was he thinking mythologically? Or primarily in theological terms?
What did the celestial bodies mean to him? I shall argue that several modes of
reading can be traced throughout his work, often interwoven, but that he is nei-
ther an astrologer-magus as some have presented him, nor the anti-astrologer
he sometimes appears to be. A modern visual response to Ficino's view of the
heavens is shown in Figure 12.1.

[1] Marsilio Ficino, *Platonic Theology*, 6 vols., trans. Michael J. B. Allen, ed. James Hankins
with William Bowen, The I Tatti Renaissance Library (Cambridge, MA: Harvard Univer-
sity Press, 2001-2006), 4: XIII.5.4.

Fig. 12.1: Ficino Fable, *sculpted by Tanya Russell ARBS, 1999. Inspired by Marsilio Ficino's fable, 'Without wisdom, power does not hold sway', this bas-relief shows Prometheus climbing to heaven to learn from Jupiter the close relations between Mercury and the Sun.[2] Photograph with kind permission of Alan Marshall Photography and Shepheard-Walwyn (Publishers) Ltd.*

Ficino had views on planetary bodies and their motion in which the circle and the sphere were forms of perfection.[3] He came tantalizingly close to heliocentric thinking through Platonic comparison of the Sun to God, although he never quite let go of the earth-centred Ptolemaic system. His practical skills appear in a letter to the Pope written on Christmas Day, 1478: with three other astronomers he has been studying past and future conjunctions of Saturn and Mars, the Sun and Aries, and eclipses of the Sun and Moon, and a worrying combination of

[2] Marsilio Ficino, *The Letters of Marsilio Ficino*, 10 vols. to date, translated by members of the Language Department of the School of Economic Science, London, (London: Shepheard-Walwyn, 1975-), Vol. 6, p. 20.

[3] *Platonic Theology*, 1: III.2.8 and IV.2.8-11.

Mars and Jupiter is predicted. Strife in the heavens portends general calamity on earth, but these astrological warnings form only the introduction to a carefully crafted appeal based on moral and spiritual arguments.[4] Other examples of astronomical readings are scattered throughout Ficino's correspondence. On 3 July 1488 he writes to Pico della Mirandola,

> Saturn may have been the cause of my coming to you much later than usual last month, as he was retrograde the month before that, after moving in Capricorn to a trine aspect with the Sun in Taurus. But the fact that yesterday I twice set out to you, both morning and evening, and twice retraced my steps, should be blamed, if any blame lies with the gods, on Jupiter, as yesterday Jupiter began to regress, since he too was coming into trine aspect [in Pisces] with the Sun [in Cancer].[5]

It was Pico himself (the anti-astrologer) who had introduced the astrological trope, pleading with Ficino not to let Saturn deprive him of Ficino's company, through being retrograde.[6] Modern calculations confirm that Jupiter did indeed cease his forward motion, and by 3pm on 3 July 1488 would have appeared to be moving backwards.[7] But Ficino was also making important non-astronomical points: Saturn stands for contemplation and discipline in study, for memory and perseverance, and for melancholy. Ficino considered himself to be under Saturn's rule: Saturn had 'impressed the seal of melancholy' on him from the beginning.[8] Saturn aids contemplation by helping the soul to 'gather itself into itself', recalling the mind 'to its own concerns', bringing it to rest in contemplation, and enabling it to 'penetrate to the centres of things'.[9] In his letter Pico had specifically called Saturn Ficino's *nous*, that highest part of the mind that reflects the divine intelligence.[10] The Sun, Pico's star, stands for brilliance, light, intellect and inspiration. Jupiter, who holds all things in balance under his wise rule, was sometimes a code name for Lorenzo de' Medici.

So what are we to take from this letter? Information about the planetary movements on the night of 3 July 1488 at 43°46' north? Or a gentle caricature of the writer, the recipient and the man they both defer to? Is it a friendly provocation or a philosophical meditation on the inter-relatedness of earth and sky? Perhaps it has elements of all of these. It is certainly a far cry from the wholesale denunciation of astrologers he had written around 1477-78.[11] As

[4] *Letters*, vol. 5, pp. 15-19.

[5] *Letters*, vol. 7, p. 72.

[6] *Letters*, vol. 7, p. 71.

[7] 'Yesterday … began to regress' must therefore indicate the stationary condition just prior to apparent backward motion.

[8] *Letters*, vol. 2, p. 33; see also vol. 5, pp. 122, and vol. 8, pp. 25-26.

[9] *Platonic Theology*, 4: XIII.2.2-3.

[10] *Letters*, vol. 7, p. 71.

[11] *Letters*, vol. 3, pp. 75-77.

regards the great controversy on astrology, Ficino is always careful to point out, in this letter and elsewhere, that the planets do not actually cause the effect being discussed, but simply grant the opportunity for it. This is significant. For the debate about astrology was not a dispute between scientific astronomers and crystal-ball-gazing charlatans. It was about astrological determinism versus human beings' free will. If the stars determine all – even if they are under the governance of Divine Providence in doing so – then theology has little moral guidance to offer. The issues of free will, providence, choice, causality and predestination were all related to astrology, and were hotly debated.

In January 1482, Ficino had taken a firm stand on the limitations of astrology in a letter to Federico da Montefeltro, Duke of Urbino. Its title proclaimed that divine law cannot be made by the heavens but may perhaps be indicated by them.[12] At issue here is the causative power of the stars in the rise and development of religion. Ficino was trying to disentangle the true claims of astrologers from false ones. His target appeared to be those who accounted for the birth of Christianity through entirely natural causes, namely a conjunction of Saturn and Jupiter. Such reasoning, reported by St Augustine, had erroneously predicted the necessary fall of Christianity exactly 365 years after its start.[13]

Around the same time he advanced arguments that the Star of the Magi was a comet, but one produced by the angel Gabriel taking his stand in the middle region of the atmosphere and gathering to himself a thousand furlongs of the surrounding air, binding it to himself as a soul binds a body. Compressing the air led to visible emanations of light, turning midnight into day for the shepherds and for the Magi, who, being Chaldaeans, had special knowledge of the stars.[14]

In the letter to Montefeltro, Ficino also argues that evil and disorder, while they may be portended by the stars, cannot be caused by them, as the stars themselves are full of excellence and move with perfect order. They are like the faces of heavenly beings. Just as we can predict someone's actions through their eyes, gestures and words, so can we predict events through alignments in heaven, but with the same limiting factors: though we read a person's intentions through their words and gestures, what they do is caused by their will. So on the cosmic scale, what takes place is caused not by the stars but by the will of divine minds, which in turn obey God. His authorities for this view come from all the main traditions: on this occasion he names Ptolemy, Albumasar, Manilius and Zaeles (Sahl ibn Bishr), representing Greek, Persian, Roman and Arabic astrology.[15] Making the same point at greater length elsewhere, he adds the main writers of the Platonic tradition (Plotinus, Porphyry, Iamblichus and Proclus),

[12] *Letters*, vol. 6, pp. 23-31.

[13] Augustine, *City of God*, trans. Henry Bettenson (Harmondsworth, Middlesex: Penguin, 1972), XVIII, 54.

[14] *Letters*, vol. 6, pp. 60-65.

[15] *Letters*, vol. 6, p. 28.

and three leading Aristotelians (Theophrastus, Avicenna and Algazel).[16] Here, even the will expressed through the stars is not all-powerful. Human wisdom can ward off the stars, just as divine wisdom governs them.

Ficino makes another important distinction: the rays of the stars influence our bodies, but the souls of the stars influence our souls.[17] Every influence is a good one, but may get perverted on the way – by us, by matter, or by conflicting influence. In this way, the prudence of Mercury may turn to malice, the magnanimity of Mars to ferocity, Venus's love to lust, and so on. This is why the astrologers so often get things wrong. Causes are incorporeal. They are, in order of importance, God, the angels and the souls of the celestial bodies. Any apparent corporeal causes (and this would include the bodies of the stars) are purely instrumental. While on the attack, he notes that astrologers cannot see all the heavenly bodies; they are rarely sure about the precise moment of birth, let alone conception or entry of the soul to the body, nor do they take account of parental influence, nurture, schooling and a host of local customs.[18]

Despite these remarks Ficino was consulted from time to time on personal horoscopes, and he gave replies stressing the qualities imparted by planetary influences at the time of birth and the way these might play out in life.[19] Nevertheless, man is above the stars, and the wise man may even 'rule' the stars. Anticipating (or perhaps even inspiring) Shakespeare's famous dictum, 'The fault, dear Brutus, is not in our stars, But in ourselves',[20] he writes to Lorenzo,

> We often find ourselves searching in the stars for what will happen to us from other people's actions. But what I am going to receive from you, magnanimous Lorenzo, I have been carefully observing for many years now, not in the heavens but in yourself. For I know that a wise man is not subject to the stars.[21]

In an earlier letter Ficino had deliberately withheld an adverse astrological reading from Lorenzo until the last minute, in order not to burden him with fear and unease in advance.[22] The stars in the sky may allot us our fate, but this is purely mechanical. What really governs our life is how we dispose for ourselves the stars within. In a famous letter to Lorenzo di Pierfrancesco de'Medici, Ficino instructs the young man in how to dispose his own inner heavenly signs and gifts. The continuously moving body and mind is the Moon, Mars swiftness, Saturn tardiness; the Sun signifies God, Jupiter law, Mercury reason and Venus human nature; body and mind should be turned towards the Sun – to God's

[16] *Platonic Theology*, 5: XV.5.8.

[17] *Letters*, vol. 6, p. 26 and *Platonic Theology*, 1:IV.1.24-25.

[18] *Letters*, vol. 6, pp. 25 and 42.

[19] E.g., *Letters*, vol. 8, pp. 7-8 and 51-53.

[20] Shakespeare, *Julius Caesar*, I, ii, 140-41.

[21] *Letters*, vol. 7, p. 46, dated 1 March 1487. Shakespeare, *Julius Caesar*, I, ii, 140-41.

[22] *Letters*, vol. 5, pp. 59-60, dated 26 September 1480.

life-giving rays, the source of our selfhood and our worth; Jupiter, law, is not to be transgressed, Mercury, reason, will give counsel and discernment; and Venus, not to be despised, is the source of love and kinship, majesty and magnanimity, liberality, great actions, gentleness and restraint.[23] In a separate note to the young man's tutor, Ficino said,

> I am writing a letter about the prosperity destined by fate, which for the most part we receive as our portion from the stars outside us; but also about the happiness freely available, which we obtain as we will from the stars within us.[24]

In two letters of June 1477 Ficino mentions a work he prepared against astrology, 'a book on the Providence of God and the freedom of human will'. Its preface forms a third letter in the same volume.[25] The book itself never appeared, but a manuscript preserves the material intended for it.[26] Its final passage states that the stars may have an influence on the body and the senses, but intellect and will stand apart from any such mechanistic interpretation. Making our minds subject to the heavens would imply that mind operates purely at the sensory level, which even Aristotle denies.[27]

Finally, we should turn to Ficino's last published statement on astrology. Writing to the poet Angelo Poliziano on 20 August 1494, he declares himself against any form of astrology that detracts from the operation of divine providence or human free will.[28] 'The host of astrologers, like the Giants of old, strive vainly and impiously to wrest from Jupiter his heavenly kingdom.' He prefers the way that Plato and his followers represent the heavens, describing their features but neither accepting nor rejecting conclusions drawn from them. Plotinus even laughed at such conclusions, and Ficino follows his example. However he admits to two occasions when he bent his own rules. The first was in his *De vita*, three books on life, published in 1489. Even though it began as part of his Plotinus commentary, he develops there the argument for astrological interventions. Farmers follow the stars, and so should doctors. Even where a treatment has no rational basis, if it brings benefit, it may be used. So medicines and even talismans, prepared at moments of maximum influence of the heavenly

[23] *Letters*, vol. 4, pp. 61-63.

[24] *Letters*, vol. 4, p. 63.

[25] *Letters*, vol. 3, pp. 48, 63 and 75-77.

[26] Marsilio Ficino, *Disputatio contra iudicium astrologorum* (1477) (Florence: Biblioteca Nazionale Centrale, MS Magliabecchiana XX 58); P. O. Kristeller, *Supplementum Ficinianum*, 2 vols. (Florence: Leo S. Olschki, 1937) 2: pp. 11-76. Some sections were incorporated into the *Letters* and *Platonic Theology*.

[27] Kristeller, *Supplementum*, 2: p. 74; Cf. *Platonic Theology*, 3: IX.4.11-18.

[28] Marsilio Ficino, *Opera omnia*, 2 vols. (Basel: 1561, 1576, repr. Turin: 1959, 1962, 1979, 1983; Paris: 2000), p. 958 (translation forthcoming in *Letters*, Vol. 11).

body whose powers a person feels the need to attract, are worth using.[29]

The second exception is his book on the sun, *De sole*.[30] He admits to confusing what belongs to poetry and what to philosophy in this moral, allegorical and anagogical study of the sun. Ultimately his concern was with the invisible sun that lights the sun that we see in the sky, that is, with the pure source that kindles light in heavenly bodies through its intellectual light, and warmth in earthly ones through its ray of love. The sun we see in the sky moves, whereas the real source of light is unmoving. To understand how this single source can produce and sustain the multitudinous forms of the creation, permeating all yet ever unaffected and undiminished, Ficino invites the reader simply to look up at the stars. They have been created for the very purpose of making all this evident:

> And as you look up, on the instant, the heavenly bodies looking down on you will declare to you the glory of God through the rays of the stars, as through their own glances and nods, and the firmament will show you His handiwork.[31]

A considerable literature has been devoted to the apparent contradictions in Ficino's views on astrology, and how far they really differed from those of Pico.[32] Here I have tried simply to outline the range of his thinking about celestial bodies, whose perfection he took for granted. He was not afraid to get involved in controversy, and he hotly challenges anyone who dares to think that the heavens are not alive and are not connected intimately with earth.[33] Yet Ficino's talk of the heavens belonged as much to metaphysics as to physics. For him, far more important than the visible or invisible rays of the stars is the light emanating from beyond the heavens, that supercelestial light that gives life to all. We should never forget its presence.

[29] *Opera omnia*, p. 958, referring to *De vita*, III, 26.

[30] *De Sole* (1492) was enlarged and published with *De lumine* in 1493. Ficino's important views on the physics, physiology and metaphysics of light lie beyond the scope of this paper.

[31] *De sole*, 2; *Opera omnia*, p. 966.

[32] See for example works by Carol Kaske, Melissa Bullard and Sheila Rabin listed in the bibliography.

[33] *Platonic Theology*, 1: IV.1.21-18; *Letters*, vol. 8, pp. 37-41.

THE HEAVENS AND KING LEAR

Nick Davis

The major eclipses of the Moon and Sun that are often used to date the composition of *King Lear* took place on 17 September and 2 October (that period's reckoning) 1605.[1] They were a lunar eclipse which covered the whole of the Moon in the Earth's umbral or penumbral shadow and a solar eclipse which, as seen from London, covered 90% of the Sun.[2] Astronomers had long predicted these eclipses; their prognostic significance as *coincidental* eclipses, a particularly unusual cosmic occurrence, had been discussed in England since the 1580s.[3] We find that they are emphasised by the makers of almanacs for 1605: John Dade is representative of these in expressing anxiety about what they may prognosticate while declining to make specific predictions.[4]

These eclipses were, then, discussed as a matter of common knowledge and concern around the time of preparatory work on *King Lear*. Shakespeare quite often referenced eclipses across the range of his writings, as for example in Sonnets 35, 60 and 107. The idea of a double eclipse, considered as a portent of catastrophe, is put forward in *Othello*: the hero, having strangled Desdemona, states, 'Methinks it should be now a huge eclipse / Of sun and moon, and that th'affrighted globe / Should yawn at alteration' (5.2.98-110); the yawning here is an opening of great fissures by earthquakes. *Macbeth* presents a remarkable range of cosmic disturbances, including an eclipse of the sun and an earthquake,

[1] See Stanley Wells and Gary Taylor, *William Shakespeare: A Textual Companion* (Oxford: Clarendon Press, 1987), p. 128.

[2] See David H. Levy, *The Sky in Early Modern English Literature: A Study of Allusions to Celestial Events in Elizabethan and Jacobean Writing* (New York: Springer Books, 2011), p. 29. On p. 23, Levy reproduces the chart of the 1605 eclipse produced by Fred Espenak with the assistance of NASA computers.

[3] See John Harvey, *A Discoursiue Problem Concerning Prophesies* (London: John Iackson, for Richard Watkins, 1588) [STC 12908], p. 119.

[4] Dade declines to speak of their 'signification (...), onely beseeching God to direct vs with his holy spirit, that we may liue as true Christians, faithfully professing the Gospel of Iesus Christ: and hartily praying for the preseruation of our most excellent & renowned Iosias, our good Queene, with his Maiesties royal offspring, and the happie estate of his most honourable priuie counsel, and the true and faithful subiects of this Land'; *A Prognostication in Which You May Behold the State of This Yeere of Our Lord God. 1605* (London: Company of Stationers, 1605) [STC 434.17], pp. B3, 6-7. The reference to Iosias is a pointed one, in that the scriptural narrative credits him with having averted the divine punishment which threatened Judah by instituting religious reform. For more on contemporary almanac treatment of the eclipses, see Nick Davis, *Early Modern English Writing and the Privatization of Experience* (London: Bloomsbury, 2013), pp. 68-69.

which attend the murder of Duncan; as recounted in the conversation between Ross and the unidentified Old Man at 2.24, they also comprise a huge storm, an explosion (perhaps), the crying of an unknown bird, the killing of a falcon by an owl, and cannibalism in horses.

Coincidental solar and lunar eclipses like those of 1605 are also among the apocalyptic phenomena of the *Book of Revelation* in the *New Testament*: 'And I beheld when [the Lamb] had opened the sixth seal, and, lo, there was a great earthquake; and the sun became black as sackcloth of hair, and the moon became as blood' (6.12).[5] Coincidental eclipses are endowed with reasonably specific prognostic significance in the *Centiloquium*, one of the Hermetic writings which had considerable cultural influence at this time: 'In the world many evils will happen, when in one month there shall happen an eclipse of both luminaries; chiefly in those places subject to the sign in which they happen'.[6]

In *King Lear* characters adopt differing attitudes to eclipses, which have, in the narrative time of the play, recently occurred. Gloucester introduces the topic:

> These late eclipses in the sun and moon portend no good to us. Though the wisdom of nature can reason thus and thus, yet nature finds itself scourged by the sequent effects. Love cools, friendship falls off, brothers divide; in cities mutinies, in countries discord, palaces treason, the bond cracked between son and father. (Quarto 1.2.97-103)[7]

Gloucester speaks as one who understands what *causes* eclipses at the level of physical determination. John of Hollywood's thirteenth-century scientific treatise, *Of the Sphere*, still circulating in Shakespeare's time, is particularly clear on the matter: this is something which, for Gloucester, 'the wisdom of nature' can satisfactorily explain. Nevertheless, in his reasoning, these mechanically predictable eclipses can still yield 'sequent effects' consisting of disruptions of the natural order. They seem to have portended the recent turmoils in the kingdom – his son's (apparent) plotting against him, of which he has just been told; Lear's rejection of Cordelia, which the audience has seen occur in the preceding scene; and other conspicuous departures from nature's ordinary, predictable course. Gloucester's illegitimate son Edmund pretends, as part of his duping of Edgar – the legitimate son – to take the same view: 'O, these eclipses do portend

[5] This answers to Luke 21.11 and 25: 'And great earthquakes shall be in divers places'; 'And there shall be signs in the sun, and in the moon, and in the stars'. Pliny's *Natural History* notes, in quite a different perspective, the coincidence of earthquakes with eclipses.

[6] Deborah Houlding, ed., *The Centiloquium of Hermes Trismegistus*, section 53; accessed 20th July 2012, http://www.skyscript.co.uk/centiloquium2.html. This text circulated in Western Europe from the thirteenth century, having been translated out of Arabic.

[7] References, which privilege the Quarto version, are to René Weis, ed., *King Lear: A Parallel Text Edition* (London: Longman, 1993). The Folio version of the play is generally considered to be later in composition as well as later printed than the Quarto version.

these divisions'. In the Folio version he sings a discordant sequence of notes, 'Fa, sol, la, mi', evoking the cosmic discord ('divisions' in Edmund's statement covers both 'musical intervals' and 'divisions between people' making for conflict). Hearing what his half-brother says, Edgar is sceptical, and asks, 'How long have you been a true believer in astrology, a "sectary astronomical"'? (Quarto, 1.2.123-37). In private, Edmund *is* entirely sceptical, and judges that people only invoke the heavens' influences in order to evade responsibility for their own actions (see Quarto 1.2.106-120). But Edmund is also the play's cynical villain, and it would be naïve to conclude that the play necessarily and straightforwardly endorses his rejection of celestial influence.

Seneca's *Thyestes*, a classical text which strongly influenced English Renaissance tragedy, offers a model of an action which foregrounds its characters' divergent interpretations of an eclipse and, behind this, of human-cosmic relations, of which relations between human beings may be considered to be an integral part.[8] *King Lear* also poses these as live conceptual problems, deliberated through action. In the counter-hypothesis to Edmund's, the components of the cosmos at all levels, including that of human life, are interconnected by a sympathetic bond; this is the *sumpatheia* of ancient and classical thought, much emphasised by Stoicism in particular, and adduced by Ptolemy as astrology's basis. In *Tetrabiblos* 1.2 he characterizes *sumpatheia*'s medium of connection thus:

> A very few considerations would make it apparent to all that a certain power emanating from the eternal ethereal substance is dispersed through and permeates the whole region about the earth, which throughout is subject to change, since, of the primary sublunar elements, fire and air are encompassed and changed by the motions in the ether, and in turn encompass and change all else, earth and water and the plants and animals therein.[9]

In this conception, celestial events bear directly on the human scene, and this functional interconnectedness, like that of a living body's components, is a given of which wise thought and action take account. Conversely, denial of cosmic connection, the position taken by Edmund, can go in practice with the severing of linkage between human beings: we find that Edmund experiences no compunction in attempting to bring about the deaths of his father and half-brother. Lear's attitude to the cosmos is more complex and seems to be rooted in the conception that the monarch *is* a cosmic force, comparable in majesty of action to one of the celestial bodies. In the opening scene, Lear acts to sever the natu-

[8] See Katharina Volk, 'Cosmic disruption in Seneca's *Thyestes*: two ways of looking at an eclipse', in K. Volk and Gareth D. Williams, eds, *Seeing Seneca Whole: Perspectives on Philosophy, Poetry and Politics* (Leiden: Brill, 2006), pp. 183-200.

[9] Ptolemy, *Tetrabiblos*, ed. and trans F. E. Robbins (Cambridge, MA: Harvard University Press, 1940), pp. 5-6.

rally-grounded interconnection with his loved daughter Cordelia. Invoking the inexorability of cosmic process, he attempts to give the judgement he renders on Cordelia the same kind of irresistible force: this is, in Lear's conception, a mighty, quasi-godlike action which exceeds ordinary human and natural constraints. The attitude to the cosmos which he projects in this scene is reminiscent of that adopted by Seneca's Atreus as he plots an atrocious revenge on his brother. The 'eclipse dragon', the astronomers' charting of nodes in the lunar orbit which makes eclipses predictable and which is based in ancient notions of a prodigious creature that devours the sun, is referred to twice in *King Lear*: in Edmund's sceptical joking ('My father compounded with my mother under the Dragon's tail', Quarto 1.2.115-8, which evokes both the eclipse dragon and the constellation Draco), and in Lear's warning to Kent as Kent tries to check him: 'Come not between the dragon and his wrath' (Quarto 1.1.111). The royal dragon of British heraldry fuses, in these words to Kent, with the cosmic dragon whose movements define the conditions of eclipse.[10]

Ancient thought, following Pythagorean teaching, had constructed a musically organised cosmos. As Edmund's discordant singing implies, one of the perceived manifestations of functional cosmic interconnection is musical concord, while discord betokens cosmic breakdown, what Dryden in a brilliant phrase calls the untuning of the sky.[11] The earlier, Quarto version of the play has Cordelia bring Lear back to sanity partly through the force of music which, operating alongside other medicines, retunes him to the order of the cosmos. This is in accord with the era's astrological, *sumpatheia*-orientated conceptions of medical practice; in the Quarto version a doctor is present to direct Lear's cure, reintegrating the activity of his mind with the orderly cosmic motions. But in the Folio version the music and ministering doctor are dropped, which gives more importance to the influence of Cordelia herself; in the doctor's place we more simply have a concerned 'Gentleman' who stands back to let Cordelia take charge. One wonders how the change came about. Perhaps the Folio version is one which Shakespeare's company found more viable in performance. But we can say that the period's uncertainties and oscillations of view concerning the relation between the human scene and the heavens are replicated in the action of the play – for example in its setting Gloucester's alignment of celestial and terrestrial events against Edmund's scorning of the idea, and use of it to manipulate others – and also replicated in its composition history, where in the episode of Lear's revival the idea of a musically concordant cosmos,

[10] The eclipses dragon had been referred to in *Tamburlaine 2*, in Christopher Marlowe, *Doctor Faustus and Other Plays*, ed. David Bevington and Eric Rasmussen (Oxford: Oxford University Press, 1995), 2.4.51-54, p. 91. Here Tamburlaine describes the effects of Zenocrate's illness on him as being equivalent to lunar and solar eclipses. The motif of the cosmic dragon or serpent must have been generally recognisable.

[11] See 'A Song for St. Cecilia's Day, 1687'; for the intellectual background, see Gary Tomlinson, *Music in Renaissance Magic* (Chicago: University of Chicago Press, 1993).

interconnected between part and whole, seems to have become relegated in dramatic importance, as the Folio presentation of the text apparently shows.

The humans-heavens relation is both exposed and tested in what transpires throughout the play between Lear and Cordelia. Their initial gigantic quarrel precipitates a catastrophic sequence of events working through at every human level. When Lear pronounces banishment on Cordelia to punish what he interprets as her betrayal of him; his warning to Kent invokes, as has been said, the astronomers' eclipse-determining dragon. Prior to this, Lear has, in pronouncing judgement on Cordelia, pledged himself to what he states 'By all the operation of the orbs / From who we do exist and cease to be' (Quarto 1.101-2). Lear speaks, until broken by events, as one who has the grand motions of the cosmos as his personal point of reference. It is not fanciful to see the Lear-Cordelia action as shadowing an 'eclipses' plot.[12] Brian Rotman's account of the play highlights the significance that its action confers on mathematical zero, an object of frequent reflection in Shakespeare's writing.[13] As I have explained elsewhere, offering historical contextualization for Rotman's account, a central feature of the zero in Shakespeare's evocation of it is that it does not articulate with the Roman system of numeration, which during this period is still in predominant practical use and, to most people, more readily comprehensible. The zero is, in the early seventeenth-century cultural setting, a considerably more paradoxical thing than any of the Roman numerals: it multiplies value, but also stands for its absence, and lacks the Roman numerals' simple integrality.[14] We should at this point recall the era's classification, following well-established traditions, of the moon as feminine and the sun as masculine. Cordelia's very powerful and disruptive 'Nothing', as uttered in the first scene, is to be projected visually as a zero, a blank circle. Its utterance immediately *darkens* the solar Lear, after the manner of an eclipse, on which he bids to eclipse *her* as 'moon' by removing her importance and lustre: to the astonishment of all present he declares her to be a thing without value and significance. Cordelia's departure and Lear's ensuing dependence on her sisters diminishes *him*, in due course producing his madness. In other words, one of our templates for conceptualisation of the play's action is what occurs in one of those astronomical periods, like that of 1605, during which eclipses happen in sequence, hard on one another's heels. Whatever one thinks about the terrestrial-celestial relation as such, the play's human action, which seems to be conceptualised partly by reference to the celestial phenomena of an eclipse period, certainly has the character of a huge, widening disaster. The word 'disaster' is, we may recall, of

[12] See further, Nick Davis, *Stories of Chaos: Reason and its Displacement in Early Modern English Writing* (Aldershot: Ashgate, 1999), pp. 141-45.

[13] See Brian Rotman, *Signifying Nothing: The Semiotics of Zero* (Basingstoke: Macmillan, 1987); and my discussion in *Stories of Chaos* (Aldershot: Ashgate, 1999), pp. 143-48.

[14] See Davis, *Stories of Chaos*, pp. 122-24, 137.

cosmological origin[15] and seems to be especially applicable here. *King Lear* was only performed in an ameliorated or 'lightened' version – where Cordelia does not die – from the later seventeenth to the early nineteenth century. The horror which the play inspires in its original version has to do in some measure with the forcefully offered suggestion that, in these appalling conflicts and mutual damagings of human beings, the world itself is reeling towards destruction.

In the final scene of the play Lear enters with the body of Cordelia in his arms, addressing onlookers thus:

> Howl, howl, howl, howl! O you are men of stones
> Had I your tongues and eyes, I would use them so
> That heaven's vault should crack. She's gone for ever.
> I know when one is dead and when one lives.
> She's dead as earth. Lend me a looking-glass;
> If that her breath will mist or stain the stone,
> Why, then she lives.

The three highest-ranking figures present now respond as choric witnesses:

> KENT Is this the promised end?
> EDGAR Or image of that horror?
> ALBANY Fall and cease
>
> (Quarto 5.3.250-57)

Contextualised by the action's continuous probing of the human-to-cosmos re-lationship, the scene's apocalyptic symbolism is powerful. It finds a way of bringing onstage, though a use of human avatars, the kind of eclipse action which happens offstage in Seneca's *Thyestes*. The moon, as has been said, was usually gendered as female and the sun as male. Here we have a dying sun, howling in torment, holding in his arms an already dead moon – in the lan-guage of Sonnet 107 a 'mortal moon' who has not 'endured' eclipse – and on the verge of dying through the effects of the grief which this loss produces. As Lear, bearing Cordelia's body, advances across the stage the pair are, to the loyal Kent, enacting full cosmic dissolution in the characters of a ruling sun and moon heading towards extinction. Kent asks 'Is this the promised end?' In *Thyestes*, similarly, the members of the Chorus take the play's eclipse to be a sign of the world's ending. Their lengthy speech, veering between registration of terror and acts of reflection, concludes thus:

> Out of so many people, is it judged that we
> deserve to be crushed
> by the overthrow of the axis of heaven?
> Has the final age come upon us?
> O, we were born with a heavy fate,
> whether we lost the sun through misfortune

[15] It is, according to the *Oxford English Dictionary*, in its primary sense 'an unfavourable aspect of a star or planet (Greek *aster*)'.

or drove him away!
But let laments go, let fear depart:
a glutton for life is one that is loath
to die when the whole world perishes with him.[16]

Kent, in the final scene of *King Lear*, has a sense he is witnessing the world's destruction, and is prepared to die: 'I have a journey (…) shortly to go; / My master calls, and I must not say no' (Quarto 5.3.313-4). Edgar on the other hand, opting for a mentality of survival, advises more cautious interpretation of what we have before us: this humanly-enacted double eclipse is an 'image of that horror', the world's end; not the end itself, but a vehicle for conceiving of the terrible thing which it will be.

[16] Seneca, , *Tragedies II*, ed. and trans. John G. Fitch (Cambridge, MA: Harvard University Press, 2004); *Thyestes*, ll. 875-84.

SPIRITUAL SYMBOLISM IN W. B. YEATS'S 'THE PHASES OF THE MOON'

Faisal A. W. Hayder Al-Doori

ABSTRACT: William Butler Yeats (1865-1939) was both a cosmopolitan and an Irish poet. He absorbed most of the known cultures and religions of the world into his poetry because these constitute the basis of his imagery and symbolism. He was particularly interested in having the mystical appeal of these religions broaden his poetic and philosophic prospects. His interest in symbolism led him to create his own special system to interpret human personality and the movement of history via symbols. His poem, 'The Phases of the Moon', reveals the basic elements of this system.

This paper focuses on Yeats's symbolism in this poem and how these symbols contribute to the entire Yeatsian philosophy regarding spirituality, mystical wisdom, perfection and beauty. It discusses his classification of personality based on the phases of the moon, the effect of astrology, and the rendition of the major character in the poem, Michael Robartes. The discussion consults Yeats's book, *A Vision*, to explain the ambiguities in this poem and to provide a broader background for the poem.

W. B. Yeats's Symbolism

In the dedication of his book, *The Symbolist Movement in Literature*, to Yeats, Arthur Symons asked the poet whether he was a representative of the Symbolist movement in the UK. Symons confirmed this response by referring to the 'transcendental' art and 'mysticism' which are 'essential in the doctrine of Symbolism'.[1] Yeats's work demonstrates that his symbolism is profoundly related to these two terms. Symons describes the French Symbolist Movement as an attempt to 'spiritualise literature' and rebel against the more common views of 'exteriority', 'rhetoric' and a 'materialistic tradition'.[2] Yeats did not adhere to any particular culture or religion. He went wherever he could find a possible potential route to universal truth. He remained largely in agreement with Blake's maxim that 'all religions are one'.[3] In his book, *A Vision*, Yeats promoted a highly complicated system of symbolism. His poem 'The Phases of the Moon' communicates the core meaning of that book.

Symbolism in 'The Phases of the Moon'

The essence of Yeats's book, *A Vision*, is found in this poem. The poem is not merely a story; it formulates the structure and deep meaning that formed Yeats's

[1] Arthur Symons, *The Symbolist Movement in Literature* (London: Constable & Company, Ltd., 1911), pp. v-vii.

[2] Symons, *The Symbolist Movement*, pp. 8-9.

[3] F.A.C.C. Wilson, *W. B. Yeats and Tradition* (New York: The Macmillan Co, 1958), p. 16.

philosophy and his personal system regarding the circular movement of history. The importance of this poem also emerges in its links to the other poems of Yeats that relate to the moon and his major fictional character, Michael Robartes. The poem is structured as a dialogue between Robartes and the other imaginary character, Owen Aherne. Through this dialogue with a reference to the poet in the poem, who is actually Yeats himself, Yeats reveals his thoughts directly or symbolically. These two characters are seen as visiting a poet who is seeking mystical wisdom in his lonely tower by reading a book or a manuscript:

> The lonely light that Samuel Palmer engraved,
> An image of mysterious wisdom won by toil;
> And now he seeks in book or manuscript
> What he shall never find.[4]

As it is mentioned in *A Vision*, the poet has received the mystical book from Robartes, who admits that the poet will not find what he is looking for, simply, because 'mysterious wisdom [is] won by toil'.[5] Unlike Robartes, who experienced practical wisdom from too much travelling, especially to the East, the poet has confined himself in a tower with his books to read. Robartes asserts the significance of the reaction between theory and practice to discover a full vision of life and the afterlife. Aherne also knows this truth, as is clear in his suggestion to Robartes:

> Why should not you
> Who know it all ring at his door, and speak
> Just truth enough to show that his whole life
> Will scarcely find for him a broken crust
> Of all those truths that are your daily bread;
> And when you have spoken take the roads again?[6]

The comparison between the poet and Robartes reveals that the poet, by his isolation, cannot reach the truth, whereas Robartes, by taking 'the roads again', can easily find it. Robartes, as Yeats states, 'has but lately returned from Mesopotamia, where he has partly found and partly thought out much philosophy'.[7] Mesopotamia is not only known for its study of philosophy, but also for astrology, another area that Yeats is highly interested in using to build his system that depends on the related movements of the moon and the sun. The twenty-eight phases of the moon, which Yeats borrowed from the Arabs, were reshaped into

[4] Peter Allt and Russell K. Alspach, eds, *The Variorum Edition of the Poems of W. B. Yeats* (New York: The Macmillan Company, 1957), II, 17-20.

[5] George Mills Harper and Walter Kelly Hood, eds, *A Critical Edition of Yeats's "A Vision" (1925)* (London: The Macmillan Press Ltd., 1978), p. xix.

[6] Allt and Alspach, *Variorum*, II, 21-25.

[7] A. Norman Jeffares, *A Commentary on the Collected Poems of WB Yeats* (Stanford CA: Stanford University Press, 1984), p. 173.

the twelve gyres of his own system.[8] He then turned them into ten divisions representing the ten Sephiroth of the Cabbalistic Tree of Life.[9]

Fig. 14.1: The antithetical and primary gyres diagram.[10]

Yeats's philosophy is based on the unity of the opposites as a reflection of the Unity of Being. The opposite movement of the sun and the moon is identified on his wheel and depicts his primary idea regarding the behaviour of man who 'seeks his opposite or the opposite of his condition'.[11] Yeats's concept of perfection is exemplified by regarding man as a microcosm and the precise movement and arrangement of the universe as a macrocosm. Unlike the traditional wheel of the Zodiac, which is based on a division of the ecliptic, the Sun's apparent path through the sky, Yeats's wheel encloses both the lunar and solar signs as the Arabic zodiac does. He also refers to the Arabic influence on designing his wheel as a kind of magic, as follows:

> Even when I wrote the first edition of this book I thought the geometrical symbolism so difficult, I understood it so little, that I put it off to a later section; and as I had at that time, for a reason I have explained, to use a romantic setting, I described the Great Wheel as danced on the desert sands by mysterious dancers who left the traces of their feet to puzzle the Caliph of Baghdad and his learned men.[12]

[8] Harper and Hood, *A Critical Edition*, p. 12.

[9] Aryeh Kaplan, *Sefer Yetzirah: the Book of Creation in Theory and Practice* (York Beach, ME: Weiser Books, 1997).

[10] Anonymous, 'The Tinctures', http://www.yeatsvision.com/Tinctures.html.

[11] W. B. Yeats, *A Vision (1925)* (London: The Macmillan Press Ltd., 1974), p. 12.

[12] Yeats, *A Vision*, pp. 80-81.

Fig. 14.2: Arabic Zodiac diagram. Image source: http://bit.ly/298n4WA

Yeats's imaginary character, Michael Robartes, lives with the Arabs for some years and learns their philosophy, magic and astrology:

> Sing me the changes of the moon once more;
> True song, though speech: 'mine author sung it me.'[13]

In his *Autobiographies*, Yeats points out the difference between the song and the speech: 'I shall, however, remember all my life that evening when Lionel Johnson read or spoke aloud... They were not speech but perfect song,...'.[14]

The song relates to poetry and the speech to prose, but here the song also embodies the spiritual truth, while the speech explores the Other. Through the voice of Robartes, Yeats explains his philosophy on the movement of life and death, the movement of history and civilisations, and the identification of personalities according to the phases of the moon:

> Twenty-and-eight the phases of the moon,
> The full and the moon's dark and all the crescents,
> Twenty-and-eight, and yet but six-and-twenty
> The cradles that a man must needs be rocked in:
> For there's no human life at the full or the dark.[15]

The first phase, which is *primary* or objective, is not human as the fifteenth phase, which is antithetical or subjective, because of absoluteness; absolute objectivity and subjectivity, respectively. These two phases are interchangeable as Yeats clarifies that 'the old *antithetical* becomes the new *primary*' and the reverse is true due to the cyclical motion of the Great Wheel.[16]

[13] Allt and Alspach, *Variorum*, II, 29-30.
[14] W. B. Yeats, *Autobiographies* (London: The Macmillan Press Ltd., 1973), p. 301.
[15] Allt and Alspach, *Variorum*, II, 31-35.
[16] Harper and Hood, *A Critical Edition*, p. 88.

Fig. 14.3: *The Great Wheel of the phases of the moon diagram.*[17]

Fig. 14.4: *'The first phase, which is primary or objective'.*
Solar and lunar signs of the Zodiac diagram.[18]

Through these two phases, the poet links the mortal with the immortal, the physical with the spiritual. The first phase points out the beginning of life and the shaping of the human by the hands of Nature or the supreme Divine power. The dough, which 'cook Nature' deals with, is the body in its formation or the soul in its unity with the body.[19] So, the realistic beginning of life starts at the second phase:

> From the first crescent to the half, the dream
> But summons to adventure and the man
> Is always happy like a bird or a beast;
> But while the moon is rounding towards the full
> He follows whatever whim's most difficult
> Among whims not impossible, and though scarred.[20]

[17] Anonymous, 'The Phases of the Moon', http://www.yeatsvision.com/Phases.html.

[18] Anonymous, 'The Principles', http://www.yeatsvision.com/Principles.html.

[19] Yeats, *A Vision (1925)*, p. 183.

[20] Allt and Alspach, *Variorum*, II, 36-41.

Happiness in this stage 'from the first crescent to the half' is ascribed to the enjoyment found in discovering the world; however, the poet does refer to the sensuous life of a bird or a beast to designate the major characteristic of this stage. The beauty of the body does prevail:

> As with the cat-o'-nine-tails of the mind,
> His body moulded from within his body
> Grows comelier. Eleven pass, and then
> Athene takes Achilles by the hair, [21]

Juno, the Greek Moon-Goddess, sent Athena, the Goddess of Wisdom, to calm Achilles's anger.[22] The cycle of history in this poem begins with the Trojan War and the beauty of Helen of Troy, which was the cause of that war. The Twelfth phase is characterized by heroism, as it relates to its symbols – Hector from ancient history and Nietzsche's modern theory of the superman:

> Hector is in the dust, Nietzsche is born,
> Because the hero's crescent is the twelfth.
> And yet, twice born, twice buried, grow he must,
> Before the full moon, helpless as a worm.[23]

The consecutive birth and death or rebirth recalls the idea of reincarnation, as Yeats calls out that concept in each phase. The image of 'helpless as a worm' might refer to either the baby or the very old man. However, the progressive soul in these phases also suffers a war with the body:

> The thirteenth moon but sets the soul at war
> In its own being, and when that war's begun
> There is no muscle in the arm; and after,
> Under the frenzy of the fourteenth moon,
> The soul begins to tremble into stillness,
> To die into the labyrinth of itself![24]

The poet may here be referring to the effect of the fourteenth phase of the moon on the psychology of the animate beings, but the same is also true for the fifteenth, or rather this same phenomenon is ascribed to the full moon. The human physical power is at its climax, so sexual love is significant in this period, as it may cause the death of the soul. The poet describes the struggle that occurs in the phases that lie between the twelfth and eighteenth as a search for unity or the Unity of Being.[25] There is a search for balance between the antithetical and primary elements of life, except during the fifteenth phase, which is absolutely

[21] Allt and Alspach, *Variorum*, II, 42-45.
[22] Harper and Hood, *A Critical Edition*, p. 60.
[23] Allt and Alspach, *Variorum*, II, 46-49.
[24] Allt and Alspach, *Variorum*, II, 50-55.
[25] Harper and Hood, *A Critical Edition*, p. 60.

antithetical.[26] This phase is defined as 'complete beauty,' where the soul and the body are united or they dissolve into each other to be invisible and out of our world:[27]

> All thought becomes an image and the soul
> Becomes a body: that body and that soul
> Too perfect at the full to lie in a cradle,
> Too lonely for the traffic of the world:
> Body and soul cast out and cast away
> Beyond the visible world.[28]

The beauty in phase fifteen is divine; however, as the poet explains in *A Vision*, the greatest human beauty is attained in phases fourteen and sixteen.[29] The antinomy of beauty versus ugliness or deformity moves on through the second half of the wheel, and the poet gives to the 'cook Nature' the tasks of kneading and producing a new generation in the first phase of the moon when the cycle starts once again. However, when 'cook Nature' divides the dough and allocates it to every individual's fortune of physical beauty, 'cook Nature' doesn't forget that his task can be balanced by the beauty of the mind. The poet explains this equation in prose to those who are fated to be deformed: 'here also are several very ugly persons, their bodies torn and twisted by the violence of the new *primary*, but where the body has this ugliness great beauty of mind is possible'.[30] According to Yeats's philosophy, which can be perceived from reading his poetry in general, beauty of mind is mostly a spiritual quality.

To conclude, Yeats's 'The Phases of the Moon' is a highly symbolic poem, which introduces this poet's thoughts and philosophy on life, history, and personality. Influenced by the French symbolists, Yeats formulated his ideas in prose to initiate his own type of symbolism. His mystical experience and his interest in many religions provided him with rich symbols and deeper concepts that then affected his thoughtful and poetic discourse as a writer. The importance of this poem is that it is considered a key to understanding most of his other prose and poetic writings. In this poem, Yeats applies the Arabic mansions of the moon to build his theory on the cycle of life, history, civilisation and human character. He uses these symbols in a way that is different from their concrete realities. Yeats's concern is with poetry and absolute thought, not solid facts. This poem can be easily considered as the culmination of his poetic career and also the answer to his long philosophic inquiry.

[26] Harper and Hood, *A Critical Edition*, p. 69.

[27] Yeats, *A Vision (1925)*, p. 131.

[28] Allt and Alspach, *Variorum*, II, 58-63.

[29] Yeats, *A Vision (1925)*, p. 140.

[30] Sarah E. Simons, ed., *The Iliad of Homer*, trans. William Cullen Bryant (Boston: Houghton Mifflin, 1916), p. 10.

SEPTENTRION: URSA MAJOR IN THE FIN DE SIÈCLE

Leon Burnett

ABSTRACT: Near the end of his innovative poem of 1898, 'Un coup de dés', the French Symbolist poet Stéphane Mallarmé made an obscure allusion to 'le Septentrion aussi Nord', which he glossed as 'a constellation/ cold with forgetfulness and disuse'. In 1903, Bram Stoker, more famous as the author of *Dracula*, published a novel about an attempt to resuscitate a mythical queen of ancient Egypt. The novel was called *The Jewel of Seven Stars*, a reference to the constellation of Ursa Major, which was also known in former times as the Septentrion. This paper explores the connotations of the contrasting symbolic representations of the same stellar configuration in an attempt to explain its attraction for two *fin-de-siècle* authors whose works appeared within five years of each other at the turn of the century, but whose artistic achievements differed so starkly from each other in almost every conceivable way. One clue to the common ground between the endeavours of Mallarmé and Stoker is offered by T.S. Eliot, almost fifty years after the appearance of the two works that are the focus of the paper, when he wrote, in *Four Quartets*, of the life within the human body as being 'figured in the drift of stars', reformulating an idea that is as old as Heraclitus, who proclaimed that the way up and the way down are one and the same.

The main interest of this paper is in the configuration of the seven-star asterism of Ursa Major as represented in the literary interlude commonly referred to as the *fin de siècle*, which Janus-like looked back to the esoteric doctrines of a mystically inspired nineteenth-century Symbolism and forward to a more self-assured, but also a more self-preoccupied, twentieth-century Modernism. The eclectic world of the *fin de siècle* included such contrasting figures as Vincent van Gogh, Stéphane Mallarmé and Bram Stoker, each in his own way an exponent of the symbolic imagination.

Although the main emphasis is on two writers, I start with a painter in order to introduce the essentially visual quality of the imagery discussed. In 1888, van Gogh painted a canvas known as *Starry Night over the Rhone*.[1] In the centre of the picture, high in the sky, is the unmistakeable asterism of the *Grote Beer*.[2] Beneath it, the evening lights from Arles are reflected in the water, providing a complementary source of illumination, while in the foreground a couple stands arm-in-arm with their backs to the whole spectacle. It is not that the two humans are excluded from the cosmic display; they are simply oblivious to it. A year later, in the Saint-Rémy asylum, van Gogh painted another scene of a starry

[1] Vincent van Gogh, *Starry Night over the Rhone*, oil on canvas, Arles, France, September, 1888. Musée d'Orsay, Paris.

[2] The asterism known affectionately in Dutch as *Steelpannetje*, 'little saucepan'.

night.[3] In it the stars have become much larger, the asterism is less certain (if it is there at all), and the sky has taken on more of a Munch-like swirl. The town is still visible beneath the night firmament, but human figures are no longer present in the foreground.

The first of the literary works I want to consider is Mallarmé's poem 'Un coup de dés' ('A Dice-Throw'), in which we find the motif of what the poet calls a 'stellar issue'.[4] Towards the end of this poem, Mallarmé employs the word *Septentrion*. His usage demonstrates his awareness of the dual meaning of the word, initially a name for Ursa Major, but one which came to signify the north more generally:

<div align="center">

le Septentrion aussi Nord
UNE CONSTELLATION

</div>

In 'Un coup de dés', the overriding effect is visual; on the author's own admission, narrative is avoided.[5] The words are scattered on the page, which, rather than the line, functions as the unit of composition. In the preface, Mallarmé observes disingenuously that his poem is 'without novelty except for the spacing out of the reading' (*un espacement de la lecture*).[6]

Mallarmé's arrangement of the words on the page is analogous to the trajectory of dice falling and rolling to a halt. There are two phases to the trajectory of thrown dice, first a downward, and then a horizontal, motion before the objects come to rest. This movement is captured graphically in the organization of Mallarmé's pages, several of which consist of a series of step-like lines followed by a more solid block of text lower down. The typographic composition to which its author refers in his preface offers an iconic representation of a crisis, the print strewn and dispersed on the page, imitative of a deadly shipwreck, which is the ostensible, if flimsy, subject matter of a poem devoid of narrative.

The staircase-like structure is already apparent on the first sheet of the poem, in which two different upper-case typefaces are adopted, taking the reader from the suspended image of dice about to be thrown to the final word lower down the page that announces the shipwreck.[7] It is on the next sheet, however, that the visual motif is fully established in the imagery of *aile* ('wing'), *voile* ('sail' or 'veil'), *Abîme* ('abyss') and *ombre* ('shadow'), all of which may also be envisioned

[3] Vincent van Gogh, *Starry Night*, oil on canvas, Saint-Rémy, France, June, 1889. Museum of Modern Art, New York.

[4] The poem was first published in 1897. The text was under revision when its author died suddenly on 9 September 1898 and, according to Roger Pearson, *Unfolding Mallarmé: The Development of a Poetic Art* (Oxford: Clarendon Press, 1996), p. 11, it is 'still awaiting a definitive edition'. The edition used here is Stéphane Mallarmé, *Mallarmé*, introduced and edited by Anthony Hartley, with plain prose translations (Harmondsworth: Penguin, 1965).

[5] '[O]n évite le récit': from the preface to the poem (*Mallarmé*, p. 210).

[6] *Mallarmé*, p. 209.

[7] Where 'sheet' is used in preference to 'page', it indicates the spread of two pages, as in an opened book.

in the textual graphic and are of central importance in appreciating the symbolic level of the poem.

At the end of the poem, Mallarmé takes up a thematic reference to the French word *vague* (which may be translated as 'wave' or 'vagueness') 'in which all reality dissolves'. Here, as elsewhere, we encounter a configuration that represents the rolling dice on the left-hand side and an extended block on the right as they come to a halt. The poem ends where it began – with the words 'un Coup de Dés': 'Toute Pensée émet un Coup de Dés'.[8] This final statement is preceded by allusions to rolling ('roulant') and coming to a halt ('s'arrêter'), the most explicit references to the imagined trajectory of a dice-throw that the poet allows himself in the whole poem.

Mallarmé was doing more than merely playing with formal structure; he was laying an emphasis on duality. This is one reason why the existence of *two* dice is important. Van Gogh's painting of the *Starry Sky over the Rhone* offers a clue to a reading of the duality implicit in Mallarmé's introduction of two dice. For each of the seven stars glowing in the heaven in the Dutch artist's work, there is a matching reflection from the town's artificial lighting in the water directly below. The celestial light, then, has its counterpart on earth. A similar equation operates in 'Un coup de dés'.

In the midst of the final sheet of the poem four words stand out in larger and upper case typeface. Thus, we encounter the two words 'UNE CONSTELLATION' either immediately through the visual prompt of a typeface shared by these four words to read 'EXCEPTÉ PEUT-ÊTRE UNE CONSTELLATION', or we come to 'UNE CONSTELLATION' more gradually through the text, after descending, as it were, a ladder of lines. In the latter course, we reach in the line immediately preceding 'UNE CONSTELLATION' a reference to 'le Septentrion aussi Nord'.

The final lines of the poem as they drop down the page describe the roll of the dice after they leave the hand, but the passage also alludes to a movement *towards* the stars.[9] In the poem, the shipwreck motif is addressed directly through such words as 'abyss' and 'gulf', signifying the danger of both physical and metaphorical depth, but it is also present in a rhymed pairing that carries a particular charge in Mallarmé's poetry, *ombre* ('shade' or 'shadow') and what may be regarded as its celestial partner, *nombre* ('number'). One of the poem's earlier sheets starts, high up, with the announcement:

> C'ÉTAIT LE NOMBRE
> issu stellaire

If descent is associated in the poem with *ombre*, then ascent is associated with *nombre*.

The existence of *two* dice, then, hints at a duality in the poem, the descent into

[8] 'All thought emits a dice-throw'.

[9] The French word *vers* ('towards') occupies a line of its own.

the sea, symbolised by *ombre*, which maps out a passage into a watery death, and its opposite – a catasterism, symbolised by *nombre*, representing the poem's 'stellar issue'.[10]

If separate letters combine to form words, then analogously individual stars take on meaning as constellations. Mallarmé, however, named only one constellation – or asterism – in his poem: Septentrion (in Ursa Major). We may be confident that this most meticulous of poets did so, as always, with deliberation. The 'spacing out of the reading' identified with the shipwreck motif, which mimics the trajectory of a dice-throw, also traces the outline of the Septentrion, with the three stars that form the handle of the Plough representing the initial throw of the dice and the four stars that nearly form a square (or cube in two-dimensional profile) corresponding to the dice at rest.[11] The black spots on the white dice replicate black lettering on white paper and the light of stars shining in the encompassing blackness inverts the visual impression of what is printed on the page.

One possible reading of the text, when the word selection, the poem's symbolism and, above all, the 'spacing out of the reading' viewed as a catasterism are taken into account, is to see the pattern of the printed words superimposed upon a star configuration. This approach comes with the endorsement of the poet, who, in a letter to André Gide (on 14 May 1897), wrote:

> In this poem the constellation will, fatally, assume, according to precise laws and in so far as it's possible in a printed text, the form of a constellation. The ship will list from the top of one page to the bottom of the next, etc.: for, and this is the whole point of the issue (which I was obliged to omit in a 'periodical'), the rhythm of a sentence about an act or even an object has meaning only if it imitates them and, enacted on paper, when the Letters have taken over from the original etching, must convey in spite of everything some element of that act or that object.[12]

The fundamental idea behind this equation is expressed in the aphorism from Heraclitus that T. S. Eliot quoted (in Greek) as an epigraph to 'Burnt Norton', the first of his *Four Quartets*: 'the way up and the way down are one and the same'.[13] It is to be noted that Eliot introduced his own astronomical allusion later in the second section of the poem.

[10] The Greek word *katasterismi*, literally 'placings among the stars', is the term used for the transformation of mortal beings into stars or constellations, as in the myth of Kallisto, the nymph who is first changed into a bear on Earth and then into the Great Bear in the heavens.

[11] Pearson, *Unfolding Mallarmé*, offers a detailed account of the significance for the poem of the number seven.

[12] Stéphane Mallarmé, *Selected Letters of Stéphane Mallarmé*, ed. and trans. Rosemary Lloyd (Chicago: University of Chicago Press, 1988), p. 223.

[13] T. S. Eliot, *Collected Poems: 1909-1962* (London: Faber and Faber, 1974), p. 189.

The dance along the artery
The circulation of the lymph
Are figured in the drift of stars
Ascend to summer in the tree
We move above the moving tree
In light upon the figured leaf
And hear upon the sodden floor
Below, the boarhound and the boar
Pursue their pattern as before
But reconciled among the stars.[14]

A more concise formulation of the same principle, attributed to the semi-divine Hermes Trismegistus, is 'as above, so below'. The doctrine of the oneness of all things and the unity of earth and heaven that it expresses acquires an Egyptian provenance through Hermes' association with Thoth.[15] It is this pedigree that Bram Stoker exploits in his novel, *The Jewel of Seven Stars*.[16]

We move, then, from a poem of the *fin de siècle* that was to serve high Modernism so well in its austere blend of obscurity and craftsmanship to a prose work that appealed to a broader interest in the gothic, in the oriental, and in the mysterious conjunction of a strange and distant past world with a familiar present one; in short, to a novel that, far from avoiding narrative, depended upon devices of suspense and disclosure for its very existence.

The asterism that Mallarmé refers to as the Septentrion is at the heart of Stoker's novel, where it goes by the more familiar name of the Plough. Yet, despite the application of its English name, Stoker (or, rather, his narrator, Malcolm Ross) shows himself to be fully aware of its association with the north.[17] Framed by a conventional love story – the narrator's attraction to Margaret Trelawny, daughter of an eminent Egyptologist – the main plot concerns the attempt to bring the mummified body of an ancient Egyptian queen back to life in a northern location with the seven stars of Ursa Major shining down upon the corpse. The title of the novel refers to the Star Jewel belonging to Queen Tera which, it is hoped, will act as the key to the successful consummation of what is called 'The Great Experiment'. This experiment is an attempted resurrection, as much subject to chance as any throw of the dice, and it remains uncertain until the final pages of the last chapter what the outcome will be. Indeed, the experiment, one might argue, has two, radically different, outcomes, for Stoker revised the last chapter, when the book was republished in 1912, to furnish his readers with a palliative ending far milder than the original apocalyptic – and what could be regarded as an appropriately *fin-de-siècle* – conclusion to the first edition of 1903.

[14] Eliot, *Collected Poems*, p. 191.

[15] Thoth (Djehuty) was identified with Hermes in his function as messenger of the gods.

[16] Bram Stoker, *The Jewel of Seven Stars* (London: Arrow Books, 1975).

[17] In literary English usage, the primary sense of *Septentrion* is the north. Both Shakespeare and Milton employed it in this way.

As the story unfolds, the framing narrative and the central plot become inextricably linked as the reader begins to appreciate that Margaret Trelawny is, in effect, the double of Queen Tera. Just as the jewel of seven stars is fashioned in the shape of the Plough, so the living woman appears in the likeness of the dead queen. As above, so below; as in the past, so in the present: time and space take on an aspect of mystery. In the novel, Stoker demonstrates his familiarity with the findings of nineteenth-century Egyptology and it may be conjectured that he was also aware of alternative names for the asterism, particularly one that emphasized the number seven. The number seven and the compass direction of north are recurrent motifs in the novel.

It is repeatedly emphasized that Queen Tera is destined for the North, and that the North is to be identified with the Plough. When Abel Trelawny and his associate, Eugene Corbeck, reach the chamber of the sarcophagus in the Valley of the Sorcerer in Egypt, they find that 'there was everywhere a symbolism, wonderful even in a land and an age of symbolism':

> In every picture where hope, or aim, of resurrection was expressed there was the added symbol of the North; and in many places – always in representations of important events, past, present, or future – was a grouping of the stars of the Plough. [Tera] evidently regarded this constellation as in some way peculiarly associated with herself.[18]

The explorers conclude, from their interpretation of the hieroglyphic inscriptions and their symbolism, that Queen Tera 'had intended her resurrection to be after a long time and in a more northern land, under the constellation whose seven stars had ruled her birth'.[19] By the end of the novel, she has been transported to a cave in Cornwall, where the 'great experiment' takes place.

Where Mallarmé had been subtle in the deployment of his calculus, Stoker was determined to ram his message home. The magical number seven is crucial to the novel. We are told, in no uncertain fashion, that seven was a magic number for Queen Tera: in addition to the seven stars and the corresponding jewel, there is a Magic Coffer of seven sides, seven lamps to illuminate the sarcophagus, and the right hand of Queen Tera has seven digits. This hand, in a gruesome detail of the narrative, has been severed and still bleeds, thus providing the prototype for later melodramatic film versions.[20] Stoker's macabre legacy to posterity, for better and for worse, has been a morbid Mummy and a blood-sucking Count, both seemingly susceptible to repeated reincarnations … in film and fiction.

To conclude, despite a clear divergence in genre and appeal, there is significant common ground between 'Un coup de dés' and *The Jewel of Seven Stars*, a correlation that marks them both out as products of the *fin de siècle*

[18] Stoker, *The Jewel of Seven Stars*, p. 140.
[19] Stoker, *The Jewel of Seven Stars*, p. 141.
[20] Her transposed familiar, the cat belonging to Margaret Trelawny, has seven claws.

and helps to explain their lasting, if quite distinct, attraction for subsequent generations, the former for its recondite allusions combined with meticulous attention to form and the latter for its frisson of horror allied with a pseudo-scientific, but ultimately supernatural, set of explanations. In each case the appeal is to the conjunction of the visual and the invisible (or hidden), in which number symbolism plays a crucial part. One key feature that they share is a focal interest in the Great Bear. It is through the appropriation of this constellation – and, in particular, the asterism of the seven stars – that they approach each other most closely and, perhaps, most fully reveal their affinity as works that are truly representative of the *fin de siècle*; not only with its sense of an ending, but also in its expectation of a new beginning, for the master theme that links 'Un coup de dés' and *The Jewel of Seven Stars* is one that is recurrent in all centuries as they draw to an end and as new ones take their place, and one that can be counted among the compendium of heavenly discourses: a fascination with the enigma of death and resurrection.

TO THE STARS AND BACK:
THE INFLUENCE OF MANNED SPACE FLIGHT
ON SOVIET SCIENCE FICTION

Natalia Karakulina

ABSTRACT: This paper will explore the ways in which Soviet Russian science fiction responded to Iuri (Yuri) Gagarin's flight into space. It will suggest reasons why authors were more likely to set their works in space or on other planets before 1961, and why, as the decade went on, their writing came to explore other themes in science fiction. While the first Soviet fiction works about space appeared already in 1918, it was during the 1934 Congress of Soviet Writers that the role of science fiction was established officially and preferable themes were outlined. Authors who chose to write about the triumph of Communism in the near future were supported, while fiction set in space was discouraged. The optimism that followed the post-Stalin thaw of the mid-1950s was accompanied by an upsurge of science fiction works set in outer space. Ivan Efremov's novel *Andromeda Nebula*, published in 1957, still remains one of the most well known Soviet novels about space. However, in 1961 Iuri Gagarin had shown that space travel was possible, and the space exploration which followed his flight turned space from fiction into the subject of news tabloids. The theme was losing its appeal both to the public and the authors, who turned their attention back to terrestrial concerns. The science fiction of the 1960s tended to become a vehicle for covert criticism of the Soviet system. Censors responded with heightened vigilance, making it much harder for the genre of science fiction to survive. The Strugatskii brothers' novel *The Snail on the Slope* and its difficult publishing history provides an insight into the science fiction of this period.

This paper was prompted by an article in the Russian science fiction and fantasy magazine, *Mir Fantastiki*.[1] The article, dedicated to Iuri Gagarin's flight into space, traced the history of Soviet science fiction, arguing that this historic event caused science fiction writers to seek themes other than space travel for their stories. This paper considers the shift in themes in science fiction literature in the 1960s, and the relationship of this genre to the exploration of space. It concludes that one does not directly follow the other, but instead both are related to larger scientific developments in the world.

In order to trace the impact of Gagarin's achievement on Soviet science fiction, it is necessary to analyse the main arguments and expectations regarding this genre prior to this event. Therefore, I start by outlining the literary atmosphere of the newly established socialist Russia of the early 1920s. Russian literature of that time was going through a period of uncertainty, with many authors

[1] Boris Nevskii, 'Zvezdnyi put': sovetskaia kosmicheskaia fantastika', *Mir fantastiki* 50 (2007), also available online: http://www.mirf.ru/Articles/art2258.htm [accessed 30 June 2015].

welcoming the ideas of the revolution and willing to propagate the will of the party, but not necessarily knowing how exactly to achieve this. The political and moral ambiguity in the literature of the period will be shown using the example of Aleksei Tolstoi's novel *Aelita* (1923).

In the years following the Bolshevik assumption of power in 1917, attitudes to the nature and purpose of literature were diverse. On the one hand, there were countless artists who welcomed the revolution and the idea of a classless society. On the other, different literary groups were fighting for the right to be called the party's official representatives in art, accusing their adversaries of having an anti-socialist mentality.

It was during this time, in 1923, that one of the most well known Russian works of space science fiction, *Aelita*, was written.[2] Its author, Aleksei Tolstoi, used the space travel theories of Konstantin Tsiolkovskii to bring his two protagonists, the scientist Los' and his travelling companion, the ex-soldier Gusev, from the communist Russia of the future to Mars. The planet is inhabited by a humanoid civilization which is suffering from population decline and is facing extinction; however, its leaders refuse to take action, saying that the Martians should peacefully and gracefully accept their fate. This idea is unpopular, and the society is on the brink of civil war. Full of recklessness, Gusev leaps into action, and the revolution on Mars begins. However, after initial success, the revolution is suppressed and the protagonists barely manage to escape back to Earth, with Los' having to leave his Martian lover behind.

This work is generally assigned to the genre of science fiction, as it describes the process of building a rocket and the subsequent space travel. However, it can be argued that those parts of the narrative are included to provide a backdrop for describing social events, the development of characters and their relationships with each other. The editorial board of *Istoriia Russkoi Literatury XX veka. 20-50-e gody*, an anthology of Russian literature of the 1920s to the 1950s, describe *Aelita* as social fantasy, a genre which uses science fiction elements as a setting to focus on certain social and psychological conflicts.[3]

As the Communist party established itself in power, its attention turned more closely towards literature. At the first Soviet Writers Congress in 1934 the Communist party presented writers with a depiction of what literature should aspire to be. Real life, and especially the life of the proletariat, was to become the centre of writers' attention. The party representative Andrei Zhdanov gave a speech outlining what the party expected from the writers. Joseph Stalin called writers 'engineers of human souls', and the Communist party believed that

[2] Aleksei Tolstoi, *Aelita* (Moscow: AST, 2011).

[3] A. Avramenko, B. Bugrov, M. Golubkov, C. Kormilov, A. Ledenev, E. Skorospelova, and N. Solntseva, *Istoriia Russkoi Literatury XX veka. 20-50-e gody* (Moscow: Izdatel'stvo Moskovskogo universiteta, 2006), p. 147.

literature should play a central role in public education.[4] While this gave Soviet writers a high status, it also placed certain restrictions on their work. Zhdanov suggested that in order to become an engineer of human souls, a writer should, among other things, ground his work in real life and not describe imaginary situations or imaginary heroes.[5] Thus science fiction found itself at the margins of Russian literary world. A year later, in 1935, literary critic Mikhail Kozakov, summed up the literary reality of Soviet Russia by saying that Soviet writers were simply not interested in introducing fantastical elements into their work. Kozakov expressed his disappointment at this fact, as he believed that science fiction had the capacity to be the driving force behind inventions and discoveries.[6]

As the century progressed the Communist party accorded great ideological significance to science, and to making Russia the most scientifically advanced country in the world. Rosalind Marsh in her work, *Soviet Fiction since Stalin: Science, Politics and Literature,* talks in some detail about how Soviet authorities exploited literature in their campaign to spread scientific knowledge among the population.[7] While the production of such literature was halted by World War II, from the early 1950s more and more science fiction works appeared. However, their standards were quite different from that of the 1920s. In 1950 the engineer V. Strukova and the academic V. Shevchenko described the conventional views of the period on science fiction. They argue that 'the basis of every good book can be formed by only such scientific theory which is not a pure invention, but a continuation of science, the science of our Tomorrow, following from the achievements of the science of Today'.[8] This article was published in *Literaturnaia Gazeta,* one of the major newspapers reviewing the literary life of the Soviet Union. The authors argue that the most important criteria for judging the success of a science fiction work is its realistic reflection of scientific problems. The authors also criticise the idea (which they find typical

[4] A. Zhdanov, 'Rech sekretaria TsK VKP(b) A. A. Zhdanova', *Pervyi vsesoiuznyi s"ezd sovetskikh pisatelei 1934 (Stenograficheskii Otchot)* (Moscow: Sovetskii pisatel', 1990), p. 4; ('инженеры человеческих душ'). All translations from Russian are my own; I present the original Russian after the reference.

[5] Zhdanov, 'Rech sekretaria', p. 4.

[6] M. Kozakov, 'O fantastichaskikh proizvedeniiakh', *Literaturnaia Gazeta* 28, no. 519 (1935): p. 6.

[7] R.J. Marsh, *Soviet Fiction since Stalin: Science, Politics and Literature* (London: Croom Helm, 1886), p. 6.

[8] V. Strukova and V. Shevchenko, 'Fantastichaskie izmyshleniia vmesto nauchnoi fantastiki', *Literaturnaia gazeta* 5, no. 2596 (1950): p. 3; ('В основу хорошей книги может лечь только такое научное прежположение, которое является не отвлечённым вымыслом, а продолжением науки, наукой нашего Завтра, вытекающей из достижений науки Сегодня'.)

of bourgeois thinking) that humans are incapable of controlling nature.[9]

The idea of humanity taking full control of nature and utilising it to its full potential was dominant at the time, and was described in great detail in what is now considered the most significant science fiction work of the period, *The Andromeda Nebula*. Written in 1957 by Ivan Efremov, the novel has two main plot lines: the crew of the exploratory space ship Tantra are on their way home to Earth, but they are delayed by a forced landing. Meanwhile, their friends back on Earth are awaiting news from the crew. Tantra's struggle to get home and the experiences of the characters on Earth are secondary to the depiction of our planet and the society of the future: communism has fully established itself as the only socio-economic system and there are no individual countries. Human nature itself has changed. Scientific achievements enabled the people to improve the climate and solve starvation. Thus an idyllic world exists, in which every human is driven by the desire to be a useful member of society.

Surprisingly, this novel, which became one of the most frequently reprinted works of Soviet literature, was not mentioned in the discussion on the problems of contemporary science fiction held at the Moscow House of writers in 1960. The general view of the development of science fiction presented at the discussion proclaimed that: 'science fiction writers' direct calling is to stand on the front line of the struggle for our communist future'.[10] The speakers generally agreed that communist society should be at the centre of the science fiction writer's focus. The importance of the viability of scientific elements was also key in the topics of several speakers. This suggests that science fiction was still seen by many mainly as a tool for advancing scientific ideas and introducing them to the public. Several people in the discussion voiced their disapproval of the widespread usage of the space theme, arguing that writing about the near future on Earth should be a dominant theme in science fiction.[11]

In 1957 the Soviet Union launched its first satellite, Sputnik-1, inaugurating a new era. Space became the focus of public attention. In an article from 1960 the literary critic Vsevolod Revich summed up the general mood of the public: 'it is impossible to predict what will be discovered with man's each new step into space, but we know well that surely something will be discovered that even the most vivid imagination has not dreamed of'.[12] In response to public's eager expectation of untold wonders from outer space, the topic became part

[9] Strukova and Shevchenko, 'Fantastichaskie', p. 3.

[10] G. Tushkan in 'Problemy sovremennoi fantastiki', *O literature dlia detei* 5 (1960): p. 238; ('Прямое призвание писателей-фантастов – находиться на первой линии борьбы за наше коммунистические будущее'.)

[11] Anon., 'Problemy sovremennoi fantastiki', *O literature dlia detei* 5 (1960): pp. 328-338.

[12] V. Revich, 'Fantasty, toropites'!', *Literaturnaia Gazeta* 10, no. 4135 (1960): p. 1; ('Невозможно предугадать, что именно будет открыто при каждом новом шаге человека в космосе, но мы хорошо знаем, что обязательно будет открыто нечто такое, что не грезилось и самому пылкому воображению'.)

of public theories and scientific debates. Several months after the publication of Revich's article in August of 1960, two dogs, Belka and Strelka, became the first animals to survive space travel. Less than a year later Yuri Gagarin's achievement presented the final proof that space travel was no longer science fiction. His flight had far reaching consequences not only for space science, but also for the international political atmosphere.

While the world was celebrating space travel becoming a reality, Soviet science fiction was undergoing its own changes. The importance of the quality of scientific information cultivated in literary criticism in the 1950s was slowly replaced by critical articles and essays on the importance of the literary merits of science fiction works. In 1960, A. Siniavskii wrote: 'science fiction is sometimes seen as half-literature, which has to be scientific but does not have to be artistic'.[13] This opinion, which became more and more widespread through the early 1960s goes against the dominant view of the previous decade.

The demand for artistic merit was not the only change that science fiction was undergoing. As space travel became the topic of newspaper reports, science fiction writers turned to other topics. *The Snail on the Slope* by Boris and Arkadii Strugatskii is a prime example of this tendency. Again we are presented by two plot lines: the Bureau and the Forest. At the Bureau for Forest Affairs philologist Perets is trying to see the Forest, but is refused a permit. Neither can he go back home, as he is refused a car. Thus he stays in the Bureau, witnessing its absurd life and strategies for controlling the alien forces represented by the Forest. Alongside this comes the story of the ex-member of the Bureau, Kandid, whose helicopter had crashed in the Forest. He loses his memory and is saved by the aborigines. Kandid has glimpses of his previous life and is determined to return to the Bureau. In his attempt he learns that the Forest is controlled by Amazons who have powers over life in the Forest and who have renounced men. The Amazons are attempting to destroy the aborigines' villages, but their efforts are no more organised than the Struggle of the Bureau against the Forest. The novel finishes with Kandid returning to the aborigines, determined to protect them from the Amazons. Perets, in a surreal twist of events, finds himself the leader of the Bureau, and, under the pressure to create a new regulation, orders the members of the Extermination Division to exterminate themselves.

The novel was originally published in two parts, following the two main characters' story lines. The Kandid part was published first, in 1966, while the Perets part was published nearly two years later in 1968. Shortly after the appearance of the second part, the literary journal *Baikal*, where the Strugatskii brothers published their work, was deemed ideologically improper by the government. There are different opinions on whether this official condemnation

[13] A. Siniavskii, 'Realizm fantastiki', *Literaturnaia Gazeta* 2, no. 6127 (1960): p. 3. ('Научная фантастика рассматривается иногда как полу-литература, которая должна быть вполне научной, но имеет право быть не вполне художественной'.)

was connected to the publication of the novel, but regardless, critics accused the novel of being pessimistic and propagating the inhumanity of scientific progress.[14]

The Strugatskii brothers confessed that the *Snail on the Slope* was first designed to be a space story about the adventures of the astronaut Gorbovskii on a dangerous planet, Pandora. However, according to the brothers, they lost interest in this version of the plot as they wanted the story to introduce issues which were important for them at the time.[15]

In the same article, published in *Literaturnaia Gazeta* in 1970, the Strugatskii's also provided a review of science fiction genre. Written over forty years ago, it still proves to be poignant. They separated 'science fiction' (such texts as *20,000 Leagues under the Sea* by Jules Verne and *Amphibian Man* by Aleksandr Beliaev) from 'realistic fantasy' (the Strugatskii brothers considered such texts as *Master and Margarita* by Bulgakov and *Metamorphosis* by Kafka to fall in this category). According to them, science fiction focused on representing innovative scientific ideas and aimed at educating the population and introducing science to young people. 'Realistic fantasy' (a term created by the brothers) focuses on the relationship among individuals and between individuals and society, using fantastical elements as a background. Therefore science fiction, according to the Strugatskii brothers, is a relatively new genre, born from scientific discoveries, and realistic fantasy is as old as literature itself. The Strugatskii brothers predicted that science fiction would only exist as a genre in a society which valued and was actively interested in scientific achievements, while realistic fantasy would always exist and was likely to become increasingly popular in the future, to reflect the complexities of the modern world.[16]

From 1917 to the 1960s Soviet science fiction underwent a series of transformations: from the uncertain conclusions about Communism, to detailed

[14] L. Ashknazi, '*Ulitka na Sklone*: kriticheskaia retseptsiia, analiz reaktsii kritikov, literatorov i chitatelei', at *Biblioteka Moshkova*, http://fan.lib.ru/a/ashkinazi_l_a/text_2410.shtml (2006) [accessed 8 August 2011].

[15] A. Strugatskii and B. Strugatskii, 'Davaite dumat' o budushchem', *Literaturnaia Gazeta*, no. 4240 (1970): p. 5.

[16] Strugatskii and Strugatskii, 'Davaite dumat'. The full quote reads: 'it is commonly known that a more or less comprehensible theory of science fiction literature does not yet exist. And thus to avoid confusion let us first of all define the terminology... All of the texts of this kind [those, which include fantastical elements] can be spread into a very wide spectrum, on the one side of which we can see... (those texts which are commonly referred to as science fiction), and on the other – ...(those texts which we tend to call realistic fantasy)'. ('Как известно, сколько-нибудь общепризнанной теории фантастической литературы пока нет. И поэтому во избежание недоразумений давайте сразу же договоримся о терминах... Все произведения такого рода [с элементами фантастического] могут быть развернуты в весьма широкий спектр, на одном конце которого расположатся...(то, что обычно именуется фантастикой научной), а на другом – ...(то, что мы склонны именовать фантастикой реальистической)', p. 5.

depictions of innovative scientific ideas, to future utopias. While depictions of communist society on Earth dominated works of Soviet science fiction, space has always remained a popular theme, both for those who wanted to depict a social drama and for those who were interested in exploring the scientific theories of space travel. In the 1960s both the focus and the themes of Soviet science fiction began to change. This was a gradual process; critics began arguing that the push to ground fantasy in the technology of the day has lead to science fiction works having little artistic merit, as one had to be a scientist in order to write them. As fewer writers with a background in science were published, professional writers would more often use science fiction elements as a set up for the development of their characters. This was what the Strugatskii brothers called realistic fantasy. They also suggested that, as writers were experiencing a world which was becoming more and more complex, realistic fantasy would become more and more popular.

Iuri Gagarin's flight into space coincides with this shift in science fiction, thus one might think that Gagarin's achievement directly influenced the writers. However, this relationship between scientific and political developments in the late 1950s and early 1960s is rather complex. While the science and politics of the time represents the great optimism as humankind entered a new era of technological progress, writers of the time become concerned with many complexities which arose from such rapid technological advance.

INTERSTELLAR MESSAGING:
AN EMBODIED PERSPECTIVE

Carrie Paterson

ABSTRACT: This paper proposes using organic molecule signatures for sending interstellar messages in the search for extra-terrestrial intelligence (Active SETI) and suggests how such messages could comprehensively represent our understanding of chemistry and the composition of the universe, as well as the embodied experiences of terrestrial, and not just human, inhabitants. As a thought experiment or a reality, new approaches to Active SETI (as opposed to passive SETI – listening for signals) must be considered. Historically, Active SETI message proposals by government and private agencies have contained embedded cultural assumptions. Existing proposals consider math, music, the Internet, and Twitter as more neutral areas of human culture from which to create a signal, as they would be easily encoded in the required digital form; however, as much information as they would contain, these types of signals would only represent a fraction of the total human experience. The binary aspect of digitizing information is problematic in ways that date back to the onset of biological systems being figured in scientific and cultural discourse as 'mechanical', which later became figured as informatic systems of 'code'. This paper dismantles binary suppositions of interstellar messages to date through a discussion of how signatures of molecules that have a specifically recognizable scent and are therefore meaningful to humans and other creatures could better represent the cultures and microcosms that make up Earth. As background to these ideas and the way humans have studied the sky and given it meaning, the paper connects scent, art and science by reviewing astro-anthropological and scientific findings, including star maps and discoveries of nucleotide bases in meteors and of amino acid/protein precursors in interstellar mediums. While it is widely accepted that radio signals are currently the most suitable way to send interstellar messages, and thus require binary translation, other delivery methods and their implications for the topic of embodiment/signalling are also being considered. Development of laser technologies and space telescopes with high fidelity may prove relevant to these topics as efforts turn toward searching for ETI within an 'intersubjective'[1] communication framework of call-and-(wait for)-response.

This paper suggests rationales and new methodologies for sending interstellar messages in the search for extra-terrestrial intelligence (Active SETI). While it is widely accepted that radio signals are the most suitable way to send interstellar messages, other methods should also be explored. As an example, I propose that an array of lasers with various forms of light polarization and different wavelengths could be considered for sending signals, because a multi-channel signal

[1] David Dunér, 'Interstellar Intersubjectivity: Significance of Shared Cognition for Communication in Space', paper presented at *Communicating Across the Cosmos: How Can We Make Ourselves Understood by Other Civilizations in the Galaxy?*, Mountain View, CA, USA, 10-11 November 2014.

could also be pluralistic and represent in a complex way the multitude of terrestrial environments and embodied experiences of living on Earth. But this is only one way to get around the problems inherent in using binary math, and other hypothetical scenarios should be considered. This paper provides the scientific and astro-anthropological findings that underpin these suggestions. As far as we know, Earth is a unique heavenly body, though new research via the Kepler space telescope mission suggests that habitable planets in the Milky Way galaxy and the universe on the whole are plentiful. Any Active SETI signal sent should acknowledge that life on Earth – and indeed, human intelligence – arises from and is specific to our planetary environment. This paper does not concentrate on technical aspects of how interstellar messages are encoded so as to differentiate a signal from noise.[2] Neither does it concentrate on the physics of polarized optical signals. It will, however cover the historical aspects of interstellar messaging and a critique of how our bodies have been envisioned and translated into binary code for transmission through space. In addition, I lay the groundwork for future exploration of the new potentials for innovation as well as conflicts that technological developments have brought to the science of interstellar messaging, and show how reassessing past efforts can open a window onto creative ideas for constructing future signalling methods.

As an artist-researcher I have studied the history of interstellar communications, both in signalling methods and material documents attached to spacecraft, as well as current trends in this field. While my focus has been on the aesthetics, cultural assumptions and underlying meanings in such constructed messaging, I have also been keen to explore the way humans absorb information through multiple sensory inputs beyond the visual. Sight is, interestingly, privileged in both astronomy and art. To dismantle this innate hierarchy of the senses in both fields is not an easy task – some may say, perhaps, an impossible one – but studying the artworks and communications intended for extra-terrestrial audiences creates an opportunity. Communications meant to represent something as diverse and complicated as 'humanity' have changed over time in fascinating ways, and should keep evolving as we learn to understand ourselves and our universe as comprising many 'dimensions'. One way to move forward is to look beyond our wilful 'blinders' in how we explore space, which makes use of visual tools exclusively. Countering the prejudice toward visuality is a worthy endeavour for cultural discourse as well. In fact, these two activities happen in parallel through interstellar message construction, because any message we send out is also, ultimately, a message we send to ourselves. What the next steps are to be in the effort to send interstellar messages is an open

[2] For an excellent discussion of power laws, including Zipf's Law, informatics, and an analysis of entropy and complexity in communication signals, see Fernando J. Ballesteros, *E.T. Talk: How Will We Communicate with Intelligent Life on Other Worlds?* (New York, Dordrecht, Heidelberg, and London: Springer Press, 2010), pp. 135-40.

question that is important to entertain – be it as a thought experiment or a new signalling method – so as to influence the thinking of scientists who have taken it upon themselves to represent us all, or may do so again in the future.

'Active SETI' is otherwise known as CETI (Communicating with Extraterrestrial Intelligence) and by the more common acronym METI – Messaging Extraterrestrial Intelligence – which was coined by Alexander Zaitsev, an early proponent of trying to contact other sentient beings. While SETI, the search for extraterrestrial intelligence, has been going on since 1959 through individuals, governments like Soviet Russia and organizations like the SETI Institute,[3] and is a kind of cloaked spying, which suggests pre-emptive actions like war, evasion, strategy and control, METI has its own aims, critical and technical issues and social functions to be discussed.

We have been listening to the universe most carefully with large arrays of radio telescopes positioned strategically all over the globe. Presently, SETI activities take place at locations as diverse as Arecibo in Puerto Rico; the University of Western Sydney in Australia; in people's home via the SETI@home project, which solicits individuals to use their personal computers during off-times to analyse data; and the large Allen Telescope Array in Northern California.

Apart from the general noise of radio and TV broadcasts emanating from our planet – making us a loud little dot in the sky – we have been issuing intentional communiqués into space in one form or another since 1972. We have sent solid forms of data with every spacecraft. The *Pioneer* probes, launched in 1972 and 1973, carried small, gold-anodized aluminium plaques featuring drawings of a male and female human, the trajectory of the launch, Earth's location in the galaxy according to our sun's distance from fourteen pulsars, as well as characteristics of hydrogen, the most abundant element in the universe (Fig. 17.1).

The *Voyager I* and *II* probes, both launched in 1977, bear the famous 'Golden Records' with greetings and pictures of Earth; in September 2013, *Voyager I* was announced to have exited the heliosphere (the plasma 'bubble' created by our sun) and has started its journey into interstellar space, with *Voyager II* expected soon to follow.[4] All of the Rover probes sent to Mars carry CDs with thousands of names.

The first radio message designed as a METI communication was sent from Arecibo, Puerto Rico in 1974, a pictogram designed by Carl Sagan and Frank Drake.[5] Over the coming decades, more pictograms were sent by radio astronomer Alexander Zaitsev, as well as his 'Cosmic Call' messages in 1999 and 2003 from 'people as diverse as David Bowie to Ukrainian schoolchildren'.[6] In 2001, the Yevpatoria Deep Space Center in Crimea transmitted the 'First Theremin

[3] http://archive.seti.org/seti/seti-background/ [accessed 1 November 2014].
[4] http://www.jpl.nasa.gov/news/news.php?release=2013-277 [accessed 1 November 2014].
[5] Keith Cooper, 'SETI: Cosmic Call', *Astronomy Now* (3 May 2010).
[6] Keith Cooper, 'SETI: Cosmic Call'.

Concert for Aliens'.[7] And in 2009, the Canberra Deep Space Communications Complex in New South Wales, Australia sent text messages from around the world parsed from HelloFromEarth.net to a possibly habitable planet twenty light years from Earth, Gliese 581d.[8] The last is due to arrive in 2029,[9] and it can be hoped an answer might arrive within the lifetime of one of our currently living human generations.

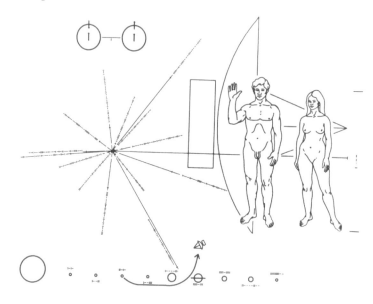

Fig. 17.1: Pioneer plaques, 25 February 1972, NASA.

Our METI communications, as opposed to our SETI activities, have suggested diplomacy. This activity has to continue to be targeted toward appropriate planet candidates in a considerate and careful way. Arguments are frequently made that we need to rethink what we put forth. Every piece of our collective history – mistakes, issues that have surfaced in human conflicts around the planet, the legacies of colonialism and the knowledge of our own biology – might inform what we send. Below I consider why it is important to present an honest portrait of where our species is in its development and evolution, including representations of the function of desire (perhaps a vestigial aspect of reproduction) and our consideration (or lack thereof) for our environment, not only indications of

[7] http://www.thereminworld.com [accessed 1 November 2014].

[8] Leonard David, 'Send ET a Text Message from Earth', *Space.com*, at http://www.space.com/7140-send-text-message-earth.html [accessed 17 November 2012].

[9] David, 'Send ET a Text Message from Earth'.

our so-called 'advanced intelligence', a false measure against which we have as yet found no comparison.

In lieu of any received ET signal, it has been widely observed that METI is likely a time-capsule project. What we send reflects the sender and the historical period. In this undertaking with METI we are in the middle of a great humanistic exercise; our messages primarily show how we communicate amongst ourselves and reveal who we think we are at a particular moment in time. Looking back in hindsight, the reflection we see is not particularly flattering and may be even a little embarrassing, as technological advances drive us rapidly into a more and more sophisticated future and our social morays change.

METI signals are ultimately legacy projects, perhaps to be read long after the human species is extinct. The instigator for the first message on *Pioneer 10*, Eric Burgess, then with the *Christian Science Monitor*, wrote: 'Once there was a planet called Earth that evolved an intelligent species, which could think beyond its own time, and beyond its own Solar System'.[10] There is a bittersweet tone and edge of sadness on the margins of all the enthusiasm for METI. In fact, my take-away from *SETIcon I* (a conference held 13-15 August 2010 by the SETI Institute in the heart of optimistic Silicon Valley, California) was an underlying, unspoken mistrust of humanity to pull itself away from its seeming march toward its own self-wrought destruction. To me, a hint of misanthropy is contained in METI efforts, relating to our incessant wars, constant upheavals, and inability to stave off the most inevitable fate, death. The latter reveals itself in the unreasonable insistence that our only chance for survival – indeed our destiny – is to upload our collective consciousness to artificial intelligence (AI). The *SETIcon I* lectures and others I have since attended have suggested a desire to show 'someone' that humans were once alive; I interpret this as a noteworthy counterpoint to the scientific rationalism that denies the power of religion and 'god' because the wish for a 'someone' still participates in religions' perhaps vestigial function to give comfort before we die.

The existential crisis bordering METI is nevertheless overshadowed by its central, supporting belief system – the conviction that SETI efforts will result in new information about other intelligent, technology-based civilizations during the next few decades. The Drake Equation (Fig. 17.2) is a formula that conveniently determines a massive number of extra-terrestrial planets with characteristics that may bear life and be able to communicate with us.

While this seems totally logical, though now heavily critiqued,[11] and efforts are being made to give it an update,[12] it is noteworthy that the equation also suggests

[10] Ballesteros, *E.T. Talk*, p. 141.

[11] The Drake Equation has been critiqued by many people – from scientists to science fiction authors like Michael Crichton – since it was first articulated by Frank Drake in 1961. For a brief run-down on the critique, see George Dvorsky, 'The Drake Equation Is Obsolete', *Sentient Developments* (31 May 2007).

[12] Many participants at the SETI Institute workshop *Communicating Across the Cosmos*

we will hear from intelligent beings within the lifetime of those humans who advocate for the SETI projects. In other words, we must consider the possibility that the Drake Equation may be cited simply because it provides a backbone for a grand, collective delusion; or more cynically, as a fundraising instrument to leverage capital. If there are no extraterrestrials sending us messages, then, what are we doing of value by conducting SETI and METI activities?

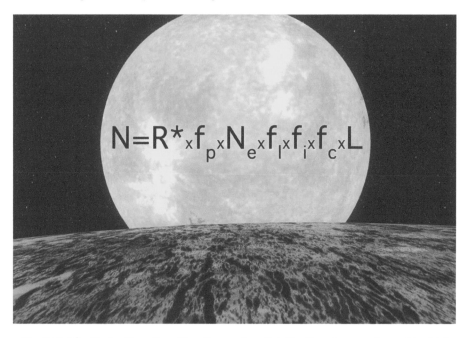

Fig. 17.2: The Drake Equation. N = *the number of civilizations in our galaxy with which communication might be possible; and* R^* = *the average rate of star formation per year in our galaxy;* f_p = *the fraction of those stars that have planets;* n_e = *the average number of planets that can potentially support life per star that has planets;* f_ℓ = *the fraction of the above that actually go on to develop life at some point;* f_i = *the fraction of the above that actually go on to develop intelligent life;* f_c = *the fraction of civilizations that develop a technology that releases detectable signs of their existence into space;* L = *the length of time for which such civilizations release detectable signals into space.*[13]

In the early years of METI, an important role influencing the popular culture of belief in extra-terrestrial intelligence was played by astronomer and cofounder of SETI Carl Sagan, who was enthusiastic about the possibility of ET civiliza-

have proposed ideas.

[13] Text from Lauren Aguirre, 'The Drake Equation', *NOVA ScienceNOW*, 1 July 2008, http://www.pbs.org [accessed 1 February 2012]; background for graphic: View from Planet Kepler-10b, NASA/Kepler Mission/Dana Berry.

tions but also a rigorous critic of any evidence of alien abduction, UFO's, etc.[14] Sagan was inspired to consider exobiological life in our own solar system by the *Viking* probes, which landed on Mars in 1976 and reported the existence of methane in the atmosphere. Methane is unstable due to ultraviolet radiation, so when it exists in large quantities as it does seasonally on Mars, it seems to be an important indicator for astro-biological life; subsequent probes and analysis would yield similar hypotheses.[15] Unfortunately for Sagan, scepticism concerning the *Vikings'* results reigned for nearly thirty years: the probes' readings were dismissed on the grounds that they contained too great a margin of error, certain experiments were found to be not working, and critics noted that methane does occur naturally through volcanism.[16] However, with the sophisticated super-computer modelling available to scientists in the twenty-first century and the availability of large amounts of spectroscopic information, the idea of methane as a life signature on Mars has traction again.[17]

There are interesting cultural dimensions to the shifts back and forth between belief and enthusiasm and scepticism and fear regarding whether or not there is ET life and whether it knows about us. At the risk of being superpower-centric, as a U.S. citizen I have to ask whether there is a coincidence between enthusiasm for METI and our traumatic forays into 'extra-American' environments. One must at least consider the time bracket: the 1970s and the 2000s. The first signals and spacecraft bearing friendly greetings (Fig. 17.3) occurred in parallel with the failure and atrocities of the war in Vietnam. The war and its resulting domestic problems, including the institution of martial law and killing of civilians, is a great shame in the American psyche, and was soon after introduced into popular culture as escapism clothed in filmic scenes of horror, violence, and fear (as film historian Kurt Forman has noted) but also alternatively as 'wonder' of the Carl Sagan variety.[18] Inasmuch as these two modes are different, they are also both spectacular in the phenomenological sense, with viewers (often figured in the films as spectators within the narrative) watching stunned and helpless in the face of larger forces.[19] Contemporarily, the U.S.-led wars in the Middle East now lasting more than a decade have resulted in harsh economic realities, and

[14] http://www.pbs.org/wgbh/nova/space/sagan-alien-abduction.html [accessed 1 November 2014].

[15] Ballesteros, *E.T. Talk*, pp. 44-47.

[16] Ballesteros, *E.T. Talk*, pp. 44-47.

[17] Ian O'Neill, 'Methane on Mars: The Signature for Life?', *Astroengine* (15 January 2009). One scientific goal of the European Space Agency's ExoMars mission for 2016-2018 will be to confirm the quantities and sources of methane in the Martian atmosphere; see http://exploration.esa.int/mars/46038-methane-on-mars/ [accessed 1 November 2014].

[18] Kurt Forman, interview by author, South Pasadena, California, 31 October 2010. Unpublished.

[19] Scott Bukatman, *Terminal Identity: The Virtual Subject in Postmodern Science Fiction* (Durham, NC: Duke University Press, 1993), p. 178.

the 'other 1%' of returning soldiers have an extremely high rate of suicide as well as physical and psychological problems. With the wars in Afghanistan, Pakistan, Iraq and now Syria, there is a need for a great new hope for humanity. We cannot save ourselves from this morass of violence and chaos, we do not like ourselves, and perhaps 'someone' out there just might 'live' this precious life better. Reaching back further to the first onslaught of science fiction in American popular culture during the first Cold War space race and American shame in front of Yuri Gagarin being the first man into orbit, it is clear that space offers one utopian site of resolution/revolution which a secular society has to believe will help it survive.

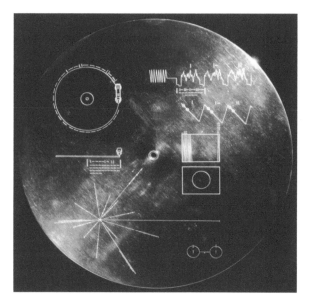

Fig. 17.3: The Cover for the Voyagers' Golden Records, 1977.

In the panel discussion 'Alien Aesthetics: Approaching ET and the Universe with Art and Music' at *SETIcon I*, Doug Vakoch, Director of Interstellar Messaging for the SETI Institute, echoed this thought. He suggested that the human experience to date of 'struggle to survive' is a 'precariousness' that 'an old ET civilization may have surpassed' and of which 'they only have dim recollections'. The assumption here is that survival is ultimately possible, and the goal of civilizations. (Could there be such a thing as a graceful exit?)

How do we put our 'best foot' forward, then? The 'Golden Records' include greetings to an extraterrestrial presence in almost all languages spoken by a million or more people.[20] The greetings are all different – some shorter, others

[20] http://www.jpl.nasa.gov/news/news.php?feature=555 [accessed 1 November 2014].

longer, some more polite, others less formal – all befitting the idea that 'humanity' is made up of a variety of societies and cultures and we want to reach out and say hello. The spirit of cooperation and 'human' connection that accompanies this attempt at communication with extra-planetary realms, if taken sincerely at face value and not as a Trojan Horse, is showing our higher selves.

One particular interstellar message also based in this idea of an 'essential human truth', sent by Drake and Sagan from Arecibo in 1974, features our one great, shared 'human code,' not of conduct, but DNA. While DNA seems quite representative of what makes us human, there are assumptions in this METI signal that need to be considered. As N. Katherine Hayles points out in *My Mother Was a Computer*, 'code' is a particular kind of metaphor for the body that grew out of the concept of the body as a mechanical instrument, which dates back to the Scientific Revolution and Descartes.[21] Body-as-machine, and now body-as-code, are 'very consequential metaphors' that dehumanize, according to Hayles, suggesting improbably that we are – or at least, should be – always on task.[22] As our tools become more-so a part of our flesh, with touch screen technologies and developments in haptic, seamless interfaces to virtual realities, we are nevertheless returning as a species to our primary 'cyborg' state, where we use our hands as primary instruments of communication and our bodies as holistic sensory objects.

I argue that a sense of the whole body needs to be communicated to the stars, not just what we know through the genome, calculations of data, telemetry and observation through ocular devices, all of which reinforce Cartesian power dynamics inherent in observer-observed relationships. As on the *Pioneer* probes, the Arecibo message was a 'picture' of the human body, rather than a 'sense' of it. Its binary transmission when decoded was meant to form a picture of human DNA, almost to the letter the kind of gesture that through Hayles we can determine as problematic. DNA might seem at first to be the most logical message to send: as a 'code,' it describes us organically and our reproduction, solving, or in response to, the *Pioneer* probes' limitations. The *Pioneer* images of man and woman, designed by Carl Sagan and realized by his wife Linda Salzman Sagan, for example, were charged as 'scientific pornography' by religious groups, and thus were censored; as a result, the male and female appear without genitals, the woman's breasts without nipples, removing any indication that we need two sexes to reproduce and subsequently without that basic information, it is not clear what kind of life forms we are.[23]

See Carl Sagan et al., *Murmurs of Earth: the Voyager Interstellar Record* (New York: Ballantine Books, 1978).

[21] N. Katherine Hayles, interview with the author, 5 March 2008. Unpublished. See *My Mother Was a Computer: Digital Subjects and Literary Texts* (Chicago: University of Chicago Press, 2005).

[22] Hayles interview.

[23] Ballesteros, *E.T. Talk*, p. 143.

The Arecibo message consisted of 1,679 bits of information, the product of two prime numbers that form a grid to make a picture of, among other things, a pixilated human and a double helix (Fig. 17.4).[24]

Fig. 17.4: Arecibo message. *Graphic: Arne Nordmann, 2005. Wikimedia Commons.*

Included were also the atomic numbers of the most common elements in the universe: hydrogen, carbon, nitrogen, oxygen and phosphorus; chains of deoxyribose and phosphate, the backbone of DNA; and nucleobases encoded at the 'top' of message.[25] The *Pioneer* and Arecibo examples are 'pictures' at both the macro and micro level – 'essentially' speaking – but are not about what motivates us, what we desire, why we want to have communion with extra-terrestrials (ETs), or anything that would compel an extra-terrestrial species to send a response back to us.

However, the Arecibo message presented the idea that chemistry, apart from math and physics, might be a common language to share with ETs. Could it be more complex and more representative than what we have sent before, or even, what is being considered now? The current search for ET intelligence is being pursued by government and private agencies and is considering using primarily math and music.[26] While these seem most easily encoded in a signal, they only

[24] Ballesteros, *E.T. Talk,* p. 147.

[25] Ballesteros, *E.T. Talk,* p. 149.

[26] 'Alien Aesthetics: Approaching ET and the Universe with Art and Music', panel discussion (*SETIcon I*, Santa Clara, CA, USA, 13-15 August 2010), also see http://meti.org/

represent a fraction of human experience; in addition, there are embedded cultural assumptions in their proposals about beauty and harmony that stem solely from Western traditions.

Much can be gained in a reconsideration of METI by simply rethinking the initial presumption – that recipients will have the eyes/vision to make out forms. Extra-terrestrials also may not use photo-stimulation as their primary sentient trigger:[27] this makes the assumption that 'thought' manifests most intelligently as a result of vision worth reconsideration. What about touch/aural stimulation through sound vibrations? What about scent/taste, which are so important to humans and other creatures of Earth? To represent all our senses, our emissaries into space might instead indicate the valued elements of our planet, our 'gold' – like frankincense and myrrh, sage, jasmine and roses – which all have meaning as offerings and connect to our cultural or even sacred pasts.

At the conference *Space: Planetary Consciousness and the Arts*, held in Switzerland in May 2005, radio astronomer Alexander Zaitsev from the Yevpatoria facility in Crimea that sent the 'Cosmic Call' messages, postulated in a paper co-authored with Richard Braastad that METI could encompass three areas of the arts: the visual, music and dance. The first two seem obvious, but the third is mysterious. How could one encode 'dance'? The ramifications of the suggestion are profound. The suggestion is that we send an art form encompassing haptic, spatial awareness; choreography; and rhythm. Zaitsev and Braastad specifically addressed the role of the body in culture and provisioned sending the 'sense' of our bodies to the stars.

Communication with *others* means going beyond one's body boundary. As an argument in favour of encoding the Fibonacci sequence, the Golden Mean, the fractal Sierpinski Gasket (Fig. 17.5), and pentatonic (5-tone) vs. harmonic (12-tone) scales, music archivist Pierre Schwab remarked, 'The beauty of numbers exists outside ourselves'.[28]

To design new METI signals, Schwab's comment promotes asking the following questions: is it possible to design a signal that reflects something outside ourselves – like math – but also comes from within the frame of subjective experience? What is there of essential importance to us that could also be a common language? How could we construct a METI signal based on human social contexts? Can we define a contract that binds us together as a species – in other words, what do humans have in common, beyond biological functions, that creates society?

strategic-plan-0

[27] Doug Vakoch at 'Alien Aesthetics: Approaching ET and the Universe with Art and Music', panel discussion (*SETIcon I*, Santa Clara, CA, USA, 13-15 August 2010).

[28] Pierre Schwab at 'Alien Aesthetics: Approaching ET and the Universe with Art and Music', panel discussion (*SETIcon I*, Santa Clara, CA, USA, 13-15 August 2010).

Fig. 17.5: Sierpinski Gasket. *Wikimedia Commons.*

My proposal is to create a METI signal that would be a sensual reflection of human culture. It would use complex chemical signatures of molecules that have a specifically recognizable scent and are meaningful to humans and other creatures, so as to better convey the cultures and environmental microcosms that make up Earth and upon which we rely. Organic molecule signatures could also comprehensively represent our understanding of chemistry and the composition of the universe, something proposed by Frank Drake at *SETIcon I*: this would not only be important but plausible. Drake considered sending a signal that was basically a march down the periodic table. The idea I was able to propose to Doug Vakoch at the conference, with positive reception, is instead to use symphonies of elements, composed without hierarchy, that relate something of us and, at the same time, something of our knowledge of the universe.[29]

A few key molecules encoded as part of my proposed composition would reflect both the embodied experiences of terrestrial inhabitants and our discoveries. To give a discrete example, ethyl formate was discovered by the Max Planck Institute for Extraterrestrial Physics in great quantities in the interstellar medium in 2009; this molecule gives rum its scent and raspberries their flavour, but this simple scented molecule is also a precursor to amino acids, which form proteins and DNA.[30] This astonishing discovery occurred during a period of my

[29] I was able to elaborate this proposal in my presentation 'Making Scents of Life on Earth: Embedding Olfactory Information into Multi-Channel Interstellar Messages', in *Communicating across the Cosmos: How Can We Make Ourselves Understood by Other Civilizations in the Galaxy?* (SETI Institute, Mountain View, CA, USA, 11 November 2014); the talk is archived at https://www.youtube.com/watch?v=FWQlop5Yedk, and an article by Tracey Logan on BBC.com summarizes the points. See
http://www.bbc.com/future/story/20141112-will-et-understand-our-messages.
[30] Ian Sample, 'Galaxy's centre tastes of raspberries and smells of rum, say astronomers', 20 April 2009, *The Guardian,* http://theguardian.com (1 May 2009).

own art making between 2008-2010, which helped me to interface with people at SETI and form the idea for this paper and future lectures. At the time, I was making perfume bottles that modelled the solar system. These have references to the coincidence of micro and macro structures, to Plato's idea that the planets travelled around the Earth on hard crystalline spheres, to the Copernican revolution, and to atomic models (Fig. 17.6).

Fig. 17.6: Copernican System No. 1. © *Carrie Paterson, 2009.*

I have been intrigued by the spatial concepts in outdated models and scientific diagrams, which often get something very right about the *culture* of science, even as on the whole they are proven inaccurate or wrong. What I discovered in making this bottle was I had serendipitously made a model of consciousness: self within the mind, within the body, within society, within the world, the solar system, the galaxy, within the universe, and beyond; some might even extend to 'within god'. This three-dimensional spatial model of what I will call 'the embodied mind', after Lakoff and Johnson's Container Schema (Fig. 17.7),[31] had something specific to say to science and particularly to astronomy.

[31] George Lakoff and Mark Johnson, *Philosophy in the Flesh: The Embodied Mind and Its Challenge to Western Thought* (Basic Books, 1999), p. 32. My thanks to Athena Hahn for pointing me to this reference.

B

A

X

Container Schema Logic: X is in A; A is in B
∴ X is in B

Fig. 17.7: Container Schema Logic.

What is the embodied mind? Cognitive scientist George Lakoff suggests our neural connections structure our concepts; therefore, abstractions and philosophy are reflections of, and limited by, our brains. One might therefore extend the idea that bio-chemo receptors play a major part in how we think. We evolved from creatures with a highly adapted olfactory sense and our olfactory bulbs are part of the reptilian brain, the oldest part of brain. Lakoff says, 'Anything we can think or understand is shaped by, made possible by, and limited by our bodies, brains and our embodied interactions with the world. This is what we have to theorize with… Is it adequate to understand the world scientifically?'[32]

For a new METI signal, we can look to ideas generated by star maps. As we focus our attention on parts of the sky, they become emblematic of our civilization and representational of our needs. Where does our current condition meet the star map? What is our environment and how do we reflect that outward? From personal care products to environmental engineering in shopping malls, synthesized environments of petrochemicals have left us bereft of our natural abilities to pick up common and important scents found in nature, to the detriment of culture and neuroreceptors, and by extension, thought itself.[33]

[32] John Brockman, 'Philosophy in the Flesh: A Talk with George Lakoff', 9 March 1999, *Edge*, http://edge.org [accessed 1 February 2012].

[33] Gayil Nalls, interview by the author, 4 October 2011. Unpublished. Nalls is the creator of *World Sensorium*, a social olfactory sculpture/fragrance synthesizing natural essences from 230 different countries' responses to inquiries as to the emblematic scents of their cultures. It was presented at the millennium ceremonies in Times Square in New York, Washington DC and the Vatican with the endorsement of the United Nations; http://worldsensorium.com.

Presented repeatedly at the conference *Heavenly Discourses: Myth, Astronomy, and Culture* were variations on star maps that can be understood as documented cultural projections. Maps and interpretations of star patterns differ greatly. To take one example, the 'Crux' or 'Southern Cross' (Fig. 17.8) is known as a stair in Quechua mysticism; it is a prominent part in the Centaur for the Greeks; the Maori think of it as an anchor; and in Java it is a granary. Some early cave paintings in Southern France are now thought to be star maps, not the least of which is found in the famous caves at Lascaux, where the map of the Pleiades seems to sit on a shoulder of a Bison. There is some debate about this example, but I cite it because whether it is the Pleiades or not, and we may never know for sure, celestial observations as simple as the fact the sky 'moves' in coordination with the seasons – i.e., hunting – indicate that these cave drawings combine astronomical observation with lived earthly experiences. Yes, our visual representations of our observations of the stars have a mythological, symbolic component, but they also meaningfully tell us about the activities of our bodies. The interpretations stand after millennia, and are a pictographic DNA, connecting us back to our ancestors, to their campfires, to the movement, size, smell and taste of the Bison.

Fig. 17.8: The Southern Cross. Image © Yuri Beletsky, graphic overlay by the author.

Before I met Gayil Nalls at *Scents and Medical Sensibilities* in Washington DC in 2010, an exhibition that included both our artworks, I had started playing with skeletal formulae from organic chemistry, thinking that charting the stars in the sky using chemistry would be most reflective of our historical moment, including a kind of tricky place for feminists that see social constructions/mythology as the flip side of biological determination, but nevertheless integral components of the same social currency. This was in 2009, and my *Chemisphere* star-map (Figs. 17.9-10) has since been in development as a multi-sensory fine art print and installation.

Fig. 17.9: Chemisphere, *56 x 22 inches, ink and fragrant oils on vellum;* © *Carrie Paterson 2009.*

Fig. 17.10: Chemisphere, *detail Southern Sky;* © *Carrie Paterson 2009.*

Of the molecules that would have significant factors for human recognition and appreciation, I chose those I felt were best connected to culture in specific regions; for example, globulol, the scent of rose, and beta-caryophyllene, a cannabinoid. To go back to the 'Crux', there I placed indolall, a critical odor for humans that is part of what we identify as a faecal smell. Oddly enough, this molecule is also used in perfumes – it acts on your receptors subtly under all those flowery and musky notes, making you crinkle your nose, sniff, and sniff again. Placement in the sky was also important; next to indolall is a large nebula, the 'Coal Sack', which I thought was a relevant association, as indolall is part of

a suite of molecules used to make so-called 'dirty' notes.

Because the interstellar medium is teeming with organics, my *Chemisphere* star-map includes not only significant stars, but also interstellar gas clouds, as points. A function of stellar death and the ejection of massive amounts of carbon, galactic systems and the interstellar medium are plentiful in 'aromatic' compounds (characterized by a benzene ring, not necessarily scent) and chains of hydrocarbons,[34] many of which, like the rum-flavoured ethyl formate, are crucial to the production of 'life'.

The more astonishing connections made recently between the mechanisms of the universe and the chemistry of life comes in several confirmations that amino acids and nucleotide bases can be formed off-planet, specifically in the atmosphere of Saturn's moon Titan and on meteors. In 2010 a research team from the University of Arizona announced at the Planetary Science Division of the American Astronomical Society's annual conference that nucleobases may rain down on the surface of Titan in great quantities, spontaneously forming in the upper atmosphere as deduced by production of such in similar laboratory conditions; this has additionally been confirmed by scientists at NASA's Jet Propulsion Laboratory and astrobiologists at NASA Ames.[35] In 2011 it was confirmed that nucleobases are found on meteorites.[36] (Fig. 17.11).

In 2012, speculation emerged that Earth itself in its earliest years, when the planet was just beginning to breed simple life forms, was struck by such a bombardment that life-bearing Earth *ejecta* could have been flung far and wide across the galaxy.[37]

This would be exciting news for the star system of Gliese 581 and its super-Earth known as 'd', which orbits in what is understood to be the edge of the temperature constraints that permit liquid water – the 'habitable zone' (Fig. 17.12).

[34] http://amesteam.arc.nasa.gov/Research/cosmic.html [accessed 5 November 2014].

[35] *Astronomy*, 8 April 2013, http://astronomy.com [accessed 5 November 2014]. It was recently pointed out to me by the Australian science journalist Morris Jones that although Titan may very well be littered with nucleic acid materials, we don't know of any heat sources that could create the necessary spark there for life.

[36] 'Carnegie: Meteorites – Tools for Creating Life on Earth', in the *Proceedings of the National Academy of Sciences*, 8 August 2011, http://spaceref.com [accessed 5 November 2014].

[37] Tetsuya Hara, Kazuma Takagi, and Daigo Kajiura, 'Transfer of Life-Bearing Meteorites from Earth to Other Planets', 8 April 2012, http://arXiv.org [accessed 29 April 2012].

Fig. 17.11: Nucleobases and analogues found in carbonaceous chondrites. Image: NASA's Goddard Space Flight Center/Chris Smith.

A team of Japanese physicists have calculated that 'the probability is almost one' that our solar system contains microorganisms from an exosolar system, and that meteorites originating from the bombardment of Earth would have taken only one million years to reach those planets orbiting Gliese 581.[38] Accreted molecules would need to be covered by ice or other elements in order to endure cosmic radiation during the travel.[39] But the hypothesis gives credence to the panspermia idea of life in the universe, making all efforts to message 'others' not just a thought experiment, but also one that may bring real results. Future SETI/METI activities are dependent on better transmission/reception sites, for

[38] Hara et al., 'Life-Bearing Meteorites'.
[39] As also elaborated by Wallis and Wickramasinghe, 2004.

Fig. 17.12: Planets of the Gliese 581 System, rendering by Lynette Cook, with newly discovered habitable zone planet GJ 581g in the foreground. NASA.

example on the dark side of the Moon,[40] and will inspire more discussion about an appropriate and democratic response or greeting from the citizens of Earth. Participants at *Communicating Across the Cosmos* posed many such questions about fair 'representation' of Earthlings and 'cultural diversity' in a message to ET civilizations. It was acknowledged that thus far, the enterprise of trying to contact alien intelligence has been impulsed by the few attempting to speak on behalf of the many, principally from an ideological Western frame of reference and from within the scientific community. Now, we all must begin a deep consideration about what communication is, how we go about it in our daily lives on Earth, and what we might do differently. In addition, a considered appreciation for our 'biosphere'[41] as an integrated whole comprising evolution,

[40] TEOSETI (Tradate European Optical SETI) will be best suited for the dark side of the Moon, Astro Tiare. 'Interview with Bruno Moretti: A radio telescope on the far side of the Moon', *SETI cl.* 10 June 2010, http://seti.cl [accessed 10 January 2012].

[41] I use 'biosphere' in reference to Vladimir I. Vernadsky, early twentieth–century Russian scientist who proposed that life is a geobiochemical evolutionary force. His suggestion, more than half a century before James Lovelock's Gaia theory, is that life terraforms planets, and thus we might extend, intelligent life that much more so because of the way tech-

chemistry, and intelligence must inform how we think about our bodies and our environment, both of which have little chance of survival beyond the boundaries of our atmosphere, except, perhaps, in an intentional message.

nology changes the pace of this geobiochemical evolution.

FICTIONAL EXPLORATIONS OF ASTRONOMY: HOW TO REACH THE PARTS OTHER NARRATIVES MISS

Pippa Goldschmidt

ABSTRACT: In this paper I look at the way that astronomers report their work, and attempt to show that this reporting necessarily leaves out important aspects of how that work is done. I argue that literature can investigate aspects of astronomy in ways that scientific reports are not always able to do. Literature can look at how and why astronomy is done, and what impact it can have at a human level. And it can also be used to communicate the processes of doing astronomy to a wider audience.

Let's start with examining the way that astronomy is usually reported: through formal scientific papers mostly published in peer-reviewed journals. The ostensible aim of these papers is to present a problem and a solution. The solution can be found through experiment or through theory. The solution can actually be a sort of anti-solution, in that it can rule out existing solutions and not actually postulate anything to replace them.

Scientific papers have elements in common with a detective story. The problem is set up and defined in the opening paragraphs, the preferred approach to solving the problem is explained, the results of that approach are presented and analysed, and the outcome is identified and discussed, along with the resulting impact on the existing science and possibilities for future work. There is a clear and logical sequence to the events and an implicit chronological structure. There is a beginning and an end. Hey presto – we have a narrative.

But note the following excerpts from papers published in astronomy journals:

- 'A recalculated value of the mass of Ceres is presented'.[1]
- 'A sample of 87 quasars were chosen at random...'[2]
- 'Observations of 0217+70 were made with the NRAO Very Large Array (VLA)'.[3]

[1] A. B. Kovacevic, 'Determination of the mass of Ceres based on the most gravitationally efficient close encounters', *Monthly Notices of the Royal Astronomical Society* 419, Issue 3 (January 2012): p. 2725.

[2] P. Goldschmidt, M. J. Kukula, L. Miller, and J. S. Dunlop, 'A Comparison of the Optical Properties of Radio-loud and Radio-quiet Quasars', *Astrophysical Journal* 511, no. 2 (February 1999): p. 612.

[3] S. Brown, J. Duesterhoeft, and L. Rudnick, 'Multiple Shock Structures in a Radio-Selected Cluster of Galaxies', *Astrophysical Journal Letters* 727, no. 1 (January 2011): p. 25.

- 'The data were calibrated...'[4]
- 'Absolute visual magnitudes were calculated...'[5]

There is a ghost in this machine. Where is the narrator? He or she has been banished through the use of the passive voice. In all of these excerpts, the writers have absented themselves. So the reader is faced with a curious inevitability to the whole affair, as if events have unfurled like clockwork.

This tradition of using the passive voice may have developed to encourage a belief in the universality and objectivity of the actions and results being reported. If the individual is not present in the work, then there can be nothing subjective in the findings or nothing specific or unique in the doing of this piece of work by these particular people. Now note these excerpts, also taken from papers published in astronomy papers:

- 'We present a model for star formation and supernova feedback'.[6]
- 'We achieve photometric redshift accuracies competitive with other... techniques'.[7]
- 'We use semi-analytic techniques to study the formation and evolution of brightest cluster galaxies'.[8]
- 'We present an analysis of the host properties of 85,224 emission-line galaxies'.[9]
- 'We show that disks heated primarily by external irradiation always satisfy the standard cooling time criterion'.[10]
- 'We discovered a previously unknown M-star companion to HD 1051'.[11]

[4] B. S. Mason, E. M. Leitch, S. T. Myers, J. K. Cartwright, and A. C. S. Readhead, 'An Absolute Flux Density Measurement of the Supernova Remnant Cassiopeia A at 32 GHz', *Astronomical Journal* 118, no. 6 (December 1999): p. 2918.

[5] S. M. Faber, 'Variations in Spectral-Energy Distributions and Absorption-Line Strengths among Elliptical Galaxies', *Astrophysical Journal* 179 (1973), p. 423.

[6] V. Springel and L. Hernquist, 'Cosmological smoothed particle hydrodynamics simulations: a hybrid multiphase model for star formation', *Monthly Notices of the Royal Astronomical Society* 339, Issue 2 (February 2003): p. 289.

[7] J. E. Geach, 'Unsupervised self-organized mapping: a versatile empirical tool for object selection, classification and redshift estimation in larges surveys', *Monthly Notices of the Royal Astronomical Society* 419, Issue 3 (January 2012): p. 2633.

[8] G. de Lucia and J. Blaizot, 'The hierarchical formation of the brightest cluster galaxies', *Monthly Notices of the Royal Astronomical Society* 375, Issue 1 (February 2007), p. 2.

[9] L. J. Kewley, B. Groves , G. Kauffmann, and T. Heckman, 'The host galaxies and classification of active galactic nuclei', *Monthly Notices of the Royal Astronomical Society* 372, Issue 3 (November 2006): p. 961.

[10] K. M. Kratter and R. J. Murray-Clay, 'Fragment Production and Survival in Irradiated Disks: A Comprehensive Cooling Criterion', *Astrophysical Journal* 740, no. 1 (October 2011): p. 1.

[11] D. R. Rodriguez and B. Zuckerman, 'Binaries Among Debris Disk Stars', *Astrophysical Journal* 745, no. 2 (February 2012): p. 147.

- 'We examine how the time variation of the gravitational constant influences the variation of the orbital elements of planets'.[12]

Here, instead of the passive voice, the collective voice is being used. Quite often, the collective voice is used in the abstract of the paper and the passive voice is used in its main body. Does this use of the collective voice help stamp authority on the reported work and findings?

As a result of the use of these grammatical structures, the interior background to the work, including the interaction between the individual authors and their world, cannot be fully explored. If 'Dr Nobody' or 'Dr Us' is reporting this work, then which individuals made the decisions? It means we cannot fully understand the choices made by the narrators because they cannot discuss themselves. And if the choices are not scientific, they become invisible in the traditional scientific narrative.

Does popular science do any better? We might assume that it is not as constrained as more formal papers. The following are examples taken from the reporting of science on various news websites:

- 'Scientists are to expand a clinical trial of a new malaria vaccine'.[13]
- 'Scientists track falling satellite'.[14]
- 'Scientists have created autistic mice that could help unlock the riddle of the increasingly common condition'.[15]
- 'A team of Russian and American scientists will set off on an expedition this week to try to solve the mystery of the Abominable Snowman'.[16]
- 'Scientists have detected higher than expected energy emitting from the Crab Nebula'.[17]

You can see that language is not exactly used to its fullest effect here. The people responsible for all these different activities and experiments do not even have

[12] L. Li, 'Influence of the time variation of the gravitational constant on the orbital elements of planets', *Monthly Notices of the Royal Astronomical Society* 419, no. 3 (January 2012): p. 1825.

[13] Matt McGrath, 'Malaria vaccine trial raises hope' at http://www.bbc.co.uk/news/health-15008866 [accessed 12 January 2012].

[14] Ian Sample, 'Scientists track falling satellite expected to hit Earth this week' at http://www.guardian.co.uk/science/2011/sep/21/falling-satellite-to-hit-eart [accessed 12 January 2012].

[15] Fiona MacRae, 'Scientists create world's first autistic mice in bid to unlock riddle of condition' at http://www.dailymail.co.uk/health/article-2045701/Scientists-create-autistic-mice-lead-new-drugs-condition.html [accessed 12 January 2012].

[16] Anon, 'Scientists set off to find the abominable snowman' at http://www.bbc.co.uk/news/world-15167866 [accessed 12 January 2012].

[17] TWS Space reporter, 'scientists detect 'stunning' energy gamma ray emission from Crab Nebula' at http://www.theweatherspace.com/news/TWS-100711_gamma-ray-crab-nebula-energy.html [accessed 12 January 2012].

proper job descriptions – they are all lumped together under that generic term 'scientists'. They are rendered anonymous, as faceless white coats. Apart from some fine individual examples of biographies of famous scientists, in most popular science there is little interest displayed in the humans behind the work.

Why is this important? It means there are gaps in the narrative, and these gaps are human sized. As an extreme example, a purely scientific account of Galileo's observations of the moons of Jupiter cannot show one of the most revolutionary aspects of this discovery: what the destruction of the Earth-centred model of the universe implied for the all-powerful religious authorities of the time.

Can literature do any better? If so, why? Because, even if there is no science overtly in the text, there may be similarities between what motivates a writer and what motivates a scientist. And that desire lies in not knowing, and wanting to know, the outcome to an initial set-up. Writing a story entails following the logic implicit in the set-up. For example, the premise of Flaubert's novel, *Madame Bovary*, can be expressed as the following: 'what happens if a young woman becomes bored with her life and takes a lover or two?'. The set-up of *Timescape*, the science fiction novel by Gregory Benford, can be expressed as: 'what happens if people are able to transmit warnings back to the past about impending ecological disaster?'.

Literature can be considered to be a type of thought experiment.[18] Just like scientific thought experiments, they are another way of testing out hypothetical scenarios. As I said earlier, even formal scientific papers rely on a narrative structure, in the way that literature does, and thus there are aspects in common between science and literature. Let's look at how literature can investigate science and what this investigation can uniquely add to our understanding. For example, John Banville's two novels about Copernicus and Kepler attempt to situate these astronomers' discoveries within their lives and to explain where their discoveries came from.[19] They imagine an answer to the question 'what was it about these men's characters and lives that made them see the universe in such revolutionary ways?'.

The novels can inhabit real characters, invent new characters, and fill in the holes of imperfectly documented lives, so readers feel they can understand the reasons behind the discoveries. Literature's liberty to explore lives without being tied to documented facts may mean the end results are not historically true, but they can be psychologically true.

We will never know if Banville's account of how Kepler came up with his laws of planetary motion is the way it actually happened, but thanks to Banville's ability as a writer, when we read his account we believe it might have happened

[18] P. Swirski, *Of Literature and Knowledge: Explorations in Narrative Thought Experiments, Evolution, and Game Theory* (Oxford: Routledge, 2007).
[19] John Banville, *Kepler* (London: Secker and Warburg Ltd, 1981); John Banville, *Doctor Copernicus* (London: Secker and Warburg, 1976).

in this way and that allows us to think about Kepler and his work in a more concrete way. Literature makes science human-sized; it shows us how and why humans engage in science, what their concerns are with it, and how it impacts on them.

One of the most powerful tools that literature uses to make concepts tangible is metaphor. For example, here is Banville's Kepler musing on Copernicus' heliocentric model and its inadequacies in its reliance on epicycles and equants:

> It was as if the master [Copernicus] had let fall from trembling hands his marvellous model of the world's working, and on the ground it had picked up in its spokes and the fine-spun wire of its frame bits of dirt and dead leaves and the dried husks of worn-out concepts.[20]

In another passage, Banville shows how Kepler is spurred on by the desire to find harmony in the seemingly chaotic observations bequeathed to him by Tycho Brahe:

> Troubled by inelegance in the Ptolemaic system, Copernicus had erected his great monument to the sun, in which there was embedded the flaw, the pearl, for Johannes Kepler to find... Harmony was all. And harmony as Pythagoras had shown was the product of mathematics, therefore the harmony of the spheres must conform to a mathematical pattern.[21]

Here the flaw in the Copernican model is compared to a pearl; not only is this biologically accurate, but it is also a powerful way of illustrating the value to Kepler of finding this flaw. Banville's Kepler is motivated by a desire for symmetry and simplicity in the same way that a modern astronomer might be, but what gives us pause for thought is the fact that this desire is expressed in very different ways. For example, Kepler is desperate to link the relative distances between planets to other patterns found in nature, such as musical harmonics or the relative sizes of Platonic shapes. Banville, having brought this dilemma to life, beautifully illustrates two ideas:

1. Are Kepler's apparently misguided attempts to identify order and patterns in the universe in any way similar to contemporary scientific work?
2. Even though the initial premise behind Kepler's work looks misguided, the outcome is correct. Kepler's laws are empirically valid.

I think literature's ability to link science with humans is especially important for those scientific disciplines which are not human-sized to start with, such as astronomy, geology, or nuclear physics. It's difficult to imagine a successful novel about atoms unless you humanise them, but you could write a novel set

[20] J. Banville, *Kepler*, p.28.
[21] J. Banville, *Kepler*, p.29.

in CERN. The challenge is always to make sure that the science is integral to the plot and not just there as high-concept decoration.

So, is literature just experiment? Is it totally synonymous with science? When we write fiction, is all we are doing simply experimenting in a made up world?

There are differences, and some of these differences lie with the reader. When a writer of literature writes, they set up the initial conditions of their thought experiment. They may or may not describe the outcome or interpretation of that experiment. But regardless of how specific they are about the outcome, it is always incomplete until the reader or audience 'experiences' the experiment and comes to their own conclusion.

This conclusion may not be what the author anticipated, but unlike the scientist, the author may not want to anticipate any specific reading of their work. Because of this incompleteness in the work, the reader is as essential as the writer to the overall process of carrying out the experiment.

This is different to the ostensible aim of the thought experiment in science in which the experimenter is aiming for a clear result. Indeed, this incompleteness in literature is probably essential to its success. Let's look at a counter example, at what can happen when things start to get too assertive. The playwright Bertolt Brecht rewrote his famous biographical play, *Life of Galileo*, several times. The first version, written in the late 1930s, shows Galileo as a wily old man by the end of the play, publicly telling the Catholic Church and its inquisitors what they want to hear, but only as a strategy for survival so that he can secretly carry on with his work. In this version, he's a typical Brechtian anti-hero, fully able to subvert the power of the authorities for his own purposes.

The second version of the play was written when Brecht was in America at the end of the war, at the time when the atom bomb was dropped. The work of the Manhattan Project, which had until then been secret, became public. In response to this, Brecht rewrote the play to show Galileo as someone who recants his life work, simply out of fear of the Inquisition. Even when other characters in the play attempt to put a better gloss on his actions, he corrects them and says he was afraid of being tortured and that is why he gave in. In this version Galileo has a long speech at the end of the play in which he says:

> Science's sole aim must be to lighten the burden of human existence. If the scientists, brought to heel by self-interested rulers, limit themselves to piling up knowledge for knowledge's sake then science can be crippled and your new machines will lead to nothing but new impositions. Your cry of triumph at some new achievement will be echoed by a universal cry of horror. As a scientist I had a unique opportunity. Had I stood firm the scientists could have developed something like the doctors' Hippocratic oath, a vow to use their knowledge exclusively for mankind's benefit.[22]

[22] Bertolt Brecht, *Life of Galileo*, trans. J. Willett (London: Methuen London Ltd, 1986), p. 108.

So the moral of the story has completely changed in this version, from 'subvert the authorities in any way possible', or 'the ends justify the means' to 'behave in such a way as to set an example to others, or the means are all-important'.

Obviously a character's beliefs are not necessarily synonymous with those of the author. But it is clear that the speech I have just quoted was written by Brecht in response to his horror at what scientists had created in Los Alamos. However, Brecht damages his argument through its reliance on polemic. His attempts to force the audience to come to a particular conclusion risk making the narrative too mechanical. We stop believing in the inner lives of the characters. This did not bother Brecht, but it should have, because when literature becomes so categorical and assertive there is a danger that it can be used for the same political ends of which it accuses science.

Does science require the same certainty as propaganda? Is it the purpose of a scientific text to convince the reader that there is only one interpretation?

This may indeed be the purpose of the writer, but the reader is free to reject it. There is a difference between the ostensible aim of scientific writing and its reception. In practice, other scientists read scientific accounts in order to test them, to pick holes, and to find the gaps in logic and the uncertainties in the data. These gaps are essential; out of these spring the new work.

However, even if the literary experiment fails in some ways, it can still be said to succeed in its ability to communicate. Almost by definition, a literary work on science reaches out to new audiences. To summarise, I have attempted to show that literature is a valid way of investigating science and should be seen as complementary to scientific descriptions of the world. Conversely, science has great potential for helping literary writers to define their universes.

PART THREE: DISCOURSES IN SOUND

HEAVENLY DISCOURSES:
MYTH, ASTRONOMY AND CULTURE

June Boyce-Tillman

ABSTRACT: This paper will examine the ways in which music and the heavens have been variously linked using a phenomenographic model of the musical experience.[1] It will examine the use of celestial subjects in the expressive area of the experience citing such pieces as Holst's *The Planets*. It will also interrogate the visionary experience in the creative process in the work of composers like Hildegard of Bingen.[2] In the domain of Construction it will examine the notions of Platonic proportions and how these are found in ways in which pieces are constructed with such ideas as the Golden Sequence.[3] It will look at areas where heavenly Values have impinged on musical pieces. In the area of Materials it will look at connections between music and the natural world. This paper will set out a model of understanding the way in which various periods in western culture music and the heavens have been linked.

Opening Song

CHORUS:
Sing us our own song the song of the earth,
The song of creation, the song of our birth,
That exists in belonging to you and to me,
To the stars and the mountains, the sky and the sea.

1. Listen! You're hearing the song of the earth,
They sing it who know of their value and worth,
For they know they belong with the sea and the sky,
To the moonshine at midnight, the clouds floating by.
CHORUS

2. It is not one song but patchworks of sound.
That includes all the pitches that people have found
That includes the vibrations of earthquakes and bees
Of the laughing fire's crackling and murmuring bees.
CHORUS

3. All blend together to make the earth song,
Fragmented parts separated too long,
True notes and rhythms and colours and beat
Make sacred spaces where we all meet.
CHORUS[4]

[1] June Boyce-Tillman, *A Rainbow to Heaven* (London: Stainer and Bell, 2006).

[2] June Boyce-Tillman, 'Music as Spiritual Experience', *Modern Believing: Church and Society* 47, no. 3 (3 July 2006): pp. 20-31.

[3] Jamie James, *The Music of the Sphere: Music, Science and the Natural Order of the Universe* (London: Abacus, 1993).

[4] Boyce-Tillman, *A Rainbow to Heaven*.

Framework

I start with this song as it represents my attempt to restore the connectedness of music including its connection with the heavens. Throughout the history of Western music, spirituality or the heavenly and music have been associated – from the ancient goddess traditions.[5] It was seen, as the opening song suggests, as connecting human beings to one another, to God and spiritual or heavenly beings and to the earth. Inspiration was seen for the vast majority of Western history to come from some heavenly source, whether it be the Muses or God. It was in the hands of the philosophers of the Enlightenment that the link between music and the heavenly became weakened and the search for the spiritual became an essentially human search located in the unconscious, rather than one rooted in the essentially exterior spirituality of the heavens.[6]

The spiritual became associated with notions of self-actualisation and self-fulfilment in Maslow's hierarchy of human needs in which he included the aesthetic – the need for beauty, order and symmetry.[7] As Western culture edged towards an aggressive individualism, a sense of finding some place in a larger whole – the cosmos – became a priority in the human search.[8] But this was now to be sought by exploring the heavens materially rather than with the imaginal mind.

This process of objectifying the cosmos associated with the advance of science had not happened in the same way in Eastern cultures; and it was on these cultures that the New Age and some areas of rock and jazz traditions drew, in order to offer the desired sense of relationality.[9] This included a more holistic view of the mind/body/spirit relationship, with transcendence approached through physical practices such as chanting or dancing.[10]

This paper will look at the heavenly through the lens of the spiritual. It will use a phenomenography of the musical experience to examine different

[5] For ancient goddess traditions see S. Drinker, *Music and Women, The Story of Women in their relation to Music* (1948; City University of New York, The Feminist Press, 1995); for Plato see Joscelyn Godwin, *Music, Magic and Mysticism: A Sourcebook* (London: Arkana, 1987), pp. 3-8; for Hildegard of Bingen see June Boyce-Tillman, *The Creative Spirit- Harmonious Living with Hildegard of Bingen* (Norwich: Canterbury Press, 2000).

[6] Jonathan Harvey, *Music and Inspiration* (London: Faber and Faber, 1999).

[7] bell hooks, *Killing rage, ending racism* (London: Penguin, 1996).

[8] Abraham H. Maslow, 'The Creative Attitude', in *Explorations in Creativity*, ed. Ross L. Mooney and Taher A. Razik (New York: Harper and Row, 1967), pp. 40-55.

[9] For New Age see June Boyce-Tillman, *Constructing Musical Healing: The Wounds that sing* (London: Jessica Kingsley, 2000), pp. 155-66; and for some areas of rock and jazz traditions see Peter Hamel, *Through Music to the Self – How to appreciate and experience music anew*, trans. Peter Lemesurier (Tisbury: Compton Press, 1978 [first published in German in Vienna, 1976]), pp. 134-35.

[10] For chanting see Robert Gass and Kathleen Brehony, *Chanting: Discovering Spirit in Sound* (New York: Broadway Books, 1999).

dimensions of the musical experience. It will draw largely on Western classical traditions, which will base them largely within a frame of Christianity.

A Phenomenography of the Musical Experience

This paper draws on this history to establish four domains of the music experience. To take Allegri's choral piece *Miserere* from sixteenth-century Italy, in the area of Materials it consists of a choir. In the area of Expression it is peaceful with fluctuations as the plainchant verse come in. In the area of Construction it is an alternating psalm with full harmonic verses and plainchant alternating verses. This is intimately related to its role as a psalm, liturgically. In the area of Value it is held as a masterpiece within the western canon of music and is frequently recorded and achieved a place in classical music charts; it represents an important statement about the Christian's attitude to penitence based on a Jewish psalm, especially as expressed at the beginning of the penitential season of Lent.[11] Drawing on these it is clear that the musical experience contains a number of different domains that the experiencer enters during the experience (which here includes a variety of ways of musicking-listening-in-audience, composing/improvising, performing/improvising).[12] They are:

> Expression – the area of feeling, emotions and associations
> Values – the area of culture of the music and the experiencer
> Construction – the world of abstract ideas
> Materials – here materials from the environment are used as sound sources

All music consists of organisations of concrete Materials drawn both from the human body and the environment. These include musical instruments of various kinds, the infinite variety of tone colours associated with the human voice, the sounds of the natural world and the acoustic space in which the sounds are placed. In indigenous cultures the relationship with the natural world is central to their belief system and the process of using the earth materials for instruments had/has a sacred dimension. The process of choosing the tree to give its wood for the drum would be surrounded by religious ritual. On the drums from the Sami people of northern Scandinavia the mixture of their religious tradition is apparent with some images of indigenous sacred objects – trees, reindeers and so on – intermingled with images of churches. The drum in indigenous cultures is a sacred instrument having similar qualities to sacred objects like the bread

[11] June Boyce-Tillman, (2004), 'Towards an ecology of Music Education', *Philosophy of Music Education Review* 12, no. 2 (Fall 2004): pp. 102-25; Boyce-Tillman, 'Music as Spiritual Experience', pp. 20-31.

[12] Elsewhere I have linked this musical experience with the notion of encounter and I use the frame of the 'I/Thou' experience described by Martin Buber, *I and Thou*, trans. Walter Kaufmann (New York: Charles Scribner's Sons, 1970); June Boyce-Tillman, *Experiencing Music – Restoring the Spiritual* (Oxford: Peter Lang, 2016).

and wine of Christianity.

Other religions also have retained the idea of sacred qualities associated with particular instruments, like the association of meditation with the *shakuhachi* of Buddhism. This is used for the practice of *suizen*–blowing meditation. The sound is full of breath and allows the overtones to play freely around the main note. As such it reminds the player and listeners of their bodiliness – the breath being central to the work of music in the body. In other traditions like Christianity particular instruments are associated with the holy spaces – like the organ – but as Western culture alienated itself from the natural world this profound link with the natural world is no longer seen as having sacred qualities.

However, in my opinion, this is an area of the musical experience in which Western music could re-establish the role of the material world as an experience of the spiritual in the West. Modernism traditionally denied this for a world of abstraction.[13] Within Western theology, human beings became alienated from the natural world – or indeed superior to it. This resulted at best in a patronizing stewardship and at worst domination and outright rape. All music making using instruments involves human beings in contact with the natural world. It is one of the most intimate relationships human beings have with the environment other than eating it. In traditional societies a drummer would reverence the tree and the animal that give the material for his/her drum. Sadly in the West the loss of the connection with the natural world has been reflected in the way we treat and regard instruments. We need to re-establish this reverence in relation to instruments in our Western fragmented culture.

The domain I have called Expression is concerned with the evocation of mood, emotion (individual or corporate), images, memories and atmosphere on the part of all those involved in the musical performance. It is the area where emotions are validated within the experience and this was crucial in William James' writing on the spiritual experience, originally in 1903.[14] This is where the subjectivity of all involved – composer/performer and listener – intersect powerfully. The listener may well bring extrinsic meaning to the music-meaning that has been locked onto that particular piece or style or musical tradition because of its association with certain events in their own lives. Popular music, in particular, often conjures up a range of associations as does hymnody, associated as it often is with significant rites of passage like baptism, marriage and death. The phrase 'They are playing our tune' reflects the association of certain emotional events with certain pieces. The medieval abbess Hildegard of Bingen expresses this domain through images:

> In music you can hear the sound of burning passion in a virgin's breast. You can hear a twig coming into bud. You can hear the brightness of the spiritual light shining from heaven. You can hear the depth of thought of the prophets. Music

[13] John V. Taylor, *The Christlike God* (London: SCM Press, 1992).
[14] William James, *The Varieties of Religious Experience* (1903; NY: Simon and Schuster, 1997).

expresses the unity of the world as God first made it.
Scivias 3.13.13[15]

As Romanticism progressed mood became increasingly central to the musical experience and to its portrayal of ideas of the heavens. Gustav Holst at one point called *The Planets* a set of 'mood pictures'. Written 1914-16, but first performed publicly in 1920, the set examined the Planets through the lens of astrology; he only added the titles of the planets later in the life of the piece. He visited Spain with the astrologer Clifford Bax. Through him, he rediscovered a former interest in theosophy, possibly reading Alan Leo's *The Art of Synthesis*. The titles of the movements appear to be drawn from it:[16]

> Mars, the Bringer of War – Venus, the Bringer of Peace – Mercury, the Winged Messenger – Jupiter, the Bringer of Jollity – Saturn, the Bringer of Old Age – Uranus, the Magician – Neptune, the Mystic[17]

Various critics have seen deeper patterns in the set. One theory sees the order as rooted in the interface between the astrological signs of the zodiac and the planets. A further suggestion is that the planets are ordered in their terrestrial relation to the Sun – the first four being the inner terrestrial planets and the last ones being the gas planets. There is a theory (from David Hurwitz[18]) of mirror imaging in the ordering with Jupiter at a pivotal place in the middle, so that the motion of Mars is balanced by the static feel of Neptune which has a similar 5 beat rhythm; the ethereal nature of Venus is balanced by the earthiness of Uranus and the lightness of Mercury by the heaviness of Saturn. Holst reinforces the mystery of Neptune by using a fade-out ending, unusual in classical music of the day. He requires women's choruses 'to be placed in an adjoining room, the door of which is to be left open until the last bar of the piece, when it is to be slowly and silently closed',[19] and that the final (scored for choruses alone) is 'to be repeated until the sound is lost in the distance'.[20] Whichever of these theories about the piece were in Holst's intention with the piece, he never used this subject matter again and all that was retained of his attraction to astrology was casting his friends' horoscopes. He came to dislike the popularity of the piece.

[15] Robert Van der Weyer, ed., *Hildegard in a Nutshell* (London: Hodder and Stoughton, 1997), p. 79.
[16] Alan Leo, *How to Judge a Nativity* (1904; London: Modern Astrology Office, 1928, reprint).
[17] Raymond Head, 'Astrology, Modernism and Holst's «The Planets»', *Astrology Quarterly* 65, no. 1 (Winter 1994-5): pp. 40-54.
[18] 'The Planets – Mirror Theory',https://www.youtube.com/watch?v=5mJoxAj7Ikg [accessed 15 May 2015]
[19] Gustav Holst, *The Planets: Suite for Large Orchestra* (London: Boosey and Hawkes, 1921), p. 142.
[20] Holst, *The Planets*, p. 142.

Earlier in Western musical history, ideas of heaven or the sublime were rooted in theories of the sound of the universe and situated not in the domain of Expression but that of Construction, with a heavenly connection being made by means of numbers associated with the spinning of the heavenly spheres.[21] It is in this domain where many claims for a spirituality associated with order have been made by traditional writers on aesthetics and spirituality linked with James' view of the religious experience associated with harmony.[22]

The notion of the Music of the Spheres underpinned a great deal of thinking in the Classical World.[23] The fundamental idea concerns *musica universalis* (or *mundana*) or the music of the spheres. This sees the proportions in the movements of celestial bodies – the Sun, Moon and planets – as a form of music. It is not regarded as literally audible, but as a mathematical or religious concept designed to represent the essential harmony of the universe. In this ancient view of the cosmos, the planets were thought to ascend from Earth to Heaven like the rungs of a ladder. Each planet corresponded to a musical note to produce a musical scale the underpinned the universe and these were related to the rates of rotation around the Earth. It originated in the ideas of Pythagoras.[24] This link meant that religion, science, mathematics, music, medicine and cosmology, and body, mind and spirit were linked in a complex synthesis. The theories filtered into medieval Europe through writers like Augustine (354-430 CE).

> Music enabled one to study the relations pervading God's creation, relations which have their source and supporting ground in the eternal God, who *is* music.[25]

The linkage of a celestial numerology with the heavens and the Divine ideas also underpinned the design of many of the great cathedrals of medieval Europe and produced spaces of unparalleled resonance. Associated systems of numerology developed through mystical movements like the Rosicrucians and figures like Robert Fludd (1574-1637) and Johannes Kepler (1571-1630).[26]

If all musical construction was deemed to be rooted in the celestial in the conceptual frames of the Middle Ages, it was lost during the secularization that characterized the Enlightenment. However, some more contemporary composers have sought to re-enchant Western music by re-examining these principles. One of the people who attempted this was Olivier Messiaen. According to Sholl:

[21] Plato, *Timaeus*, 90d3-7, http://classics.mit.edu//Plato/timaeus.html [accessed May 2015].
[22] James, *The Varieties of Religious Experience*, p. 59; James, *The Music of the Sphere*.
[23] James, *The Music of the Sphere*.
[24] James, *The Music of the Sphere*, p. 30.
[25] St. Augustine discussed in Jeremy S. Begbie and Steven R. Guthrie, Introduction to *Resonant Witness: Conversations between Music and Theology*, ed. Jeremy S. Begbie and Steven R. Guthrie (Grand Rapids, MI: William B. Eerdmans Publishing Company, 2011), p. 14.
[26] Godwin, *Music, Magic and Mysticism*.

In the middle of the triumph of rationalism that produced serial technique and pitch set theory, the staunch Catholic Messiaen who was organist at St Trinite Church in Paris, unashamedly wanted to re-enchant the 20th century.... [He] communicated the eternal mysteries of his Catholic faith in a way that not only drew people to them, but enabled his listeners to participate in and be transformed by his visions of glory.[27]

Messiaen turned to the area of Construction to achieve his end. Robert Sholl describes in detail how Messiaen's use of his structural technique of 'modes of limited transposition' – collections of pitches that can only be transposed a limited number of times before the original pitches return – which he uses to construct chords and gives his music a distinctive colour.[28] Messiaen was fascinated with the relationship of time to eternity, or in terms we have discussed above, the heavenly and the earthly: 'For Messiaen, even mundane measured time remotely echoes eternity, while duration echoes eternity to a still higher degree'.[29]

Messiaen returned to the ideas of Aquinas to develop his theory of the celestial qualities of his music:

> Time is a space, sound is a colour, space is a complex of superimposed times; sound-complexes exist at the same time as complexes of colours. The musician who thinks, sees, hears, speaks, is able, by means of these fundamental ideas, to come closer to the next world to a certain extent.[30]

However, Messiaen's music in terms of Expression (comparing it with the Holst described earlier) does not always convey the heavenly characteristics for its audiences to which he aspires. According to Alex Ross,

> "St. Francis" is not easy listening. It is five hours long, devoutly Catholic in content, and by turns dissonant, jubilant, voluptuous, and austere.... It harks back to one of those archaic Christian liturgies in which spells of boredom give way to precisely staged epiphanies.[31]

[27] Robert Sholl, 'The Shock of the Positive: Olivier Messiaen, St Francis, and Redemption through Modernity', Chapter 7 in *Resonant Witness: Conversations between Music and Theology*, ed. Jeremy S. Begbie and Steven R. Guthrie (Grand Rapids, MI: William B. Eerdmans Publishing Company, 2011), pp. 163.

[28] Sholl, The Shock of the Positive', p. 171-72.

[29] Catherine Pickstock, 'Quasi una sonata: Modernism, Postmodernism, Religion and Music', Chapter 8 in *Resonant Witness: Conversations between Music and Theology*, ed. Jeremy S. Begbie and Steven R. Guthrie (Grand Rapids. MI: William B. Eerdmans Publishing Company, 2011), pp. 198.

[30] Sholl, 'The Shock of the Positive', p. 172-73.

[31] Alex Ross, 'Messiaen's *St. Francis*', *The New Yorker*, 28 October 2002, accessed 10 October 2011, http://www.therestisnoise.com/2004/04/messiaens_st_fr_1.html.

The domain of Values is related to the context of the musical experience and the values implicit within it, linking the experience with the wider culture and society. The musical experience contains both implicit (within the music) and explicit (within the context) Value systems. However, these two areas of Value interact powerfully. Notions of internal values within music are a subject of debate in musicological circles.[32] However, as soon as a text is present – either in the music or associated with it – Value systems will be declared, like the words of hymns.[33] Music mirrors the structures of the culture that created it and people's ways of being in them.[34] This is particularly true in relation to the church context. Many religious traditions are very hierarchical and elitist in relation to music. In many cultures the leadership is male whether it is the drumming traditions of sub-Saharan Africa or the boys' choirs of the Christian tradition. The Values of those in power in the time will be implicit within the music itself as well as the context. The predominance of patriarchy in Western society is why feminist theologians fail to get a spiritual experience out of much of traditional hymnody with its non-inclusive language:

> Listen to the hymn. It falls like icicles on snow. Or, if it happen to be one of the old genuine outcries of the church, sprung from real human anguish or hope, it maddens the listener, and she flees from it, too sore a thing to bear the touch of holy music.[35]

In the domain of Values the theology of the spiritual space is constructed. This includes where the music comes from. My own experience of staying with native Canadians illustrates the differing value systems very clearly:[36]

> I was privileged to spend some time with a native people in North America. I had been present at several sweat lodges at which a particular medicine man had been working. I had also purchased a small hand drum and he had consented to beat the Bear Spirit into for me. One evening he was preparing for a sweat lodge and said that he needed a powerful woman to help him and sit along side him. This would usually be his wife but she was unable to be there so would I help him. I was both honoured and terrified; but he said he would help me with the ritual and so I agreed to the role. The first round of prayer took place and he concluded it by saying that now June would sing a song about the eagle and the sunrise. It was here that I thought that I had met an insuperable problem. I knew

[32] Susan McClary, *Feminine Endings* (Minneapolis: University of Minnesota Press, 1991).

[33] Andrew Blake, *The Land without Music: Music Culture and society in twentieth century Britain* (Manchester: Manchester University Press, 1997), p. 7.

[34] John Shepherd and Peter Wicke, *Music and Cultural Theory* (Cambridge: Polity Press, 1997), pp. 38-39.

[35] Elizabeth Stuart Phelps Ward, *Chapters from a Life* (New York: Arno Press, 1896), pp. 97-98.

[36] Author's journal, 2004.

no songs from the culture. But I remembered that in the songs I had heard each phrase started high and then went lower in order to bring the energy of the sky to the earth. So I started each phrase high and took it lower while singing about the eagle and the sunrise. It was a powerful experience for me and my voice seemed to come from a place of power deep inside that I had not experienced before. With the prayer round ended we went outside to cool in the night air. 'Great song, June' said the leader of the sweat lodge. I was about to say that, or course, I had to make it up and then remembered from my previous conversations with some of the women singers that in this culture everything is given, not the creation of an individual. So I replied: 'The Great Spirit gave it to me when I was in the Lodge.'[37]

Here I was in a culture where the intuitive way of receiving musical material – construed as coming from a connection with a spiritual source – was the dominant way of knowing, not the individualistic, humanistic way of the individual composer creating an individual song from their own experience in their own personal subconscious. I had previously been in a women's sweat lodge after which the leader had said that she thought the Great Spirit had given her the whole of the song when she was in the Lodge and that previously she had only received part of it. In the West we would probably have said something like that we had not yet finished it and were working at completing it.

However, the notion of receiving music in this way from a Divine source would not have been remarkable for Hildegard of Bingen in medieval Europe, she composed nothing herself but received everything directly from God. In medieval Europe intuitive ways of receiving material were more acceptable than in contemporary western culture. The visionary person was valued and esteemed rather than consigned to the realm of the mad.

The Spirituality of the Experience

Whereas these four domains exist as overlapping circles in the experience, Spirituality, I am suggesting, exists in our relationship with these domains and their interrelationship, see Figure 19.1.

I am defining Spirituality as the ability to transport the people to a different time/space dimension – to move them from everyday reality to 'another world – that has a quality of transcendence'. The perceived effectiveness of a musical experience – whether of performing, composing or listening – is often situated in this area.[38] Indeed some would see music as the last remaining

[37] June Boyce-Tillman, *Unconventional Wisdom* (London: Equinox, 2007), pp. 23-24.

[38] Philip W. Jackson, *John Dewey and the lessons of Art* (New Haven: Yale University Press, 1998.)

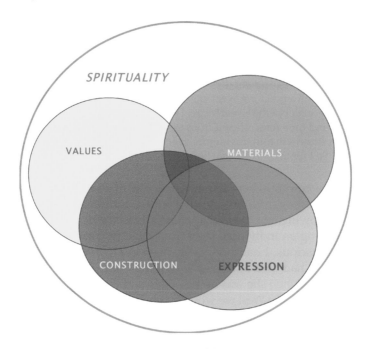

Fig. 19.1. Spirituality of the experience.

ubiquitous spiritual experience in a secularised Western culture.[39] Here, I have subsumed within my own thinking the following ideas:

- flow, coming in from psychologists of creativity (M. and I. S. Csikszentmi-halyi and Lori Custodero[40]);
- ecstasy, often associated with idea of 'the holy' coming from the religious/spiritual literature (Rudolf Otto and Marghanita Laski[41]);
- trance coming from anthropological (Gilbert Rouget[42]), New Age (Matthew

[39] June Boyce-Tillman, 'Sounding the Sacred: Music as Sacred Site', in *Indigenous Religious Musics*, ed. Karen Ralls-MacLeod and Graham Harvey (Farnborough: Scolar, 2001).
[40] M. and I. S. Csikszentmihalyi, *Optimal experience Psychological Studies of Flow in Consciousness* (Cambridge: Cambridge University Press, 1988); Mihaly Csikszentmihalyi, *The Evolving Self* (New York: Harper and Row, 1993); and Lori A. Custodero, 'Observable indicators of flow experience: A developmental perspective of musical engagement in young children from infancy to school age', *Music Education Research* 7, no. 2 (2005): pp. 185-209.
[41] Rudolf Otto, *The idea of the Holy: An inquiry into the non-rational; factor in the idea of the divine and its relation to the rational* (Oxford: Oxford University Press, 1923); and Marghanita Laski, *Ecstasy: A Study of some secular and religious experiences* (London: Cresset Press, 1961).
[42] Gilbert Rouget, *Music and Trance: A Theory of the relations between Music and Possession*, trans. Brunhilde Biebuyck (Chicago: University of Chicago Press, 1987).

Colin[43], Jonathan Goldman[44] and R. J. Stewart[45]) and psychotherapeutic literature (Inglis[46]);

- mysticism, coming from religious traditions, especially Christianity (Evelyn Underhill in Marianne Rankin[47]);
- peak experiences (Abraham Maslow[48]);
- the religious experience (Marianne Rankin[49]);
- the spiritual experience of children (David Hay and Rebecca Nye[50], Clive Erricker et al.[51], David Hay[52], and Edward Robinson[53]);
- liminality (Victor Turner[54]).

Turner's concept of liminality draws on an analysis of ritual. The notion of transformation is central to religious ritual whether it is a Christian Eucharist or a shamanic healing rite.[55] It can be personal or communal or both. Van Gennep saw parallel stages in any ritual.[56] This he entitled: 'severance, transition and return'. Severance he associated with leaving everyday life by means of ritual gestures like holding hands or lighting candles. In the Transitional or liminal phase contact was made with the transpersonal; and this might take the form of change of consciousness. The Return phase signalled a coming back to earth and the beginning of a new life. It is possible to identify these moments in a musical

[43] Matthew Collin, *Altered State: The Story of Ecstasy Culture and Acid House* (London: Serpent's Tail, 1997).

[44] Jonathan Goldman, *Healing Sounds: The Power of Harmonics* (Shaftesbury: Element Books, 1992).

[45] R. J. Stewart, *Music and the Elemental Psyche: A Practical Guide to Music and Changing Consciousness* (Wellingborough: The Aquarian Press, 1987).

[46] Brian Inglis, *Trance: A Natural History of Altered States of Mind* (London: Paladin, Grafton Books, 1990).

[47] Evelyn Underhill, quoted in Marianne Rankin, *An Introduction to religious experience* (Lampeter, Wales: Religious Experience Research Centre, 2005).

[48] Maslow, 'The Creative Attitude', pp. 4-55.

[49] Marianne Rankin, *An Introduction to religious experience* (Lampeter, Wales: Religious Experience Research Centre, 2005).

[50] David Hay and Rebecca Nye, *The Spirit of The Child* (London: Fount, 1998).

[51] C. Erricker, J. Erricker, C. Ota, D. Sullivan, and M. Fletcher, *The Education of the Whole Child* (London: Cassell, 1997).

[52] David Hay, *Exploring Inner Space* (Harmondsworth: Penguin, 1982).

[53] E. Robinson, *The Original Vision: A Study of the Religious experience of Childhood* (Oxford: The Religious Experience Research Unit, 1977).

[54] Victor Turner, *The Ritual process: Structure and Anti-structure* (Baltimore: Penguin Books, 1969); and Victor Turner, *Dramas, Fields and metaphors: Symbolic action in human society* (Ithaca, NY: Cornell University Press, 1974).

[55] Tom F. Driver, *Liberating Rites: Understanding the Transformative Power of Ritual* (Boulder, CO: Westview, 1998).

[56] Arnold Van Gennep, 1908, quoted in James Roose-Evans, *Passages of the Soul* (Shaftesbury: Element Books, 1994), p. 6.

piece even when not associated with ritual and to relate accounts of transformation through experiencing music with this concept. He develops it to include the notion of encounter, sometimes with the material through the process of healing and sometimes inner to do with mind or spirit.

Clarke's notion of the transliminal way of knowing is drawn from cognitive psychology.[57] In her thinking, this way of knowing is to do with our 'porous' relation to other beings and is where spirituality sits. It is in contrast to 'propositional knowing' which gives us the analytically sophisticated individual that our culture has perhaps mistaken for the whole.[58] To access the other way of knowing we cross an internal 'limen' or threshold. Langer suggested a 'non-discursive' form of communication that characterised music and religion which is different from propositional ways of knowing.[59]

The Spiritual domain, then, is defined as a time when in the experience of the experiencer there is a perfect fit between all the domains.[60] This can happen gradually as this account by Ian Dunmore shows:

> For the first twenty-five minutes I was totally unaware of any subtlety…whilst wondering what, if anything, was supposed to happen during the recital.
> What did happen was magic!
> After some time, insidiously the music began to reach me. Little by little, my mind all my senses it seemed – were becoming transfixed. Once held by these soft but powerful sounds, I was irresistibly drawn into a new world of musical shapes and colours. It almost felt as if the musicians were playing me rather than their instruments, and soon, I, too, was clapping and gasping with everyone else… I was unaware of time, unaware of anything other than the music. Then it was over. But it was, I am sure, the beginning of a profound admiration that I shall always have for an art form that has been until recently totally alien to me.[61]

We see here the Materials of the sound and the 'shapes' of the Construction gradually begin to be integrated into his/her own being so that the experiencer and the experienced become fused. This experience can be represented as four interlocking circles of Materials, Expression, Construction and Values surrounded by the circle of Spirituality. To achieve a 'fit' that is likely to produce a spiritual experience in the experiencer, there has to be sufficient congruence

[57] M.A. Thalbourne, L. Bartemucci, P.S. Delin, B. Fox, and O. Nofi, 'Transliminality, Its nature and correlates', *The Journal of the American Society for Psychical Research* 91 (1997): pp. 305-31.

[58] Isabel Clarke, 'There is a crack in everything – that's how the light gets in', in *Ways of Knowing: Science and Mysticism Today*, ed. Chris Clarke (Exeter: Imprint Academic, 2005), p. 93.

[59] Suzanne Langer, *Feeling and Form: A Theory of Art* (London: Routledge and Kegan Paul, 1982).

[60] Boyce-Tillman, 'Music as Spiritual Experience', pp. 20-31.

[61] Ian Dunmore, *Sitar Magic, Nadaposana One* (London: Editions Poetry, 1983), pp. 20-21.

between the various domains of the experience between the experienced and the experiencer. This will be affected by words and experiences surrounding the event.

It is possible that the spiritual domain is most likely to occur in situations where there are shared Value systems, experiences that are shared between the musicking participants, where the Materials and Constructions are familiar.[62] Ian Ainsworth-Smith draws attention to the fact that the areas of religion, culture and spirituality interface with one another powerfully.[63] However, this is not entirely predictable because of the extrinsic elements involved in the experience and the openness of the experiencer at that particular time. The converse is where this is a disruption in one area or between two areas that means there is no spiritual experience at all. I now find it difficult to listen to Wagner's *Ride of the Valkyries* without thinking of the powerful moment in *Apocalypse Now* where it is associated with the flight of helicopters in the American war in Vietnam and the wiping out of the soft village music that is playing as they arrive.

I am suggesting that it is not possible to put these disruptions in other domains aside and that they will interrupt the likelihood of entering the Spiritual (or internal heavenly) domain where notions of culture, meaning, Construction and Materials need to intersect in a special way for this to occur.

Summary

This paper has set out the various areas of the musical experience and issues of heaven drawn from astrology, astronomy and theology have been integrated into pieces of music and musical traditions. It has suggested a sacred connection with the earth in the domain of Materials, a connection with a mood (often different from ordinary moods) in the domain of Expression. Mathematical views of the interaction between the music and the cosmos that characterises the Construction domain, supported by Graeco-Roman and medieval Christian thought, have been rediscovered by some figures in the twentieth century. Values often show a certain conservatism resulting in the exclusion of some ideas, but it is in this place where theological explanations of the liminal space are to be found and notions of the heavenly.

But to access the internalised experience of moving through the spheres or heavens will only happen if we can make a relationship between ourselves and all the four domains. The closer that relationship is, the more intense the experience of entering a different realm. Maybe the heavens are no longer the metaphor that people will use for this in an age when we can access them in material form by space travel. But they will still have the experience of leaving

[62] However, this is not entirely predictable because of the extrinsic elements involved in the experience and the openness of the experiencer at that particular time.

[63] Ian Ainsworth-Smith, 'The Spiritual and Pastoral Dimensions of Chaplaincy Work', *Journal of Interprofessional Care* 12, no.4 (Nov. 1998): pp. 383-87

the everyday terrestrial world into a different reality which may now be more linked with internal consciousness. This antiphon of Hildegard expresses the way the connection between the heavenly and earthly is connected by a third 'connecting' wing; I suggest that music performs this function:

> **HILDEGARD'S** *Antiphon to Wisdom*
> O the power of Wisdom:
> You, in circling, encircle all things,
> You are embracing everything in a way that brings life into being;
> For you have three wings.
> One of them reaches highest heaven
> And another is sweating in earth
> And the third is flying everywhere.
> Therefore it is right to give you praise,
> O Sophia wisdom. [64]

[64] June Boyce-Tillman, *Singing the Mystery: 28 Liturgical Pieces of Hildegard of Bingen* (London: Hildegard Press and Association for Inclusive Language, 1994).

ASTROSONIC EDUTAINMENT:
OR, TALES FROM A DARK SKY PARK

Chris Dooks

ABSTRACT: In 2009, Forestry Commission Scotland successfully established part of Galloway Forest Park as the first 'Dark Sky Park' in Britain – it is one of the darkest parts of the UK mainland for stargazing. Artist/Composer Chris Dooks is making music from the voices of local astronomers and other patrons of the park. In this paper, he defines the project and contextualises the work with other astromusic that has influenced it, such as: a) The Chromatics, a touring science *a cappella* troupe; b) Singing Science Records, a vinyl edutainment project of the 1950s; c) The Symphony of Science, 'The phenomenon of auto-tuning', featuring Carl Sagan, Richard Dawkins and Stephen Hawking. Dooks' work (more akin to the philosophies of composer Steve Reich) features phrases garnered from astronomer-interviews that are woven into a fifteen-minute, public-domain electronic music piece. The astronomers' accents and conversation form the motifs, phrases and cadences of the piece. Here, local viewpoints kindle supermassive views. This way of working gives the work both an accessible and otherworldly flavour, linking a kind of regionalism to the universal. In 1995, Dooks made a film (which won a national competition) about the nature of artificial light: 'Beacons'. Now, sixteen years later, he complements the work with a piece about the struggle to find darkness in increasingly light-polluted skies. This paper was presented with a semi-live performance in Bristol during the Heavenly Discourses conference, the aim being to compose a warm and potentially emotional response to this precious view of the night sky.[1]

Preface

> 'There's antimony, arsenic, aluminum, selenium,
> And hydrogen and oxygen and nitrogen and rhenium...'[2]
> (Sung to the tune of 'The Major-General's Song' from *The Pirates of Penzance.*)[3]

This paper examines the ongoing novelty of imparting scientific and astronomical information through music and the sonic arts. Through exploring idiosyncratic examples, I hope to shed light on my own astromusic piece, which collates and collages the voices of astronomers as the primary compositional source. This paper is an autoethnographic account of my journey towards that goal.[4] At the Heavenly Discourses conference itself, the paper concluded with a fifteen-minute composition about Galloway Forest Dark Sky Park in southwest Scotland.

[1] An audio version of this paper is available at https://chrisdooks.bandcamp.com/album/tales-from-a-dark-sky-park-2011 [accessed 10 October 2014].

[2] Tom Lehrer, 'The Elements Song', *More Songs by Tom Lehrer*, 1959, Rhino.

[3] W. S. Gilbert and Arthur Sullivan, 'The Major General', *The Pirates of Penzance*, 1879.

[4] For an explanation of autoethnography see: T. Muncey, *Creating Autoethnographies* (London: Sage, 2010), p. 2.

Apple Pies, Fingernails and Spots

i. Apple Pies

'If you wish to make an apple pie from scratch, you must first invent the universe': the astrophysicist Carl Sagan sings these words from the grave on a limited edition 7' single, the b-side of which displays engravings copied from 'The Golden Record', famously mounted on the Voyager probe to Jupiter.[5]

ii. Fingernails

On her album and multimedia project, *Biophilia*, Icelandic composer and singer, Björk, informs us that the rate at which our fingernails grow is the same rate in which the Mid-Atlantic Ridge drifts.[6]

iii. Spots

During the recent International Year of Astronomy, a jazz-choral piece about sunspots by an *a cappella* troupe, The Chromatics, explains solar rotation: '*A strange kind of movement to do a full roll, 25 days in the middle, 36 at the poles'*.[7]

Introduction

We live in an accelerated culture. Finding ourselves media-saturated, could music and song be a way of filtering important information about life, the universe and everything? If our main method of communication were the still the oral tradition, would we now be listening to songs about The Large Hadron Collider and travelling faster than the speed of light? If our news channels created one song per month about a leading story, would we recall that story for longer? And could this method be a way of humanising news about the cosmos? News which – for many people – is remote, cold and irrelevant. For the time being, it seems unlikely that our news presenters will become troubadours, so we'll have to survey whom is making music *now* about the cosmos.

Music for Our Times

A bizarre combination of science and song would fit perfectly into our times. The three-minute pop song is a succinct but rarely exploited form of communication; in the main, pop songs aim to engage the heart but few songs exist (for example) about the *physiology* of the heart, or contain empirical data. As offbeat as this sounds, it's not as unlikely or incongruous a proposition as we might think. Song-forms are excellent containers of information, as I'll explore.

Moreover, as a consequence of the current ease of sharing and propagating *any* music through social networks and 'smart' devices, niche music and niche audiences are now clustering together with unprecedented ease.

[5] Carl Sagan, *Cosmos* (New York: Random House, 1980), p. 218, and reproduced by Symphony of Science as *A Glorious Dawn*, 2009, Third Man Records.

[6] Björk, 'Mutual Core', *Biophilia*, 2011, One Little Indian.

[7] The Chromatics, 'The Sun Song', *AstroCappella 2.0*, 2001, produced by Jeff Gruber and The Chromatics.

On services such as Facebook, Twitter, Spotify, Mixcloud and blogs, these niches can and do overlap, cross-pollinating audiences and forging musical hybrids, including songs about astronomy or the earth sciences. Despite such artistic fusions being a kind of creative 'puffery' or one-upmanship, they at least place the love of knowledge centre-stage. In media contexts, music with scientific content may have potential to usurp jaded Facebook users, or engage bored television audiences where popular science formats fail (for whatever reason).

Songs about the universe could appeal to people who are turned off by documentaries or news media. What is more, such songs can flag and mainline cosmic stories that don't even *make* the news but perhaps *should*. The competitive nature of the Internet is forging astute artists who tap into audiences that love science, but whom perhaps didn't succeed within a traditional school pedagogy.

But why use *song-forms* as vehicles for information? It is because there is evidence to suggest music is one of the most stubborn tenants of the brain. Music is a *squatter*.

Patients with advanced Alzheimer's and Dementia have often been shown to have a functioning musical memory, frequently with verbatim reproduction, even in cases where other aspects of memory and cognition have been very seriously compromised by illness. Oliver Sacks dedicates a chapter to the topic in *Musicophilia*.[8] It seems there is much value in continuing an oral tradition for this medical reason alone. Sacks cites the musical form as one of the most fundamentally ingrained patterns of our brain, and it is because of the ability of the mind to retain these patterns that I am interested in using them as containers of information. They could help me learn and recall information about the earth and cosmos. I'd like to turn to a personal example of this.

The World's Largest Iceberg

In 2008 Benbecula Records released an LP of my songs entitled 'The Aesthetic Animals Album' where each song referred implicitly or explicitly to an animal.[9] One song was titled 'The Penguin'. At the time, I was gripped by the story of Antarctic Penguins near the Ross Ice Shelf, who were unable to get back to their chicks after the landscape of ice was rapidly changing due to the worlds largest iceberg blocking their path – a problem as it was easily over 100 kilometres long. At the time of writing the song, the iceberg had 'calved' or jettisoned much of its bulk, creating the enigmatically named B15(A), which eventually calved (B)15B. I used information found inside a copy of National Geographic to write the song.

[8] Oliver Sachs, *Musicophilia* (London: Picador, 2008) pp. 371-79.
[9] C. Dooks, *The Aesthetic Animals Album*, 2008, Benbecula Records; Benbecula Records no longer exists, but the record is available electronically at http://chrisdooks.bandcamp.com/album/the-aesthetic-animals-2008 [accessed 10 October 2014].

The world's largest iceberg, is B15(A)
And it's run aground on The McMurdo Sound again.
It is preventing penguins from entering their colonies
It is preventing scientists from carrying out their follies

B15(B), took the kinder route
It shattered on the sea-bed, with minimal repute
Once a motherlode, once leviathan
Disintegrating Iceberg, and iceberg traffic-jam

I believe until the day I die I will remember iceberg B15A. Perhaps the fact that it was not a passive piece of information helps. At the time of writing it I didn't realise there is a living tradition behind song-forms that impart astronomical or earth science data, but there is, and it is alive and thrives in niche pockets of the Internet. There is however, no accepted genre as such so we need a clunky phrase such as 'Astrosonic Edutainment'. The examples I teased you with at the start are part of this tradition. Let's open them up a little more.

Astrosonic Edutainment Example One: Björk's *Biophilia* (2011)

At the time of writing, I managed to obtain a press preview of the latest work by Icelandic singer and composer Björk. *Biophilia* is much more than a CD. Björk has described the project as a multimedia collection 'encompassing music, apps, internet, installations, and live shows'. It is not often that your average CD comes with academic essays, but that is what is promised here. It is an example of an artist without a so-called 'scientific' background using their ongoing music practice as a form of research. This project is a venture of sci-art hybridity, and in the process it locates metaphors, both poetic and scientific, at the same time. Let's look at the lyrics of the track 'Mutual Core':

> *As fast as your fingernail grows*
> *The Atlantic ridge drifts*
> *To counteract distance*
> *You know I gave it all*
> *Can you hear the effort of the magnetic strife?*
> *Shuffling of columns*
> *To form a mutual core* (Björk, *Biophilia*, 2011).

What is useful here is the union of interpersonal with the planetary. I'll turn to another personal example as to why I think this is important.

About three years ago I started to get serious about my interest in astronomy and invested in a telescope. The kind I have, a 'Dobsonion Reflector' means that there is a simple and manual adjustment of the scope during the night. When focused on an object, say the planet Jupiter, when looking close up, I would adjust the scope every thirty seconds or so for it to remain in the centre of the field of vision.

Such was my concentration, after a few weeks of this I began to feel ever so slightly dizzy. I was actually getting a kind of motion sickness from realising that

we, on this planet, are moving. And moving very fast. I was becoming aware of my psychophysical being, tracking a planet whilst on a moving surface. The solar system was becoming, ever so slightly, part of my own biology. In Björk's song, she is speaking about a similar kind of union.

Astrosonic Edutainment Example Two: The world of Symphony of Science

We looked at a quote from Carl Sagan earlier, here it is slightly expanded, from *Cosmos*: his now legendary book and series for PBS in the 1980s:

> If you wish to make an apple pie from scratch, you must first invent the universe... [and] ... It is just barely possible, by plunging into a black hole, you might emerge in another part of space-time somewhere 'else' in space, some 'when-else' in time...[10]

Now, the sadly departed Sagan sings these words from beyond the grave. They have been highly edited into bite-sized chunks – remixed, retuned and re-appropriated by the web project Symphony of Science.[11] I remember these words because they have been turned into a musical 'hook'.

What the Symphony of Science (.com) does is to use software which forcibly retunes the incoming pitch of audio – in this case, Sagan – into a user-defined scale, a musical phenomenon now known as 'auto-tuning'. Auto-tune was developed by Antares, initially for studio engineers to perfect the pitch of 'problematic' studio artistes recording in the 1990s. As I mentioned, Carl Sagan never *sung* these lines but auto-tune can make anyone sing – even against their will, or knowledge, and in the case of Sagan, even if they are dead!

I'd audaciously state that 'Symphony of Science' is a kind of folk music. At folk festivals, I have heard many debates around the idea that true folk music is constantly in flux, adapting to revisions, accents, variable musical ability and cultural quirks. It is also criticised for this adaptability and of mis-hearing lyrics, and jettisoning the original form altogether is common, not to mention inserting or replacing lines to fit the cultural time. These debates rage perennially at such traditional music festivals. But I feel that as long as there isn't a *total* 'Chinese-whisper effect' at play, it is acceptable for the medium to repackage the message, to an extent, as long as the core of that message remains unaffected.

The use of 'music for memory' is illuminated in Marshall McLuhan and Quentin Fiore's 1967 book *The Medium is The Massage*.[12] In particular, a chapter examines classical Greece, where musical memory is a pedagogical strategy, quoting Socrates. Socrates argues for the oral tradition and is wary

[10] Carl Sagan, 'The lives of the Stars', *Cosmos*, Episode 9, aired 23 November 1980 at https://www.youtube.com/watch?v=X7L6SZPxgNg [accessed 10 October 2011].

[11] http://symphonyofscience.com/.

[12] Marshall McLuhan and Quentin Fiore, *The Medium is the Massage* (London: Penguin, 1967).

of technological change in *Phaedrus*: 'The discovery of the alphabet will create forgetfulness in the learners' souls, because they will not use their memories; they will trust to the external written characters and not remember of themselves… they will appear to be omniscient and will generally know nothing'.[13]

The oral tradition still thrives in our world, but in terms of music being used for memory, it is something of a loss, in this author's opinion, that we cease to learn through song at primary school.

Replicating information through song can never replace *enquiry*, but it can stitch questions inside one's biology and get the ball rolling. Admittedly, if you give a song too much attention, it can stumble back into your home like a drunk relative at Christmas! Song lives inside the brain in such away that I might be cleaning the kitchen and a rhyming couplet might assault me, seemingly from nowhere.

We are all susceptible to the dreaded 'earworm' – the song which can become stuck inside one's head, so why not have a rhyming couplet serve some actual us whilst there? As a new parent I know all the irritatingly catchy songs from TV's *In The Night Garden*, but I'm seriously thinking of replacing that irritation with purpose such as storing my Internet banking details inside them for example.

Astrosonic Edutainment Example Three, The Chromatics

Lets now expand on Astrosonic Edutainment Example Three. In their song about the sun, a particular verse inspired me to take up solar observing sessions, watching sunspots from my garden:

> *Those spots move around the face of the Sun*
> *Proving to all… solar rotation!*
> *A strange kind of movement, to do a full roll*
> *25 days in the middle, 36 at the poles.* (The Chromatics, *The Sun Song*, 2001).

We might argue that this is not a big deal, OK so the sun happens to rotate in an idiosyncratic manner. But even though these are just a few lines aimed at children (or anyone), what this music does for me is forge curiosity and crucially, it begins a partly unconscious chain of events. Because of its memorable delivery, the song has essentially primed me… Almost unconsciously, I now gravitate (pardon the pun) naturally towards information about solar rotation, almost in a pre-programmed manner, even within my gloopy and exhausted consciousness.[14] Because of this song, I find myself using my NASA sun viewer app on my iPhone, asking the local Astronomy society to lend me the Hydrogen-alpha scope they have to spot sunspots. These songs, even if I don't particularly like them as songs *per se*, are still effective stimulators of awe.

[13] Marshall McLuhan and Quentin Fiore, *The Medium is the Massage* (Berkeley: Gingko Press, 2001 [first published in 1967 by Penguin Books]) p. 113.

[14] I have CFS-ME, or CFIDS as it is known in the USA, an exhaustion-related illness.

At the time of writing this paper I know now that *because* the middle of the sun rotates faster than the poles, that the sun's magnetic currents can become twisted, forming characteristic loops of plasma that I'd seen on television documentaries, but never understood until this song anchored that image inside my mind.

Astrosonic Edutainment Example Four: Singing Science Records
We have talked about a few current examples of who is making music *now* about the cosmos, but sometimes that 'now-ness' these days is often defined as who has resurrected a past project most effectively. Let's move to our last example for a nostalgic and kitsch view of the cosmos.

You would not imagine the writer of the song *Unchained Melody* to have been the mastermind behind some of the most beautifully crafted children's science songs, but that is exactly what Hy Zaret did in the late 1950s, collaborating with Lou Singer on a six-album series called 'Ballads for the Age of Science'; different volumes covered space, energy and motion, experiments, weather and nature. Of these albums, the most popular is *Space Songs*, now recently re-released on iTunes.[15] There is a real effort to cover different genres of song and the production value is extremely high; from vaudeville stylings, sea shanty forms and even a slight romantic edge, these songs are comforting, gentle and sweet. Listening to these you wouldn't be under the impression that we could be wiped out by a meteorite at any moment.

Here's a sample lyric from my favourite song: *Constellation Jig* from *Space Songs*:

> *Hercules, Delphinus and Andromeda and Lyra*
> *Pegasus and Sagitta, Dorado and Lacerta*
> *Usra Major, Ursa Minor, Cetus and Orion*
> *I could name a dozen more*
> *If I were really tryin'.*

Because of this particular song, I was intrigued by the constellation Sagitta. I thought Tom Glazer, the singer, was pronouncing Sagittarius in an idio-syncratic manner. I now know that Sagitta or 'arrow' is a totally separate constellation, and is one of the 48 listed by Ptolemy in the second century CE. It seems a few of the constellations chosen for the song are for their rhyming convenience and not for notable objects in which to learn the night sky. Some of these constellations are actually quite faint. However, in the late 1950s, we may have had a much brighter night sky in which to see the stars. Even so, it is a weirdly idiosyncratic song and album.

So where does this (finally) lead me with my own work? I interview amateur

[15] H. Zaret and L. Singer, *Space Songs* from *Ballads For the Age of Science*, 1959, New York, Motivation Records, MR 0312.

astronomers in South West Scotland about what draws them to the night sky and why Galloway Forest in particular. I take these recordings and I remove the context and the question, so neat statements are created – and occasionally, they become poignant when isolated in this way. They are then embedded in an electronic soundscape. In my work, interviewees become accidental poets and lyricists. It is a cross between a radio documentary and a kind of spoken song-form. This has been one of my trademark ways of working for over a decade. In 1995, my film *Beacons*[16] saw myself and a friend interview people from all over the UK about two things:

1. How they lit their own home and
2. Recalling any paranormal experiences they may have had.

By removing the context, the edited statements and question-categories become malleable, blur into each other, and open up the work. This is similar to what I am doing now in the Dark Sky Park. Using repetition and layering, I highlight the innate music in astronomer's voices. Everyone who has a speaking voice also owns their own set of scales, influenced by accent, social factors and biological difference. So what I am doing is almost an ethnographic survey of the area, but instead of the results being a report or a paper, it's a piece of recorded music from an ethnographic source.

The artist that influenced me the most in this piece is undoubtedly Steve Reich, one of the most influential minimalist composers still working today. In his 1980s piece about the holocaust and Jewish heritage, *Different Trains*, Reich uses diverse interviewees as source material and by listening to the microscopic changes in the pitch and rhythm of these people, he scores work for a string quartet to play alongside the voices.[17]

In another piece Reich makes two tape recordings from the same spoken sample (a street preacher shouting *It's gonna rain*) and is able to alter the speed of playback of one of the recordings in order to make a simple phrase create complex patterns and back into unity again at the end.[18] Paying homage to this, I use a similar technique back in Galloway Forest Park, interviewing astronomers in their own home.

In one of the movements of my piece about the dark sky park entitled *Eternity isn't a very long time. Eternity is the absence of time*, I deliberately use Reich's technique employed in *It's Gonna Rain* – where a simple mathematical formula will see the piece fall in and out of synch. I find this technique totally analogous to the idea of the earth being in a 'habitable zone' where only for a few million

[16] *Beacons*, directed and produced by Chris Dooks and Alex Norris, 1995, Glasgow, London, Manchester, Scottish Screen, http://chrisdooks.bandcamp.com/track/beacons-ost-1995 [accessed 10 October 2011].
[17] Steve Reich, *Different Trains*, 1988.
[18] Steve Reich, *It's Gonna Rain*, 1965.

rotations of this planet, in this 'Goldilocks' distance to the sun, are we able to exist, temporarily on the planet. Through a journey in my own music practice now, when synch arrives or departs, I am always thinking of how vulnerable and temporary all of life is.

Fig. 20.1: Chris Dooks, '300 Square Miles of Upwards 12" LP'.[19]

[19] Available at http://tinyurl.com/dooks300, this LP expands the sonic work the author presented at the Heavenly Discourses conference into a vinyl and digital edition.

PART FOUR: DISCOURSES IN IMAGES

SEEING EARTH: TRANSFORMATIONAL REPRESENTATIONS OF THE UNIVERSE

Jürgen Heinrichs

ABSTRACT: This paper discusses representations of the universe at different historical moments in relation to changing concepts of human subjectivity. Close analyses of selected works of art highlight how the human view of outer space changed in relation to evolving philosophical and scientific contexts. Working with a broad spectrum of media, ranging from woodcuts over paintings to space photography, I map the shifting positions of the imaginary eye in visual representations of the universe. Departing from earlier cosmologies, pre-modern depictions of the skies go hand in hand with Earth-based perspectives. By contrast, more recent representations of the universe that have accompanied space exploration bring into play extraterrestrial points of view. Generated by ever more powerful cameras and telescopes, such photographs doubtlessly provide the most striking vistas of the universe. I argue that Renaissance art and thought, in particular the philosophy of Giordano Bruno, may still provide the key for understanding the enduring human desire to observe, envision and map the heavens. In its sophisticated and timeless approach, Bruno's thought charts new perspectives on what structures the interactions between humans and nature. Surprisingly, Bruno's seemingly obsolete thinking, as I will show, may still offer some of the most engaging ways of coming to terms with current representations of space, both in the popular realm and in scientific discourses.

Childhood Stargazing

The American artist Joseph Cornell recalls an account of childhood stargazing that many readers may relate to. Late one night, when he was a teenager and home on vacation from boarding school, he woke up his sister, who recalled: 'Shivering awfully, he asked to sit on my bed... He was in the grips of panic from the sense of infinitude and the vastness of space as he was becoming aware of it from studying astronomy'.[1]

This episode vividly describes the terror of one's first conscious experience of seeing outer space. Children, it appears, are particularly sensitive to these initial moments of grasping the vastness of space. It is precisely this moment of first comprehending the sheer infinity of the universe, and realizing the relativity of one's own position within it, that seems to fade as one grows up. Borrowing from psychoanalysis, we may consider it a 'primal scene' of sorts. Formulas, theories and, frequently, visual representations seem to take the place of this initial shock. In fact, looking at representations of space has become such an

[1] Betty Cornell Benton, as quoted in Robin Cembalest, 'The Space Beyond (Turn Left at the Giraffe)', in Rosetta Brooks, *Altered States* (New York: Kent Fine Art/ ZG Publications, 1988), p. 66.

ordinary experience that we hardly think about their deeply profound and potentially unsettling meaning. Consider, for instance, a university's former email login screen (Fig. 21.1). As we busily tend to our daily tasks, we hardly ponder that logging in to check email virtually catapults us into outer space. A segment of planet Earth in the upper left corner of the screen reminds us that we are accessing the system from some extraterrestrial location.

This essay maps shifting positions of the imaginary eye in representations of space with particular attention to the unstable position and fluctuating perspective of its assumed viewer. I shall first review depictions that share an Earth-based perspective before focusing on more recent representations that emerged with the advent of space exploration. Generated by ever more powerful cameras and telescopes, such dazzling photographs doubtlessly provide the most striking views of the heavens. Yet, it may be Renaissance art and thought, I argue, that provides the most compelling opportunities for understanding what drives the enduring human desire to picture the skies.

Fig. 21.1: Screenshot of "GroupWise WebAccess" Email login screen, © Novell Corp., ca. 1999.

Anchored Views

A well-known engraving serves as an introduction to the subject. Published in

1888 by French astronomer and author Nicolas Camille Flammarion, this widely circulated print of unknown origin has frequently, yet erroneously, been viewed as an illustration of medieval cosmology (Fig. 21.2).

Fig. 21.2. Anonymous, Untitled engraving, published in Camille Flammarion, L'atmosphère: météorologie populaire *(Paris 1888), p. 163.*

Though the work is easily dismissed for the apparent artifice of its nineteenth-century stylistic mannerisms, the engraving continues to inhabit a central place in the popular imagination as it illustrates what had long believed to have been core tenets of medieval cosmology and Renaissance micro-macrocosmic principles.[2]

The print features a large dome that shelters a landscape with towns and villages amidst rolling hills. A friendly, anthropomorphic sun illuminates the worldly dome as moon and stars embellish the interior of the sphere. A tree in the foreground provides compositional balance between the sun on the right

[2] Astronomer Joseph Ashbrook concluded that Flammarion drew the picture himself and based this composite on the ideas of Sebastian Münster's 1550 astronomical work *Cosmographia* and on the medieval Macarius legend. See Joseph Ashbrook, 'An enigmatic astronomical woodcut,' in *The Astronomical Scrapbook: Skywatchers, Pioneers, and Seekers in Astronomy* (Cambridge: Cambridge University Press, 1984), pp. 444-49.

that seems to keep an eye on the crawling human figure on the left. Dressed in a cloak and holding a pilgrim's staff, the male figure kneels on the ground as his head penetrates the sphere to observe the spectacle beyond. He gazes at celestial objects lined up along the cloudy, fiery edges of the outer spheres. His body is anchored in the earthly realm, while his head, left hand and staff protrude beyond the dome. Driven by curiosity, the figure's head remains the only part of his body to transcend the boundary separating inner and outer spheres. Turning his back to the viewer in a manner reminiscent of the nineteenth-century *rückenfigur*, he invites us to share his experience. The work references a pre-modern world in which the celestial order remains familiar and reassuring. Earth appears as a flat disk with a protective dome. The observation of the heavens is launched from the safety of Earth and occurs at the point where heaven and Earth touch. Grounding and calming, Earth absorbs the shock of viewing the unknown wonders of the outer worlds.

Untethered Visions

During the 1950s and 1960s, space exploration had begun to change human perceptions of Earth. In September 1959, Explorer VI, an unmanned space probe, transmitted pictures from space. For the first time, humans glimpsed a mechanical representation of Earth floating in space. The photographs recovered were remarkable, for they showed the rotundity as well as the curvature of the Earth: as conventional aerial photographs resemble maps, these resemble sections of a globe. In December 1968, Apollo 8 astronauts took the first man-made photographs of Earth. The following year, Apollo 11 generated even more spectacular shots, among them a magnificent view of the half-lit, rising Earth that greeted astronauts as their spacecraft emerged from behind the moon (Fig. 21.3). From a distance of more than 240,000 miles, astronauts contemplated their home planet. During their first moonwalk in 1969, Neil Armstrong and Edwin Aldrin coined the legendary description 'The sky in space is black, the world has an unexpectedly high degree of cloud cover, and the earth is a blue planet'.[3]

Portraits of Earth from orbiting satellites, spacecraft or the surface of the moon offered a fundamentally new perspective of the planet. In these photographs, space, the object of observation, becomes the very arena and vantage point of human exploration. But the newly gained perspective came at a price, for these thrilling new vistas implied an utterly unhinged point of view. Though angle, distance and size of other celestial objects may allow astronomers to determine the orbital position from which Earth is being viewed, space-based photography implies a radical sense of detachment. What does it mean to look at representations of the very planet upon which humans live and exist? Does it matter that we are enjoying this breath-taking spectacle while floating in the

[3] Margaret Dreikausen, *Aerial Perception: The Earth as seen from Aircrafts and Spacecraft and its Influence on Contemporary Art* (Philadelphia: Art Alliance Press, 1985), p. 44.

same vast, endless space?

John Mathews and Charles Garoian, a team of physicists, explored such questions in their ambitious 1994 space art project *Earthview*. The scientists proposed to retrieve real-time video footage from Earth-orbiting satellites and solar system probes and to broadcast these images continuously via cable and transmitters to television sets around the world. This large-scale installation sculpture was never realized, yet it would have provided humans with intriguing opportunities to come to terms with their position within the universe.[4] As Merton Davies and Bruce Murray have pointed out, 'the profound importance of photographic exploration is that it provides the opportunity to discover the situations that were unimaginable beforehand'.[5]

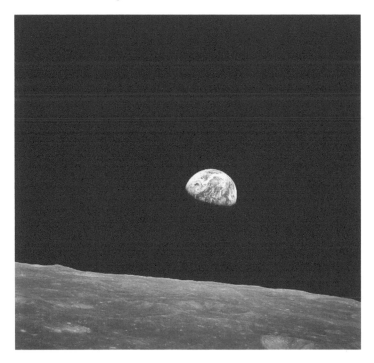

Fig. 21.3: William Anders. Earth Seen from Moon, *December 24, 1968* (Apollo 8 *mission*). *Photograph, NASA.*

Of course, not all views of Earth from space necessarily prompt sensations of uprootedness in the viewer. In fact, contemplating Earthrise from the moon

[4] John Matthews and Charles Garoian. 'Earthview: Looking Down at Ourselves', *Leonardo* 27, no. 2 (1994): pp.101-2.
[5] Merton Davies and Bruce Murray, *The View from Space: Photographic Exploration of the Planets* (New York: Columbia University Press, 1971), p. 59.

through the astronaut's camera still has a reassuring effect. The blue planet ascends in familiar fashion from behind the lunar horizon just as the sun appears to behave on Earth. The sky is completely dark. The surface of the moon pictured in the foreground, however barren and inhospitable, still provides an anchoring view by setting a familiar stage with its resemblance of terrestrial landscapes and associated viewing conventions.

The advent of spacewalking, a daring technological innovation, dispersed any remaining sense of a grounded perspective. In 1965 astronaut Edward White became the first human to 'walk' in space, or to 'go EVA', 'extravehicular activity' in NASA's terminology. Photographs documenting this risky endeavour demonstrate that the astronaut, apart from spacesuit and tether, has shed any protective containment. Two decades later, the introduction of Mobile Manoeuvring Units (MMUs), made even the tether obsolete as it allowed astronauts to float freely without umbilical cords linking them to the spacecraft. In 1984, Bruce McCandless engaged in the first untethered spacewalk using this new propulsion device. Firing thrusters powered by compressed nitrogen gas, the astronaut ventured more than one hundred meters away from the safety of the spacecraft. Photographs captured the moment as the astronaut hovers in space. McCandless has literally turned into 'spaceship man' against the immense vacuum of space. Viewers had only recently adapted to seeing the blue planet float in space; now they encountered a singular, isolated human figure in the same perspective. Hence, space exploration not only changed our *weltbild* but, as Margaret Dreikausen proposed, 'it redefined the relationship of man "in the world" and the earth within the universe'.[6]

Earthviews: Looking Back at Ourselves

Rapid technological developments continue to fuel speculation that new insights about our cosmic origin or other worlds are attainable. As John Wilford observed, 'Every few weeks brings more spectacular pictures from the depths of space, pictures of the moons of Jupiter, the nurseries of newborn stars and the galaxies taking shape when the universe was young. They embolden cosmologists, the historians of the universe, in the audacious belief that many answers to questions of cosmic origin and evolution may be within their grasp'.[7]

In contrast to such visionary stances in the face of ever more breath-taking astronomical representations, we cannot help but register that these images, however magic at first, quickly lose their enchanting aura. Their initial lure dissipates as portraits of the blue planet move out of scientific journals and resurface in every imaginable setting of everyday popular culture, in which representations of Earth become ubiquitous staples of consumer advertising.

[6] Dreikausen, p. 62.

[7] John Wilford, 'Scientists step up search for extrasolar planets', *The New York Times* (9 February 1997).

Floods of ads featuring depictions of Earth promote uncounted products and services, ranging from telecommunication devices to environmentally safe household cleaners.

This proliferation of contemporary space imagery prompts us to turn to Giordano Bruno (1548-1600), Renaissance philosopher, astronomer and mathematician, for an uncommon yet ever fresh perspective on the subject at hand. In 1585, Bruno published *De gli eroici furori* (*The Heroic Frenzies*), a series of dialogues that comment on love sonnets.[8] The fourth set discusses a popular ancient myth, the tale of Diana and Actaeon. Originally narrated by Ovid, the myth describes the story of the young hunter Actaeon, who glimpses the beautiful goddess Diana during her bath.[9] Upon discovery of the mortal intruder, the offended goddess splashes him with water. This act transforms Actaeon into a stag that subsequently falls prey to his own dogs. Popular during the Renaissance, the story of Diana and Actaeon appeared in emblem books that became sources of inspiration for many artists.

Titian masterfully commemorated the mythic events. Titled *Diana surprised by Actaeon*, the 1559 oil painting depicts the moment when Actaeon surprises the goddess and her entourage in the bath. The hunter's bow has fallen to the ground as he raises his arms in awe about the sight of the goddess. Surrounded by her nymphs, Diana attempts to conceal her body, while her stern eyes fix Actaeon in a manner that foretells the fateful events to come. Red curtains and evenly placed bodies emphasize the theatrical composition of the scene that invokes a delicate play of desire, voyeurism and mirror relationships.

Bruno's *Dialoghi* explore the ancient myth as a metaphor for the process of enlightenment, here understood as the acquisition of transformational knowledge about the human condition. Actaeon's adventure symbolizes the philosopher's quest for truth and beauty. As a lover of truth, Actaeon sets out to seek enlightenment. The hunting dogs represent Actaeon's thoughts, whereas Diana manifests divine truth. Bruno describes Actaeon as young and inexperienced. His life is short and his passion for truth is capricious. Uncertainty and ambivalence obscure emotion and reason. The chase traverses wild forests and undeveloped areas that no human ever set foot in before. Love for truth, Bruno suggests, does not follow ordinary paths of thought. The author differentiates between *veltri*, the faster hounds, embodying human thoughts, and *mastini*, the slower bulldogs, representing the human will. Actaeon's

[8] Giordano Bruno, *The Heroic frenzies*, trans. P. E. Memmo, Jr. (Chapel Hill, NC: University of North Carolina Press, 1964).

[9] Ovid, *Metamorphoses*, III, 131-252, trans. Frank Justus Miller (Cambridge, MA: Harvard University Press, 1984). Leonard Barkan noted that 'While Ovid's account of the meeting between Diana and Actaeon is by no means the first or even the most typical classical version of the story, it is the version that signals the entrance of the myth on the main stage of cultural history'; 'Diana and Actaeon: The myth as synthesis', *English Literary Renaissance* 10 (1980): p. 318.

glimpse of Diana represents the hunter's encounter with divine truth. However, as punishment for his transgression Diana turns him into a stag, which is to be torn apart by his own dogs.

Actaeon's fate may be read as a fusion of the subject with the object of his desire. Tellingly, Diana's splashing of water with its symbolism of baptism emphasizes this transformation of identity. Seeing, for Bruno, is the primal human sense. He proposes a successive process of gaze, enlightenment and transformation. It is through seeing that the limited human spirit participates in the universal order of God. For Bruno 'to see' means 'to suffer original form'. Suffering enlightenment is both death and rebirth. Bruno views the death of Actaeon in symbolic terms as the highest wage for man seeking enlightenment. Actaeon undergoes a transformation from subject into object status precisely at the moment he recognizes divine truth. In other words, the quest for knowledge causes a reversal of subject and object during the very moment of enlightenment. Jean-Pierre Vernant has described Diana-Artemis as a figure that negotiates transitions between the spheres of civilization and wilderness, and between life and death: the hunt, the care of the young, childbirth, war and battle – Artemis always operates as divinity of the margins with the twofold power of managing the necessary passages between savagery and civilization and of strictly maintaining the boundaries at the very moment they have been crossed'.[10]

Mapping Bruno's reading of the ancient myth onto contemporary space photography would evolve as follows: as Actaeon searches for truth, humans push to deepen their knowledge about the universe. Actaeon hunts by sending out his dogs to guide him while humans launch probes, spacecraft or go EVA, engage in 'extravehicular activity'. Actaeon's hunt leads him through ever more remote areas of wilderness just as humans dare to breach ever more distant frontiers. As Actaeon glimpses Diana and loses his own identity in the process, humans continue to push the deep space frontier in their quest to unlock the secrets of the universe. As they turn around and look back they momentarily recognize and grasp everything and the only thing they have ever known: Earth. Glimpsing their home planet brings into play a reversal of subject and object positions. Earth, once the all-engulfing frame of reference for human subjectivity has turned into a detached, free-floating object. Consider, for instance, astronaut Mark Lee as he hovers outside the cabin of the space shuttle during a 1994 test flight of the SAFER (Simplified Aid For EVA Rescue) propulsion device (Fig. 21.4).

[10] Jean-Pierre Vernant, 'The figure and functions of Artemis in myth and cult', in *Mortals and Immortals: Collected Essays*, ed. Froma Zeitlin (Princeton, NJ: Princeton University Press, 1991), p. 204.

Fig. 21.4: Astronaut Mark Lee floats free of tether during Extravehicular Activity (EVA). 16 September 1994, *STS-064. Photograph, NASA.*

The astronaut appears faceless. Instead, we see his helmet's visor reflecting the glaring sun within the blackness of space. It appears as if the astronaut who had set out to explore the mysteries of space has now himself become a faceless *terra incognita.* Any human space exploration, Stephen Pyne reminds us, would sooner or later face an inescapable look into the mirror:

> The third great age of discovery, our age, would have to achieve understanding without interpreters, translators, native guides, hunters and collectors. No one could live off the land, go native, absorb the art and mythology of an alien consciousness, experience an alternative moral realm. There would be no one to talk to except ourselves; despite, or perhaps because of, attempts to treat it according to the prescriptions of the past, discovery inexorably becomes a colossal exercise in self-reference and self-reflection.[11]

Rapidly evolving technological advances alone do not necessarily enhance our understanding of the universe. On the contrary, the proliferation of images of Earth in popular culture may point to a visual amnesia of sorts, a move to cover up, obscure, or otherwise render invisible what would otherwise be a deeply

[11] Stephen Pyne, 'Voyage of Discovery', in Valerie Neal, ed., *Where next, Columbus? The future of space exploration* (New York: Oxford University Press, 1994), p. 31.

unsettling consequence of pondering the profound impact of seeing our very planet float in space. Let us remember that any mindful contemplation of Earth in all its fragility might prove too threatening to bear as the English language idiom of an 'earth-shattering' experience registers. Thus, the sight of Earth floating in space perhaps must remain concealed by layers and layers of popular imagery or 'visual noise', for we might otherwise be crushed by our inability to grasp the ever elusive truth of what we thought we had known all along: the human experience.

ASTRONOMY AND COSMOLOGY IN BYZANTINE ART: BRINGING BYZANTINE ART INTO THE TWENTY-FIRST CENTURY

Valerie Shrimplin

ABSTRACT: Fundamental links between theology and astronomy are widely reflected in the Judaeo-Christian tradition. From Genesis to Revelation, the great mysteries of the beginning and end of the universe, and the cycles of birth and death of individuals, are explained in terms of cosmological concepts. These are in turn reflected in art and architecture and nowhere more broadly, perhaps, than in Byzantine architecture and decoration. Following the Iconoclast prohibition of images in the Orthodox Church (726-843), the mid-Byzantine period (843-1204) witnessed the primacy of the representation of the heavens in art and architecture. Reinforced by such writers as Cosmas Indicopleustes and Pseudo-Dionysius the Areopagite, not only were individual images reflective of the heavens (nativity and rebirth at the winter solstice and rebirth/resurrection at the spring equinox) but entire cycles of church decoration were devised so as to reflect the ordering of God's universe. The architecture and decoration of the quintessential mid-Byzantine cross-in-square church was symbolic itself of the universe, as at Hosios Loukas and Daphni (11th century). From the location of the Pantocrator in the central celestial dome, to the descending zones of squinches and pendentives and the lowest earthly zones, decorative schemes are used to reflect the view of the sky/heavens above the earth. Hierarchical systems depicting the life of Christ and ascending/descending ranks of saints and angels were rigorously adhered to, with Mary in the apse as bridge between heaven and earth. By re-examining Byzantine art as image of the universe, we can bring this abstract expressionist art form metaphorically into the twenty-first century.

The sky is so blue and the sea is so blue that it is impossible in Greece not to be conscious of the heavens, the horizon, celestial phenomena and the surrounding cosmos. In contrast to northern climes, endless blue skies by day and the dome of stars by night make contemplation of the universe an inevitability. From Homeric times to classical Greece, perceptions and observations of the skies and astronomy permeated everyday life, from the changing seasons to links with the deities and forces that moved the cosmos. Epic, narrative and scientific texts relating to Greek astronomy from classical times are well known, but the same themes apply to the Byzantine era (313-1453 CE), which is often overlooked due to lack of understanding and even criticism of the Byzantine epoch in the West. This was promoted from the time of the split between Eastern and Western Churches in 1054 CE, and with regard to artistic achievement particularly during and after the Renaissance period when it was criticised by Vasari and others for lack of naturalism. Vasari comments on 'the dead tradition of the Greeks... paintings and mosaics covered with heavy lines and contours... their crude stiff

and mediocre style', not appreciating the symbolic and abstract approach, but criticising artists for not making their art 'softer and more realistic and flowing', something that they were clearly not trying to do.[1] Byzantine art should actually be regarded as abstract- symbolic and, as such, it is actually very closely linked to the view of the cosmos, and in turn reflected in art and architecture, in a way that will be argued in this paper as very modern in outlook.

Fundamental links between theology and astronomy are widely reflected in the Judaeo-Christian tradition. From Genesis to Revelation, the great mysteries of the beginning and end of the universe, and the cycles of birth and death of individuals, are explained in terms of cosmological concepts. The key issues – What is the universe? How does it work? Where are we in it? – have been widely examined by scientists and thinkers but also reflected in art and architecture. Byzantine architecture and decoration can lay claim to being amongst the foremost of these. The heavens have shaped spiritual and religious thinking with the result that they have been interpreted and exploited in art and architecture in order to convey, in one way or another, the great tenets of orthodox religious thought.

The Byzantine view of the cosmological ordering of the universe is first and foremost derived from the scriptures. From the opening descriptions in Genesis I of 'the beginning' to the analysis, in the book of Revelation, of 'the end', innumerable texts lay out the Judaeo-Christian view of the universe. The fundamental concept of the flat earth covered by the dome of heaven is derived from Isaiah 40:22 where God is described as the creator 'who sitteth upon the circle of the earth' and 'stretcheth out the heavens as a curtain and spreadeth them out as a tent to dwell in' (Psalm 104, Jeremiah 10:12). These provide the main sources for the view of the universe as a flat earth covered by the dome of heaven, from which much of the Judaeo-Christian tradition of church building is derived. This is clearly linked with the basic idea of the directional 'up for heaven' and 'down for hell' view in which the good are rewarded and the bad punished after their earthly existences. Byzantine art and architecture in turn aim to reflect such concepts, reinforcing the overall messages as well as creating an otherworldly atmosphere in a highly decorated architecture. Unlike Western church architecture where buildings are highly decorated with symbolic and especially narrative scenes on the exterior, Byzantine churches intentionally have rather sombre exteriors, in order to emphasise the transition into heavenly realms as the congregation enter within. The typical Byzantine domed church thus aims, overall, to be imitative of the flat earth covered by the dome of heaven whilst the rich mosaic-covered interiors convey the spectator to another heavenly world.

Such concepts, laid out in the scriptures, were reinforced and reinterpreted

[1] Giorgio Vasari, *Lives of the Artists* (1568; Harmondsworth: Penguin, 1971), p. 50. Citations refer to the Penguin edition.

over time, being further examined in various writings, of which the writings of Pseudo-Dionysius the Areopagite (6th century) and the *Christian Topography* of Cosmas Indicopleustes (7th century) are but two examples. Not only were individual images reflective of the heavens as represented in art but entire cycles of church decoration were devised so as to reflect the ordering of God's universe. The scriptural concept of the flat earth surmounted by the heavens, with hell beneath the earth's surface, had an immense influence on mid-Byzantine architecture and decoration. In this way, the ordering of the architecture and decoration of the quintessential mid-Byzantine church was itself symbolic itself of the universe. An effective shorthand of this schema is to be found in Cosmas Indicopleustes' *Christian Topography*.[2] This clearly corresponds to the concept of the flat earth, as the drawing of the universe is shaped somewhat like an antique travelling trunk (Fig. 22.1). The shape of the Holy Tabernacle (Exodus 25-27) was rectangular and twice as long as it was wide, the earth being held to be the same shape. Cosmas dismisses the ancient theory (of which he was surely aware) that the earth might be spherical, regaling the concept as ludicrous – for surely then rain would fall upwards (in the southern hemisphere)?[3] The correlation between the perception of the cosmos and church architecture is apparent. Similarly, in his drawings of the universe in cross section, the dome of heaven is evident and there is also an immediate and obvious correlation between this diagram, showing the universe in cross section, with the layers of celestial and terrestrial realms.[4]

Following the period of iconoclasm when visual images were prohibited in the Eastern Orthodox church (726-843), cosmological themes reached their height in the Middle Byzantine period (843-1204). Art and architecture were used to reinforce dogma and heighten theological and cosmological concepts at a time when it was difficult to think in such abstract terms. This contrasted with the narrative approach of Western art and architecture based on the use of church art and architecture as 'the Bible of the illiterate'. The typical structure of the mid-Byzantine domed Greek Cross-in-Square Church is related to concept

[2] Cosmas Indicopleustes, *The Christian Topography* (Cambridge: Cambridge University Press, 1909). Illustrative material relating to this paper is widely available on the Internet, and links/references are provided as appropriate. For the *Christian Topography* of Cosmas Indicopleustes see for example: http://commons.wikimedia.org/wiki/Category:Cosmas_Indicopleustes [accessed 30 January 2015)]; and http://commons.wikimedia.org/wiki/File:Cosmas_Indicopleustes_-_Topographia_Christiana_1.jpg [accessed 30 January 2015].

[3] For illustration see: http://commons.wikimedia.org/wiki/File:Cosmas_-_antipodes.jpg [accessed 30 January 2015].

[4] See V. Shrimplin, *Sun-symbolism and Cosmology in Michelangelo's Last Judgment* (Kirksville, MO: Truman State University Press, 2000), Fig. 14 and compare Fig. 15. See also Karl Lehmann, 'The Dome of Heaven', in *Modern Perspectives in Western Art History: An anthology of twentieth-century writings on the visual arts*, ed. W. E. Kleinbauer (New York: Holt, Rinehart and Winston, 1971).

of natural eye observation of the universe. It can be examined by focusing on two leading examples of the period: the monastery of Hosios Loukas in the Phocis area of Greece and the monastery at Daphni, near Athens.[5] The design of the church itself focuses on the ancient Greek mathematical attempt to 'square the circle' by placing a circular dome on the square cross piece created by the crossing of the arms of the church (the arms generally being of equal length, in contrast to the elongated naves and shorter transepts of Western churches).

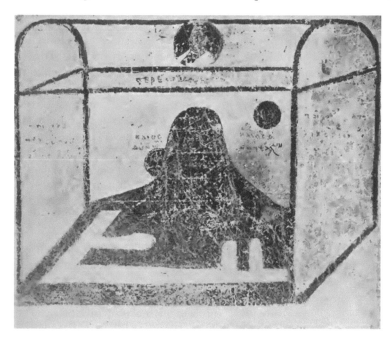

Fig. 22.1: Diagram of the universe, after The Christian Topography *of Cosmas Indicopleustes, seventh century. Wikimedia Commons.*

As mentioned, the exteriors are plain, rather than decorated with narrative scenes as in the west. Inside however, the entire church and its decoration are divided into specific zones that correlate with the areas of the universe. As Demus points out, 'They were not created as independent pictures. Their relation to each other, to their architectural framework and to the beholder must have been a principal concern of their creators'.[6]

[5] For illustrative material on Daphni, see, for example
http://www.ellopos.net/gallery/daphni-gallery/default.asp [accessed 30 January 2015].
[6] Otto Demus, *Byzantine Mosaic Decoration* (London: Routledge, 2nd edition, 1953), p. 3. Although first published in 1948, there are few better texts to provide an understanding of Byzantine iconography.

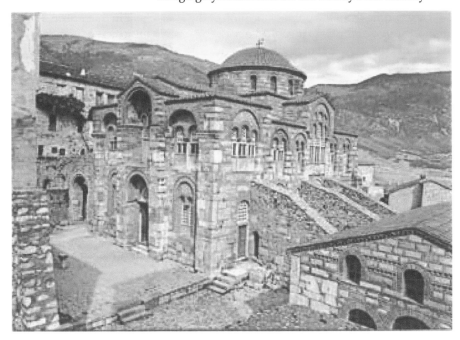

Fig. 22.2: The monastery of Hosios Loukas, Phocis, Greece. Wikimedia Commons.

The best examples of classic decorate schemes were clearly the great mid-Byzantine monasteries, such as Hosios Loukas (first half of the eleventh century), Daphni, mid-eleventh century, and Chios, late eleventh century. All of these (and many others) conformed to the standardized systems of Byzantine iconography. By the time of the building of Hosios Loukas, the Byzantine view of the cosmos had become more sophisticated than in the time of Cosmas, but the approach was fundamentally the same. Byzantine architecture is basically conceived as a 'hanging architecture' as the various realms descend from the Dome of Heaven itself. This contrasts with a significantly different approach in the West where, for example, the architecture aspires to reach upwards and heavenwards, as with the vertical emphasis of soaring Gothic vaults. In Byzantine architecture, together with its corresponding iconography and decoration, the layout is basically divided into three zones. The uppermost zone is reserved for events taking place/located in heaven itself. Hence the main dome is reserved for the *Pantocrator* as all-powerful cosmic deity rather than the 'Lamb' of the New Testament, as demonstrated by the *Pantocrator* at Daphni, or the *Descent of Holy Ghost* to the apostles at Hosios Loukas.[7]

[7] For illustrations of Hosios Loukas and Daphni, see Demus, *Byzantine Mosaic Decoration*, or other suitable sources, for example, Richard Krautheimer, *Early Christian and Byzantine*

Descending from the point of location of the *Pantocrator* in the central celestial dome, the iconography of the middle zone (of apses, squinches and pendentives) represents the next layers in the hierarchy of the descending zones of heaven, with scriptural images and figures organized and reflected in their position in the great scheme of things.[8] Mary, mother of Christ, is depicted in the apse as the bridge between heaven and earth. The emphasis here is on the Festival cycle where the key festivals of the Orthodox calendar year are organised, not according to the chronological narrative of Christ's life (as in the Western tradition) but in accordance with the occurrence of the Festivals during the year. Decorative cycles were not only dependent on hierarchical schemes analogous to the ordering of God's universe, but also to the liturgical year. The life of Christ is not depicted in a chronological or narrative sequence, as is more usual in the West, but in accordance with the associated astronomical events, such as birth and new life at the winter solstice (*Nativity*, 25 December), and rebirth at the spring equinox (*Crucifixion* followed by *Resurrection*). The cycle of mosaics at Hosios Loukas clearly demonstrates this, as the order is *Annunciation* (25 March) *Crucifixion* (April – full moon after the spring equinox), *Anastasis/Ascension* (forty days after Easter), *Pentecost* (50 days after Easter), *Nativity* (25 December, winter solstice), *Baptism* (celebrated at the *Epiphany*, 6 January), *Epiphany* or the visit of the kings (6 January), *Presentation in the Temple* (2 February) and so on, according to the feast days not the chronology of the life of Christ. The recurring cycle reflects the eternal motions of the heavens as proof of the existence of the heavenly realm, rather than aiming at a narrative of events. The illusion of space is also not attempted, but rather the use of the real physical space of the church.

Finally, the lower earthly zones are reserved for lesser saints and prophets, according to the hierarchy, which is dependent on the cosmological view of the universe in its hierarchical arrangements. Thus the church as an entity is used as a means of reflecting the view of the sky and heavens situated above the earthly regions. Hierarchical systems, depicting Christ and hierarchies of saints and angels, were rigorously adhered to and the approach to space is also significant. Real space is used for the mosaics at Hosios Loukas as the figures relate not only to the beholder, but also to each other in real space as they simultaneously face the beholder and each other across the apses and squinches (see Fig. 22.4). Concepts of infinity in the golden abstract backgrounds are also indicated.[9] Mosaicists were not interested in the depiction of lifelike figures in real space

Art (Harmondsworth: Penguin, 1984 edition), who analyses the cross in square church as image of the Universe and provides further references for the acceptance and practice of such symbolism in church building.

[8] Arthur O. Lovejoy, *The Great Chain of Being* (Cambridge: Harvard University Press, 1936); also, A. Koestler, *The Sleepwalkers: A History of Man's Changing Vision of the Universe* (Harmondsworth: Penguin, 1984 edition).

[9] The theory of the icon is best explained in Leonid Ouspensky, *La théologie de l'icône dans l'Église orthodoxe* (Paris: Editions du Cerf, 1980).

but in a symbolic approach that related to much higher concepts concerned with the cosmos. Reverence or worship is not paid to the icon but to the personage represented, much as a modern flag represents and symbolises the state.

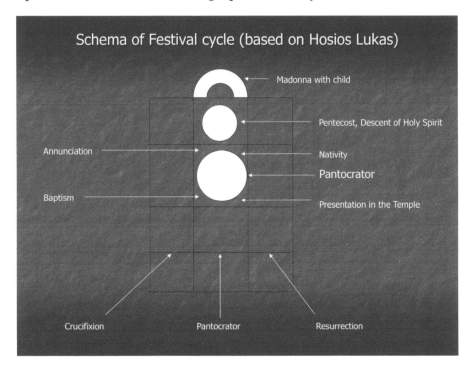

Fig. 22.3: Diagram of the Festival Cycle, image by Valerie Shrimplin.

In individual scenes also, cosmic concepts of infinity and eternity are explored through the depiction of abstract gold backgrounds, without limit. Individual astronomical elements are also much in evidence. The sun and moon feature in crucifixion scenes, used to emphasise the cosmic nature of Christ's sacrifice. Stars and celestial vaults are also included, even if somewhat abstracted and stylized (Fig. 22.4). Such images have been criticised in the west as 'crude, stiff and mediocre', and for being unable to depict three-dimensional space.[10] However, Byzantine artists should hardly be criticised for not doing what they were not intending to do. Would Picasso be criticised for not depicting naturalistic space? Is the Byzantine approach similarly to be viewed as an abstract interpretation of the cosmos?

[10] Vasari, *Lives of the Artists*, p. 50.

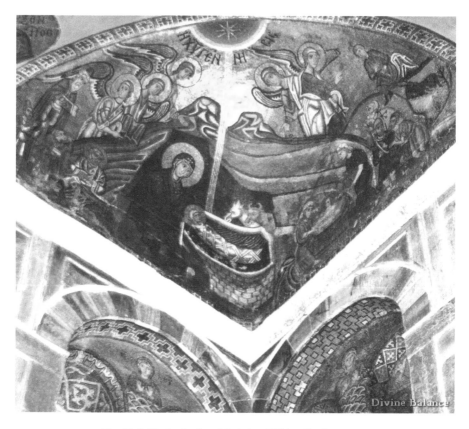

Fig. 22.4: Hosios Loukas, Nativity. Wikimedia Commons.

In the church at Daphni, slightly later than the mosaics at Hosios Loukas, the same principles apply. The awesome *Pantocrator* in the dome dominates the internal space, and the central and lower zones are also arranged in the same way so as to emphasise the 'other worldliness' of the interior of the church and its function as a reflection of God's ordering of the universe. The cosmological tradition is evident in later works, for example St. Saviour in Chora (now known as the Karie Djami), Constantinople, where the rolling out of the heavens is clearly depicted in accordance with the biblical text, 'And the heaven departed as a scroll when it is rolled together' (Revelation 6:14).

It is important to remember that during the Middle Ages, there were frequently exchanges of work in Byzantine and Islamic scientific circles. The Byzantine Empire initially provided the medieval Islamic world with Ancient and early Medieval Greek texts on astronomy, mathematics and philosophy for translation into Arabic since the Byzantine Empire was a leading centre of scientific scholarship at the beginning of the Middle Ages. Later, as medieval Islamic cultures became centres for scientific knowledge, Byzantine scientists

such as Gregory Choniades visited Moslem observatories and translated books on Islamic astronomy, mathematics and science into Medieval Greek.[11] Byzantine scientists also became acquainted with Sassanid and Indian astronomy through various Arabic texts.

The Byzantine tradition of cosmological church architecture and decoration was at its height in the mid-Byzantine period but it continued to play a part in subsequent centuries. The influence of Byzantine theories and principles is evident in the West, in spite of the very different approach to space and realism in the Renaissance. Indeed, it was partly the dispersal of great Greek thinkers after the taking of Constantinople in 1453 that was to precipitate the Renaissance. The traditional links between ecclesiastical art and architecture established in Byzantine art was also influential in Italo-Byzantine works in Ravenna (particularly San Vitale where the sphere of the universe is depicted in the apse), Monreale and St Mark's Venice. It travelled thence to influence Giotto's star covered ceiling in the Arena chapel in Padua and then to underlie the Renaissance tradition of domes and vaulted architecture which is a foundation for much of Western architecture. It might even be claimed as underlying some of the Renaissance approach, such as the Sistine Chapel, which is built in the same proportions as the universe (like Cosmas's 'travelling trunk') and originally with a star-covered and then later with Michelangelo's own cosmic vault.[12]

Re-examination of Byzantine art as an expression of the view of the universe brings this abstract expressionist art form, metaphorically, into the 21st century. The emphasis on 'other worldly', spiritual and inspirational aspects was intended for spiritual monastic communities, not as stories for the laity. Similarly, ecclesiastical architecture was held as symbol of the universe based on circular cycles / circles (not directional towards the altar, as in the West). Flat earth cosmology reflecting an 'up for heaven/down for hell' approach was combined with individual features (stars, sun, moon, sky), helping to shape religion and hence society and identity. As stated at the 7th Ecumenical Synod (2nd Nicaea) in 787 when images were restored to use, 'Art belongs to the artists but the disposition of it is the prerogative of the Holy fathers'.[13] Astronomy and Christian iconography reflected established traditions and formats. The views of cosmology and astronomy were fundamental to the hierarchical systems in Byzantine Art, centred on abstract theology, rather than popular piety and narratives and the saving of individuals (as in the West). The attempts to understand cosmology and worldview seem to reflect a genuine cosmic, abstract-expressionist approach.

[11] For Gregory Choniades (d. 1302), see David Pingree, 'Gregory Choniades and Palaeologan Astronomy', *Dumbarton Oaks Papers* 18 (1964): pp. 135-60.

[12] Shrimplin, *Sun-symbolism and Cosmology in Michelangelo's Last Judgment*, p. 14.

[13] For the ruling of the Council of Nicaea, see Emile Mâle, *The Gothic Image* (London: Fontana, 1961), p. 392.

GIORGIO VASARI'S 'SALA DEGLI ELEMENTI' IN PALAZZO VECCHIO, FLORENCE: THE SYMBOLISM OF SATURN AS HEAVENLY AIR

Liana De Girolami Cheney

We have an entire sky within us, our fiery strength and heavenly origin: Luna, which symbolizes the continuous motion of soul and body, Mars speed, and Saturn slowness, the Sun God, Jupiter law, Mercury reason, and Venus humanity.[1]

ABSTRACT: In 1555, Cristofaro Gherardi assisted Giorgio Vasari in designing and painting a mythological and cosmological theme in the *Sala degli Elementi*, an apartment of Duke Cosimo I de' Medici at Palazzo Vecchio. The *Sala degli Elementi* is dedicated to the four elements (air, earth, fire and water), which in antiquity were considered to be at the origin of the world or cosmos. The four elements are personified as a 'history painting' theme. In the Venetian-like sunken ceiling is the element of Air, personified by several events: its centre is depicted with *Saturn Mutilating Heavens*, revealing the castration of Saturn as a manifestation of heavenly power and the creation of the cosmos; surrounding this scene are *The Chariots of the Sun and the Moon*, the images of *Day* and *Night*; and in the corners of the ceiling reside the virtues of *Peace, Fame, Justice* and *Truth*. This study investigates how Giorgio Vasari (1511-1574) created mythological paintings for private decorative cycles (*camera intellecta*), how he appropriated classical and emblematic imagery in his mythological paintings, and how he fused the humanistic and cultural pursuits of the sixteenth century. Included is a consideration of Vasari's role in honouring his patron, Duke Cosimo I de' Medici, through celestial and cosmic myths.

This study investigates how Giorgio Vasari (1511-1574) created mythological paintings for private and public decorative cycles, how he appropriated classical and emblematic imagery in his mythological paintings, and how he fused the humanistic and cultural pursuits of the sixteenth century. The study also focuses on Vasari's fascination with classical Antiquity, in particular his role in redefining 'history painting' as ancient mythological paintings and the development of new formal conventions for secular decorative cycles.

In his history paintings and his writings, *Vite* and *I Ragionamenti*[2], Vasari relied on classical sources in two ways, visually and intellectually, revealing the influence of the ancient writings of Ovid, Pliny the Elder and Vitruvius as well as many Renaissance writers, including Leon Battista Alberti, Giovanni Battista

[1] Marsilio Ficino, *Letter to Lorenzo the Magnificent*.

[2] Giorgio Vasari, *Le Vite dei più eccellenti pittori, scultori, et architettori*, 1550 and 1568, ed., Gaetano Milanesi (Florence: G. S. Sansoni, 1970-74), Vol. VII; J. Draper, *Vasari's Decoration in the Palazzo Vecchio: The Ragionamenti* (Ann Arbor, MI: University Microfilm, 1973), noted here as *I Ragionamenti*.

Adriani, Cosimo Bartoli, Vincenzo Borghini, Annibale Caro and Paolo Giovio. Vasari's assimilation of the classical tradition of mythological paintings derives from emblematic and mythographic sources such as Andrea Alciato, Vincenzo Cartari and Pierio Valeriano. Furthermore, Vasari's aesthetic theory reveals influences from Marsilio Ficino's Neoplatonic philosophy.

Vasari emerges as an artist with a profound humanistic interest. This is particularly true for his early decorative cycles, which he created at his house, Casa Vasari, in Arezzo (1542-1554). These early decorative cycles represent a prelude to Vasari's later works, the decorative cycles for the Palazzo Vecchio in Florence (1555-1570). In his early decorative period, Vasari promotes artistic traditions by appropriating *all'antica*, emblematic, iconographical and artistic inventions; all are on display in his paintings in Casa Vasari. Later, in his mature decorative period, he elaborates and expands on his earlier artistic conventions in a complex and fanciful visual and intellectual manner, or conceit. With these artistic patterns in place, Vasari transforms the concept of creating a mythological painting into a conceit depicting a history painting, as visualized in the *Sala degli Elementi* of the Palazzo Vecchio in Florence. Here, his conceits are revealed in the visualization of the planetary god Saturn.

In 1548, in his house at Arezzo, Vasari depicts Saturn as planetary and cosmological god on the ceiling of the Chamber of Fortune. (Fig. 23.1). Saturn is rendered as Father Time, with his attributes of the hourglass and the scythe, but also as an astrological god accompanied by the zodiac signs of Aquarius and Capricorn. In 1556, in the *Sala degli Elementi*, Vasari elaborates on the conception of Saturn as a cosmological god by depicting him as an Element of Air or a Heavenly God on the ceiling of the *sala* or chamber (Fig. 23.2) and as an Element of Earth or a God of Agriculture on the walls (Fig. 23.3).

Years later, in the *Terrazzo di Saturno*, a terrace adjacent to the Sala degli Elementi, Vasari depicts another complex version of Saturn as Father Time, but with a more negative connotation. In the centre of the terrace's ceiling, Saturn devours his children while surrounded by the twelve hours of the day. The allusion of the celestial devouring of children is paralleled with the terrestrial devouring of time (hours) in human life (Fig. 23.4).

Fig. 23.1: Giorgio Vasari, Saturn *(detail), 1548. Ceiling, Chamber of Fortune, Casa Vasari, Arezzo; photo by author.*

Fig. 23.2: Giorgio Vasari, The Castration of Uranus (Heaven), *1556, ceiling, Sala degli Elementi, Palazzo Vecchio, Florence; photo by author.*

Fig. 23.3: Giorgio Vasari, The Fruits of the Earth Are Offered to Saturn, *1556, wall, Sala degli Elementi, Palazzo Vecchio, Florence; photo by author.*

Fig. 23.4: Giorgio Vasari, Saturn and the Hours, *1568, Terrace of Saturn, Palazzo Vecchio, Florence; photo by author.*

The *Sala degli Elementi*

In 1556, Cristofaro Gherardi assisted Vasari in designing and painting a mythological and cosmological theme in the *Sala degli Elementi*, an apartment belonging to Duke Cosimo I de' Medici at the Palazzo Vecchio in Florence. The Apartment of the Elements is dedicated to the four elements (air, earth, fire and water), which in antiquity were considered to be at the origin of the world. The four elements are personified as a history-painting theme, and are depicted on the ceiling and the walls of the room. On the walls of the *sala* are personifications of the elements of Earth, Fire and Water, and on the ceiling is the element of Air, personified by several events. Its centre contains *Saturn Mutilating Heaven*. Surrounding this scene are *The Chariots of the Sun and the Moon*, the images of *Day* and *Night*, and the virtues of *Peace, Fame, Justice* and *Truth*. The complex symbolism of the Element of Air, in particular its focus on the significance of Saturn, Father Time, as a heavenly or celestial astrological god, is an aspect of this essay (Fig. 23.2).

In this *sala*, Vasari symbolically creates a virtual cosmos, a heavenly realm, while compositionally he designs a terrestrial realm composed of geometrical spatial relations. The frescoed wall decorations, for example, consist of an *istoria* placed in a rectangular format in the centre of the wall. Adjacent to this, two oval cartouches, heavily decorated *all'antica*, depict other stories associated with the *istoria* placed in the centre of the wall. The bronze coloration of the cartouches and the grey-coloured ornamentation surrounding them are fictive recollections of ancient paintings. Below the rectangular format where the main *istoria* is depicted, there is a series of square *dadi* containing mythological stories. These narrations also connect with the *istoria* in the centre of the wall. The *dadi* area is also painted in fictive bronze, matching the decoration of the cartouche above, thus imitating an ancient Roman decorative style.

Contrasting with the terrestrial realm shown in the wall decorations, the heavenly realm is depicted on the ceiling. Vasari connects the terrestrial realm with the heavenly realm at three levels: first with the depiction of the virtues of Truth, Peace, Fame and Justice, which represent ethical values for humanity to aspire to and acquire. He visually reveals how his patron, Cosimo I, in achieving these virtues, manifests his benevolence and good governance for his subjects and the duchy.

The second level connects the cyclical formation of the celestial bodies, the Sun and Moon, with the terrestrial realm, Earth, depicted on the walls of the *sala*. Vasari portrays the Sun in the image of Apollo as Phoebus, riding across the sky on a fiery chariot drawn by four wild horses. Apollo is the God of Love, Music and Hunting. Paralleling Apollo's diurnal trajectory in the heavens is his sister, Diana, Moon Goddess, whose path is nocturnal. Beautiful Diana rides her chariot with black and white horses, alluding to the day and night presence of the Moon. She carries a luminous moon to brighten the firmament. This level alludes to human dependency on the cyclical manifestation of the

celestial bodies for material and spiritual cultivation.

The third level is the Element of Air, with the depiction of Saturn mutilating his father, Uranus, Father Heaven. According to Vasari, this imagery signifies the last creation. After chaos, Uranus creates Heaven and the Elements. Once order is established, his son Saturn is formed. Saturn castrates his father in order 'to cause the generation of earthly things'. Vasari compares Cosimo I's astrological sign, Saturn, with the celestial god, Saturn, showing how both create order out of chaos and cultivate a new age, a Golden Age.

Thus, the history painting or thematic cycle evolves in three levels in an ascending *crescendo*: from the first level or *dado*, which is the lower level of the wall, to the second level or centre of the wall, and up to the third level, the ceiling. The *istoria* unveils the physical world (*dado*) through a transformation (centre of the wall) into the metaphysical world (ceiling). In Neoplatonic terms, the signification of history painting develops in successive stages from the natural realm into the spiritual realm. The symbolism reveals several levels of conceits associated not only with the political role of Cosimo I de' Medici as Duke of Florence – and later of Siena and ultimately of Tuscany – but also with the significance of his name, Cosimo, as cosmos. Thus, these conceits are metaphors for the Duke as a cosmic ruler.[3] The many levels of symbolism are connected with literary writings as well as *all'antica* imagery. Both manifestations reveal Vasari's manner of, and the Cinquecento's taste for, combining mythology and alchemy in the pursuit of political power as well as artistic virtuosity. Humanist writings of the time by Cosimo Bartoli[4] and Alobrando Cerratini,[5] as well as those of Vasari, attest to this symbolic imaging of Cosimo I as cosmos, eulogizing and aggrandizing the Duke as the God Apollo, who rules the universe, and the god Saturn, who cultivates a Golden Age.[6]

I Ragionamenti is the most significant primary source for decoding the meaning of the imagery of the *Sala degli Elementi*, in particular, the Element of Air. Vasari drafted this manuscript, but it was then edited and published by Vincenzo Borghini, Cosimo Bartoli and Vasari's nephew, also called Giorgio Vasari, after Vasari's death in 1574.

In 1558, while writing *I Ragionamenti*, Vasari conceived of a novel way to convey to his patrons and artists an explanation for the creation of his artistic

[3] Claudia Rousseau, *Cosimo I de' Medici and Astrology: The Symbolism of Prophecy* (PhD dissertation, Columbia University, 1983), p. 124.

[4] Vasari's friend Cosimo Bartoli, a humanist and advisor to Cosimo I, dedicates to the Duke *Ragionamenti Accademici* (Venice: 1567).

[5] In the 1550s, Cosimo I commissions Aldobrando Cerratini to translate into the Tuscan language Virgil's *Aeneid*, where in Book IV, Anchises prophesies the reigns under the sign of Saturn in Latium and a Cosmo in the land of the Etruscan; see Henk Th. van Veen, *Cosimo I de' Medici and His Self-Representation in Florentine Art and Culture* (New York: Cambridge, University Press, 2006), p. 31.

[6] van Veen, *Cosimo I de' Medici*, p. 31.

programs and postulation of Cinquecento art theory. Using the Cinquecento dialogue format for articulating a fictive discourse between patron and artist, Vasari offers a scenario in which he unveils the mystery of his program. In this dialogue, the patron is Francesco de' Medici, son of Cosimo I. The dialogue begins as Francesco enters the Sala degli Elementi just as Vasari is resting from his painting labours. They greet each other as friends, qualified by the natural distance of age and station. *I Ragionamenti* is concerned mostly with the significance or conceit of images and, in particular, with Vasari's paintings. These explanations are not only helpful, but they are actually necessary because of the complex literary, historical and symbolic nature of Vasari's imagery.

In *I Ragionamenti*, Vasari follows Hesiod's *Theogony*, making this connection with the *sala*. He fittingly depicts in the ceiling of the *sala* the Element of Air, revealing the castration of Saturn as a manifestation of heavenly power and the creation of the cosmos. Below on one of the walls, the Element of Water unveils the result of Saturn's divine action in the birth of Venus, whereas on another wall, the Element of Earth reveals Saturn's transformation into the God of Agriculture (Fig. 3). Vasari continues to metaphorically allude to Cosimo's cosmic divine connection and earthly political aggrandizement.

In *I Ragionamenti*, for Vasari, the scene of the Element of Air depicts:

> God Almighty creating the world after chaos. God sowed the seeds of all things, which generate themselves, and after the Elements were full of these seeds, the world became perfect through them. Once Heaven and the Elements were ordered, Saturn was created, who measured himself against the turn of Heaven. Saturn castrated Heaven, cutting off his genitals. The hoary old man lying naked and looking rather serene stands for Heaven. The other old man, who stands with his back to the viewer and turns holding a scythe, is Saturn. He is cutting off Father Heaven's genitals with it in order to throw them in the sea.[7]

Vasari further explain the iconology in the ceiling:

> There are ten powers or attributes that theologians give to God, which in fact assemble at the creation of the universe. First attribute in the center of the painting is the circle of the crown is in the highest place. Theologians consider it the first of the powers attributed to God, the Eternal Spring. I (Vasari) made it large and abundantly rich in gems and pearls.[8]

In the left side of the painting, the second attribute is Wisdom. Vasari recounts,

> The sculptor is God's son Wisdom that is the power to create all things. The third attribute is Providence. He is also flying above and breathing on the statues, which represent the Providence that God has in instilling the spirit into all crea-

[7] Draper, *Vasari's Decoration*, pp. 95–102.

[8] Draper, *Vasari's Decoration*, pp. 95–102.

tures. The clay statures stand up and take on the color of flesh, showing that they are given life.[9]

Moving to the right side of the painting, Vasari explains: 'Clemency is the fourth attribute of God because of His goodness and mercy. A nude woman, squeezing her own breast and squirting milk for the nourishment of all living things, represents Clemency. The fifth attribute is the Grace of God, which He instils in all things'. Vasari elaborates:

> I painted a woman holding a vase from which pours out precious stones, money, gold and silver vases, necklaces, pope's miters, and the crowns of emperors, kings, princes and dukes, as well as cardinals' hats, Episcopal miters, the emblems of captains and generals, and the scepters of royal authorities and other dignitaries.[10]

Vasari continues:

> The next attributed is Adornment of the Heaven. She holds the fleece of Charles V because it shows that His Majesty has also worthily adorned our duke with this sign for his fidelity of spirit and strength. She also holds flowers, which stand for virtues, alluding to the house of the illustrious Medici family. The seventh power attributed to God is Triumph. The flying figure holding a laurel crown portrays this attribute.[11]

Turning to the left side of the painting, the kneeling figures, which lift their hands to the crown 'faithfully and reverently praising it', represent the eighth attribute, which is Acknowledgement of Praise. The ninth attribute is the Firmament, the power of the Heaven, which is composed of a horizontal slab of stone decorated with a multitude of clouds where the figures rest. Vasari notes: 'The significance of the enormous globe in the middle of the composition with the sphere of heaven and the twelve signs of the zodiac is the tenth power, it represents the Kingdom. And the sceptre indicates the dominion over all living creatures'.[12]

Symbolically, Vasari connects the Element of Air to Cosimo I's astrological sign of Capricorn and the planets Mercury and, in particular, Saturn. He composes the ball of the Earth inside a great gold sphere. In addition, he depicts Saturn touching the sign of Capricorn in the zodiac band of the sphere, with his left hand holding the scythe. This action alludes to Capricorn as the body of the cosmos, which, Vasari calls the 'World by astrologers'. This is an allusion to the duke's name. He is made patron of this state (Tuscany). Vasari clarifies: 'Saturn, his planet, touches Capricorn in its ascendant, and by their aspect they send living light to the ball of

[9] Draper, *Vasari's Decoration*, pp. 95-102.

[10] Draper, *Vasari's Decoration*, pp. 95-102.

[11] Draper, *Vasari's Decoration*, pp. 95-102.

[12] Draper, *Vasari's Decoration*, pp. 95-102.

the earth, especially to Tuscany and its capital, Florence, which today is furled by his Excellency (Medici) with such intelligence and justice.'

In elucidating how Vasari manifests the appreciation of emblematic texts in his art, this study examines the specific imagery of Saturn. Vasari follows the conventional scheme in constructing the ceiling as illustrated in astrological manuscripts of the Renaissance, such as *De Sphaera* of 1460, where Saturn rules both Aquarius the Water bearer and Capricorn the Goat (Fig. 23.5).[13]

Fig. 23.5: Saturn, *in* De Sphaera, *1460, astrological manuscript, Biblioteca Estense Universitaria, Modena (Lat. 209); photo by author.*

[13] This manuscript is one of the most beautiful astrological manuscripts on the planets of the Italian Renaissance. It is located in the Biblioteca Estense Universitaria, Modena (Lat. 209).

Vasari also appropriates Vincenzo Cartari's depiction of Saturn as a planetary god, portrayed as an older man holding an ourobos snake (Fig. 23.6).

Fig. 23.6: Vincenzo Cartari, Saturn, 1556, in Imagini delli Dei de gl'Antichi; photo by author.

At the same time, Vasari adjusts his imagery to fit his decorative scheme.[14] For instance, Saturn is surrounded by other attributes such as a scythe, a globe and a crown, with each being linked to a specific signification.

In analysing the Element of Air or Saturn, a segment of the ceiling decoration in the *Sala degli Elementi*, two issues arise: how Vasari's symbolism is deeply

[14] Vincenzo Cartari, *Imagini delli Dei de gl'Antichi* (1556), ed. Walter Koschatzky (Graz: Akademische Druck Verlagsanstalt, 1963), pp. 14-21.

rooted in the artistic conventions, emblematic and mythographic traditions of the sixteenth century, and how these visual traditions, reflecting Renaissance Neoplatonic notions, are assimilated into Vasari's secular decorative cycles.

The Renaissance Neoplatonic philosopher Marsilio Ficino based his cosmological theory on the writings of classical philosophers such as Pythagoras, Empedocles and Aristotle. But most of all, Ficino was influenced by Plato's theory of the four elements – air, fire, earth and water – as astrological symbols in relation to nature and her task of creation or destruction by means of these elements (*Timaeus*, 56:58). For example, Ficino writes:

> Every spirit since it is naturally rather fiery, and light and volatile like air, is also like light, and therefore similar to colors and vocal airs and odors and move-ments of the soul. For that reason spirit can be move quickly and formed through these things.[15]

Vasari's knowledge of Renaissance Neoplatonism derives from his classic and emblematic studies. For example, in *Element of Air* scene, he reveals his assimilation of Ficino's cosmic Renaissance Neoplatonism by his use of mythic sources for representations of natural phenomena and depictions of symbols throughout his artistic life. The historical tradition provides him with the opportunity to appropriate classical art to incorporate into decorative cycles. In addition, Vasari's iconographical legacy, embedded in ancient tradition, reveals the symbolism and implications of the celestial planets on the individual's life in his decorative cycles. By depicting the Element of Air on the ceiling, he alludes to the importance of the planets' rhythmical function in controlling the vicissitudes of life on earth. Since each planet has a distinct spirit, feature and role, it affects the psyche or soul of the individual (Vasari's soul). In the ceiling, in particular in the depiction of Saturn, Vasari reflects Ficino's comments on the image of Saturn as a combination of ominous disposition and auspicious power.

> The ancients made an image of Saturn for long life in Sapphire, at the hour of Saturn, with Saturn ascending and well disposed. Its for was this: an old man sitting in a high chair or on a dragon, his head covered with a dark linen cloth, his hands extending above his head, holding in his hand a sickle or fish, clothed in a dark garment.[16]

In Vasari's imagery, Saturn also holds a sickle, which brings to mind an early

[15] Thomas Moore, *The Planets Within: The Astrological Psychology of Marsilio Ficino* (Hudson, NY: Lindsfarne Press, 1990), p. 54, quoting from Ficino, *Opera*, Chapter 11; Jean Seznec, *The Survival of the Pagan Gods*, trans. Barbara F. Sessions (New York: Harper and Row Publish-ers, 1961), p. 49.

[16] Moore, *The Planets*, pp. 165-74, and quoted in Moore, *The Planets*, p. 169, from Ficino, *De vita coelitus comparanda* (Florence: 1489), Chapter 2, and Ficino, *Opera*, p. 536.

Italian association of Saturn with the God of Agriculture.[17] Thus, Saturn (*satus*
means sown) is considered to be a promoter of the physical welfare of the Ital-
ians.[18] On one of the walls of the *Sala degli Elementi*, Vasari depicts Saturn with
this connotation in the *First Fruits of the Earth Offered to Saturn*. The Heavenly
God Saturn as the God of Agriculture is associated with terrestrial richness. The
faithful offer him the good of the cultivated earth, such as fruits, grains and an-
imals. Vasari knows as an individual how to subordinate to the laws of Nature
as well as to the Law of God. For him, then, these cosmological associations
portray the control of the stars on Nature and Art.[19] However, he emphasizes
the difference between these two realms – the realm of nature and the realm of
art. The realm of nature is one of realism with nature, while the realm of art is
of idealism with art. The realm of nature is actual, general and real, whereas the
realm of art is artificial, selective and superior to nature. The artist experiences
nature but creates art, as Vasari's *sala* reveals his artistic sagacity or *invenzione*.

In *I Ragionamenti*, Vasari explains the significations of the images, or
invenzione, in particular in the *Sala degli Elementi* and the Element of Air. For him,
invenzione means much, since he is formulating the conceit of history paintings.[20]
The word *invenzione* encompasses his conception or idea (a Neoplatonic conceit),
which governs both the iconography and iconology of his work.[21] Moreover,
when Vasari uses *invenzione*, he means the intellectual and aesthetic fabrication
at hand, whether involving one image or an entire pictorial program. His
invenzione is associated with the visual representation of a history painting, e.g.,
the Element of Air.

Furthermore, Vasari's *invenzione* in this *camera intellecta* on the symbolism of
air conflates several astral notions associated with alchemy as well as planetary
and mythological references to his patron, Cosimo I, Duke of Tuscany. The duke

[17] Cartari, *Imagine delli Dei de gl'Antichi*, pp. 14–19, 86 and 292; in the Chamber of Fortune,
Saturn is depicted as an old man carrying his traditional hourglass, a symbol of time.

[18] Erwin Panofsky, *Studies in Iconology* (New York: Harper and Row, 1962), p. 74.

[19] Fitting with Renaissance Neoplatonism, Vasari creates a theological and cosmological
analogy between God the Creator (God the Maker or God the Architect) and himself – an
artist who creates, invents and imitates because he is in *entheos* (a Greek word for 'filled
with God'); see Milton Nam, *The Artist as Creator* (Baltimore, MD: Penguin Books, 1956),
passim; Nesca Robb, *Neoplatonism of the Italian Renaissance* (New York: Octagon Books,
Inc., 1968), *passim*; Rudolf and Margot Wittkower, *Born Under Saturn* (New York: Random
House, 1963), pp. 1-16; Ernest Kris and Otto Kurz, *Legend, Myth, and Magic in the Image of
the Artist* (London: Yale University Press, 1979), a fundamental book on the links between
the legend of the artist in all cultures and the human psyche.

[20] Svetlana L. Alpers, 'Exphrasis and Aesthetic Attitudes in Vasari's Lives', *Journal of War-
burg and Courtauld Institute* XXIII (1960): pp. 190-215, for a more narrow interpretation of
invenzione.

[21] Draper, *Vasari's Decoration*, p. 409; it refers therefore to the subject and the interpretation,
which Vasari intends. *Invenzione* also implies the artist's way of expressing his/her idea,
the design and composition of the image.

was born on 12 June 1519 at 9:00PM under the zodiac sign of Gemini. This Mercurial astral influence is accompanied by the planetary impact of Venus, a water element, and Saturn, an air element like Mercury but also the ruler of Capricorn, an earth sign.[22] Vasari visualizes these astral combinations by depicting the mythological story of the Saturn's castration in the ceiling of the *sala*. Saturn is a personification of Air in the program as well as the creator of Venus, a personification of Water, seen in the wall below. Earlier in his artistic career, in 1548, Vasari depicts the *Planets* on the ceiling of the Chamber of Fortune in his house at Arezzo (Fig. 23.1), while here Saturn is a planetary and cosmological god. And later, in the *Terrazzo di Saturno*, Vasari depicts a Saturn as Father of Time who controls the secular time of earth and not the celestial planets.

Vasari's symbolism reveals several levels of conceits associated not only with the political role of Cosimo I de' Medici as Duke of Florence – and later of Siena and ultimately of Tuscany – but also with the significance of his name Cosimo as cosmos. Thus, these conceits are metaphors for the duke as a cosmic ruler. These many levels of symbolism are connected with literary writings as well as *all'antica* imagery. Both manifestations reveal Vasari's artistic and intellectual virtuosity.

The Renaissance philosophy of cyclical evolution connected with the Renaissance Neoplatonic theory of microcosm and macrocosm proclaims the myth of the eternal homecoming. This philosophy alludes to cyclic alternation and perpetual rebirth as expounded in Vasari's theory of art and reflected in his *Vite* and in the ceiling's iconographical scheme. Consequently, in depicting the *Element of Air*, he affirms both ancient and Renaissance conventions on the symbolism of orderliness, correctness and harmony. Thus, the cosmological and magical qualities attributed to Saturn are linked with Cosimo's persona as well as with his pursuit of power and esoteric interests. At another level, Vasari's imagery attests to his *invenzione* for creating history paintings in a *camera intellecta* grounded in Cinquecento culture.

Lo cielo i vostri movimenti inizia (The heavenly bodies initiate your movements)[23]

[22] Although Mercury is Cosimo's astral birth sign and Gemini is his zodiac sign, Cosimo appropriates the sign of Capricorn to parent or affiliate with the ancient Roman emperor Augustus and the present emperor, Charles V, both of whom are born under the astral sign of Capricorn and the planetary governance of Saturn; see van Veen, *Cosimo I de' Medici*, p. 31.

[23] Dante's *Purgatorio*, XVI, 73.

HOLBEIN'S HORIZONS:
THE COSMOS OF A GERMAN ARTIST
IN THE AGE OF THE REFORMATION

Jennifer A. Morris

ABSTRACT: Hans Holbein the Younger is familiar in traditional art historical literature as the German portraitist of the early sixteenth century par example. But this versatile master engaged with many different genres and subjects over the course of his career that previous scholarship has left underexplored, some of which evince an apparent interest in celestial and terrestrial cosmography, science and natural philosophy, and the arts of the occult. As this paper will demonstrate, Holbein actively engaged with cosmological, astronomical and astrological themes throughout a significant part of his oeuvre; far from being random outliers in his output, this kind of imagery appears in the artist's work for well over a decade, both in Germany and in England, and bespeaks his collaboration with the likes of astronomer Nikolaus Kratzer and cosmographer Sebastian Münster. This continuity of scientific and occult motifs in Holbein's career has not yet been sufficiently remarked in Holbein studies, nor have scholars attempted to fit their considerations of astronomical and astrological themes in Holbein's career within the framework of current Reformation theology and science. In suggesting how Holbein's cosmologies accord with contemporary preoccupations with measuring time, contemplating plague, wars and other disasters, and preparing for the End of Time, this paper will thus offer an alternate view of the artist that deepens our understanding of the intellectual, religious, and artistic milieus in which he circulated.

Hans Holbein the Younger: superlative portraitist, master of line and color, draftsman of careful studies from life. Such is the standard description of this brilliant German artist of the early sixteenth century, whose personality remains enigmatic despite the decades' worth of ink spilled upon him by generations of art historians. Here, I would like to present an alternative view of Holbein, one that focuses not on his most celebrated works known to all of us, but rather on comparatively minor works that reveal aspects of his artistic character that have hitherto been overlooked. In this paper, I will be investigating the appearance of astronomical and astrological themes in designs from Holbein's Third Basel Period, and considering the role that cosmological material played in the artist's greater *oeuvre*. Although scholars have long noted Holbein's interest in scientific or occult motifs as manifested in paintings such as *The Ambassadors* and his *Portrait of Nikolaus Kratzer*, this facet of his production has not yet been fully explored. My research therefore seeks to illuminate Holbein's engagement with cosmological themes through a focused study of the drawings he produced circa 1530 for Sebastian Münster, professor of Hebrew at the University of Basel, which I believe will enable us to look upon the artist in a new light.

When, in 1528, Holbein returned to Basel following a prolonged sojourn in England, he arrived to find a city markedly changed since his departure in 1526. The Reformation had taken root, headed by the Zwinglian radical Johannes Oecolampadius, and with it swept a violent, albeit brief, wave of iconoclasm that had reverberations for the arts for decades to come. The university, once a thriving seat of humanist learning, had temporarily closed, and the flourishing book trade momentarily suffered; indeed, in the words of Erasmus, everything in the city had 'frozen'.[1] Holbein, in turn, discovered empty, whitewashed churches, formerly Catholic patrons turned rigorously Protestant, and iconophobic and secular authorities regulated public morality by discouraging ostentatious displays of wealth and vanity.

Since there were thus limited opportunities for commissions of the scale and prestige he was accustomed to receiving, Holbein busied himself for the next several years with relatively minor projects, ranging from woodblock-making to jewellery designs.[2] Meanwhile, he forged new working relationships with scholars and publishers who had remained in Basel despite the current religious tensions and dampened intellectual climate. Chief among them was Münster, a polymathic Franciscan-cum-Lutheran, for whom Holbein executed a series of drawings to be printed as woodcut illustrations in a number of scientific textbooks.[3] The most noteworthy of these, and hence the subject of my discussion, are Holbein's designs for Münster's treatises on solar and lunar horology (which dealt with the measurement of time): the *Compositio horologiorum* of 1531, the *Horologiographia* of 1533, and the *Canones super novum instrumentum luminarium* of 1534 (Fig. 24.1).[4]

[1] Written to Peter Gillis, the town clerk of Antwerp and a fellow humanist, in a letter dated 29 August 1526: 'Hic frigent artes....'. See Ep. 1740 in P. S. Allen, ed., *Opus Epistolarum Des. Erasmi Roterodami* (Oxford: Clarendon Press, 1926), pp. 391-2.

[2] Derek Wilson, *Hans Holbein: Portrait of an Unknown Man* (London: Weidenfeld and Nicolson, 1996), p. 165.

[3] The most significant of these was Münster's magnum opus, the *Kosmographie*, which was published by Petri in 1544. See the facsimile edition published by Anne Rücker and Frederik Palm, *Sebastian Münster: Cosmographia*, 2 vols. (Lahnstein: Edition Offizin, 2007).

[4] Sebastian Münster, *Compositio horologiorum, in plano, muro, truncis, anulo, concavo, cylindro, et variis quadrantibus, cum signorum zodiaci et diversarum horarum inscriptionibus* (Basel: Henricus-Petrus, 1531); Sebastian Münster, *Horologiographia, post priorem recognita... adiectis multis novis descriptionibus et figuris, in plano, concavo, convexo...* (Basel: Henricus Petrus, 1533); Sebastian Münster, *Canones super novum instrumentum luminarium: docents quo pacto per illud inueniantur solis et lunaemedij et uerimotus, lunationes, coniunctiones, et oppositions* (Basel: Cratander, 1534).

CANONES SVPER

NOVVM INSTRVMENTVM LVMINARIVM, DO-
centes quo pacto per illud inueniantur Solis & Lunæ medij
& ueri motus,lunationes,coniunctiones,oppofitiones,capu
draconis, eclipfes,horæ inæquales,& nocturnæ æquales,
ortus folis &occafus,afcendens cœli,interuallum,au
reus numerus,&c,Per Sebaft. Munfterum.

Fig. 24.1: Canones super novum instrumentum luminarium *of 1534.*

Let us turn to the material. The first of Münster's books published with Holbein's designs, the *Compositio horologiorum*, features five woodcuts which depict various devices for measuring solar and planetary motion: a small sundial, devised of undulating strapwork with a superimposed grid connecting numbers and zodiacal symbols to their proper astrological houses; a cylindrical sundial, or 'altitude dial', with bands demarcating numbers and the zodiacal symbols, used for measuring time via the sun's altitude; a 'Schema Concavi', or type of circular sundial; a 'Nocturnal', an instrument for determining the time of night based on the orientation of the stars; and an oversized, folding sheet known as the 'Large Sundial', which is similar in composition to the smaller sundial but includes additional markings which allow for sharper horological calculations (Fig. 24.2).[5]

[5] Several scholars of the early twentieth century discussed Holbein's drawings for Münster, but they limited their discussions more or less solely to formal analyses: Hans Koegler, 'Hans Holbeins d. J. Holzschnitte für Sebastian Münsters "Instrument über die

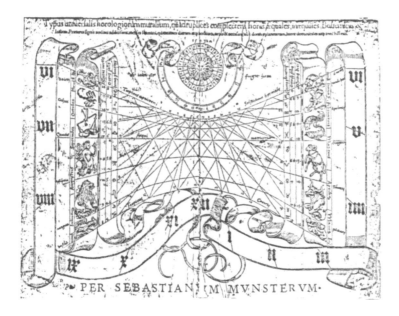

Fig. 24.2.

Each of these woodcuts served as *models* for the production of functional in-
struments. Too imprecise in their calculations simply to be cut out of Mün-
ster's books and utilized in and of themselves, Holbein's images would have
guided the reader in making and using relatively inexpensive, do-it-yourself
kinds of apparatuses suitable for scholars and amateurs alike. While Mün-
ster's text clarifies the technical aspects of constructing these various dials,
Holbein's illustrations demonstrated for the novice astrologer the appearance
of, and instructions for, user-friendly devices that would allow him to track,
and perhaps predict, solar and lunar movement on his own. Images such as
these thus played an important role in the transmission of practical scientific
knowledge beyond the small circles of the learned elite to craftsmen and other
laypersons.

The fact that Münster reprinted Holbein's designs from the *Compositio*
in a number of later publications suggests that the woodcuts enjoyed
considerable popularity, quite possibly the result of their utilitarian aspect.[6]

zwei Lichter"', *Jahrbuch der Preussischen Kunstsammlungen* 31 (1910): pp. 254-68; Emil Ma-
jor, 'Basler Horologienbücher mit Holzschnitten von Hans Holbein d. J.', *Monatshefte für
Kunstwissenschaft* 2 (1911): pp. 77-81; Martin Knapp, 'Die neu gefundene Münster-Holbe-
in'sche Kalendertafel', *Verhandlungen der Naturforschenden Gesellschaft* 22 (1926): pp. 247-
66.

[6] E.g., Sebastian Münster, *Fürmalung und künstlich beschreibung der Horologien...*, 2nd edition

In his *Horologiographia* of 1533, for instance, Münster includes three of the five images just mentioned: the 'Schema Concavi', the cylindrical sundial, and the 'Nocturnal'. But the *Horologiographia* did not merely copy the *Compositio,* for it features additional Holbein illustrations in the form of simple, rather crudely cut zodiacal signs (Fig. 24.3). Although previous art historians have contested the authorship of these images, current scholarship suggests that discrepancies in the quality of the illustrations should be ascribed to the relative skilfulness of the different woodcutters.[7]

Fig. 24.3.

Holbein's zodiacal signs are reminiscent of Albrecht Dürer's planispheric map of the Northern Sky, printed in 1515. While both artists drew upon late medieval astronomical imagery, Holbein and Dürer were among the first in the north to infuse this type of iconography with classical detail (such as the nude male figures of Gemini). Holbein did not rely solely on the Dürerian idiom, but his familiarity with the Nuremberg master's work is evident when one compares the two artists' depictions of the signs for Taurus and Scorpio, for example. One

(Basel: Henricus Petrus, 1537); Sebastian Münster, *Rudimenta Mathematica...*, 4th edition (Basel: Henricus Petrus, 1551).

[7] Susan Dackerman, ed., *Prints and the Pursuit of Knowledge in Early Modern Europe* (New Haven: Yale University Press, 2011), p. 100.

could say, though, that Holbein took more liberties in his treatment of the zodiac, concerning himself with stylistic flourishes and the streamlining of certain forms to give his designs a sleek and elegant, and not merely a descriptive, appearance. Nevertheless, like the models for instruments in the *Compositio* that were reprinted in the *Horologiographia*, the zodiacal signs here served a practical function – to assist the reader with identifying the constellations in the night sky and thereby attuning himself to the cycles of the celestial calendar.

Holbein's designs for the *Canones* are, however, perhaps the most interesting of his drawings from this period. The title-page illustration depicts two astronomer-philosophers, one holding a pair of dividers and resting his hand on an armillary sphere and the other peering into the heavens as he lifts up an astrolabe (Fig. 1). Above them hover a series of solar and lunar 'faces', each with a different expression. In this image, we thus see a fitting pictorial representation for the content of the book: the magus-like men, whether astronomers by trade or simply dilettantes, observe the movements of the sun and moon with their instruments; as the full title of the *Canones* indicates, Münster's treatise provides a guide for those wanting to measure and predict the motions of heavenly bodies. Indeed, on the second page of the tract Münster informs the reader that he, unlike other authors who deliberately obfuscate the inner workings of their devices and the theories underlying their texts, wishes to share his practical knowledge so that all may clearly comprehend the subject at hand and learn to make their own calculations.[8]

Thus, like his other tracts, Münster's *Canones* seems to straddle the line between theoretical and applied science, and the Holbein designs that appear throughout the text help to illustrate concepts that may have been difficult for the reader to comprehend or envision otherwise. The most striking and intricate of these designs, an astronomical chart comprised of multiple woodcut segments, is notable for its scale and its intended function as a removable, usable instrument (Fig. 24.4).

In the centre it depicts the phases of the moon, surrounded by the twelve zodiacal signs, and in the corners are four circular dials with computations

[8] Münster, *Canones*, p. 2: '*Non ignore optime lector, quod varia passim inveniuntur luminarium instrumenta, a maioribus nostris nobis relicta, ex quibus vel solis, vel lunae, vel utriusques imuleliciun turmotus. Namsunt, quaelunae revolutiones per singula exprimunt Zodiaci signa: alia, lunationis dies una cum luna eaugmento & decremento commonstrant. Suntrur sum quaedam, quae coniunctionem, oppositionum, & quartarumut cunquepate faciunt aspectus. Fuerunt denique qui hosmotus quam brevissime in calendariis signarunt, calculatis scilicetad certos annos veris coniunctionibus, oppositionibus & eclipsibus. Et haec quidam omnia tali tradiderunt involucro, ut qui mathematicarum rerum est imperitus, nihil hinc reportet lucri. Ego vero rem ipsamacu tangere cupiens, ita conaborte practicam & calculum docere praedictorum motuum, ut interim teorica quo quetibi pro viribus obtrudam: quo cernas, curis vel illemotus interdum opus habeat una vel duplicia aequatione, aliquando nulla: item cur in una eademque latitudine lunae, aliquando eclipsis contingant, & aliquando non*'.

for solar and lunar eclipses for the years 1530-1579. The four scenes located in the gussets adjacent to the major and minor circles represent four occupations which were thought to be ruled by planetary influences: midwifery, related to the waxing moon, and bloodletting, related to the waning moon; agriculture, dependent on the rising sun which brings spring; and medicine, because the setting sun brings death.

Fig. 24.4.

Here again Holbein showcases his skill in combining traditional imagery with contemporary pictorial styles. Although printed astronomical charts had been circulated for decades by this point, Holbein's woodcut is one of the first – if not *the* first – to juxtapose standard late medieval astronomical iconography (e.g., the professions in the four corners) with Renaissance motifs such as the putti,

foliage, and groteschi at top and bottom, the Latin minuscules in the cartouches, and the ring of naturalistically-depicted zodiac signs in such a manner. Holbein's innovation here is thus both stylistic and material, in the sense that he conceptualized the image in terms that were stylistically in vogue, despite the fact that the chart was meant to be *used* rather than prized as an artistic object.

Pictures of this kind suggest that astronomical and astrological prognostication was a common practice in the early sixteenth century, and that there would have been a ready audience for imagery of this kind. Indeed, people of all classes and trades were preoccupied with understanding the celestial happenings they believed to govern their lives; scholars and theologians in particular were consumed with adapting occult knowledge to fit a Christian worldview.[9] Astrology was more or less indistinguishable from astronomy in the sixteenth century, and was thus afforded the position of a liberal art that merited serious contemplation. Although certain aspects of astronomy and astrology *were* controversial in this period, the revival of classical learning and the evolution of applied sciences in the early modern period contributed to an intellectual mindset that justified astrology and astronomy on the basis that they would help improve the human condition by revealing the 'secrets' of the universe.[10]

Holbein's images for Münster can furthermore be discussed within the context of the early modern preoccupation with measuring and calculating time and space. According to Anthony Grafton, this so-called 'chronological mindset' was intimately linked to the study and production of calendars in the sixteenth and seventeenth centuries, which were in turn related to the computation of solar and lunar movement.[11] All of these calculations were necessary for conducting the daily rituals of secular and religious life, as planetary influences were thought to govern all aspects of man's being. Thus, by enabling Münster's readers to track and predict astronomical and astrological phenomena, Holbein's illustrations could be – and were – used as actual instruments in the quest to map out the precise dates and times of cosmological events that would affect humankind.[12] Since astronomical prognostication of this kind was seen as less dangerous than the so-called 'divinatory arts', Münster's treatises and Holbein's instruments therein would have been accepted by a broad audience of scholars and laymen – even by the severe Protestant magistrates of Basel who evidently deemed them legitimate.

[9] John David North, *Cosmos: An Illustrated History of Astronomy and Cosmology* (Chicago: University of Chicago Press, 2008), pp. 251-93; Richard Olson, *Science and Religion, 1450-1900: From Copernicus to Darwin* (Baltimore, MD: Johns Hopkins University Press, 2006).

[10] Wayne Shumaker, *The Occult Sciences in the Renaissance: A Study in Intellectual Patterns* (Berkeley, CA: University of California Press, 1972), pp. 1-27.

[11] Anthony Grafton, *Joseph Scaliger: A History of Classical Scholarship*, Vol. 2 (Oxford: Clarendon Press, 1993), p. 7.

[12] Grafton, *Joseph Scaliger*, p. 7.

The Protestant connection is, in fact, quite significant, for Holbein's images – indeed, and Münster's tracts as a whole – may also have had a religious dimension. A number of Reformation theologians, including Philip Melanchthon and Andreas Osiander, preached a type of eschatological astrology which dealt primarily with predicting the second coming of Christ.[13] Drawing upon interpretations of natural happenings as forms of divine prophecy that revealed secrets about the End of Time, these Protestant astrologers attempted to parlay people's apocalyptic fears into zeal for Christ and His gift of salvation.[14] Irregular meteorological events like comets and eclipses were seen as signs that the End was nigh, and the desire to decipher these signs resulted in the production of pamphlets and almanacs replete with interpretations of, and predictions about, the dates and times of celestial happenings.[15] Münster's horological treatises, with their instructions and devices for predicting heavenly motions, can in many ways be seen as the more cerebral counterparts of these almanacs, occupying a liminal position between popular *prognostica* and astronomical theory; and Holbein's images served as the practical guide, sometimes even the instrument itself, for this kind of astrological forecasting.

Holbein's illustrations for Münster's treatises thus sum up one of the greatest preoccupations for northern Europeans in the early sixteenth century: the quest to measure time via the movements of the sun and moon, to locate the exact coordinates that will predict aberrant astrological events, and to calculate precisely when and how natural disasters (or *the* disaster, the apocalypse) will occur. Images such as these suggest that the artist was well versed in the occult sciences, as does the fact that these themes appear in Holbein's art well before the Basel drawings under discussion. From his depictions of astronomers in Erasmus' *Praise of Folly* and his *Totentanz* series, to the ephemeral ceiling depicting the cosmos, zodiac and planets he painted at Greenwich to *The Ambassadors* and his portrait of Kratzer, Holbein engaged with astronomical and astrological motifs for well over a decade, pre- and post-dating his Third Basel Period, with collaborators both in London and in Basel. The horological drawings that Holbein created for Münster, notable for their stylistic ingenuity as well as their utilitarian function, hence can be related to broader trends in the artist's production which evince an apparent interest in celestial and terrestrial cosmography as well as in science and natural philosophy – a fact which has broader implications for the artist's *oeuvre*.

[13] Andrew Cunningham and Ole Peter Grell, *The Four Horsemen of the Apocalypse: Religion, War, Famine, and Death in Reformation Europe* (Cambridge: Cambridge University Press, 2000), pp. 22-74.

[14] Helen L. Parish and William G. Naphy, *Religion and Superstition in Reformation Europe* (Manchester and New York: Manchester University Press, 2002), p. 164.

[15] Cunningham and Grell, *Four Horsemen*, p. 76.

LOST WORLD: IMAGES OF MARS BEFORE THE SPACE AGE

Clive Davenhall

ABSTRACT: By the middle of the nineteenth century Mars was understood as a planet broadly similar to the Earth. Later in the century, and continuing into the twentieth, there developed a widespread idea in popular culture that the planet was inhabited by an advanced civilisation that had built the famous canals to husband its dwindling water supplies and stave off extinction. Most astronomers never accepted this notion, and from about 1910 they saw the planet as an increasingly inhospitable world. This paper examines some of the ways in which Mars was represented during this period by artists both within and outside the astronomical community.

Introduction

The modern understanding of Mars is the result of forty-odd years of exploration by robotic spacecraft. However, before the space age the planet had a long history of observation by Earth-bound astronomers, dating back to 1609-10 when Galileo Galilei first applied the telescope to astronomy. Mars is the only body, apart from the Moon, on which surface features were definitively identified and mapped prior to the space age. Further, the planet appeared both like and unlike the Earth, offering suggestive similarities and tantalising differences. It is unsurprising then that it played an important role in the development of ideas about planetary evolution, the debate over extra-terrestrial life, and in the development of the genre of science fiction.

In the late nineteenth and early twentieth centuries there was a widespread view in popular culture that Mars was likely to be inhabited by intelligent beings. Most astronomers never accepted this notion and as the twentieth century progressed they understood the planet as increasingly inhospitable. This paper examines some of the ways that Mars was represented from the 1870s until the Mariner 4 fly-by in 1965. The astronomical literature about Mars during this period is voluminous and there is an even larger hinterland of popular books, articles, newspaper stories and fiction. The episode has been well studied by historians of astronomy and there are several extensive recent studies.[1]

[1] O. Morton, *Mapping Mars* (London: Fourth Estate/HarperCollins, 2003); R. Markley, *Dying Planet* (Durham NC: Duke University Press, 2005); R. Crossley, *Imagining Mars* (Middletown, CT: Wesleyan University Press, 2011); Maria D. Lane, *Geographies of Mars* (Chicago: University of Chicago Press, 2011); and H. V. Hendrix, G. Slusser, and E. S. Rabkin, eds, *Visions of Mars* (Jefferson, NC: McFarland, 2011).

The Astronomical Understanding of Mars

By the middle of the nineteenth century a picture of Mars had been painstakingly assembled.[2] It was understood as a world basically similar to the Earth. Indeed it seemed the most Earth-like of the planets and the most likely to be inhabited. The Martian disk is mostly orange with smudges of grey / green markings (largely in the south). Though the details change with time, the basic features are permanent. The orange regions were usually thought to be continents and the grey / green areas to be seas. In addition there were white spots at the pole which waxed and waned with the Martian year, suggesting ice caps and seasons similar to the terrestrial ones. The planet seemed to have a substantial atmosphere which supported occasional clouds.

The year 1877 saw a favourable perihelic opposition (when Mars is closest to the Earth and thus well-placed for observation). This opposition was widely anticipated and well-observed, with many drawings, sketches and maps subsequently published. In particular, Giovanni Schiaparelli (1853-1910), a professor of astronomy from Milan, published a map showing unprecedented detail and introducing the nomenclature, based on classical mythology and geography, which still forms the basis of naming Martian features.[3] Also, his northern hemisphere showed a number of strange, hitherto unsuspected linear features which he called *canali*. The original Italian could mean either a natural or an artificial waterway, but it was usually translated into English as 'canal', with the implication of an artificial origin, which was plausible as Mars was already thought likely to be inhabitable. Initially only Schiaparelli saw the canals, but after a few years other astronomers were reporting them, and their existence became widely, though not universally, accepted. Schiaparelli himself always remained noncommittal about the origin of the canals. Others, notably Camille Flammarion (1842-1925), a widely read French populariser of astronomy, though initially sceptical, later enthusiastically embraced the artificial hypothesis.[4] The 1892 perihelic opposition was awaited with widespread interest.

One individual whose interest had been captivated was Percival Lowell (1855-1916), a wealthy American businessman, author, traveller and orientalist from Boston.[5] With considerable resources at his disposal, he founded an

[2] For example, P. Moore, 'The Mapping of Mars', *Journal of the British Astronomical Association* 94, no. 2 (1984): pp. 45-54.

[3] See M. Beech, 'Schiaparelli, Giovanni', in the *Biographical Encyclopaedia of Astronomers* (BEA), ed. T. Hockey (New York: Springer, 2007), pp. 1020-1021; Anon., 'Obituaries', *Astrophysical Journal* 32 (1910): pp. 313-319; and 'E.B.K.' (probably E. B. Knobel), *Monthly Notices of the Royal Astronomical Society* 71 (1911): pp. 282-87.

[4] See R. Baum, 'Flammarion, Camille', in the BEA, pp. 934-35; and the obituary by A. F. Miller, 'Camille Flammarion: his Life and his Work', *Journal of the Royal Astronomical Society of Canada* 19 (1925): pp. 265-85.

[5] Lowell's life and career have been well studied. For his most comprehensive biography see David Strauss, *Percival Lowell* (Cambridge, MA: Harvard University Press, 2001). More

Observatory in Flagstaff, Arizona, specifically to study Mars. Lowell's Mars differed significantly from earlier incarnations. The grey/green areas were now sparse vegetation in semi-arid areas and the orange ones desert proper. The canals were a giant civil engineering project built by an ancient advanced civilisation to irrigate their increasingly desert planet with melt-water from the poles. These ideas, however farfetched, were based in contemporary notions of planetary, biological and even social evolution. Mars was thought to be older than the Earth and planets were held to lose first their water and then their air with time. The existence of terrestrial deserts was irrefutable proof that the Earth was inexorably set on the same route down which Mars had progressed so much further.

The hypothesis that the canals were artificial was always controversial amongst astronomers. Some suspected (correctly in the event) that the canals were optical illusions. Others accepted their reality but considered them natural rather than artificial. However, from around 1909 the canal hypothesis largely fell from favour amongst astronomers. A number of lines of evidence led to this change, including: Mars' surface atmospheric pressure (then thought to be about a tenth of the terrestrial value) being too low for liquid water to exist, the failure to detect water vapour in the Martian atmosphere, the supposed hydrological cycle making no sense, the duplication of canal-like illusions from artificial disks of random patterns when viewed under similar conditions to observing the planet, and the failure of photographs to convincingly show the canals. The persuasive argument, however, came from Eugène Antoniadi (1870-1944), then the pre-eminent Mars observer, who simply failed to see the canals during the 1909 opposition while observing with the Great Meudon Refractor outside Paris.[6] His testimony was persuasive because he had previously worked with Flammarion and been an exponent of the canals.

All these arguments were contestable, and indeed contested, but a consensus emerged amongst most astronomers that the canals simply did not exist. Mars

concisely, Strauss also contributed Lowell's entry in the BEA, pp. 710-11. In the context of Mars also see W. G. Hoyt, *Lowell and Mars* (Tucson: University of Arizona Press, 1976). Louise Leonard, Lowell's secretary at the Flagstaff Observatory, reminisced about him in *Percival Lowell: An Afterglow* (Boston: Richard G. Badger, 1921), electronic version available at http://catalog.hathitrust.org/Record/001475685 [accessed 17 September 2014]; his first biography was *The Biography of Percival Lowell* (New York: MacMillan, 1935), electronic version available at http://catalog.hathitrust.org/Record/001475686 [accessed 17 September 2014], written by his brother A. L. Lowell. Also useful are the early chapters of *Explorers of Mars Hill* (West Kennebunk, Maine: Phoenix, 1994) by W. L. Putnam, another scion of the Lowell dynasty.

[6] See W. Sheehan, 'Antoniadi, Eugène', in the BEA, pp. 49-50; also R. J. McKim, 'The life and times of E.M. Antoniadi, 1870-1944. Part I: an astronomer in the making', *Journal of the British Astronomical Association* 103 (1993): pp. 164-70; and 'The life and times of E.M. Antoniadi, 1870-1944. Part II: The Meudon years', *Journal of the British Astronomical Association* 103 (1993): pp. 219-27.

remained a desert world though, and for succeeding decades it was seen as increasingly inhospitable. It was still considered plausible that it could support life, but its form dwindled to nothing more complex than the oft-mentioned 'hardy lichen'.

In the event even the astronomer's inhospitable Mars proved to be overly optimistic. The first successful fly-by, by the US Mariner 4 in July 1965, returned just 21 grainy, low-resolution black-and-white photographs, but they transformed our understanding of the planet, showing a barren, cratered landscape more reminiscent of the Moon.[7] The probe also estimated the surface atmospheric pressure to be a hundredth, not a tenth, of the terrestrial value. Subsequent probes have, of course, swung the pendulum back somewhat, revealing a fascinating world with active geologic processes and perhaps a warmer, wetter past. Nonetheless the old Mars was gone forever.

Depictions of the Astronomer's Mars

When writing in academic journals, astronomers usually restricted their illustrations to sketches of the Martian disk made at the telescope and the maps compiled from them. However, popular writing aimed at a wider audience was sometimes also illustrated with imagined landscapes. One of the earliest, and perhaps the most evocative, appeared in Camille Flammarion's *Les Terres du Ciel* (1884) (Fig. 25.1).[8] The artist has conjured an eerie landscape in which a plain criss-crossed by canals is illuminated by the setting Sun. Flammarion's later *Astronomy for Amateurs* (1904) reprised earlier ideas, showing lush vegetation bordering a broad sea, with the Earth and Moon prominent in the sky.[9]

The landscapes drawn by another Frenchman, Lucien Rudaux (1874-1947), several decades later provide a striking contrast.[10] Rudaux was a prolific French artist, commercial illustrator, enthusiastic amateur astronomer and an important figure in early 'space art'. Many of his drawings were collected in *Sur les Autres Mondes* (1937).[11] The chapter on Mars has several striking landscapes. Some are realistic depictions of Mars as it was understood in the 1920s and 30s (Fig. 25.2),

[7] Information about Mariner 4, and copies of all the images that it returned, are available from the NASA National Space Science Data Center (NSSDC), Goddard Space Flight Center at http://nssdc.gsfc.nasa.gov/nmc/spacecraftDisplay.do?id=1964-077A [accessed 3 September 2014]. For a discussion of the results of the mission see O. W. Nicks, 'Review of the Mariner 4 results', in A. Dollfus, ed., *Moon and Planets II: a session of the Joint Open Meeting of Working Groups I, II and V of the tenth plenary meeting of COSPAR, London 26-27 July 1967* (Amsterdam: North-Holland, 1968), pp. 150-185.

[8] C. Flammarion, *Les Terres du Ciel* (*The Worlds of the Sky*) (Paris: G. Marpon and E. Flammarion, 1884).

[9] C. Flammarion, *Astronomy for Amateurs* (New York: D. Appleton and Co., 1904), p. 144 (1910 ed.).

[10] R. Miller, 'The Astronomical Visions of Lucien Rudaux', *Sky & Telescope* (1984): p. 293.

[11] L. Rudaux, *Sur les Autres Mondes* (*On Other Worlds*) (Paris: Librairie Larousse, 1937).

and still seem surprisingly modern. Others, as a deliberate contrast, show Mars as it was imagined at the height of the 'canal craze' thirty or forty years earlier. In 1922 the Leeds-based amateur astronomer Scriven Bolton (1883-1929) also published a realistic Martian landscape, showing Syrtis Major as a dried-up seabed which the accompanying text described as a 'frozen swamp'.[12]

Fig. 31. — Le lever du soleil sur les canaux de Mars.

Fig. 25.1: The canals of Mars, as imagined by Paul Fouché in Camille Flammarion's Les Terres du Ciel *(1884), copyright Science Museum / Science and Society Picture Library, image no. 10324738.*

[12] S. Bolton, 'Did Germs from Other Worlds Bring Life to Earth?', *Popular Science Monthly*, 101(5) (November 1922): pp. 40-41; for biographical details see C. Davenhall, 'The Space Art of Scriven Bolton', in N. Campion and R. Sinclair, eds., 'Proceedings of the Seventh Conference on the Inspiration of Astronomical Phenomena' (INSAP VII)', in *Culture and Cosmos* 16, nos. 1 and 2 (2012): pp. 385-92.

CARACTÈRE PROBABLE D'UN PAYSAGE DANS LES RÉGIONS CONSIDÉRÉES COMME DÉSERTIQUES SUR MARS.

Fig. 25.2: The likely appearance of a Martian desert, Lucien Rudaux.[13]

Shortly after World War II, Chesley Bonestell (1888-1986), whose work is still well known, produced numerous drawings of Mars which were scientifically accurate to the knowledge of the time.[14]

Another popular theme in space art was Mars as seen from one of its moons. The earliest such scene seems to have been painted by the celebrated American landscape painter Howard Russell Butler (1856-1934). He became interested in astronomical subjects in later life and in 1924 produced two paintings showing Mars as seen from each of its moons (Figs. 25.3a-b).[15]

[13] Rudaux, *Sur les Autres Mondes,* opposite p. 152.

[14] R. Miller and F.C. Durant III, *The Art of Chesley Bonestell* (London: Paper Tiger, 2001). See also R. Miller, 'Chesley Bonestell: the Fine Art of Space Travel', in M. H. Schuetz, *A Chesley Bonestell Space Art Chronology* (Parkland, Florida: Universal Publishers, 1999), p. xvi, available online at http://www.bookpump.com/upb/pdf-b/1128290b.pdf [accessed 3 September 2014].

[15] See Jay M. Pasachoff and Roberta M. Olson, 'The Planetary and Eclipse Oil Paintings of Howard Russell Butler' (meeting no 45, presentation 108.03, American Astronomical Society, Division for Planetary Sciences, 2013).

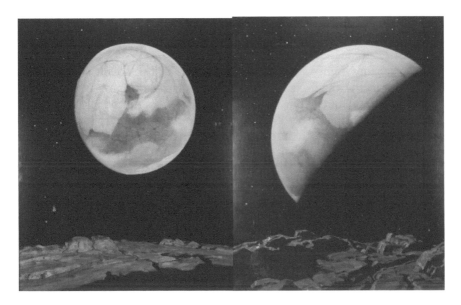

Fig. 25: Mars as seen from its moons Phobos (left) and Deimos (right), both Howard Russell Butler, oil on canvas (1924); courtesy Princeton University Art Museum, catalogue nos. PP354 and PP355.

These pictures originally hung in the Hayden Planetarium, New York, but are now owned by Princeton University. Both showed a canaliform Mars despite being painted in the 1920s. They proved sufficiently popular with the public for the Planetarium to issue postcards of them.[16] Rudaux, Bonestell and other artists all produced similar scenes, as indeed did Antoniadi,[17] and they also featured as the cover art of science fiction magazines.[18]

Mars in Fiction

Speculation about the inhabitants of Mars dates back at least to the Swedish mystic Emanuel Swedenborg (1688-1772), who reported their gentle and peaceable nature after being visited by the spirits of some deceased Martians (though their author, at least, regarded these accounts as reportage rather than fiction).[19]

[16] The present author owns an example.

[17] E. Antoniadi, *Bulletin of the société de astronomique de France* 40 (1926): p. 345. See also R. J. McKim, 'The life and times of E.M. Antoniadi, 1870-1944. Part II: The Meudon years', *Journal of the British Astronomical Association* 103 (1993): pp. 219-27, particularly, pp. 223-24, where a copy is reproduced.

[18] Examples include: *Astounding Science Fiction*, June 1938; *The Magazine of Fantasy and Science Fiction*, March 1953; *Fantastic Universe Science Fiction Magazine*, June-July 1953; and *Nebula*, March 1956.

[19] Swedenborg's extra-terrestrial visitations were originally collected as *De Telluribus in*

More conventionally, a number of novels about trips to Mars were published through the nineteenth century, such as Percy Greg's *Across the Zodiac or the Story of a Wrecked Record* (1880).[20]

In the decades immediately before and after 1900 five novels were published in response to the canal craze that were widely read, highly influential, and became foundational texts in the nascent genre of science fiction. In Germany, Kurd Lasswitz's *Two Planets* (1897), a nuanced tale of interplanetary contact and conflict, was extremely popular and influenced von Braun and his circle.[21] Alexander Bogdanov, a Russian intellectual and revolutionary, wrote *Red Star* (1908) and *Engineer Menni* (1913) which were widely read; respectively a simple socialist utopia and a tale of canal construction.[22] In English, H. G. Wells' *The War of the Worlds* (1898) was the prototype tale of interplanetary invasion,[23] and Edgar Rice Burroughs' *A Princess of Mars* (1912) and its many sequels and imitators gave rise to the genre of 'planetary romance'; swashbuckling tales set amidst the royal courts of ancient civilisations, beset by palace intrigues, hostile tribes and fearsome monsters.[24]

Mars continued to play an important role in science fiction until after the mid-twentieth century, often acting as the default background for interplanetary romances or extraterrestrial invasions. Also, starting with Stanley Weinbaum's celebrated short story *A Martian Odyssey* (1934), it contributed to developing ideas about how extraterrestrial life and intelligence might differ from their terrestrial counterparts.[25]

Mondo Nostro Solari (1758), which was largely extracted from his earlier *Arcana Caelestia* (1749-56). For a modern English translation see E. Swedenborg, *The Worlds in Space*, trans. J. Chadwick (London: The Swedenborg Society, 1997). For a general introduction to Swedenborg see, for example, G. Lachman, *Into the Interior: Discovering Swedenborg* (London: The Swedenborg Society, 2006).

[20] Percy Greg, *Across the Zodiac or the Story of a Wrecked Record*, 2 vols (London: Truebner, 1880). A reprint of both volumes was published by S. Moskowitz, ed. (Westport, CT: Hyperion Press, 1974). For a survey see Crossley, *Imagining Mars*, especially chapter 3.

[21] Kurd Lasswitz, *Auf zwei Planeten* (Leipzig: Felber, 1897), in German. A translation of an abridgement by Erich Lasswitz, the author's son, was published as *Two Planets*, trans. Hans H. Rudnick, afterword by Mark R. Hillegas (New York: Popular Library, 1971).

[22] Alexander Bogdanov, *Krasnaya zvezda* (St Petersburg: 1908) and *Inzhener Menni* (Moscow: 1913) in Russian. English versions of both novels are included in *Red Star: the first Bolshevik Utopia*, ed. Loren R. Graham and Richard Stites, trans. Charles Rougle (Bloomington, IN: Indiana University Press, 1984).

[23] H.G. Wells, *The War of the Worlds* (London: Heinemann, 1898). Originally serialised in *Pearson's Magazine*, April to December 1897.

[24] Edgar Rice Burroughs, *A Princess of Mars* (Chicago: A. C. McClurg, 1917); originally serialised under the pseudonym Norman Bean and title 'Under The Moons of Mars' in *The All-Story magazine*, beginning February 1912.

[25] Stanley Weinbaum, 'A Martian Odyssey', *Wonder Stories*, July 1934, and subsequently widely anthologised. The full text is available on Project Gutenberg, at http://www.

Mars in Popular Culture

Even before the canal craze there was already widespread popular interest in Mars in the later nineteenth century due to, for example, the works of Flammarion and the English astronomy populariser Richard Proctor (1837-88).[26] The canal craze of 1890-1910 saw a blizzard of articles and press releases from the Lowell Observatory. In addition, Lowell, who was an accomplished and persuasive author, wrote three widely read and influential books: *Mars* (1895), *Mars and Its Canals* (1906) and *Mars as the Abode of Life* (1909).[27] This material was further disseminated in countless newspaper and magazine articles which usually emphasised the most speculative and extravagant elements and were often imaginatively illustrated.

During this period there was also discussion, characterised more by optimism than practicality, of schemes for communicating with the presumed Martians.[28] Figure 25.4 reproduces a striking image by Albert Robida (1848-1926) that illustrated an article by the French science writer Wilfrid de Fonvielle (1824-1914).[29] It illustrates several themes in the popular Mars. Both the Martians and their telescope have a distinctly oriental appearance: Mars often served as a 'further orient' in a world in which there were fewer empty spaces on the map. Canals cross the middle distance, with cities along their banks. Unusually, there are smoking volcanoes in the middle-distance, and, oddly, one of the buildings is also smoking.

The idea of intelligent Martians, and the possibility of communicating with them, became sufficiently common that it appeared in advertisements; typically with the advanced Martians extolling to the backward Earthlings the virtues of whatever product was being advertised (Fig. 25.5). In this example, an understandably surprised Astronomer Royal discovers that the Martians are partial to Bird's Custard Powder. Canals are the only topographical feature shown on the Martian disk, but they are unlike the canals on actual Martian maps.

gutenberg.org/ebooks/23731 [accessed 3 September 2014].

[26] See R. Baum, 'Proctor, Richard', in the BEA, pp. 934-35.

[27] P. Lowell, *Mars* (New York: Houghton Mifflin, 1895); P. Lowell, *Mars and Its Canals* (New York: MacMillan, 1906); and P. Lowell, *Mars as the Abode of Life* (New York: MacMillan, 1909).

[28] M. J. Crowe, *The Extraterrestrial Life Debate 1750-1900* (New York: Dover, 1999), pp. 393-400.

[29] Wilfrid De Fonvielle, 'Fantaisie d'astronome: a la surface de Mars', *Journal des voyages* 220 (Sunday, 17 February 1901): pp. 186-87; illustration by Albert Robida.

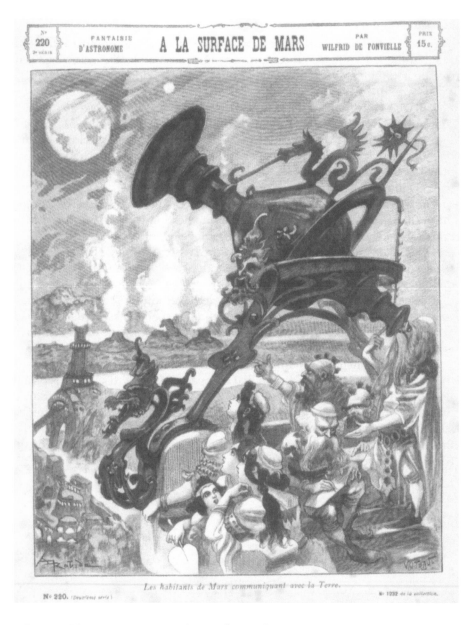

Fig. 25.4: Martian astronomers observe the Earth, *in this illustration by Albert Robida, 1901.*

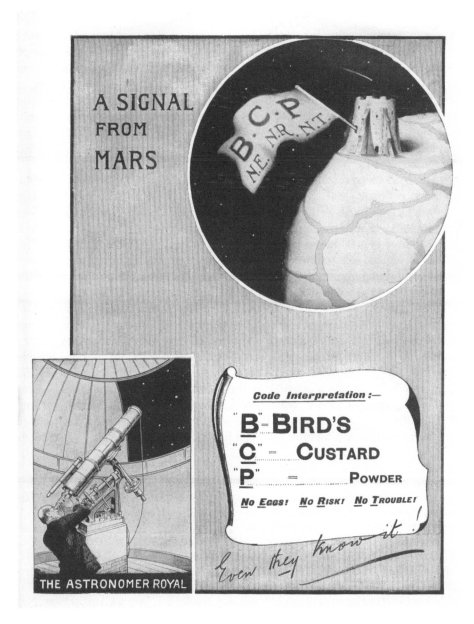

Fig. 25.5: An advertisement for Bird's Custard Powder that ran in newspapers and magazines during the summer of 1901. The copy reproduced here appeared in the weekly periodical Black and White *(London) for 13 July 1901.*

Discussion

The popular view of an inhabited Mars was both influenced by and influenced the treatment of Mars in science fiction. Conversely, the popular Mars simply parted company with the increasingly inhospitable planet of astronomers and was still firmly in place in the 1950s. As two examples amongst many, an explicitly Lowellian Mars featured in the 1952 film *Red Planet Mars* (the expository first scene features astronomical photographs of the canals and a discussion of the Martians melting their ice-caps for irrigation) and the notionally-factual episode *Mars and Beyond* of the television series *Disneyland*, broadcast in the US in December 1957.

These ideas spread beyond authors usually associated with astronomy or science fiction. Martian adventures are one of the themes mentioned by George Orwell in his essay 'Boys' Weeklies' (1940).[30] Dennis Wheatley is best remembered as an author of supernatural horror stories though he wrote in a number of genres. His wartime espionage novel, *They Used Dark Forces*, has Hitler convinced that following his suicide he will be reincarnated as a war-lord on Mars and includes an accurate description of Lowellian Mars. The story was published in 1964 but is set in the closing stages of World War II.[31]

The canal craze can sometimes seem like a phenomenon of English-speaking countries, but was more widespread. The ideas were common in France, perhaps due to the advocacy of Flammarion, and numerous early Martian novels were published in French.[32] Lasswitz's *Two Planets* was popular throughout Europe. The first film to feature a trip to Mars was the Danish *Himmelskibet* (1918).[33] Bogdanov's books were popular in Russia and had a number of successors, notably Aleksey Tolstoy's *Aelita* (1923), which was also made into a film.[34] Apparently the revolutionary leader Vladimir Lenin commented dismissively on Lowell's ideas at least once amongst his voluminous writings.[35] What seems

[30] 'Boys' Weeklies' first published abridged in *Horizon* magazine (Orwell, 1940); subsequently anthologised in *Inside the Whale* and *Other Essays* (1940) and *Critical Essays* (1946). For the full text see http://orwell.ru/library/essays/boys/english/e_boys [accessed 17 September 2014].

[31] D. Wheatley, *They Used Dark Forces* (London: Hutchinson, 1964).

[32] There is an extensive list at http://gotomars.free.fr/ [accessed 17 September 2014]; follow the link to 'Literature'. See also G. Slusser, 'Rosny's Mars', chapter 4 of Hendrix, Slusser, and Rabkin, *Visions of Mars*, particularly the first few pages.

[33] *Himmelskibet* or *Heaven's Ship*, also known as *A Trip to Mars*. Director August Blom, Nordisk Films Co, Denmark, 1918. *Himmelskibet* is sometimes incorrectly described as lost, but these reports are greatly exaggerated: the Danish Film Institute issued a complete version on DVD in 2006.

[34] See, for example, E. Yudina, 'Dibs on the Red Star', chapter 5 of Hendrix, Slusser, and Rabkin, *Visions of Mars*.

[35] Richard Stites, 'Fantasy and Revolution', introductory essay to the English edition of *Red Star*, ed. Loren R. Graham and Richard Stites, p. 10.

surprising now is not that Lenin should be unimpressed by Lowell but that he had heard of him at all.

The Mariner 4 fly-by finally ended the old popular view of Mars. However, perhaps surprisingly, it has continued to enjoy an afterlife in role-playing games such as *Space 1889* and deliberately retrospective fictions such as S. M. Stirling's novel *In the Courts of the Crimson Kings* (2008) or the recent anthology *Old Mars* (2013).[36] 2012 was the centenary of the publication of Burroughs' *A Princess of Mars* and also saw the release of a film adaptation. A more nuanced treatment is Ken Kalfus' genre-defying *Equilateral* (2013), a historical novel set during the 1890s in which an obsessive astronomer attempts to establish communication with putative Martians.[37] The old Mars may be gone beyond any recall but its allure lingers.

[36] S. M. Stirling, *In the Courts of the Crimson Kings* (New York: Tor, 2008); George R. R. Martin and Gardner Dozois, *Old Mars* (New York: Bantam, 2013).

[37] Ken Kalfus, *Equilateral* (London: Bloomsbury, 2013).

COSMIC STUTTERS: ANSELM KIEFER'S SEARCH FOR REDEMPTION IN THE STARS

John G. Hatch

ABSTRACT: Anselm Kiefer's work engages esoteric philosophy in an attempt to address German guilt regarding the Holocaust, or Shoah as it is referred to in Hebrew. Since the late 1970s, Kiefer has drawn on the Kabbalah and alchemy as two key sources that help give some sense of direction to the long process of healing the events of the Second World War. In his most recent work, Kiefer has rephrased these issues using stellar imagery, adding yet another layer of meaning to his quest. As a German Christian with little knowledge of Judaism, Kiefer had to immerse himself in the teachings of Jewish mysticism as well as the history of Judaism in Germany. Alchemy enters the fold as both a warning of the destructive excesses of the human ego, a lesson learned from Nazi Germany's appropriation of the occult, and as a torch guiding us in dealing with the barbarism of human behaviour. In particular Kiefer is attracted to the cosmic unity proposed by the seventeenth-century mystic Robert Fludd. He incorporates diverse plant imagery and the element lead in both paintings and book works which he has dedicated to Fludd; these works suggest some hope for the future but equally imply the impossibility of gaining the desired ideal of a holistic vision of the cosmos. Kiefer's work represents one of the more engaging examples of contemporary art that, through the use of the night sky, addresses in a novel way a variety of mystical sources in order to deal with a very modern trauma.

In the last fifteen years or so, the German painter Anselm Kiefer (b. 1945) has produced an intriguing series of paintings of the night sky. The subject is not so unusual. However, the manner in which it is portrayed is curious, to say the least. In the painting *Andromeda* (2001, see Fig. 26.1) numerous stars are depicted with a numerical designation next to them that employs modern astronomical observational data (for example, 015424+6341337SSB3.CAS).[1]

In addition, Kiefer has connected a group of stars in the traditional manner used to indicate constellations. However, the constellation that has been traced out is a fabrication. Added to this is the fact that a portion of the constellation extends onto a body of water at the bottom of the picture, yet the reflected lines do not mirror exactly those in the sky. In essence, we appear to witness in this painting the peaceful collision between science and fantasy, observation and imagination, or the naturally woven pattern of the human mind and the world with which it interacts.

[1] Hans J. Pirner, 'Himmelspaläste der Astrophysik' at http://www.tphys.uni-heidelberg.de/~pir/Himmel.htm [accessed 28 February 2012].

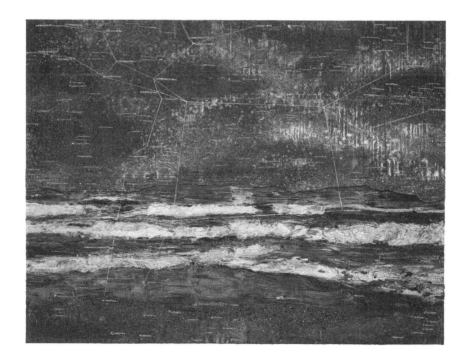

Fig. 26.1: Andromeda, *2001 (oil, emulsion and acrylic on lead and canvas, 396 x 500 cm);* © *Anselm Kiefer.*

Kiefer's interest in the type of night sky depictions found in *Andromeda* appears to have started in earnest in 1997-98. *Starfall, Pasiphae* and *Geese* all date to 1998 and employ the distinctive numerical designation mentioned above for some of their stars. The latter two retain clear figurative references that are marked out as constellations. In doing this, they play into our historical fascination with allegorizing the night sky, yet these works demonstrate a somewhat naïve, albeit playful, and stereotypical use of the night sky as subject.[2] *Starfall* and *Andromeda* are much more sophisticated renderings that pull together a number of different threads historically and personally for Kiefer.

To begin with, Kiefer appears to be referencing the German Romantic landscape tradition, specifically Casper David Friedrich, who painted some notable evening and night-time landscapes, including *Man and Woman Contemplating the Moon* (ca. 1824) and *Moonrise by the Sea* (ca. 1821). Kiefer has long had an interest in the eighteenth and nineteenth centuries, and a reworked 1969 photograph resulting in the 1980 work *The Starry Sky* bears a passage, albeit

[2] Daniel Arasse, *Anselm Kiefer* (London: Thames & Hudson and Harry N. Abrams, 2001), p. 22.

misquoted, from Immanuel Kant that reads: 'The starry sky above us, the moral law within me'.[3] It is in 1969 that Kiefer made his mark on the art stage with a notorious series of photographic works that came to be known as 'Occupations', in which he is shown at various locations, some well known, giving the Nazi or Hitler salute. This project was directed in part at bringing back to the fore the atrocities of the Second World War, which seemed to be fading further away with each passing generation.[4] One photograph of the 'Occupations' series shows Kiefer in a pose reminiscent of Friedrich's famous *The Wanderer Above the Mists* (1817-1818). This parallel speaks clearly to how the atrocities of the Nazis during the Second World War corrupted the glory of German culture, an idea discussed further below.

In the 1980s Kiefer rose to international prominence with his paintings of architectural interiors of famous Nazi buildings, continuing to reference the massive shadow cast by the Nazis. The night sky makes an appearance in *To an Unknown Painter* (1983), in which a Nazi interior is the setting for a painter's palette, with the ceiling of the building open to a turbulent cosmos above that appears to be reflected on the floor as well. The iconography here is ambiguous, and intentionally so. On the one hand, it presents a contrast between the material and spiritual worlds, with the artist as a potential bridge between the two. Kiefer is a deeply spiritual man whose turn to the arts came when he spent three weeks at a Dominican monastery in 1966; he often speaks of the artist's role and how the artist's tapping into the imagination is the one human tool that helps bridge our understanding of the divine, which the palette in the centre appears to be symbolizing.[5] However, the work has its darker side, not only with its citation of Nazi architecture but with the painter's palette itself, which likely is also meant to remind us of Adolf Hitler's failed career as an artist.[6] This type of dual reading is typical of Kiefer, whose faith in humanity is always tempered by an understanding of its cruelty; in this case, though, the question is more how does one maintain one's faith in the face of the extreme cruelty of the Second World War?

To an Unknown Painter continues what the 'Occupations' series had started, showing how, in Germany, the poetry of the human imagination was almost destroyed by the rule of Fascism. Kiefer has a number of works depicting the midsummer night on which is celebrated the birth of St John the Baptist, a Christian event that coincides with the summer solstice, which itself is related to a number of northern European pagan festivals. The night sky is prominent

[3] Katharina Schmidt, 'Cosmos and Star Paintings 1995-2001', in *Anselm Kiefer: the Seven Heavenly Palaces, 1973-2001*, exh. cat. (Ostfildern-Ruit: Hatje Cantz, 2001), p. 75.

[4] Mark Rosenthal, *Anselm Kiefer* (Chicago and Philadelphia: The Art Institute of Chicago and Philadelphia Museum of Art, 1987), pp. 14-17.

[5] Michael Auping, 'Introduction' to *Anselm Kiefer: Heaven and Earth* (Fort Worth, TX: Modern Art Museum of Fort Worth and Prestel, 2005), pp. 29-31.

[6] Auping, 'Introduction', p. 34.

in these Kiefer paintings, acknowledging the pagan celebrations, while the use of straw in works like *Your Golden Hair, Margarete* and *Midsummer Night* (1981) symbolizes the bonfires set to celebrate the Christian festival as well as signalling an undercurrent of an interest in alchemy, as we will see later. At the same time, these works speak to how the Nazis appropriated both pagan and Christian rituals; the midsummer festivities of 1941 were explicitly chosen by Hitler to mark the launch of his Russian campaign.[7] Added to that would be the memory of the bonfires used to destroy banned books under the Third Reich. The corruption by the Nazis of our creative interactions with the world, represented by rituals such as the midsummer celebrations, is even more clearly the theme of Kiefer's 1988 painting, *Siegfried's Difficult Way to Brunhilde* (1988), where the abandoned rail line shown in this work references the infamous paths to the concentration camps.

Kiefer's allusions to the plight of the Jews during the Second World War becomes a dominant theme beginning in the 1980s, in particular his view that German life was severely impoverished when the Nazis enacted the Final Solution. For Kiefer, Jewish culture is an integral element of German life, and he is at a loss to try to come to terms with why the Nazis would chop away at the roots of such an important and enriching element. This is an attitude Kiefer shared with the Romanian-born German poet Paul Celan, who is likely Kiefer's inspiration for the idea and who continues to be an important touchstone for Kiefer's work. *Your Golden Hair, Margarete* explicitly references Celan's poem *Death Fugue*, written in 1945 in a concentration camp and published in 1952. Margarete, with her golden straw hair, represents in Celan's poem the Aryan half of German culture, while the ashen-haired Shulamith is her Jewish counterpart. The terms 'straw' and 'ashen' to describe the hair of each is clearly quite intentional. In Kiefer's painting *Shulamith* (1983), her name is inscribed on the work itself in the upper left corner; in the distance in the centre are seven flames, a clear allusion to the seven-branched candlestick of the temple of Jerusalem. The structure continues to quote Nazi architecture, specifically the funerary crypt of the Soldier's Hall built in Berlin in 1939 by Wilhelm Kreis; thus, Kiefer transforms a fascist monument into a memorial for its victims.[8]

Celan writes in *Death Fugue* of 'digging graves in the sky' and this passage seems to have stuck with Kiefer since he frequently draws a correspondence between those who died in the concentration camps and the stars. With *Sternen-Lager IV* (1998, see Fig. 26.2) we encounter what appears to be a storage area containing numerous boxes, each labelled with a lengthy numerical sequence. On closer examination the numbers designate star positions, magnitudes, colour, etc., as was the case with *Andromeda*; this probably should not come as a surprise

[7] Rosenthal, *Anselm Kiefer*, p. 104.
[8] Andreas Huyssen, 'Anselm Kiefer: The Terror of History, the Temptation of Myth', *October* 48 (Spring, 1989): pp. 41-43.

since the title of Kiefer's painting is, literally translated, 'Star Store'. However, the interior cannot but remind one of Kiefer's earlier Nazi interiors, and the translation of Sternen-Lager can also be read as 'Star Camp'. This then transforms our perception of the work from a whimsical interpretation of capturing stars and keeping them in a storeroom, to viewing the boxes as possibly containing the personal effects of concentration camp victims, with the numbers alluding to the infamous tattooed identifications applied to camp prisoners.

If we look to the back of the room in *Sternen-Lager IV*, we find a polyhedron that brings to mind Albrecht Dürer's famous print *Melancolia I* that illustrates Cornelius Agrippa's 'Melancholia Imaginativa', depicting symbolically the artist's role as a mediator between heaven and earth.[9] In Kiefer's case, this role is obviously frustrated by the Shoah and underscored by Theodore Adorno's famous statement: 'To write poetry after Auschwitz is barbaric'.[10] The ladder in the back of *Sternen-Lager IV* is also found in Dürer's print and has certain alchemical connections, where the seven rungs of Dürer's ladder correspond to the seven steps of the alchemical process, the seven heavenly bodies, and the seven metals; as such, the polyhedron may represent the base metal lead and the philosopher's stone, however, the ladder in *Sternen-Lager IV* is also a visual analogue to the rails leading to the concentration camps. That said, we can also look at Jacob's Ladder as offering the hope of spiritual ascension, an image Kiefer has included more than once in his paintings.[11] Again, Kiefer's message struggles between a utopian idealism and a disheartening realism. As mentioned earlier, this is the point: that hope always has to be mitigated by the destructiveness of human behaviour. In other words, heaven is still available to us, however we must carry the weight of history in striving for it.

Kiefer took solace in the fact that Celan continued to write poetry after the Holocaust despite being the only survivor of his family of the concentration camps, although the weight of history was eventually too great for Celan and he committed suicide in 1970. Kiefer admired the American Abstract Expressionists as well, who like him turned to mythology – particularly myths of destruction and rebirth – to try and make sense of the events of the Second World War.[12] Mark Rothko's *The Sacrifice* (1946) and Barnett Newman's *The Slaying of Osiris* (1945), for example, acknowledge the violence of human behaviour while nevertheless embracing the hope for some salvation, no matter how tainted the soul of humanity may be.[13]

[9] An excellent recent summary of the research on Dürer's famous print is David R. Finkelstein, 'Melencolia I' (2007) at http://arXiv.org/abs/physics/0602185v2 [accessed 28 February 2012].

[10] Theodore W. Adorno, *Prisms* (Cambridge, MA: The MIT Press, 1983), p. 34.

[11] Arasse, *Anselm Kiefer*, p. 189

[12] Charles Molesworth, 'Anselm Kiefer and the Shapes of Time', *Salmagundi*, No. 82/83 (Spring-Summer 1989): p. 78.

[13] Coincidentally, Rothko committed suicide in 1970, although the circumstances of his

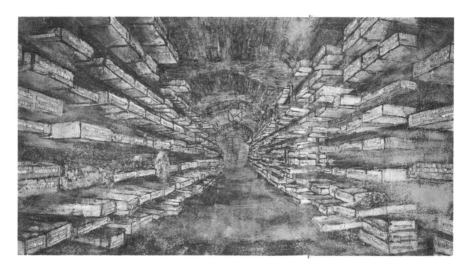

Fig. 26.2: Sternen-Lager IV, *1998 (acrylic, shellac, emulsion, sand and soil on canvas, 465 x 940 cm); © Anselm Kiefer.*

Kiefer's *Storm of Roses* of 1998 promotes hope through the symbol of the rose and includes contemporary stellar references. But it also carries the weight of history with the barbed wire acting as a reminder of the death camps. This work, which carries on Kiefer's counterpoint of hope and despair, points to a new and rather curious wrinkle in his artistic arsenal, namely the little-known seventeenth-century English esoteric philosopher Robert Fludd, whom Kiefer stumbled upon in 1995.[14] What appears to have attracted Kiefer to Fludd is that he was one of the last staunch defenders 'of a mode of thought which affirmed the living continuity of humankind and the cosmos', as Daniel Arasse puts it.[15] Fludd was an exponent of the practice of thinking by analogy, which embraced a belief in the correspondence between the microcosmic and the macrocosmic that dated back to antiquity but was soon to be extinguished by modern science. Fludd's particular cosmology was vehemently attacked by Kepler and many other of his contemporaries.[16] In the *Storm of Roses*, Kiefer embraced Fludd's notion of 'resemblance' between our world and the universe through a correspondence between flowers and stars.

death were tied to illness.

[14] Schmidt, 'Cosmos and Star Paintings 1995-2001', pp. 75-77; Paul Ardenne, 'Un Corps de Meditation', in Paul Ardenne and Pierre Assouline, eds., *Anselm Kiefer Sternenfall: Grand Palais* (Paris: Editions du Regard, 2007), pp. 173-74; and Arasse, *Anselm Kiefer*, pp. 256-57, 259, 262-63.

[15] Arasse, *Anselm Kiefer*, p. 256.

[16] William H. Huffman, *Robert Fludd and the End of the Renaissance* (London and New York: Routledge, 1988), pp. 100-33.

In a series dedicated to Fludd called 'The Secret Life of Plants', Kiefer's parallel between plants and planets, seeds and stars, finds a rather novel form of presentation in the form of some rather large books. The imagery is the same throughout, with plant seeds (sometimes literally) taking on the appearance of stars; however, the books are moulded from lead. Like Fludd (and Celan as well, it should be noted), Kiefer was fascinated by alchemy, as I have hinted at already. Lead is the first of the alchemical metals and the least pure, and Kiefer uses a great deal of it. Many of the star works discussed above use lead, more often than not in the numerical star designations. Lead in alchemy represents the human and is the lowest level of the metals, but can be transmuted into gold. Kiefer himself stated in an interview: 'I feel closest to lead because it is like us. It is in flux. It's changeable and has potential to achieve a higher state of gold. You can see this when it is heated. It sweats white and gold. But it is only potential. The secrets are lost, as the secrets of our ability to achieve higher states seem lost or obscured'.[17] There is no doubt that, like many artists before him, Kiefer sees himself as something of an alchemist who is able to transform raw material into something of value and meaning. This becomes literal with his use of lead and is implied with his use of straw in *Golden Hair, Margarete*; straw can be used to start up the alchemist's furnace, the athanor, to which Kiefer dedicated a series of paintings.[18]

Kiefer's link to Robert Fludd does not end with a shared interest in alchemy, however. Fludd, like the Renaissance philosopher Pico della Mirandola, also turned to Jewish Mysticism and to the Kabbalah in particular in discussing his ideas of the correspondence of the material world with the cosmos. Kiefer does the same in his more recent work, although he takes a step further back by drawing on the pre-Kabbalistic imagery of the Hekhaloth texts, which describe the seven firmaments connecting the earthly and the divine, each with its own palace (hence the word Hekhal, Hebrew for palace), capped off by an eighth firmament where Divine Wisdom resides.[19] Kiefer's *The Sky Palaces* of 2002 (Fig. 26.3) is inspired by Jewish mysticism and the Hekhaloth; this painting also brings us full circle in our current discussion. The Nazi buildings that Kiefer first referenced in the early 1980s have been re-appropriated by myth and belief in *The Sky Palaces*; the night sky is of more recent vintage with its stars and their scientific designations, made of lead no less, but now we find the addition of a

[17] Auping, 'Introduction', pp. 37, 39.

[18] Arasse, *Anselm Kiefer*, p. 237.

[19] There are quite a few publications that address Kiefer's interest in Kabbalistic and pre-Kabbalistic literature. Two excellent discussions are found in Harold Bloom, 'Anselm Kiefer: Troping Without End', in *Anselm Kiefer: Merkaba*, exh. cat. (New York: Gagosian Gallery, 2002), pp. 18-33; and Lisa Saltzman, 'Reading Anselm Kiefer's Book Die Himmelspaläste: Merkaba', in Peter Nisbet, ed., *Anselm Kiefer, The Heavenly Palaces: Merkabah* (Cambridge, New Haven and London: Harvard University Art Museums and Yale University Press, 2003), pp. 13-18.

large spiral dominating the night sky, which may relate to the Fibonacci series, but is likely looking at Fludd again and his image of the cosmology of creation, where the transformation of spirit into matter follows the path of a spiral.[20] Added to all of this is the palace of Jewish mystical thought.

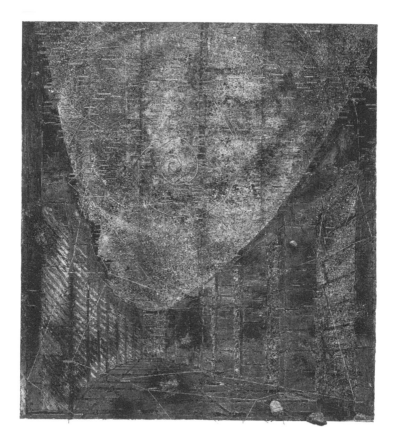

Fig. 26.3: The Sky Palaces, *2002 (oil, emulsion, acrylic, and lead objects on lead and canvas, 630 x 540 cm); © Anselm Kiefer.*

Today, Kiefer's work continues to build on this rich tapestry of interpretations and influences, folding in more interests, yet his work continues to strive for the heavens although, as always, it never frees itself from the weight of history.

[20] Joscelyn Godwin, *Robert Fludd: Hermetic Philosopher and Surveyor of Two Worlds* (Boulder, CO: Shambhala, 1979), p. 21.

MELANCHOLY AND BEAUTY IN DANNY BOYLE'S SUNSHINE *AND JULIA KRISTEVA'S* BLACK SUN

Ruth McPhee

ABSTRACT: The film *Sunshine* (2007), directed by Danny Boyle, is situated in the tradition of science fiction films which take as their subject the representationally troubled relationship between human space travel and spirituality. Boyle's film initially establishes a dichotomy between the two (possibly) opposing forces of science and religion, before developing to present a more nuanced and complex vision, one which is bound up with modern anxieties about science, spirituality, aesthetics and death. In order to explore these aspects of *Sunshine*, this paper shall focus on two central areas. First, the specifically cinematic aesthetics of the film, the striking and memorable sequences of the sun, and the original musical score. These elements are instrumental to the way that the film disrupts the science/spirituality opposition that at first seems so clear cut. Second, an address to theory that will illuminate the key themes of the film: in particular, the work of Julia Kristeva in *Black Sun* (1987), and the more recent work of Didier Maleuvre in *The Horizon* (2011). Kristeva's book takes the psychic manifestations of depression as its subject, which I will relate to the film through the theme of mourning – mourning for the dying sun, and of the characters facing their own deaths. Death permeates the film, and the theories of Kristeva and Maleuvre can help to relate this to the aesthetic and spiritual experience in which the spectator is implicated, drawing upon wider cultural concerns about the usurpation of religion by scientific discourse.

Sunshine, director Danny Boyle's 2007 foray into the science-fiction genre, can be situated within a tradition of 'existential' science-fiction cinema. It follows other films that are set in deep space which, whether obliquely or more overtly, engage not only with questions about humanity's place within the universe, but also with more fundamental anxieties about human experience and its limits. *Sunshine* joins earlier works such as *2001: A Space Odyssey, Solaris* and the more recent *Moon* in using space as an arena in which these anxieties can be articulated and tested. This more specific cinematic concern can also be situated within a broader representational tradition, a tradition recently explored by Didier Maleuvre in *The Horizon*. Maleuvre describes the history of humanity's representational obsession with the image of the horizon; stating that when we consider this particular image:

> The scene is profoundly mysterious [...] We become aware of what Blaise Pascal might have called "the grandeur and misery" of human perception: we, voyagers, can dream of would-be places and faraway worlds; we intuit the infinite; yet all this infinity highlights is, in the end, the limit of human knowledge.[1]

[1] Didier Maleuvre, *The Horizon: A History of Our Infinite Longing* (Berkeley, CA: University

The impression here is not that the line of the horizon itself is what we find so compulsively fascinating, but rather what lies beyond this line: the unseen abyss which necessarily exists as much, if not more, in the imagination as in reality. This abyss represents that which we cannot understand or adequately perceive. *Sunshine* can be regarded within the representational history that Maleuvre draws attention to; it is a film that questions the possibility of the universe as apprehendable within the limits of human knowledge and experience. Not only this, it is a film that questions the extent to which we can adequately comprehend the meaning of our own existence, our own life and death. *Sunshine* is a film which is saturated with death and dying.

The crew of the Icarus II, the central characters of the film, are on a mission to reignite the fading sun in order to save Earth (nothing less than the extinction of a planet is at stake here). On the path to achieving this aim, deaths occur in space (through burning and through freezing) and aboard the ship (murder, suicide, misadventure). Most significantly, for a large portion of the narrative, key members of the crew are aware that the completion of the mission will bring their inevitable demise as they travel closer and closer to the sun. The inescapable spectre of death is present throughout. Within Boyle's film, the infinite that Maleuvre speaks of, the grandeur and the misery of the abyss beyond the horizon, is inextricable from (perhaps even reducible to?) the experience of the human subject faced with the actuality of his or her own death. Death is, of course, the ultimate horizon: we can gaze upon it, contemplate it at length, attempt to come to terms with its meanings in endless permutations of art, religion, literature and philosophy, but we will never know, will never be able to perceive, what lies beyond. When considering death, human knowledge comes up against an immovable and impenetrable barrier. Throughout *Sunshine*, explicit parallels are drawn between this barrier and the limited attempts of humanity to understand the workings of the universe through the often-opposed discourses of science (represented by the scientists and technicians aboard the Icarus II) and spirituality (represented by Pinbecker, the demented captain of an earlier, failed, mission to reignite the sun).

From this initial discussion, two points emerge which this analysis will focus upon, points which are unavoidably intertwined with each other: the struggle to maintain or to create meaning when faced with the abyss beyond the horizon, and the constant presence of death which permeates the film with a pervasive tone of melancholy and morbidity. In order to begin to apprehend these themes, this analysis will provide a reading of *Sunshine* in conjunction with a specific theoretical text, Julia Kristeva's *Black Sun*. In this evocative study Kristeva provides an exploration of depression and melancholy informed by Freudian and Lacanian psychoanalysis, and focused upon the subjective experience of these most difficult, draining emotions. This focus on a particularly

of California Press, 2011), p. 1.

problematic articulation of subjectivity allows for a fascinating interpretation of the characterisation and themes of Boyle's film. In addition, Kristeva draws attention to what she regards as being a crucial connection between melancholic suffering and aesthetic experience: specifically, the expression of beauty as a sublimated 'counterpoise' to the sense of loss of meaning and devastation of the self that melancholia brings.[2] The exploration of the language of depression presented in *Black Sun* is extremely rich and worthy of extended analysis; here, however, the focus will be upon three interlinked aspects of her theory which resonate strongly with the experience of watching *Sunshine*. First, the imagery and significance of the figure of the sun; second, a consideration of the characters of *Sunshine* as representing 'a living death';[3] and finally, the significance of the moments of extreme, sublime beauty that the film contains.

In both Kristeva's book and Boyle's film, the sun becomes a focal point, an image which emerges paradoxically as overwhelming presence and incomprehensible absence, compelling and consuming the subject. In her introduction, Kristeva asks: 'Where does this black sun come from? Out of what eerie galaxy do its invisible, lethargic rays reach me, pinning me down to the ground, to my bed, compelling me to silence, to renunciation?'.[4] As in *Sunshine*, in which the characters talk about seeing the surface of the sun 'every time I close my eyes', the sun appears here as an image of something 'glaring and inescapable', even as something which begins to efface subjectivity itself.[5] Indeed, one of the most arresting ideas running through *Black Sun* is the image of the depressive as a subject who lingers, suffering, on the edges of conventional existence. They live 'A devitalised existence that [...] is ready at any moment for a plunge into death. [...] I live a living death, my flesh is wounded, bleeding, cadaverised, my rhythm slowed down or interrupted, time has been erased or bloated, absorbed into sorrow'.[6] The melancholic experience is articulated here as simultaneously raw and numbed, painful yet flattened, stripped of meaning and significance by the scorching and relentless rays which leave the subject parched and barren.

Following their realisation that they will not survive to make the semi-mythical 'journey home', the crew of the Icarus II exist in this very position that Kristeva describes, on 'the frontiers of life and death'.[7] They are alive, for now, but within an unexpectedly limited time frame. This temporal limitation is echoed and emphasised by the spatial confines of their ship, particularly in the latter part of the film as characters are trapped behind doors and by unyielding

[2] Julia Kristeva, *Black Sun: Depression and Melancholia*, trans. Leon S. Roudiez (New York: Columbia University Press, 1989), p. 98.

[3] Kristeva, *Black Sun*, p. 4.

[4] Kristeva, *Black Sun*, p. 3.

[5] Kristeva, *Black Sun*, p. 3.

[6] Kristeva, *Black Sun*, p. 4.

[7] Kristeva, *Black Sun*, p. 4

machinery. The ship is increasingly 'airless', not only literally, as their oxygen supply dwindles, but also in the claustrophobic, artificial atmosphere in which the narrative is played out. Capa, who in some senses is our primary point of identification within the film (his voiceover introduces the story, and he survives until the penultimate scene), displays this curious 'flattening' of experience. For a central protagonist, he remains frustratingly inscrutable, often wearing a blank expression and speaking in a monotonous tone. Searle, the ship's psychiatrist, offers a different perspective on the idea of 'a living death', becoming the embodiment of the 'wounded, bleeding, cadaverised' figure. His increasing obsession with 'sun bathing' on the observation deck leads to an increasingly visible state of decay as his face and scalp begin to burn and peel. His body is disintegrating before our eyes, an impression enhanced by the presence of Captain Pinbecker, survivor of the Icarus I. Pinbecker seems to represent Searle's fascination with the sun as taken to the extreme. The spectator is shown only blurred or partial glimpses of Pinbecker, and the overwhelming impression in these glimpses is that of scorched, raw flesh. His human identity is stripped away and he is rendered monstrous.[8]

Kristeva's account of depression is in part influenced by Freud's 1917 essay 'Mourning and Melancholia'. Freud suggests that there is a correlation between the 'pathological disposition' of melancholia and the 'normal affect' of mourning.[9] Both conditions, he argues, involve 'the same painful frame of mind, the same loss of interest in the outside world'.[10] For the crew of the Icarus II, in particular for the blank, stilted subject that is Capa, the temporality of mourning is altered by their awareness of their own imminent deaths. For them, the 'lost object' of mourning identified by Freud and Kristeva is both not yet lost and always already lost. Freud's comment about a 'loss of interest in the outside world' is also something emphasised and expanded upon in *Black Sun*, and is of great importance to the troubled relationship between the depressive subjects and the world around them. A crucial point within Kristeva's theory is the notion that the scorching rays of the black sun not only strip the subject of the ability to interact with the outside world, but, more fundamentally than this, they strip the subject of the ability to make meaning of the outside world, to find significance within it. In Lacanian terminology, the subject suffers a 'symbolic collapse', meaning that the signifying bonds which anchor the subject into the symbolic order of social reality begin to come loose.[11] The effect of this collapse is that the subject can no longer make meaning from the world in the orthodox

[8] It is in the scenes featuring Pinbecker, which increase in the last third of the film, that the genre slips from straightforward science fiction and begins to merge into horror.

[9] Sigmund Freud, 'Mourning and Melancholia', in *The Standard Edition of the Complete Psychological Works of Sigmund Freud, Volume XIV (1914-1916)*, trans. and ed. James Strachey (London: Hogarth, 1953-74), pp. 237-58, p. 242.

[10] Freud, 'Mourning and Melancholia', p. 243.

[11] Kristeva, *Black Sun*, p. 24.

way; this is a vital point underlying Kristeva's more general argument that depression has a signifying system of its own.

The concept of symbolic collapse within melancholic experience suggests another point of contact between Kristeva's theory and Boyle's film. The problematics of meaning-making are central to both; as argued above, *Sunshine* grapples with the question of how we can find meaning within the unknowable, how we can attempt to find significance in that which we cannot apprehend. Both science and spirituality, discourses which are often considered diametrically opposed, emerge in the film as possible tools for organising and giving significance to the universe and to human existence. At the outset, the relationship between these two discourses seems rather straightforward: the crew is made up predominantly of scientists who have mastered the workings of the universe sufficiently to be able to reignite the sun and save the Earth. This initial narrative setup appears to fit neatly into humanist conceptions of the universe as described by Robert Pepperell in *The Post-Human Condition*, insofar as man is regarded as master of his own destiny, and can successfully effect and shape the world he inhabits.[12] The subsequent location of spirituality with Pinbecker also supports this reading: he is monstrous, murderous, deranged and obsessed with being the last human alive, left 'alone with God.' Science is posited as a rational and positive method of meaning-making, spirituality is associated with madness and chaos. However, when taking the film as a whole and considering not only narrative but also the imagery and musical accompaniment, the equation of spirituality with the 'wrong sort' of meaning-making becomes more troubled, in accord with the anxieties articulated about unknowability elsewhere in the film. To return to Pepperell's text, such anxieties about the failure of human knowledge could be seen as situating the film more within post-human concerns. As Pepperell states, 'the Post-Human era is characterised by uncertainty about the operation of the universe and about what it is to be human. Science may now seem fragmented, flawed and limited.'[13] Returning to the central image of the sun will help to elucidate the ways in which the science good/spirituality bad formula is problematised, and in which ultimately, the sublime spectacle of the film works to overcome the threat of symbolic collapse and loss of significance which threatens subjectivity throughout *Sunshine*.

Two sequences are crucial here. Each depicts a scenario of 'death by sunshine', and each is presented as a moment of sublime beauty that overwhelms and immobilises the spectator. The first of these scenes occurs in the first half of the film as the captain of the Icarus II, Kaneda, sets out to repair a broken shield on the ship's exterior. As the ship alters course, Kaneda struggles to finish the job as the rays of the sun race towards him. The rest of the crew watch from

[12] Robert Pepperell, *The Post-Human Condition* (Exeter: Intellect Books, 1995), p. 164.

[13] Pepperell, *The Post-Human Condition*, p. 172.

inside the ship, positioned as spectators themselves alongside the cinematic spectator, helpless to assist but seemingly helpless to turn their (and our) gazes away. In the moments that precede his death, Kaneda stares into the oncoming light and Searle asks with increasing urgency and fascination 'what can you see? What can you see?'. Searle's obsession with the sun is portrayed as causing his physical deterioration, as argued above, but it also becomes apparent that he has become fixated on the idea that there is *more to see*, that staring for longer and with more intensity into the orb of the sun will reveal hitherto unseen secrets that may illuminate the meanings of the abyss beyond the horizon. Kaneda's silence leaves Searle's question unanswered, the longed-for epiphany either non-existent or forever unspoken. It is, of course, the heat of the sun that brings Kaneda to his death, but the impression given in these moments is of a figure bathed in and then dissolved in the brilliant light that floods the screen.

Although this sequence involves the death of a principal character, and is certainly engaging for the spectator in this respect, it is also immensely affecting as a result of the audiovisual components. The scene is presented as a dazzling cinematic spectacle and is one of the film's most arresting moments. This imagery is matched by the chord progression and crescendo of the accompanying soundtrack, an original composition by John Murphy and the electronic act Underworld. This music creates a highly emotive and even uplifting impression upon the spectator, despite the morbid turn in the narrative. This juxtaposition occurs even more strongly in the penultimate scene, in which Capa meets a similar fate to his captain as the Icarus II advances upon the boiling, roiling surface of the sun. Background noise fades away until all that remains is the sound of Capa's breathing and the extra-diegetic music. Silhouetted against the blazing light, Capa raises his arm and turns his face upward in a moment of sublime subjective obliteration. A close up of his face reveals an expression not of fear or of suffering, but of a kind of glorious transcendence. In these moments, death is associated with a specific type of experience that exceeds and moves beyond the limitations of scientific knowledge and human materiality. Capa, it is implied, has witnessed and understood the more to see. The possibility of finding an ultimate significance within the terrible void is once again restored. For the spectator, too, the beauty of these sequences allows for the recuperation of these characters' deaths into something more meaningful and even more spiritual than simple nothingness.

The privileged relationship between melancholia and recuperative aesthetic experience is one of the central themes of *Black Sun*. Kristeva draws upon Freud's short essay 'On Transience' to explore the possibility of sublimation as a psychical defence mechanism which protects the depressive subject against symbolic collapse.[14] She states, 'the beautiful object [may] appear as the absolute

[14] Sigmund Freud, 'On Transience', in *The Standard Edition of the Complete Psychological Works of Sigmund Freud, Volume XIV (1914-1916)*, trans. and ed. James Strachey (London:

and indestructible restorer' of the subject's lost signification.[15] Through the sublimation of melancholic impulses, suffering is aestheticised and made bearable, and the subject is able to restore meaning to the void that has come to characterise their relationship with the world. Kristeva explains further: 'sublimation's dynamics [...] weaves a hypersign around and with the depressive void. This is allegory, as lavishness of that which no longer is, but which regains for myself a higher meaning because I am able to remake nothingness.'.[16]

This concept of a hypersign returns us to the all-encompassing image of the sun as symbol within Boyle's film. However, in the final scenes it comes to represent not simply death, or life, but an image of sublimated beauty that works to counteract the melancholia, mourning and uncertainty that has come before. Kristeva's theory of the aesthetics of depression facilitates an understanding of the way in which this closing sequence represents a climatic moment in the existential problematics of significance explored by the film as a whole.

Hogarth, 1953-74), pp. 305-7.

[15] Kristeva, *Black Sun*, pp. 98-99.

[16] Kristeva, *Black Sun*, p. 99.

ILLUSTRATED SKY: CONTEMPORARY DEPICTIONS OF THE CLASSICAL CONSTELLATIONS

Melanie Schlossberg

ABSTRACT: This is an image-driven presentation of a journey into celestial cartography and mythology. The project unites the fields of cultural astronomy and art and is a collaborative endeavour with Bernadette Brady at the University of Wales Trinity Saint David. It investigates how one can represent, through cartography, the mythological vibrancy contained within the literature of the classical western images of the constellations. Thus it considers these classical constellations both through celestial cartography and their mythological background, and seeks to emblematize this in contemporary aesthetics. This lecture presents the artist's methodology and journey of this on-going project.

This paper takes the reader on a visual and narrative journey of an on-going creative project to re-illustrate the 48 classical constellations with a contemporary sensibility while adhering to the existing star positions established by Claudius Ptolemy in the second century CE.[1] Working in conjunction with Dr Bernadette Brady at the University of Wales Trinity Saint David, this project pays homage to the stories and images placed in the sky by generations of astronomers, cartographers and artists. A range of on-line star catalogues have been used.[2] It closely examines the artistic representations contained within the sky and it produces a revised set of illustrations. The presentation that this paper is based on takes the viewer through the process used to make the drawings and the unique set of challenges presented to the contemporary artist when drawing the sky.

The starting point of the project had three main goals: to make drawings that align with the positioning of the stars in Ptolemy's star catalogue the

[1] Since this paper was delivered, the project has evolved, making this paper a snapshot of one moment in a continuing artistic exploration.

[2] Jehoshaphat Aspin and Sidney Hall, *Urania's mirror or A View of the Heavens* (London: 1825), http://hos.ou.edu/galleries//19thCentury/Aspin/1825/; Jonannes Bayer, *Ioannis Bayeri Rhainani I.C. Uranometria* (Augustae Vindelicorum: Excudit Christophorus Mangus, 1603), http://lhldigital.lindahall.org/u?/astro_atlas,118; Johann Elert Bode, *Uranographia* (Berlin: 1801), http://lhldigital.lindahall.org/u?/astro_atlas,1395; Johann Gabriel Doppelmayr, *Atlas Coelestis* (Nuremburg: 1742), http://www.staff.science.uu.nl/~gent0113/doppelmayr/doppelmayr.htm; Hugo Grotius, *Syntagma Arateorum* (Leiden: 1600), http://www.atlascoelestis.com/grotius%20prima%20pagina1.htm; Johannes Hevelius, *Prodromus Astronomiae* (1690), http://lhldigital.lindahall.org/u?/astro_atlas,1671; Alexander Jamieson, *a Celestial Atlas* (London: 1822), http://lhldigital.lindahall.org/u?/astro_atlas,1961. All URLs here accessed 21 January 2012.

Almagest, to create realistic contemporary images, and to communicate the rich historical and mythological background of the constellations through powerful visual imagery.

In the *Almagest*, Ptolemy compiled a star catalogue of over 1000 stars complete with latitude, longitude, magnitude, and a short description of the visual placement within the constellation. This important catalogue tells the artist the accurate placement of the stars for her/his visual representations. For example, the star Betelgeuse in the constellation Orion is described in the *Almagest* as 'The bright, reddish star on the right shoulder'.[3] The constellations have changed over history, but the set of constellations that Ptolemy describes are still in use today, acting as the foundation to our sky. In concert with the initial goals of the project, much care was used to align the drawings with the star positions according to Ptolemy. The space where there is no star, or the star is not named or described by Ptolemy, is an open workspace to fill out the design.

The drawings have been created for Brady's software package, Starlight Software (Zyntara Publications), and they will be integrated into starry night sky visuals. Because of this, the designs had to be simple and striking on a dark night sky with star labels, planets and stick figure constellations sometimes obscuring the view. As shown by Figures 28.1 and 28.2, Starlight Software has an option to attach the Ptolemaic descriptions to the stars to which they belong. These complex screen images serve as reference guides to orient the drawings. When the software attaches the description of the 'nebulous star on the head' of Orion to a star, then that star should be in the head of Orion.[4]

Orion: Orientation of the Sky

The first stop on this journey is to understand that the visual orientation of the sky can be seen from two perspectives: internal and external. A survey of the old star atlases will show these differing views, in addition to other hybrid systems. In the internal perspective, the viewer stands on the earth and looks up at the stars. The external perspective is from space looking down on to the celestial sphere. Figures 28.3 and 28.4 illustrate the difference between the two and the effect they have on the visual representations of the constellations.

[3] Claudius Ptolemaeus, *The Almagest*, trans. R. Catesby Taliaferro (Chicago: Great Books of the Western World. Robert Maynard Hutchins ed. Encyclopedia Britannica Inc, 1988), p. 613.

[4] Ptolemaeus, *The Almagest*, p. 613.

Fig. 28.1: Screen shot of stars with the Ptolemaic descriptions attached to them. The overlapping text is caused by the close proximity of the stars to one another.

Fig. 28.2: Detail of Fig. 28.1.

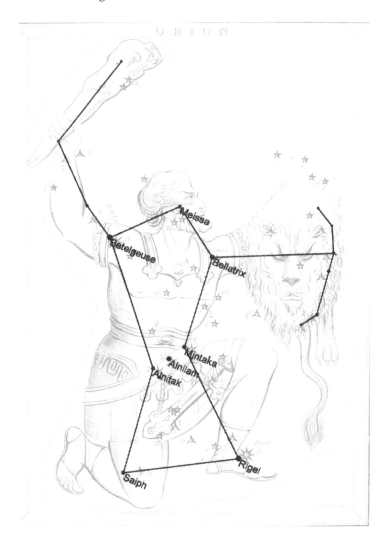

Fig. 28.3: Aspin's internal perspective.

In Figure 28.3, Orion is the internal view, of a stargazer; and the Orion in Figure 28.4 is the external view, a bird's-eye view. Essentially the perspective is swapped: one shows the front of the constellation, and the other shows the back, but they both align with the star positions that Ptolemy describes. It is worth noting that there is a hybrid of these two choices which is not shown; one example is Bayer's *Uranometria* where the stars remain in the internal view but the drawing is depicted from the external view. This hybrid positioning does not match Ptolemy's star descriptions (i.e., the star in Orion's right shoulder is described as being in the left shoulder) and therefore was never under con-

sideration as a perspective for these drawings. The drawings for this project are drawn from the internal perspective to replicate the viewer's experience on earth looking up towards the sky.

Fig. 28.4: Hevelius's external perspective.

Leo: Integrating Contemporary Imagery

My visual research started with an investigation of existing star atlases from a number of Internet sources and library collections. Most of the initial work came from collecting digital imagery. Then I created collages in Photoshop using parts from different drawings. This allowed me to match the stars and really focus my efforts on the style and visual content of the images. These collages served as the templates for the first draft of drawings that were completed by sketching them and then creating a pen-and-ink drawing, the decided final format of the physical drawings. After experimenting with a number of different media, I decided that the bold lines and simplicity of the pen and ink worked well after it was converted to a digital image and used as a background to the stars on a computerized night sky.

Upon review of the first batch of completed drawings, the image of Leo

stood out from the rest. The difference was my incorporation of contemporary photography into the collage. I wasn't taken with any images of Leo's head in the old star atlases, so I found a contemporary photograph of a lion and used that for the head. The introduction of realism made all the difference, and I realized that to make my own unique constellation images, I had to depart from the traditional figures on most star maps. So, for all the constellations I launched Internet searches for images using search tags like, 'deadliest snake' for the Hydra and 'The scales of life and death' for Libra. I also included sculptures, paintings and film stills in the collages. Live models, including neighbours, friends, and even my own hands and feet were extremely useful for the live-action poses of many of the human figures. For Canis Major, the great dog, I met and befriended nearly every dog at the local dog park.

Figure 28.5 is a comparison of Grotius's external view of Leo to the newly created collage. While some of the collages are clearer to understand than others, the set has become an additional comprehensive set of constellation images, apart from the project's original drawings.

Fig. 28.5: Grotius's image of Leo (left); my Leo (right).

Libra and Scorpius: Shared Stars

The skies have been filled with constellations for thousands of years, but those pictures and stories have changed along with history. The Babylonians, for example, had sacred scales in the sky next to a scorpion. Later the Greeks saw these stars as the outstretched claws of Scorpius and Ptolemy immortalized them in the *Almagest* as Chelae, the Claws.[5] Finally, the Romans transformed the Claws permanently into Libra, the Scales.[6] The *Almagest*, however, remains unchanged and lists all of the stars in this constellation as belonging to either the northern

[5] Gavin White, *Babylonian Star-Lore: An illustrated Guide to the Stare-lore and Constellation of Ancient Babylonia* (London: Solaria Publications, 2008), p. 175.

[6] Bernadette Brady, *Brady's Book of Fixed Stars* (Maine: Samuel Weiser, Inc., 1998), p. 278.

or southern claw. For example, the star Zuben Elgenubi, at the tip of Libra, is described as 'The bright one of the two at the extremity of the southern claw'.[7] After understanding this history, I realized that my goal of matching the stars listed in the *Almagest* could not happen here. Despite what is listed in the *Almagest*, the drawings that I was creating needed to reflect a contemporary view of the constellations. The software package that Brady and I were working on could not be minus Libra.

Looking for direction, I examined how other artists have depicted the two constellations in the past. Some show Scorpius butting up against Libra, compressing the southern claw to make room for the scales. Others show Scorpius engulfing Libra, hugging the scales. I decided to allow Scorpius and Libra to intertwine, freeing the southern claw to extend fully and allowing the two constellations to act as a single unit. I continued my use of contemporary imagery and used a photograph of the lethal Indian Red Scorpion for the body. The photographic image in the collage in Figure 28.6 is blurry because of the lower resolution that digital images on the Internet frequently have (a disappointing reality of internet searches).

Fig. 28.6: Jamieson's Scorpius is an example of a compressed southern claw (left); my Scorpius collage (right).

Ursa Major: The Bushy Tail Problem

Connecting the dots to a realistic image using the stars as labelled by Ptolemy was no small challenge. Many constellations have a star pattern that bears little resemblance to its image. The most recognizable example of this is Ursa Major, the Great Bear, whose long bushy tail sets her apart from her earthly tail-less cousins. Ursa Minor, the Little Bear who points to the North Star, has the same badger-like tail. The stars that make up the hindquarters of the celestial bears are now better recognized as the Dippers. Over time and across cultures, images

[7] Ptolemaeus, *The Almagest*, p. 606.

have been assigned to Ursa Major: a plough, a wagon, a bird, even a leg of beef.[8] No matter which image the ancient or contemporary mind sees in the stars that make up this constellation, Ursa Major and Ursa Minor remain the International Astronomical Union's (IAU) official selection for this area of the sky.[9] Therefore, the question of how to illustrate the Great Bear with a long bushy tail remains.

Finding the images to create the bear part of the image was not difficult. Internet searches for the 'great bear' and the 'largest bear' lead me to the polar bear and Alaskan grizzly. I assigned the polar bear to be Ursa Minor, whose tail star is the North Star, Polaris; to Ursa Major I assigned the grizzly. The picture that spoke to me was a bear with gentle eyes in mid-step, perfect for Ursa Major who continually roams the night sky.

Fig. 28.7: Bayer's Ursa Minor (left); my images of Ursa Major (middle & right).

In contrast, Ursa Major's tail required careful consideration. Whichever tail was chosen it could not diminish the grizzly in Ursa Major. I conducted a search for 'bushy tail' (my own description) and two choices came up: a squirrel and a fox. The fox tail, which appears much more serious, was the one upon which I decided. Figure 28.7 illustrates the transition of Ursa Major into its final state as a digital image for the software program.

Eridanus: Defining the Shore

A curious aspect of getting to know the constellations is to discover how much water is in the sky. There are boats, sea monsters, vessels, and lots and lots of fish. Stretching out from Orion's feet, the second longest constellation in the sky is Eridanus or Fluvius, the River.

[8] E. C. Krupp, *Beyond the Blue Horizon: Myths & Legends of the Sun, Moon, Stars, & Planets* (New York: Oxford University Press, 1992), p. 227.

[9] Anonymous, *The Constellations*, http://www.iau.org/public/constellations, [accessed 14 January 2012].

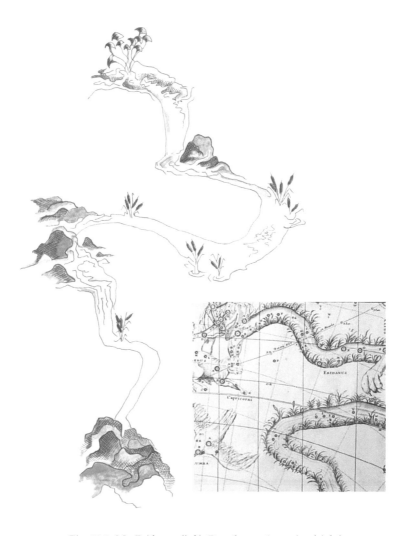

Fig. 28.8: My Eridanus (left); Dopplemayr's version (right).

I was shocked to discover there is a river in the sky, right below Orion. I did not notice the river in the old star atlases during my initial research. I thought it was simply a decorative element or an awkward representation of the Milky Way. I was not able to take any leads from the old star drawings as a starting point, so I needed to start from scratch. My challenge was to draw a water way in the sky without the benefit of the contextual features that we expect to define a river, namely the shore and a landscape.

I mapped out and sketched a river based on the path of the stars, and then

filled it with papyrus and cattails. (Unfortunately, the hippo and alligator that I included in the collage didn't make the cut into the final drawings.) To give the river more stability I added rocky shores and waterfalls. Ultimately, all of these things gave Eridanus a stronger grounding and place into the sky.

Virgo: Altering Perfection

Not all the changes to the drawings were a response to problems that I thought could be improved. Bode's Virgo, Figure 28.9, is the image of perfection. I puzzled over how to make my own representation of an image that I felt could not be improved upon. I set Virgo aside until one day, while watching the last episode of *Spartacus* on TV, I saw a potential Virgo. The body is that of Lucretia (played by Lucy Lawless) just after she is stabbed in the abdomen during a Roman slave uprising.[10]

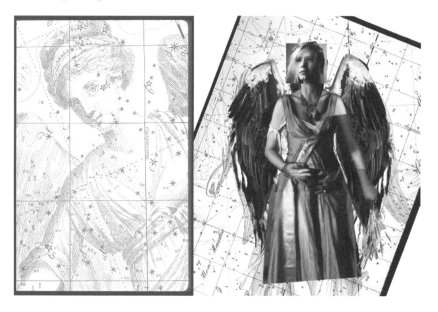

Fig. 28.9: Bode's Virgo (left); my collage of Virgo (right).

The signature element of this constellation, however, is the wings. Throughout the project I spent a great deal of time researching and analysing the wings of the many birds that are constellations in the sky. The search for the true wings of Pegasus was the most similar to the search for Virgo's wings because they are both mythical and need to be artistically interpreted. Virgo's wings are an-

[10] Steven S. DeKnight, 'Kill Them All', *Spartacus: Blood and Sand*, dir. Jesse Warn, Starz, 2004, televised 16 April 2010, http://en.wikipedia.org/wiki/List_of_Spartacus:_Blood_and_Sand_episodes [accessed 21 January 2012].

gelic, an archangel. Search results for 'angel's wings' in Google include mostly feathered costume accessories and tattooed shoulder blades. Images from art history seemed stiff and did not have the shapes for which I was looking to align with the stars. Surprisingly, the solution was to be found in a pair of vulture's wings. I compared the wings of archangels, whose wings seem to be the closest to Virgo's, to wings of various birds with a large wingspan. The vulture's wings seemed to fold in a similar way and had the definition that I was looking for. For the collage, I digitally layered the wings to create the shape and mass that was needed.

Conclusion

While there is a standardization system that has been put in place by the IAU to control the constellations, the celestial sky continues to evolve. Across the globe, cultures will continue to layer the representations of the constellations with their own stories and images. My use of modern-day imagery, photographic content, and digital collage is part of this on-going process.

THE COSMOS FROM OUTSIDE: VIEWS OF THE WORLD AND COGNITIVE COBWEBS

Michael Hoepfel

ABSTRACT: Images express specific views of the world and at the same time are a means to alter them. We are at the start of a digital era that is drastically changing the way images are produced and how we are exposed to them. With images being 'code' they seem to spread over the world by themselves, permeating it like an omnipresent reality on their own. On the other hand, written text probably once evoked similar ideas of a 'parallel world' to those who had no understanding of the concept of letters. While every medium is a 'trick' to represent the world in a particular way, man keeps developing new media to perform this 'trick' more compellingly so that (for a while) he can cherish his own illusions and let others confuse his creation with the creation or world we live in. But how do we constitute what we judge as reality? And how do differences in perception depend on the difference of the images we use to depict the world? For me as an artist, digital media are both tool and subject: the way a 3D program constitutes virtual worlds enables a different view on our world to realise aspects that might be too familiar to be seen. I think that misusing technology or searching for strange angles can interfere with the habits of our mind and indirectly alter our views. In the images I am presenting here, I combined concepts of digital imaging techniques with elements of medieval book illumination and Christian iconography. This article should, however, not be mistaken for scientific research. Moreover, these descriptions might provide a context of my work by interweaving some thoughts about images, views of the world and selected artistic methods used to depict them.

Views of the World

It has probably always been humanity's desire to get a grasp of the cosmos we live in. This made us develop views of the world as well as images to depict the greater order of things. But as time passes by, both indicate more about those who had those particular outlooks. Technology, especially, influences our imagery since new technologies often reveal new aspects of nature and thereby provide new metaphors. Geometry and musical instruments, for instance, enabled the ancient Greeks to constitute a world of ideal shapes and harmonic division ratios. In Baroque times planets orbited the sun like in a gigantic apparatus, whereas in the steam age the universe turned out to be in thermodynamic balance. With today's digital technologies the term 'information' has seemingly turned out to be a self-contained entity and the universe is about to become a multiverse inhabited by networks of communicating life forms.

The Cosmos as an Image

With our limited senses we have no way to experience 'space' as a space. For a first hand spatial impression of the universe we would need to have eyes light

years apart from each other. Space seems to us like a distant image, framed by the horizon, and it is a mental challenge to understand that we are part of it. To the naked eye it does not offer the closed shapes our perception is set up for. The disc of our own galaxy appears as a flat ribbon of starlight winding around the sky. The name 'The Milky Way' speaks for itself. Other galaxies that we spot through telescopes have fairly closed shapes and often even give us a good understanding of their orientation as discs. As we have no way to see any divergent image of them – for which we would have to travel light years or wait millions of years – each galaxy we know only exists as an image.

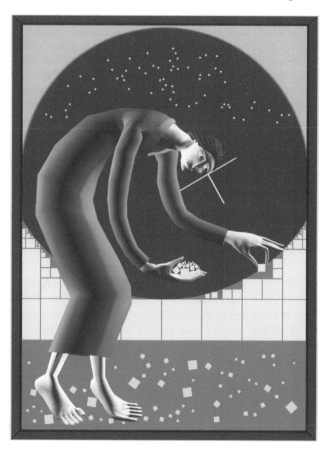

Fig. 29.1: Näherung (Approximation), *Primo Tempore series, Michael Hoepfel 1997.*

Single stars can flash up or vanish within months and constellations change over the course of eons. Compared to earthly occurrences, however, the night sky probably has been the most reliable companion of mankind. We might call it the oldest abstract image humanity has been exposed to. With a 'flat' and 'eternal'

sky all around us it is no wonder that man imagined himself to be its centre most of the time while the sky itself was understood as a divine sphere. It seems that large structures in this world most certainly evoke a sense of order and beauty in us, a phenomenon we should not take for granted. As it is said, the devil is in the small details – maybe within the gap between our theories and reality.

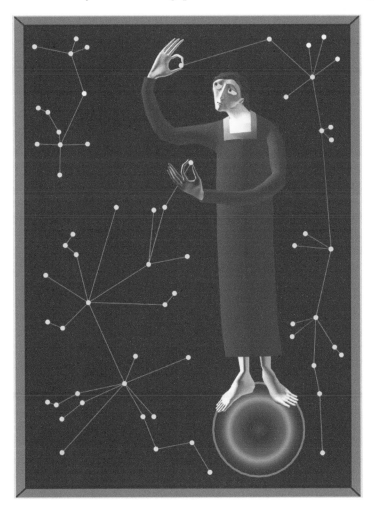

Fig. 29.2: Sternzeichen (Star Signs), *Primo Tempore series, Michael Hoepfel 1997.*

Connecting Dots & Dividing the Sky

If we are tired of looking at the stars each night as if for the first time, we begin to relate them to each other and discover constellations. This is how star signs evolved, enabling our eyes to sweep across the sky as if it were a page in a book

into which we have written our thoughts. It reminds us how our view of the world is generally formed: we create relations between single events and try to make sense of them, or we project preconceived ideas onto them. Our current star signs originate from this and stem from the same era as the oldest letters. What both have in common is that they are semiotic figures that are defined by vector lines.

Unlike letters, star signs have no orientation but a defined size, which contradicts their semiotic nature. In addition to their connecting lines, a second set of borderlines around them reveals their territorial nature. Comparable to Oceanian countries that consist of scattered islands, star signs not only connect but also separate the stars from each other and by this divide the sky into sections. The same applies to the photographs scientists take of the sky. The patchwork of digital images and the grid of their resolution break up the sky into squares of increasingly small scale. The cosmic image is rendered at higher resolutions only to create – in a way – smaller portions of infinity.

The Perspective View

In opposition to the seemingly flat night sky, the flat pictures that surround us today appear spatial. Five hundred years ago, the geometric projection of the star positions onto a map enabled the great explorers to navigate the seas and outline the continents. The mapping of the sky – partly discovered in the course of this – enabled the mapping of the world. Right at this time another geometric projection started to fundamentally encourage man's self-awareness by changing our view of the world. Today, due to photography, we have deeply internalized the concept of linear perspective. Originally it was hard to understand how distorted images could map our subjective view and create the illusion of space. A variety of physical set-ups had been developed to construct such images with great effort. What they all have in common is that a single point in front of the motif was fixed to determine the viewpoint from which the viewer of the subsequent picture would later see the depicted space. Frames with a grid or cross threads were used to transfer scanned points of the object directly onto the grid's plane (Fig. 29.3) or onto a second grid in front of the artist. From today's understanding all these methods were anticipating what a camera basically does. No doubt artists also used the *camera obscura* (its ancient ancestor) to trace perspective sketches, and maybe this is where the interest in perspective images originated.

Pictures with linear perspective create the visual illusion that lets the viewer experience being part of the image, as it defines his relation to painted objects and horizon, the ultimate ratio of depth in a visual representation. To make this illusion of a 'virtual space' perfect, the pictures would be mounted at such height that their horizons were on the spectator's eye level to merge with his personal perspective of the space around him.

In medieval times, in contrast, pictures never had the goal to reproduce the

world or an individual view of it. They demanded to show the absolute truth independent of an observer's point of view. The world was translated into a visual language or code to create a semiotic world within the image plane, where perspective and anatomy are solely subject to content and composition. Important objects might appear as if they had been opened up at their back and flattened into the image plane, which enabled the observer to see front and side views at the same time. Much later, when photography began to spread, this incoherent perspective inspired modern artists to leave the restriction of a single point of view behind. Today, photo and video cameras define our view of the world in such a manner that even 3D programs are designed to simulate cameras instead of the human eye.

Fig. 29.3: Man drawing a Lute, *woodcut by Albrecht Dürer 1525, Wikimedia Commons.*

Images from Beyond

In March 2010, newspapers published a beautiful image that looked like an eye in the sky – a galaxy with a black round in its middle (Fig. 29.4). It was announced that NASA's space telescope Spitzer had made this spectacular shot of a black hole. Yet the galaxy's disc appeared distorted, like a wide-angle photograph, which clearly contradicted the statement. It turned out that the published image was in fact a 3D rendered 'artist's impression' that many newspapers had taken for real. The original photograph was rather hard to find and to the layman showed nothing but a highlighted dot.

What looks like photography today has not necessarily ever been in front of a photographic lens. With digital image technology the most inconsistent content can be merged to something that appears real. And since science is not just the search for truth but also one for attention and raising funds, many scientific

images have become extraordinary beautiful. Images can be powerful means of seduction, especially when they look real. The more realistic an image looks the less one should trust it.

Fig. 29.4: 'This handout picture made by the Spitzer Space Telescope and released by NASA shows a young black hole'.[1]

A comparison of two illustrations of the apocalypse might clarify how the seductive power of realism can be outdone by the impact of a pointed representation. Depicting the end of the world clearly challenges an artist's imagination to the extreme. Five hundred years ago, in one of his famous and technically superb woodcuts, Albrecht Dürer obviously wanted to dazzle the viewer by the sheer density of details (Fig. 29.5). Great effort is spent on anatomy, perspective and drapery. In a surprisingly physical (if not even 'profane') way Dürer lets God pass the trumpets to the angels who receive and blow them. The world underneath the horizon is consumed by fire, sparks and smoke – imagery not too different from today's disaster movies.

[1] Picture of the day, *The Telegraph*, 18 March 2010, http://www.telegraph.co.uk/news/picturegalleries/picturesoftheday/7471758/Pictures-of-the-day-18-March-2010.html.

Fig. 29.5: The Opening of the Seventh Seal, *woodcut by Albrecht Dürer 1498, Wikimedia Commons.*

Five hundred years earlier, around the turn of the millennium, the Bamberg Apocalypse was illuminated in terms of a direct apprehension of the world's end (Fig. 29.6). Here the 'Fall of Babylon' is visualized disarmingly simply but effectively. As in all Ottonian illuminations a standard visual figure is used to represented 'the city' – comparable to a pictogram (or even an icon of today's computer interfaces). This figure is turned upside down beneath God's affirming hand. He himself stays invisible beyond the picture's edge. Instead of spelling out the countless effects of catastrophic events as Dürer does, the inverted city leaves everything to the viewer, indicating that something beyond our imagination is going to take place. This image seems to tell us: 'You haven't even the least idea of what is about to come', by explicitly *not* showing it.

Fig. 29.6: The Fall of Babylon, Bamberg Apocalypse *fol. 45r, monastery of Reichenau; ca. 1000 CE.*[2]

The Invisible Image

Although today we are surrounded by more images than ever, images themselves have become invisible. Virtually all of today's images exist as a notation of digital code before they ever reach our eyes. We have become used to the fact that they spread over the world instantaneously, are edited and re-edited incessantly, or are deleted without ever having been seen. If we talk of such images, we obviously refer to their nature as 'code'. The visual image, on the contrary, has become nothing but an option. It is simply a rendering or interpretation of the code, as it will always appear slightly differently depending on screen specifications, printing techniques, sizes and the chosen carriers.

If the code is the true nature of the digital image, what should be seen as the 'original' image? Would it be the individual print that can be rendered repeated-

[2] Photo by Gerald Raab, with kind permission of Staatsbibliothek Bamberg.

ly from the code? Or would it be the code itself that might exist a million times? Is it possible that a computer-generated image is unique? What happens if an image that touches us is only described by a logical construction? How can an image reveal and maintain its spiritual context if it can be manipulated so easily?

Fig. 29.7: Koordinatenkreuz (Coordinate Cross), *Primo Tempore series, Michael Hoepfel 1994.*

According to Christian orthodox beliefs there is no difference between contemplating a sanctified icon and what it depicts. It is also less important which artist painted an icon, as long as it complied with the canon. The canon is a detailed specification of colours, physiognomies, postures, gestures, attributes, clothing and composition that ought to be used for each type of icon. Although over time many blueprints accumulated, the canon is independent from any carrier since it primarily constitutes a spiritual archetype – the 'essence' of each icon. The canon developed over the course of centuries, with certain motifs repeatedly painted with a low rate of alterations. Therefore, no individual author or

creator of the canon exists. Like a mirror, a painted icon should reflect a glance of transcendence. The icon reveals something that goes beyond the image. Unlike a perspective representation which instinctively creates an illusion of space, the icon leaves the choice to the viewer whether to get involved in what is beyond or not. The power of each icon depends on the painter's skills. The creation process, however, should not be seen. The painting should appear as if it was not a work of man: it should look as if it had always been there, between the canon's archetypical image and its transcendent counterpart.

3D animation programs enable us to create images of virtual worlds. While these images may seem astonishingly real, the underlying virtual world is a geometric construction within the program, consisting of points and vector lines in space – so called wireframe objects (Fig. 29.8, right). No matter how close or from which angle you look at such objects, the surfaces they define remain precise due to their parametric nature. Wireframe objects are empty surfaces because their only purpose is the visual appearance. Once a viewpoint has been defined by a virtual camera, this vector world can be rendered into flat images. This is similar to taking a photograph but it demands the time consuming process of calculating 'realism' on the basis of its prior descriptions.

Fig. 29.8: Star sign and wireframe object, illustration.

While in the vector space geometric constructions describe a somewhat coherent world in space and time, a rendered image looks real but it is only a specific view of finite size – because the amount of detail is determined by its resolution.

Working with a 3D program means to start with an empty space instead of a white page. The points and lines drawn into it are spatial cobwebs that will resemble star signs, as everything the artist sees in that world, alas, appears on a flat screen.

Primo Tempore

Primo Tempore is an ongoing project that I started in 1994 to generate icon-like images by means of a 3D program. In the original version the images were printed, coated with matt foil, screen printed with a layer of gold and finally mounted on MDF plates. For a screen version the images run as real-time generated animation on stripped flat screen monitors where they keep changing their appearance in a most subtle way in terms of light, colour and textures.

Primo Tempore is Latin for 'in the first time'. The image series is inspired by Russian icons and medieval book illumination. It mingles Christian iconography with technical elements such as the graphical computer interface – especially that of the 3D program the images were created with. The images reflect man today within the technical environment he has created for himself, but at the same time amid the timeless reality of a terminated physical existence and an incomprehensible cosmos.

Fig. 29.9: Sieger (Victor), *Primo Tempore series, Michael Hoepfel 1994.*

Primo Tempore is a visual language that utilizes a 3D program but at the same time denies perspective. Its vocabulary consists of 3D models, colour palettes, textures and light setups – but most importantly a movable human figure which

can be posed however the motifs require. Gold, traditionally understood as the light of God that permeates our physical world of colour, can be interpreted as an abstract space of information which seems to be omnipresent to code and re-produce our world. However self-contained such a reality of information may be, the fact that it is seen this way is the result of a technical definition of the term 'information'.

In this respect the sacral manner of *Primo Tempore* reflects the relationship between the idea of 'pure information' and Christian transcendence which traditionally glorifies what is detached from its physically perishable body. Yet in both cases the question arises if this golden space can be some sort of self-contained reality or whether its existence depends on man, who thinks, believes, creates, and interprets it.

Primo Tempore is created in exactly such an unphysical electronic space. In the 3D program the artist assumes a divine vantage point on a simulated reality of his own creation.

Cordless Time

Cordless Time is a geometric creation myth between interstellar and molecular dimensions. It is an offspring of *Primo Tempore* as it uses its visual language. But here the figure is moving and can be seen in perspective – in theory even three dimensionally – as *Cordless Time* was originally produced for an interac-tive stereoscopic device. Short narrative animations link a network of scenes that vaguely relate to each other (Fig. 29.10).

They take place within an empty black space where interconnected spheres float as white structures. This appears to be the habitat of a single human figure which seems to create and explore it at the same time. The structures are reminiscent of molecules or star signs: some shine, some are gathered from the figure's own gown, and others burst while the figure is sleeping. Occasionally a spectral spider appears scuttling along the structures or creates its own filaments across the cosmos. Another appearance is a long and supple structure made up of a multitude of white spheres. Occasionally it winds itself weightlessly through the black space.

The Unleashed Eye

3D programs are 'linear perspective engines', based on the classic camera as projection model. Yet they overcome our way of looking by the way perspec-tive is used: experiencing 3D simulations is puzzling, we get immersed and can roam freely through them without being part of the scene. We can orbit extensive scenarios or enter the tiniest details, as we are, in fact, nothing but an unrelated point of view, freed from space and even time. Solely based on signs, computer simulated worlds can be flipped through like a book, making the computer's code unfold instantaneously before our eyes. This authorial uninvolved outlook has often been called 'God's perspective' (you might think

Fig. 29.10: Cordless Time, *four animation stills, Michael Hoepfel 2004.*

of the 'bullet time effect' from the movie *Matrix*). Meanwhile, in searching for the unleashed perspective, flying camera drones start to pursue these viewing patterns in reality. The viewing point that was fixed in times of Renaissance transforms into a spatial cloud of equally probable angles.

Fig. 29.11: Ein Drittel der Sterne (One-Third of the Stars), *Primo Tempore, Michael Hoepfel 1994.*

The Cosmos from Outside

Our technical eyes examine the cosmos and computers calculate endless piles of position and radiation data sets to research the universe's spatial structure. A sensual impression of what is hidden within the vast amount of data can only be accomplished with the help of 3D computer visualizations. Today the first three dimensional maps of the universe exist: we can experience the universe as a cubic cut-out with edges of hundreds of million light years length – and we can orbit this gargantuan object in perspective on our screen. The cosmos lies well arranged before our eyes: we finally get a spatial impression of it as we see it from outside. What a divine view! But while we need only a second to spin this cube, light needs millions of years to cross the cube's equivalent in reality. As the simulation is based on starlight that passed our home planet after long and different travelling times, the cube visualizes structures from different eras as if they all existed simultaneously. The objective view from the outside is an illusion. The universe resists our wish to grasp it.

ETHICAL IMPLICATIONS OF
ASTROPHOTOGRAPHY AND STARGAZING

Dietmar Hager

ABSTRACT: The globally increasing prevalence of stargazing and astrophotography is a most acceptable accomplishment of our high-tech society. Even the astronomical equipment for such purposes has become comparably inexpensive and readily available. But why does humanity look up to the stars? What is so fascinating about stargazing and astrophotography? More significant is the question: why is it so important to keep up this 'behaviour' and even encourage more of our friends on Earth to focus their attention to the night skies? Just as remnants of by-gone stars comprise the essential elements of our human bodies, it becomes even more imperative to seek starlight. It is a 'home-coming': for seeking the stars means to look back to the very origins of humans in the cosmos. However, with increasing light pollution we run the risk of losing this connection to nature as starlight vanishes. We become disconnected from nature and we lose our sense of responsibility. The 'products' of this behaviour can be read about in the daily news. Based upon behind-the-scenes footage at ESO (European Southern Observatory) sites in Chile, this paper suggests answers to the above ethical questions and points out the importance of being (re)connected to nature. In conclusion, a 'way out' scenario for the consequences of light pollution for the natural environment, health and the economy is presented.

Stargazing is an old habit of humanity. Most likely it dates back to the time when people first began to reason and reflect upon being. There is much evidence of the influence of the stars throughout all continents ever inhabited by humanity.[1] Remnants of such cultures are now to be seen that remind us of their way of living with the stars. Based upon those cultural artefacts that can be found on all continents we find proof of the strong influence of the stars on cultural activities.

The creation of an episteme, as well as all kinds of mythology, is based upon stargazing in the several cultures observed and studied. The observation and investigation of the starry sky is also a service to the essence of what was meant by the Latin word, *religio*. In German the closest analogy would be rückbindung, meaning 'reconnection', and reconnection to a source; such a source in turn can be 'nature', 'cosmos', or 'god'. *Religio* is then reliable tool to reunite us with the very origin of life *per se*, the cosmos.

[1] Volker Bialas, *Vom Himmelsmythos zum Weltgesetz. Eine Kulturgeschichte der Astronomie* (Vienna: Ibera-Verlag, 1998).

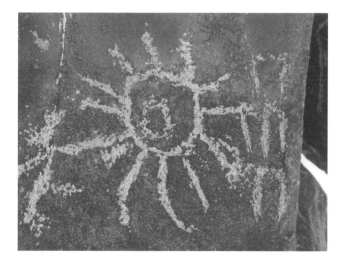

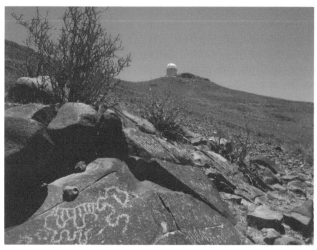

Fig. 30.1: A (top) and B (bottom). Petroglyphs as cultural artefacts in Chile near the ESO Telescope-parl at La Silla, possible evidence of the influence of night skies.[2] *Image source © Dietmar Hager.*

[2] European Southern Observatory, 'Petroglyphs around La Silla', https://www.eso.org/public/images/lasillapetroglyph-cc/ [accessed 11 March 2016]; See also Gabrielle Bernardi, Alberto Vecchiato, and Beatrice Bucciarelli, 'Possible Astronomical Meanings of Some El Molle Relics Near the ESO Observatory at La Silla', *Journal of Astronomical History and Heritage* 15, no. 2 (2012): pp. 137-45, http://www.narit.or.th/en/files/2012JAHHvol15/2012JAHH...15..137B.pdf [accessed 7 April 2016].

Fig. 30.2: Light-pollution from the perspective of the satellite.[3]

In modern society, however, it has almost become impossible to comprehend such affinity for the stars, as light-pollution tends to 'swallow' away all light coming in from the stars. Who is aware of the fact that the light arriving at planet Earth, after travelling through space for over billions of light-years, is lost in an atmosphere that is polluted with too much artificial light at night? In the cities we live in, almost no one can see more than a handful of stars. That is a shame! Starlight carries the story of remote places in the cosmos to us. It is a most communicative medium. Starlight forms the episteme. For the first time we live in era that runs the risk of losing contact with the stars. Once we lose contact, we have no relationship with the sky. If we have no relationship with it, we will no longer feel responsibility for it. But whoever has witnessed a starry sky like that in the image below will surely appreciate the majestic beauty veiled behind.

[3] Image source © www.lichtverschmutzung.de.

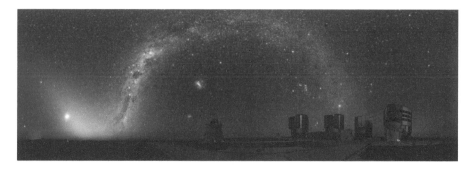

Fig. 30.3: Paranal Night Skies. The Milky Way. Image source © Dr Yuri Beletsky.

The image shows a tremendously deep insight into the night skies. You can easily see the Milky Way as well as zodiacal light. Can you imagine this? Have you ever seen this yourself? I have witnessed this myself, when standing on the observational platform in Paranal, Chile, the home of mankind's best Earth-bound astronomical telescopes (very large telescopes). When the Milky Way passed through the zenith (the meridian), the highest point in the sky, it was so bright that my body cast a shadow on the ground. One stands and stares, humbled by the luminosity of thousands of stars above. But when was the Milky Way created?

According to myth, the Milky Way was created by an incident, when little Hercules was drinking divine milk at Hera's breast.[4] However, when Hera discovered the little boy was not her son, she pushed him away. Right at this very moment, a bit of Hera's milk was spilt into the sky, forming the Milky Way. And by gazing into the stars, man had already created an episteme by then.

Modern astronomy nowadays forms an episteme based upon highly sophisticated telescopic techniques. Earthbound telescopes as well as those orbiting the Earth deliver scientific data from the most remote places in the universe. What have we learned from astronomical science so far? Some of the most important discoveries can be named here: we have learned that there is not just one galaxy but myriads of them in the universe, that most of them have a big black hole in their core, and that the universe expands at accelerated speed.[5] In addition, we have learned about the motor of stars – nuclear fusion – and, in discovering microwave background radiation, evidence was found for the Big Bang theory. We have also found planets circling around remote stars; we call them exo-planets.[6]

[4] Paul Mazon, Introduction to the *Théogonie d'Hésiode* (Les Belles Lettres, collection of the Universités de France, 1928).

[5] Timothy Ferris, *Galaxien* (Basel: Birkhäuser Verlag, 1987).

[6] Centre National D'Etudes Spatiales, 'Looking inside stars and hunting extrasolar planets', https://corot.cnes.fr/en/COROT/index.htm [accessed 11 March 2016].

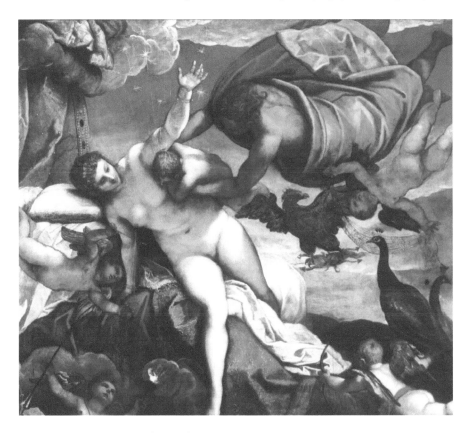

Fig. 30.4: Depiction of the Myth of Hercules, Hera and Zeus *by Jacopo Tintoretto.*[7]

But even though we have learned so much about the cosmos we live in, still many intriguing questions remain to be answered. To accomplish this, we need giant efforts to create giant telescopes. The ESO's ELT (Extremely Large Telescope) will be a giant among all the observatories ever built. At the end of 2011, the construction site at Cerro Armazones was finally opened, which will house a telescope comprising a 39m diameter main mirror. When the telescope is operational its resolution will exceed Hubble Space telescope by a factor of 10 to 30 and it will be able to gather light from the most remote stars and galaxies.[8] However, on the level of form nothing that man ever creates is stable in terms of the timeline. Look at a nuclear power plant, for example. Even though a minority makes us believe we can control nature, nature itself always teaches us that it is better to walk in humility and overcome our ambitions and intentions to exploit others and the Earth.

[7] Image source: http://commons.wikimedia.org/wiki/File:Jacopo_Tintoretto_011.jpg.
[8] www.eso.org.

Fig. 30.5: The E-ELT in relation to the Pyramids. Image source © ESO www.eso.org.

If the 'sun' is a metaphor for the blooming of our current western industrial, modern society, when it sets, we shall be judged by those who follow. Would it not be a good idea to raise buildings like astronomical observatories? Yes it is! Because these buildings are raised on the most solid foundation there is: they are built upon peace among nations! No nation can afford a 2 billion dollar observatory on its own. An international group effort is required to gain knowledge about the origins of life. Buildings that we will leave behind shall, in time, become the calling cards of our present society.

The sun could be addressed as a 'glorious provider'. We also find evidence of this worship of the sun in Egyptian culture, where the sun achieved religious functions.[9] Today we can describe the sun's tasks in terms of keeping a distinct sphere-shaped space perfectly clean and prohibiting influence from outer space that would prevent the development of life on Earth, for example (the heliosphere). As matter and energy are equivalent, one could say that the sun is a centre of high energy and a huge focus of strength, keeping the energy field around it in a life-enabling status. Its very essence, however, was always based upon the worship of it as the glorious provider.

In his TV series *Cosmos*, Carl Sagan, one of the greatest cosmologists of the last century, squeezed 13.7 billion years of creation into one Earth year to come up with a model timeline that we can relate to.[10] I mean, who can really imagine

[9] Christian Bayer, *Echnaton – Sonnenhymnen* (Stuttgart: Reclam, 2007).

[10] Carl Sagan, *Cosmos*, available at https://www.youtube.com/watch?v=Ln8UwPd1z20 [accessed 11 March 2016].

Fig. 30.6: Sunset at La Silla; the ESO's first Telescope-Park. Image source © Dietmar Hager.

a time span of one billion years? Based upon Sagan's model, in which the life of the universe equates to one Earth year, we learn that the Milky Way showed up in early January, and the sun and Earth came into being in September. Modern civilization stuck its boot onto Earth in the last seconds of the 31st of December. One single earthling, however, only lasts for a tiny part of a second, a diverting wink of an ultra-short moment. So we literally are very transitory passengers on planet Earth. Seeing the big picture now, one would want to recommend: when you are in Rome, behave like the Romans do. That means doing two things: find out the house-rules and act according to them, by learning from Mother Nature.

It is one characteristic of sentient humans on Earth to try to assess the ethical implications of being human. Intuition and the momentary status of sensing the world exterior to the level of form, that is of the forms of physical life, serve as tools to understand the cosmos we live in. The prominence of this knowledge only becomes graspable by trying this out yourself. We are invited to step beyond the borders of common methods that are called objective. The Latin origin of this word is *objectere*, meaning 'to throw out'. Anything that is not evidence based has to be thrown out of the episteme.

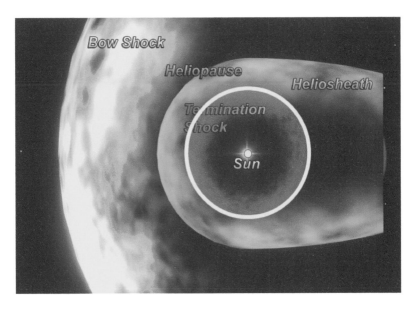

Fig. 30.7: Heliosphere and the astronomical and astrological symbol of the Sun. Image created by author.

In his book, *On the Infinite, the Universe and the Worlds*, Giordano Bruno (1548-1600) argued that the human mind exists in a broad spectrum of possibilities.[11] He exercised what was handed down to him from his teachers, like Nicholas of Cusa (1401-1464), roughly a hundred years earlier, and what this wise man called *interna lectio*, or 'internal reading' (as opposed to *interna scriptura*, or internal writing).[12] Imagine the mind as a cup or a vessel that contains knowledge. Look at it closely and you will find contents to be spilling over the brim, as more and more information always comes into your system – by radio, news, books, discussions, or reading this pamphlet. Indian yogis such as Sri Aurobindo recommend that we first turn the cup over and respectfully pour out what is inside (perhaps store the memory elsewhere first…);[13] then wait and do not fill it up from the outside, from the exoteric aspect of life, but wait for what comes from your very core, from the esoteric aspect of being. Mind is a wonderful tool but no more. To then sit in stillness and sense the substantial content from being is a

[11] Giordano Bruno, 'On the Infinite, the Universe and the Worlds', in Dorothea Waley Singer, *Giordano Bruno: His Life and Thought* (New York: Henry Schuman Inc., 1950), http://www.positiveatheism.org/hist/bruno00.htm [accessed 7 April 2016].

[12] Giordano Bruno, *Cause, Principle and Unity*, trans. Richard J. Blackwell (Cambridge: Cambridge University Press, 1998); Pieter A. Verburg, *Language and its Functions*, trans. Paul Salmon (Philadelphia, PA: John Benjamins Publishing Company , 1998), p. 203.

[13] Wilfried Huchzermeyer, *Sri Aurobindo – Leben und Werk* (Karlsruhe: Edition Sawitri, 2010).

Fig. 30.8: Giordano Bruno and the night-skies. Image source © Dietmar Hager and Dr Yuri Beletsky.

most fascinating experience. Many people have exercised this most successful-ly and reported about what they have learned. Sit and hover over a topic that appeals your interest and do not think about it. Stop the mental process and be amazed about what might show up when filling the mental cup from the inside. It is a clear instruction to use a tool that might be addressed as intuition and maybe, say, inspiration.

Pythagoras believed that numbers are the keystones to understanding the anatomy of the cosmos.[14] We could say that the universe consists of numbers. Modern humans might call them quanta, as Max Planck did.[15] Consequently, numbers and trails of numbers can be found anywhere in nature, as they truly seem to be a conceptual structure of the cosmos. Fibonacci sequence numbers are

[14] Kenneth Sylvan Guthrie and David R. Fideler, *The Pythagorean Sourcebook and Library* (Grand Rapids, MI: Phanes Press, 1987), pp. 28-30.

[15] Wolfgang Gerlach, *Die Quantentheorie: Max Planck, sein Werk und seine Wirkung* (Bonn: Universitätsverlag, 1948).

just one good example.[16] Be it the construction of plants, the order of branches of plants, the order of succession of animals, or the anatomy of a thunderstorm, the same basic structures are based upon numbers found almost anywhere in the known universe.

Numbers in arts can be found as the so-called 'golden ratio' – another application of Fibonacci sequence numbers.[17] Whenever we sense a painting or a photograph of a face as beautiful, we simply go into resonance with the numbers veiled behind, which hover there in a harmonic relation. Even music and harmonic sounds are encoded this way. Kepler's laws of planetary revolution are also a form of such order; he was the first to pick up Pythagoras' ideas and analyse them for their mathematical implications.[18] A positive side effect was the discovery of the planetary laws. Certainly this knowledge is rather old, as ancient buildings were designed based upon this relationship. Most amazing for me as a physician, was to realize that the relationship of the length of bones – the ratio of bone lengths like those in the hand – follow the 'Fibonacci sequence'. The conceptual structures of the micro- and macro-cosmos are connected by analogy. Finally, evidence-based science reveals what has already been identified in an intuitive way for so many thousand years.

Fig. 30.9: Bones and Fibonacci. The length of bones is determined by cosmic numbers.[19]

In my view, the notion of *panta rhei* (that the entire world is in a continual state of flux) ascribed to Heraclitus also refers to the rhythms of life that pervade nature. Evidence for such rhythm can be found everywhere, be it a star that rises out of the ashes of a decayed star that dissolved billions of years before, or planets that are formed around a newborn star that itself will have to wither away more or

[16] Carl Boyer, *A History of Mathematics* (New York: John Wiley, 1968), pp. 254-6.

[17] Boyer, *A History of Mathematics*, pp. 254-56.

[18] Johannes Kepler, 'Harmonies of the World', in Johannes Kepler, *Epitome of Copernican Astronomy and Harmonies of the World*, trans. Charles Glenn Wallis, in *Great Minds Series* (Amherst, NY: Prometheus Books, 1995), pp. 167-245 (pp. 183-201).

[19] Image source http://commons.wikimedia.org/wiki/File:Creation_of_Adam.jpg.

less spectacularly to give back all the elements that have been synthetized within the core of such a star. The debris will serve as the fundamental basis for the next generation of stars, planets and life.

Many sorts of rhythms can be observed: the analemma reveals the rhythm of solar position throughout the year, the rhythm of the seasons, the rhythm of day and night, the rhythm of a human's life. There is no rational reason to assume that we as humans are excluded from Heraclitus' *panta rhei*.

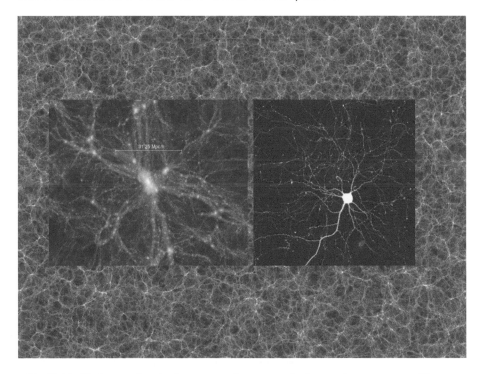

Fig. 30.10: Obvious analogy in the conceptual structure of micro- and macro-cosmos. The cosmic web compared with one single neuron cell of a human.[20]

Acceptance of such rhythm and finding oneself embedded within it makes life become more precious, as it leads to realizing the importance of self-responsibility in thoughts, emotions and actions. This results in a self-conscious individual who is always aware about the essence of being. Self-observation then serves as a viable tool to reflect upon one's true intentions and ambitions. One is required to let the mind become absolutely still, which we find very

[20] Image source of the cosmic web http://www.mpa-garching.mpg.de/galform/millennium/. Image source of a brain cell http://img.medicalxpress.com/newman/gfx/news/hires/2013/transplanted.jpg.

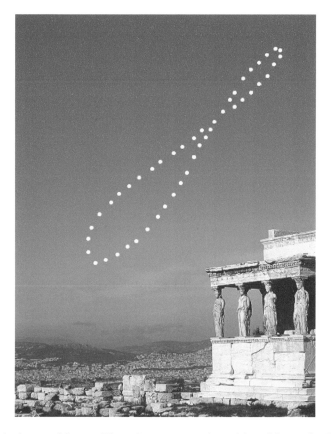

Fig. 30.11: *Analemma of the sun. Throughout one year, the position of the sun has been imaged on a given time of the day, yielding an image that reminds one of the symbol of eternity.*[21]

difficult, as the mind is mostly undisciplined activity and 'fires' one thought after the other. Eckhart Tolle calls this 'mental noise'.[22] It also means that we do not seem to have control over our mind; it is more the other way around. It is as if the mind has power over us.

Now what are the ethical implications for astrophotography? By increasing light-pollution, imaging in Europe has become almost impossible. The most ambitious astrophotographers just transplant their observatories to very remote places to avoid light pollution. Then they go on imaging and making glossy

[21] Image source © Anthony Ayiomamitis, http://www.perseus.gr/.
[22] Eckhart Tolle, *The Power of Now* (London: Hodder and Stoughton, 2005); Eckhart Tolle, 'The Power of Now and the End of Suffering', interview with Tami Simon https://www.eckharttolle.com/article/The-Power-Of-Now-Spirituality-And-The-End-Of-Suffering [accessed 5 March 2015].

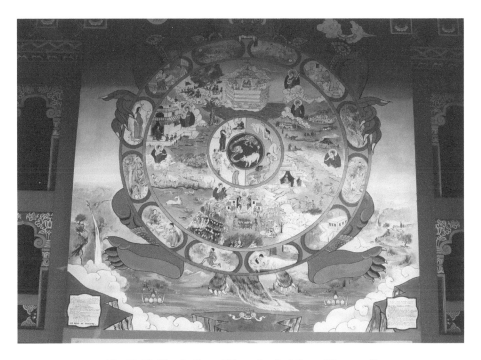

Fig. 30.12: The rhythm of life; and a depiction of Samsara.[23]

photos of the universe. However, the question has to be: what purpose do as-trophotos serve? Taking starlight from starry night skies for displaying the uni-verse and telling stories about it to people who are not aware of the cosmos is a valuable task, for sure. But we have to make sure not to run into an imbalance of give and take. What do we give back to such starry night skies? Again: what purpose does it serve to be committed to astrophotography?

To create one glossy image after the other and present them to the commu-nity; to have it discussed and gain recognition – but what for? Can there be a more devoted purpose as well?

An ethical approach in astrophotography would match the needs of our society much more. We shall no longer just have the images serve our own egotistical needs. Instead we can give something back to the universe, which provides us all with the beauty of starlight. We can inform our communities about the problems of light pollution and bring starlight to the attention of our neighbours. We can tell people why it is so important to keep up stargazing! And why is that? Because, as Carl Sagan emphasized, human bodies and everything on Earth are comprised of elements that have been synthesized in stars that have

[23] https://fr.wikipedia.org/wiki/Dashang_Kagyu_Ling#/media/File:134_Temple_des_ mille_Bouddhas_La_roue_du_Samsara.jpg [accessed 16 April 2016].

withered away so many billions of years in the past.[24] We are the offspring of such stars, and therefore children of the cosmos. So, when looking up to the stars, we literally look back to our very origins and pay tribute to the privilege of being human on this wonderful planet. Maybe we can start by sitting in stillness and learning to be present in the only moment there ever is, the now. We can become aware of the unity we all are embedded in, connected and united, as we are depending on each other. We can stop being VIPs – very inactive persons – but can become active, not yesterday, not tomorrow, but right now.

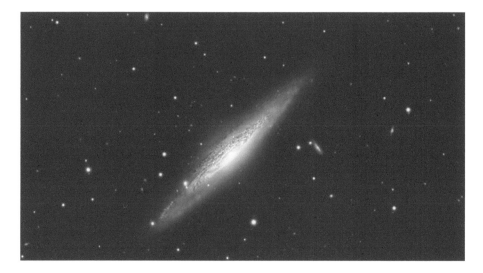

Fig. 30.13: NGC 2683. A remote galaxy. Image source © Dietmar Hager, Torsten Grossmann.

[24] Carl Sagan, *Cosmos: The Story of Cosmic Evolution, Science and Civilisation* (London: Warner, 1994).

REVEALING A UNIVERSE OF COLOUR

David Malin

ABSTRACT: The mystery of what is seen in the night sky and the urge to understand it has been with us since we became sentient beings. The telescope dramatically increased our understanding but the application of photography to night-time astronomy in the 1880s revealed the Universe to be bigger and more mysterious than anyone had imagined. A hundred years later, colour photography showed it to be beautiful as well, and the co-lourful cosmic landscapes revealed and emphasised our intimate connection with the distant stars and galaxies.

Introduction

It is rare nowadays to stand beneath the night sky and wonder about it in any profound way, at least when we see it in familiar surroundings. We may wonder why the sky is yellow at night and when the bus is due, but that is usually as far as it goes. The stars, if we can see them at all, are insignificant, though the Moon occasionally attracts the eye. However, wondering about the night sky has a long history and is probably what made us human.

Our most distant ancestors, who we might imagine to be unencumbered by dwellings or security lights, lived at a time when the night sky filled half their visual field and half their day; in other words half of their space above the Earth, for half their time on it. Until relatively recently, to most people, the night sky comprised nature's largest and most mysterious visual phenomenon. By day there is the procession of the Sun and the Moon, by night an awe-inspiring canopy of thousands of stars appears out of the twilight. At some time in the distant past our ancestors must have lifted their eyes from the campfire (the first security light) and wondered about this subtle and ever-changing spectacle. To express a sense of wonder and to discuss what it might mean, abstract language is needed: curiosity and the communication of abstract ideas are very human characteristics. They are also the essence of art and science.

No doubt other aspects of life in the raw would have prompted speculation as well, but, unique in our experience of the natural world, the night sky is a purely visual phenomenon. The starry sky is silent and, unlike the Sun, the Moon's inconstant light lacks warmth. One cannot sniff or taste a star or reach out to it to see if it is hot or cold, friend or foe. Similarly, we learn nothing of the distance or dimensions of the stars by simply looking, and walking beneath the starry sky neither changes its perspective nor brings it nearer. Unsurprisingly, this night-time sensory deprivation and feeling of detachment from the real world heightens the mystery of the dark, often prompting the questions about origins and destiny that seem to appear spontaneously in every culture.

Sadly, as a species we seem to have lost contact with the stars in the last 120

years or so. This is especially true in the northern hemisphere, where most of the world's population is found, together with almost all the planet's industries. This is the source of the pervasive haze of particulate air pollution that fills the night sky with the reflected glow of the brightly lit cities and suburbs where most of us live. There are very few places north of the equator where we can recapture the star-spangled velvet blackness of the night that for thousands of generations so moved and inspired our ancestors.

As an aside, the southern hemisphere is much less affected by pollution from either lights or airborne dust. The population density is much lower and the land masses much smaller. As a consequence there is relatively little heavy industry, and the air is cleansed by the vast expanses of the southern oceans. Happily, the particulate pollution of the northern hemisphere is washed out by the rains of the equatorial regions, so little crosses the equator, unlike the steadily increasing carbon dioxide, which knows no boundaries.

In this paper I will concentrate on the lesser-known aspects of the history of astronomical photography and some other relevant matters that are of interest to me but not widely known, especially colour photography in astronomy. Much of the technical material that relates to my own work has been published elsewhere and will be referenced.

Early understanding

Whatever the spiritual feelings engendered by the night sky, and ignoring the obvious change from day to night, ancient peoples must soon have noticed the seasonal variations in the positions of sunrise and sunset on the horizon, punctuated by the regular yet changing appearance of the Moon. These celestial cycles give the appearance of consistency, predictability, and perhaps even a sense of purpose in the heavens that is less apparent in daily life, so it is not surprising they were considered to be a manifestation of some divine, supernatural or unworldly force creating order out of chaos.

In reality, of course, the obvious cycles of the day, the month, the year and the changing seasons are manifestations of several completely unrelated phenomena. The length of day reflects the spinning of the Earth in space, and the length of month is determined by the orbital period of the Moon around it. The year is the orbital period of the Earth around the Sun while the seasons are determined by the orientation of the Earth's axis in space. These explanations came late to our species, and mark the beginnings of science, thus completely changing our perspective of our place among the stars and our relationship to them.

On a more mundane level, and without knowing anything of celestial mechanics, the motions of the heavenly bodies can be used as a reliable clock, calendar and compass, some of which are necessary to carry out the five pillars of Islam, for example, not to mention navigation.[1] At some stage the wandering

[1] David King, *Islamic Astronomy and Geography* (Aldershot: Variorum, 2012).

motions of the planets would also have been recognised as following the same path across the sky as the Sun and the Moon – the ecliptic – and hence the Western zodiac. That these astronomical phenomena were important to our ancestors is obvious in the standing stones of Stonehenge and elsewhere in Europe, and the alignment of the pyramids in Egypt.[2] That the celestial clockwork seems to revolve around us is a very convincing illusion; demonstrating that we were not at the centre of creation marked the beginning of modern science (Fig. 31.1).

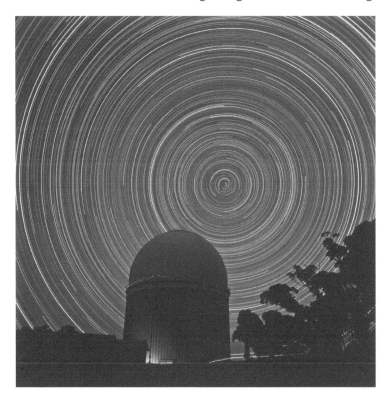

Fig. 31.1: Star trails over the AAT dome. A long exposure shows that the stars seem to move on great circles around two points in the sky, the north and (in this case) south celestial poles. This property of the stars was well known in ancient times, and emphasised the impression that we are the centre of creation.

It is clear from the earliest records that the mystery of the night sky was a constant stimulant to the imaginations of many cultures around the world. By joining the dots, people found form and structure in the random patterns in the stars, which can be thought of as a giant Rorschach test, using pinpoints of light

[2] Clive Ruggles, ed., *Handbook of Archaeoastronomy and Ethnoastronomy* (Heidelberg: Springer-Verlag, 2014).

rather than inkblots to stimulate the imagination.[3] Unlike the Rorschach test, which was intended to uncover some mental abnormality, the responses of the early stargazers to the patterns in the sky reflected the cultures and environments from which they came. Where we in Australia see the Southern Cross in Crux, some Australian Aboriginal peoples recognise the kite-like outline of these stars as a stingray, while South African Bushmen see the distinctive shape of a giraffe's head in that constellation.[4]

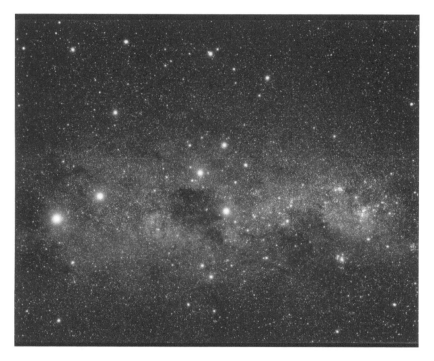

Fig. 31.2: The Southern Cross. The stars of the Southern Cross. Dante Alighieri never saw these stars, but wrote that those who lived at north latitudes were 'bereft and widow'd', deprived by their absence in the northern sky. Photo: Akira Fujii.

In the fifteenth century, the earliest Spanish and Portuguese navigators to venture to the southern hemisphere recognised a sign of divine guidance in the Southern Cross. However, this group of stars was known earlier (as a part of the constellation of Centaurus), and Dante (1265-1321) ascribes to its four principal

[3] Loren J. Chapman and Jean Chapman, 'Test results are what you think they are', in *Judgment under Uncertainty: Heuristics and Biases*, ed. Daniel Kahneman, Paul Slovic, and Amos Tversky (Cambridge: Cambridge University Press, 1982), pp. 238-48.

[4] C. P. Mountford, *Records of the American-Australian Scientific Expedition to Arnhem Land. Volume 1: Art, Myth and Symbolism* (Melbourne: Melbourne University Press, 1956), p. 494.

stars the Cardinal Virtues of Wisdom, Justice, Fortitude and Temperance.[5] I can confirm that these are indeed well known attributes of those of us who live beneath the southern stars.

The Eye and the Sky

Until 1609, all observations of the sky had been made with the unaided human eye. Before the invention of the telescope, for timekeeping and navigation and probably for astrological purposes, simple instruments such as the cross-staff and astrolabe were developed for more sophisticated measurements, and these involved looking with one eye, which is not as good as looking with two. Of course these devices did not improve the sensitivity of the eye, merely the accuracy of measurement. While the human eye is perfectly adequate for this kind of activity, it is almost insensitive to colour when light levels are low, and for quite different reasons it is also insensitive to the colour of very small points of light.

Though red and yellow star colours are mentioned in the ancient literature, and the name of the visibly red star Antares (for example) encourages comparison with the similarly ruddy planet Mars, apart from Manilius, there is little mention of blue stars or references to them until modern times.[6] In reality, most of the bright stars that make up the main constellation figures are hot giant or super-giant stars, with colours that are about as blue as the bluest daytime sky. The discovery that many stars were blue was made photographically about 120 years ago.

Despite the eye's numerous deficiencies as an astronomical detector, much was learned about the night sky before the invention of the telescope. After its invention, more precisely after its application to the night sky by Galileo Galilei (1564-1642) in 1609, everything changed. The telescope was a new technology applied to an old science, and it revolutionised it. The telescope's introduction coincided with Kepler's work on planetary orbits and the gradual acceptance of the Copernican heliocentric ideas. An amazing series of events marked the beginning of modern science, which combines and compares theory with observation in a systematic and objective way.[7]

The telescope made its astronomical contribution partly by the magnification it offered, but mainly by its increased light gathering power. Magnification was useful for the telescope's terrestrial applications, where ships and armies could be identified at a distance. However, in astronomy, the telescope's front lens (the

[5] Dante, *Purgatorio* Canto I:22-27.

[6] Marcus Manilius described Sirius as 'sea-blue' – frigida caeruleo', in Manilius. *Astronomica*, trans. G. P. Goold, ed. Jeffrey Henderson, Vol. 469, Loeb Classical Library (Cambridge, MA: Harvard University Press, 1977), p. 37

[7] Michael Hoskin, 'From Geometry to Physics: Astronomy Transformed', in *The Cambridge Concise History of Astronomy*, ed. Michael Hoskin (Cambridge: Cambridge University Press, 1999), pp. 94–124.

objective) effectively becomes the pupil of the eye, so its diameter determines how much more light reaches the retina. Galileo's earliest telescope has a 12mm objective that allowed him to see thirty or more times fainter than the unaided eye. After Galileo's time telescopes rapidly improved in light gathering power, a process that continues to the present day. However, if you ask a professional astronomer what is the magnification of his or her telescope, the answer is likely to be a blank stare.

Galileo is rightly celebrated for his drawings of the stars, of the moons of Jupiter, and of the Moon itself. He was not the first to sketch the Moon; that honour goes to Thomas Harriot (ca. 1560-1621), who made some drawings some months before Galileo.[8] However, Harriot did not publish his work whereas Galileo did, quickly, conspicuously and to great effect. The telescopic drawings in Galileo's *Sidereus Nuncius* (1610) were literally central to the book; indeed he delayed publication so that several extra (and un-numbered) pages could be inserted as an illustrated centrefold at the last minute. The extra pages contained his sketches of the region around Orion's Belt and of the stars of the Pleiades as well as other well-known groups of stars. In Orion he found himself 'overwhelmed by the enormous multitude of stars and lack of time [to count them]' and he put off a thorough assessment for another time; he added 'to the three in Orion's Belt and the six in his sword that were observed long ago, I have added eighty others', none of which had been seen before.[9]

It is one thing to see the light of the stars in the telescope, which is almost always an unshared experience. It is quite another to recall, draw and communicate what was seen, and what is seen is a random scattering of stars or some faintly structured nebula whose form has no earthly counterpart. Unrelated to this issue of visual memory is another of the eye's deficiencies: its inability to integrate light over long periods. To aid recollection, astronomers made sketches of what they saw through the telescope, and they saw best when they were well dark-adapted, a process that takes 15 minutes or so and cannot be hurried. But to make a sketch light is needed, so the sketch is made from memory and can never be checked against what is seen; the seeing and the drawing can never be simultaneous. These issues were to remain a problem until a new way of capturing light appeared.

Daguerre, Arago and Herschel

The long history of the discovery of photography has a large literature, but its debut as a usable system occurred in 1838-39 with the announcement by Louis Daguerre (1787-1851) of his eponymous process.[10] I use the word 'discovery'

[8] 'Thomas Harriot's Moon Drawings', *The Galileo Project*,
http://galileo.rice.edu/sci/harriot_moon.html [accessed 7 September 2015].
[9] Galileo Galilei, *Sidereus Nuncius, or The Sidereal Messenger*, trans. Albert Van Helden (Chicago: University of Chicago Press, 1987), p. 59.
[10] For what follows see Maria Joseph Eder, *Geschichte der Photographie*, or *History of Pho-*

rather than 'invention' mainly because the process evolved through many iterations before it became practically useful. Conspicuous figures at the birth of the new process were two astronomers, one of whom, Sir John Herschel (1792-1871) was the first to use the words 'negative' and 'positive' in a photographic context. However, Herschel's crucial contribution was his knowledge that Daguerre's essential light-sensitive ingredient, silver iodide, could be dissolved in a solution of sodium thiosulphate, often known as 'hypo'. He discovered this seemingly arcane fact when he was experimenting with chemistry in 1819, but it literally solved the problem of making the early images permanent by quickly dissolving the normally extremely insoluble, light-sensitive silver iodide that Daguerre's process (and subsequent ones) involved. Without its removal the images deteriorated on further exposure to light. Many readily available materials are light sensitive. The essence of photography is fixing the image so that it is permanent, and sodium thiosulphate ('hypo') and its derivatives are still used as a 'fixer' today where traditional, silver-based photography is practiced.

The other important player in this story is François Arago (1786-1853), the French polymath, who was (often simultaneously) mathematician, physicist, politician – and astronomer. He was a member of the French Chamber of Deputies from 1830 and later Prime Minister of France for a short time.[11] He was also director of the Observatoire de Paris from 1834 until his death. As both a scientist and politician (nowadays a very rare species) he recognised early the scientific and cultural value of Daguerre's discovery, especially its astronomical and scientific potential. He successfully petitioned the French government for a lifetime pension for Daguerre if he made the details of his process public.[12] Daguerre obliged, and so did the French Government, and mirror-like daguerreotypes soon became an item of commerce all over the world.

The Daguerreotype plate was too insensitive to capture images of heavenly bodies other than the Sun and the Moon. It was also an expensive process to use and a Daguerreotype was unique and could not be copied. After about 1850, the negative-positive processes were sufficiently advanced to be able to photograph the stars with a suitable telescope and could produce multiple prints, but the process itself was tedious. The plates had to be prepared in the dark just before use, exposed wet, and then processed immediately afterwards. The wet collodion business was lengthy and inconvenient but beautiful results were achievable. It was not until the 1870s that a 'dry-gelatin' process became available, ancestor of most of today's photographic processes. This allowed the light-sensitive silver

tography, trans. E. Epstean (New York: Columbia University Press, 1945; New York: Dover Publications, 1978).

[11] Paul Murdin, 'From artilleryman to head of state – how astronomy inspired Francois Arago', *Culture and Cosmos* 16, nos. 1 and 2 (Spring/Summer and Autumn/Winter 2012): pp. 219-24.

[12] R. Derek Wood, 'A State Pension for L. J. M. Daguerre, for the Secret of his Daguerreotype Technique', *Annals of Science* 54, no. 5 (1997): pp. 489-506.

salts to be prepared in a solution of gelatin (the emulsion) that could be coated on to glass plates, which could be dried and stored for future use. They could be exposed for any length of time and developed at leisure.

By 1880 modern photography had arrived. In the U.S., George Eastman (1854-1932) recognised that a flexible film derived from celluloid could be coated with photographic emulsion and in 1888 he patented the first 'Kodak' box camera using rolled film. Photography was rapidly democratised and spread amongst the affluent, just as the iPad and like devices have done recently.

Many others soon realised that they were at last free of the limitations of the wet collodion process, and in 1883 the English astronomer Andrew Ainslie Common (1841-1903) was able to make a long-exposure (37 minute) photograph of the Orion nebula that showed stars that were too faint to be seen by eye when using the same telescope. Longer exposures showed even fainter stars. In an instant, photography was transformed from a recorder of some scene visible to all to a detector of the unseen. This advance was as important for astronomy as was Galileo's introduction of the telescope, and it allowed the fledgling science of astrophysics to flourish. Over the following century, until about 1990, photography was in use at all professional observatories, gradually being displaced by the solid-state digital detector, which has created a revolution all its own in the last decade or so.

Photography and modern astronomy

As with its introduction to the telescope, photography completely changed the way astronomy was done, and a whole new generation of telescopes was built from about 1910 onwards to exploit its light-gathering power. For almost 100 years from about 1890 onwards, photography was the main detector of light in astronomy and much of what we know about the Universe was derived from photographic plates. Photography allowed spectra to be recorded as well as images, and these revealed the composition of the stars and the physics of their evolution, from the star-forming nebulae such as that in Orion to the glowing remains of their demise as supernovae or planetary nebulae. From data gathered in this way we now know we are made of stardust, a quite poetic idea, and that the life-sustaining Sun is powered by a nuclear reactor, a concept with different overtones.

I referred to the colours of the stars earlier. Once these could be measured from photographic plates taken in green and blue light, it was realised that the colours indicated stellar temperature. As in medicine, stellar temperature is a powerful diagnostic, and if the distance of the star was also known, its total energy output could be calculated. This value was found to be closely related to the star's mass. Most stars fitted into a narrow range of possibilities, known as the 'main sequence', and the diagram that compares temperature (i.e., colour) with a star's absolute magnitude has a predictive power that allows the ages and lifetimes of stars to be estimated. The diagram is known from its founders

as the Hertzsprung-Russell diagram, and after 100 years is still a cornerstone of stellar astrophysics.[13]

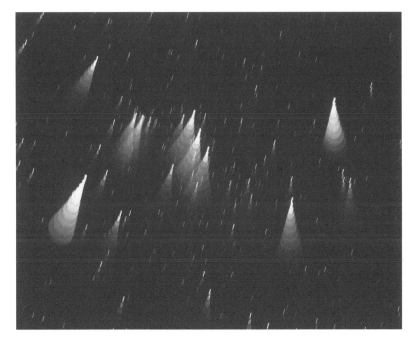

Fig. 31.3: The colours of the stars in Orion. This 30-minute exposure was made by de-focusing the lens of a fixed camera in a series of steps as the stars are carried across the sky by the Earth's rotation. As the images spread out the colours of the stars (and the red of the Orion nebula) become visible.

The other major contribution made from spectra captured on photographic plates was evidence for the expansion of the Universe, an idea that led to the concept of the Big Bang.[14] This discovery is usually credited to Edwin Hubble, but many others made pivotal (and sometimes unacknowledged) contributions. Hubble and his associates used very long exposures to record feeble spectra of ever more distant galaxies, to measure their redshift and thus their distance.[15] From these data we can know the size, age and something of the origins and destiny of the Universe itself. However, more recent work that does not involve

[13] Anonymous, 'The Hertzsprung-Russell Diagram', at http://en.wikipedia.org/wiki/Hertzsprung-Russell_diagram [accessed 14 November 2011].

[14] Anonymous, 'Big Bang', in *Cosmos – The SAO Encyclopaedia of Astronomy*, http://astronomy.swin.edu.au/cosmos/B/Big+Bang [accessed 18 November 2011].

[15] Anonymous, 'Redshift', in *Cosmos – The SAO Encyclopaedia of Astronomy*, http://en.wikipedia.org/wiki/Red-shift [accessed 18 November 2011].

photography has uncovered the mysterious Dark Matter and Dark Energy, and with it the realisation that we are only familiar with the stuff that comprises about five percent of the Universe. The rest, Dark Matter and Dark Energy, remains to be understood.[16]

Colour photography

I joined the then Anglo-Australian Observatory as its photographic scientist in mid-1975, just as photographic astronomy was at its zenith. I had enjoyed an eighteen-year career as a chemist and microscopist in England and was looking for a change of direction, which I certainly found.[17] My brief was to establish the photographic laboratories and procedures at the newly commissioned Anglo-Australia Telescope, to support visiting astronomers, and undertake my own research projects. This was essentially a research support job, but it quickly led to some astronomical and photographic discoveries that gave me more of a research role.[18] Almost incidentally, I was also asked find a way to make colour images of objects in the largely unexplored but spectacular southern sky to advertise our shiny new telescope. Happily, some of the techniques I was using for research activities fitted perfectly with the techniques I developed for colour images.

At this time colour photography in astronomy was not new: the first colour images were made using telescopes at Mt Palomar in California 1958, using colour film.[19] But exposure times were inconveniently long and the results uncertain, mainly because colour film was intended for snapshot exposures, and it did not work well with exposures of an hour or more, producing unexpected and uncorrectable shifts in colour balance. My solution was to go back to first principles and adopt the process underlying James Clerk Maxwell's (1831-1879) first demonstration of colour photography in a demonstration at the Royal Institution in London in May, 1861.[20]

[16] Entries for 'Dark Matter' and 'Dark Energy', in *Cosmos – The SAO Encyclopaedia of Astronomy*, http://astronomy.swin.edu.au/cosmos/D [accessed 18 November 2011].

[17] D. F. Malin, 'Photography with the Anglo-Australian Telescope', in *Celebrating the AAO, Past Present and Future*: Proceedings of a Symposium Held in Coonabarabran 21–25 June 2010, to Commemorate 35 Years of the AAO and its Transition to the Australian Astronomical Observatory, ed. R. D. Cannon and D. F. Malin (Canberra: Commonwealth of Australia/DIISR, 2011).

[18] D. F. Malin, 'David Malin publications – Scientific Papers and Patents', http://203.15.109.22/images/general/scipap.html [accessed 18 November 2011]; D. F. Malin, 'About Astronomical Photography', http://203.15.109.22/images/general/photography.html [accessed 18 November 2011].

[19] William C. Miller, 'The First Color Portraits of the Heavens', *National Geographic* 115, no. 5 (May, 1959): pp. 670-79.

[20] Anonymous, 'Additive color', https://en.wikipedia.org/wiki/Additive_color [accessed 14 November 2011].

Maxwell was keen to understand the nature of colour vision, probably as part of his much broader quest to understand the nature of light itself, and he devised an experiment to explore the possibilities. He employed a photographer (Thomas Sutton, 1819-1875) to make separate black and white negatives of a piece of coloured tartan through a series of red, green, blue and yellow filters made from coloured liquids. From the negatives, Sutton made positive slides for projection using a 'magic lantern'. In the Royal Society demonstration, three projectors were used side by side and carefully positioned so the projected images were superimposed in register. Again colour filters were used, this time in front of the projector lenses so that the slide from the negative taken in red light was projected through a red filter, that taken in green light used a green filter, and so on. Maxwell found that a combination of slides taken with red, green and blue light produced the most realistic-looking image on the screen – the world's first colour picture – and in the process settled a basic question about colour vision.

As an aside, I should mention that this is a demonstration of 'additive' colour mixing, where a white screen in darkness reveals colour by illumination with coloured light. When equal intensities of the additive primary colours, red, green and blue (RGB) are superimposed on it, the screen looks white. In the more familiar subtractive colour mixing, one starts with an illuminated white surface and coloured pigments or dyes are layered on it. The primaries here are yellow, magenta and cyan, which absorb blue, green and red light, respectively. Mix together yellow, magenta and cyan pigments and the result is very close to black.

There were several reasons why Maxwell's experiment should not have worked, the main one being that the photographic plates that Sutton used were most sensitive to blue and ultraviolet light, much less sensitive to green light and almost insensitive to red. However, Maxwell was not aware that his red filter 'leaked' ultraviolet light, which is why he was able to make a red-light image at all. Despite its deficiencies, Maxwell's demonstration is the origin of all colour reproduction systems in use today.

Faced with the need to make colour images in astronomy, I used an updated version of Maxwell's additive process. The glass plates used at the telescope were exposed behind colour filters to produce a matched set of three separate negatives containing the RGB information from the object of interest. From these plates, contact positive, monochrome film copies were made. These were projected one at a time using a photographic enlarger on to a sheet of colour film held in a simple registration device. Each positive image was projected through a blue, green or red filter, as appropriate, to assemble a true-colour image on the colour film. Though it sounds simple, there were many technical niceties that required attention before good results were obtained; however, once these were addressed, the process was reliable and reproducible.[21] Because

[21] David F. Malin, 'A Celebration of Colour in Astrophysics', *Current Science* (Indian Acad-

an essential ingredient was the production of a positive copy of the original plate, other techniques, such as photographic amplification or unsharp masking that also produce a positive derivative, could be used to control the dynamic range, sharpness and colour balance of very faint images that had never been imaged in colour before.[22] These techniques were also very useful in scientific investigations that did not involve colour imaging.

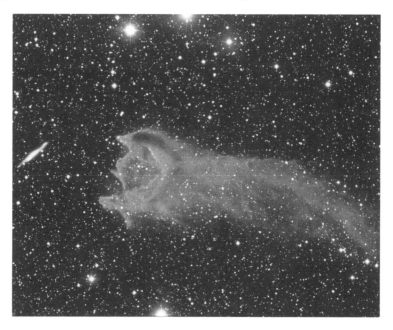

Fig. 31.4: The 'Hand of God' nebula. This small cloud of gas and dust is extremely faint and was not discovered until 1976. The true-colour image was made fifteen years later, using special techniques to reveal the colours that tell of the complex chemistry and physics of interstellar dust clouds.

Additive colour imaging using an analogue process was a rarity in 1978 when I made the first colour images. However, with the advent of the computer and digital camera it is now universal, and the digital equivalents of unsharp masking and photographic amplification are found in most image manipulation software.

The impact of colour astronomical imaging cannot be overestimated. It was a surprise to find that the Universe was so colourful, since, because of the eye's deficiencies, visual observations gave no hint of it, except with bright objects

emy of Sciences) 60, no. 1 (1991): complete issue.

[22] David F. Malin, 'Unsharp Masking', *AAS Photo-Bulletin* 16 (1977): pp. 10-13; David F. Malin, 'Photographic Amplification of Faint Astronomical Images', *Nature* 276 (1978): pp. 591-93.

such as the planets. While the images I made in the twenty years after 1978 were well received and widely published, it was the reaction of my professional colleagues that was most gratifying. This was mostly along the lines that their favourite object or class of object (especially galaxies and star-forming regions) had been revealed to them, literally in a new light, and often gave them new insights that monochrome images could not. Later, from about 1993 onwards, the Hubble Space Telescope took astronomical imagery and its presentation to the public to a new level.

I am very grateful to the organisers of this conference for the opportunity to review elements of the history, successes and motivations of astronomical imagery and show how astronomical imagery in colour emerged from earlier ideas. I was delighted when they suggested they would hold an exhibition of my work in conjunction with the meeting. The images on the walls of The Bristol Gallery were made from the original, black and white film copies of the original plates. I scanned these using a normal flat-bed scanner and combined them into colour images in my computer using Adobe Photoshop, which thinks in RGB. The results are better than anything I could have done in the darkroom and took a fraction of the time. I think that Maxwell would have been pleased.

Lightning Source UK Ltd.
Milton Keynes UK
UKHW050621290422
402235UK00001B/1